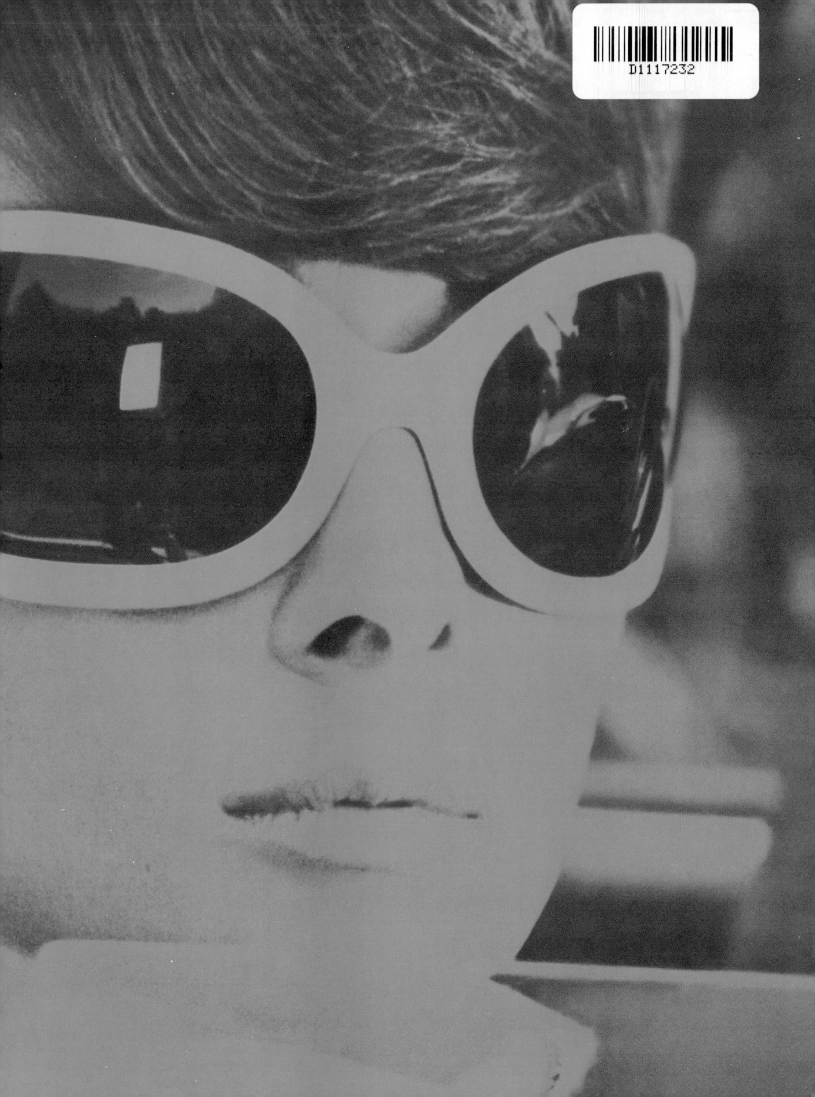

AN IMPRINT OF
HARPERCOLLINS*PUBLISHERS*
YourItList.com

drey

The 60s

David Wills

and Stephen Schmidt

Contents

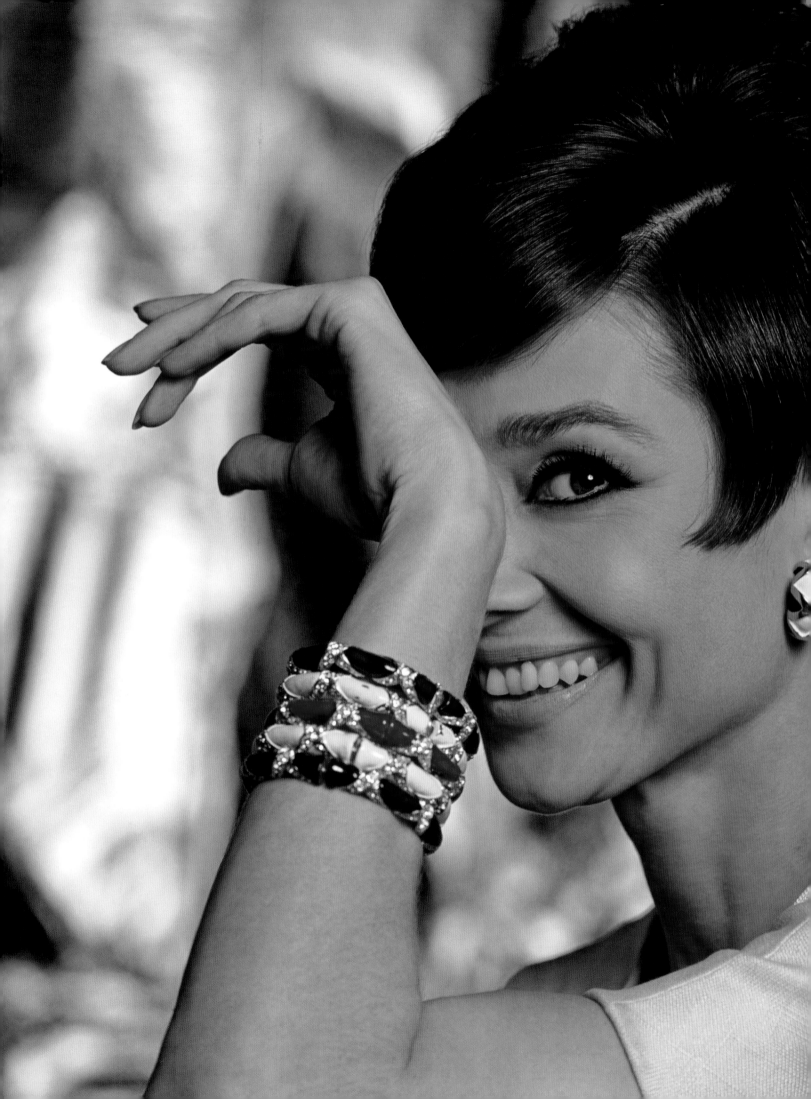

INTRODUCTION

Who *is* Holly Golightly?

Is she Truman Capote's "wild thing," or Audrey Hepburn's free spirit?

Holly on the page is nineteen, world-weary but beguiling, a backwoods hick fleeing her only semblance of family, a scrambling call girl sporting stylish frocks, among which is one hard-fought Mainbocher. She is choosing her life by the minute, and she chooses to vanish. The screen Holly is circling thirty, womanly, effortlessly chic, a high-class escort, a country girl transformed by an upper-crust accent and the contents of a tiny closet overstuffed with Givenchy. Asking "How do I look?" while knowing the answer, she exists on a diet of champagne and compliments, swinging from benefactor to benefactor, and seems always two steps ahead of disaster. This Holly has all but

chosen her destiny, is romantically intercepted, and falls for a Hollywood ending.

Without doubt, Hepburn's Holly has now totally eclipsed Capote's original creation. At first mention, *Breakfast at Tiffany's* no longer evokes a story set in late forties Manhattan, but rather an early sixties motion picture starring a fashion icon and Hollywood legend.

Capote's novella, a minor sensation in 1958, made for a tricky translation to screenplay. A lighter tone was needed, so Paramount employed George Axelrod to clean house. Axelrod swept away the explicit, installed some moral ambiguity, and spiffed up a heroine for mass consumption. Initially concerned about playing a "hooker," Hepburn was assured by director Blake Edwards that the character would be "purified by the style in which he would shoot the picture."

Purified—and glamorized. Paramount ensured that the movie would have "a very stylish look" when the actress was engaged to play the part for $750,000. Edith Head, the grande doyenne of studio costuming, would be quickly passed over (a slight Ms. Head would never forgive) as the designer of the greater part of "Holly's" wardrobe. Hubert de Givenchy, Audrey's long-standing couturier and confidant, would instead be in charge of the major fashion moments. By late 1960, with all elements in place, the

newly refurbished Holly Golightly was ready to appear before the camera.

The opening scene—Fifth Avenue deserted at dawn, a cab slowing to a stop outside Tiffany & Co. to discharge a sleek passenger wearing a black column dress, sunglasses and pearls, and nibbling on a coffee-counter breakfast—is not in the book. But having been put on film so simply and authoritatively, it feels inevitable, an instant classic, and so ravishing that it all but announces the reimagining of Audrey Hepburn. The reluctant coquette of the fifties, in voluminous skirts and skinny capris with ballet flats, was now giving way to a sexy sophisticate. The black dress, ingeniously sculpted and as intriguing from the back as it was from the front, shifted seductively with the polished steps of its wearer. Two copies were made – one for walking and a narrower version for standing and posing.

The film's signature creation, however, appears later. Teamed with a scarfed hat, the same Wayfarer sunglasses, and alligator shoes, this dress—sleeveless, bateau-necked, and with an embellished hem—was evidently considered ideal for a day trip to Sing Sing, and is truly the one that spawned a billion imitation LBDs. Other catwalk moments include the box coat with architectural seaming, the structured fur cloche (not quite suitable for pinching a bowl of goldfish), the trench coat (dry or drenched)

paired with black turtleneck, and the shocking-pink cocktail dress as a counterpoint to shockingly bad news. Hair stylist Nellie Manley alternately swept Audrey's hair into a streaked chignon, double ponytail (a dash of Lulamae), or let it fall loose to the shoulder. Wally Westmore's makeup adapted to the times by shifting focus from the oversaturated and lacquered lips of the fifties to the bold and dramatically lined eyes of the sixties. She also sported newly streamlined eyebrows. The costume jewelry that Holly acquired, though not the Tiffany gems she aspired to, were created by Joan Joseff in bold and brilliant form. All this array was gathered to delicately delineate a character the studio was wary of promoting. She was a callgirl, yes, but in Hepburn's care audiences willingly went along for the ride.

When Holly stands at the bus station and gently explains to her abandoned husband through eyes welled with tears, "Please, Doc. Please understand. I love you, but I'm just not Lulamae anymore. I'm not," it heart-wrenchingly spoke to a generation of young women sitting in movie theaters all over the world, on the cusp of reinvention, eager to move to the big city and become the creation of their mind's eye. Indeed, Hepburn's Holly suggests a new woman for a new decade. Feminists at the time must have been hesitant to espouse this dynamic, Capote's girl being at least an immoral opportunist, and Hepburn's woman at most

an amoral role model. However, here is a mainstream example of the broadening of possibilities. Holly leaves an unhappy marriage to escape an intolerable future, making her own choices from an unconventional agenda; she does not let herself be caged by propriety, and never apologizes for her actions. Through the looking glass that was Audrey Hepburn herself, the intelligence, the cleverness, the hint of androgyny in the angular face and curveless figure, the character offers a subliminal alternative to the era's traditional female aspirations. The role became a surprising signature, synonymous with the decade and the fresh Hepburn image. In early 1961, at the dawn of what would become that avalanche of change known as "The Sixties," Audrey as Holly personified a dream.

Today of course the emphasis has shifted, and Hepburn's Holly looks back at us from a thousand posters, T-shirts, calendars, and fridge magnets. Her image, deified by time, has become a benchmark—the unrivaled blueprint for a fashion lifestyle.

Following *Breakfast at Tiffany's*, Audrey opted for a change of play and signed for *The Children's Hour*, to portray a girls' school teacher, an everyday workingwoman nearly destroyed by rumors of relations with a female colleague. Her choice was intended to broaden her range, counter her clotheshorse reputation with a skirts-and-sweaters role, and manifest a

kinship to the rising film-as-social-commentary movement coming largely out of Great Britain. Reviewed tepidly at best, the picture is remembered most for its failure to live up to its own sociocultural ambitions.

With *Charade*, Audrey stepped back into familiar territory, shooting a romantic thriller in Paris, the location of four of her films. She was paired with an older leading man, Cary Grant, worked with one of her favorite directors, Stanley Donen, and appeared in ensembles created for her by M. Givenchy. Dashing about the landmarks of the city in her "wealthy widow chic," Hepburn dazzles in sharply tailored coats, conservative body-skimming dresses, pillbox hats—all in neutrals, pastels, and very little black. Here she further establishes herself as a couturier's best mannequin, despite Cary Grant's concern at the time that the clothes were "too over the top. Too fashionable."

Audrey's next film, once again set in the City of Lights, reunited her with *Sabrina* costar William Holden. Titled *Paris When It Sizzles*, it unfortunately set up an irresistible critical punch line using the word "fizzles." However, with Givenchy close at hand, Audrey gallops gamely through each setup in her beautifully detailed, yet simple, soft tangerine dress and summer hat. In one scene, she lounges for her leading man on an enormous round bed and frees her hair from its proper chignon

(created by hair stylist Dean Cole), letting it fall enticingly below one shoulder. In one of the film's few interesting scenes, a lost opportunity occurs when Audrey, as Gabrielle, dons medieval garb for a masquerade ball, and appears very awkward in a much too plain, indeterminately blue court gown and conical headpiece, topped by a lengthy waft of chiffon that sails from the sunroof of the car as she and Holden speed to the airport in search of the movie's climax.

Following a widely reported casting controversy, Audrey was awarded the title role in *My Fair Lady*, the most lavish musical yet filmed. For one million dollars, she would be acting, dancing, but singing only ten percent of Eliza Doolittle's songs. Due to vocal inadequacies, unflattering publicity, and an exhausting and troubled shoot, it was a truly polarizing moment in her career; despite a charming performance, Audrey's reviews ranged from faint praise to mild condemnation.

However, period virtuoso Cecil Beaton held sway over the epic musical's total ambience, from settees and soirées to lace and lorgnettes, and Audrey appears touchingly beautiful in her transformation from grimy flower girl to the fairest of ladies. The "Ascot Gavotte" sequence inspired a black-and-white extravaganza, complete with lofty picture hat and fresh visage (by makeup artist Frank McCoy), while the empire-cut

and beaded ivory chiffon gown, towering coif (by Jean Burt Reilly and Dean Cole) and glittering tiara made for a stunning entrance at the embassy ball. No trends were set, but the scenario was familiar and reassuring, recalling the makeovers so pivotal to *Sabrina* and *Funny Face.*

Audrey's *My Fair Lady* coiffures, especially the foot-high "Edwardian" for the gala, were infused with *au courant* style and the wildly excessive daydreams of Diana Vreeland, then editor in chief of American *Vogue.* Such fantasy head-toppers, designed by stylist extraordinaires like Alexandre de Paris, the Carita sisters and Ara Gallant, were made architecturally possible by assembling mounds of swirling Dynel hairpieces to often rock-solid infrastructures of balsa wood, chicken wire, industrial staples and glue. Accompanied by dense half-moon eyeliner, rainbow shadowing, and multilayers of false eyelashes, these dramatic, seemingly impossible hair constructions shocked the pages of *Bazaar* and *Vogue,* and spread an exotic theatricality over fashion editorials everywhere. Audrey was swept into this cultural combustion and, not confined to the physical trappings of a character, was able to have fun during her fashion shoots, experimenting with hairpieces, falls, and a more exaggerated eye makeup.

Cecil Beaton was not alone in his esteem for Audrey as

mannequin. She in fact blurred the line between movie star and fashion model as no screen actress ever had, and was a favorite of many of the most prominent photographers of the era. Audrey's work with Richard Avedon, Irving Penn, Bert Stern, William Klein, Douglas Kirkland, and Beaton rivaled anything they produced with the rail-thin, doe-eyed models of the day. Even in the fifties, the ingenue Audrey had attained a high fashion distinction that her contemporaries—Monroe, Taylor, Kim Novak, and even Grace Kelly—lacked, and in the sixties continued to be considered the "ideal."

After a voluntary hiatus from moviemaking to spend time with family, Audrey was coaxed back before the cameras in 1966 to film another picture set in Paris, *How to Steal a Million*, with Peter O'Toole as her leading man and Givenchy, of course, as couturier-in-residence. With quicksilver chemistry evident between the two actors, Audrey shifted into "caper" mode by donning a helmet hat, slim suits in shades of vanilla and sorbet, and geometric white-frame Oliver Goldsmith sunglasses, as she motored around the boulevards in a tiny apple-red roadster or a Jaguar XKE. The film's defining fashion moment is a sheer black lace cocktail dress with diaphanous veil that modestly filters the drama of silver pavéed eyelids shimmering in tandem with her Cartier diamond earrings.

Picking up a fresh runway trend, Audrey wears a flirty assortment of patterned hose to match her kitten heels. A clever reversal is the "make-under" Simon (O'Toole) instigates by bagging Nicole (Hepburn) into the garb of a museum scrubwoman. Sensing her displeasure, he quips, "Well, for one thing, it gives Givenchy a night off." The movie's pace is energized by Audrey's new short "do," courtesy of Alexandre de Paris and kept sharp by Grazia de Rossi. Adroitly written, charmingly acted, and light as a soufflé, the picture was evidently as fun to make as it is to watch.

The next project was problematic, but resulted in what is now considered a modern classic. The time-fractured structure of Frederic Raphael's vigorous, innovative, and very adult screenplay for *Two for the Road* was a definite attraction for Audrey, who perhaps for the first time was feeling the heat of a new generation of leading ladies rising to prominence behind her. Making the leap into a fresh, fast, and modern approach to filmmaking, and with the encouragement of her other "great protector," director Stanley Donen, she played with considerable zest half of a British couple on the move through a twelve-year rocky relationship. Audrey and Albert Finney, as Joanna and Mark, travel the rough roads of the South of France, jump-cutting time and place and the clothes on their backs.

These clothes initially presented a problem for Audrey, who had expected her usual Givenchy wardrobe. Donen surprised his star by explaining that the story could not be told wrapped in couture, and that they needed to pinpoint Joanna "off the rack." Alarmed but trusting, Audrey relented and the film was shopped to include ready-to-wear from British designer Mary Quant, American Ken Scott, Paco Rabanne, Cacherel, and Michele Rosier, "the vinyl girl," via her V de V (Vestements de Vacances) sports label. The *New York Times* also reported that "Odds and ends were found in London and Paris boutiques."

This updated Audrey *à la mod* peppers the film in oversize wraparound sunglasses, space-age plastic visors, hard-edged synthetics, saturated colors, metallics, minidresses, and mini heels, capped by a super-angular version of Audrey's short haircut (by Grazia de Rossi) and heavy-lined lids and layers of false eyelashes devised by Alberto de Rossi. From the black PVC "Steve McQueen" jacket and pants to the eye-popping Rabanne "Unwearable Dress" of aluminum pailettes, the look is playful, edgy, and young. All are inspired indicators of the mod revolution and trends to come. As a result, following the release of *Two for the Road*, Audrey became a fresh subject in fashion and photography, modeling the latest, the newest, and at times the most "avant," making her relevant and ubiquitous yet again.

Offscreen, everything about Hepburn's appearance at this time said one thing: affluence. Her crisply tailored pant suits, Louis Vuitton shoulder bags, oversized sunglasses, and a softened modification of Sassoon's five-point bob became a jet-set staple: a look suitable for descending gang planks in Saint-Tropez or lunching at La Côte Basque.

A Broadway hit on its way to the screen, *Wait Until Dark* brought Audrey back to Hollywood in 1967 for a suspense thriller. In it she would portray a blind woman terrorized in her own home by violent thugs in search of a child's doll filled with heroin. A tour de force at the ready, Audrey prepared thoroughly with careful study and sightless training, and consequently fussed minimally about wardrobe, which was bought and fit from Givenchy Nouvelle Boutique, Dior Boutique, Miss Dior, Rose Bertin, and Charles Jourdan. The low-key look still allowed Audrey to appear appropriately styled in a well-tailored trench with coordinating skirt in patterned wool, low-heeled suede boots and a comfortable turtleneck—the turtleneck being a staple of her personal wardrobe. Her hair remained short, overseen for the shoot by Jean Burt Reilly, and her makeup by Gordon Bau, soft and mature.

Audrey retired from steady moviemaking after receiving her fourth Oscar nomination for *Wait Until Dark*. She appeared

before the cameras only occasionally, her family becoming the absolute priority she always felt it should be. The world remained entranced by her film legacy, and inspired by her untiring work for UNICEF in Africa and beyond.

Her personal style is a rare constant as subsequent generations discover her anew and look to her as a template for chic that no one else, except perhaps Jacqueline Kennedy Onassis, represents. Today's stars and their stylists might do well to look past the flash and excess of current headline-making, red carpet run-ins with current couture, and look to the polish and sophistication of a worthy role model. They don't have to be safe, just smart. Celebrities often profess outsize admiration for Audrey Hepburn's example, but in the glare of the press and public eye seldom achieve the simple elegance she so effortlessly embodied.

So who *is* Audrey Hepburn? She might be a personal touchstone, a universal vanguard, a serene and joyous presence. Classically styled but uniquely trendsetting, she resonates as an emblem of elegance, grace, intelligence, sensitivity, and beauty—in her youth, through the sixties, and, just maybe…always.

David Wills
Los Angeles, 2012

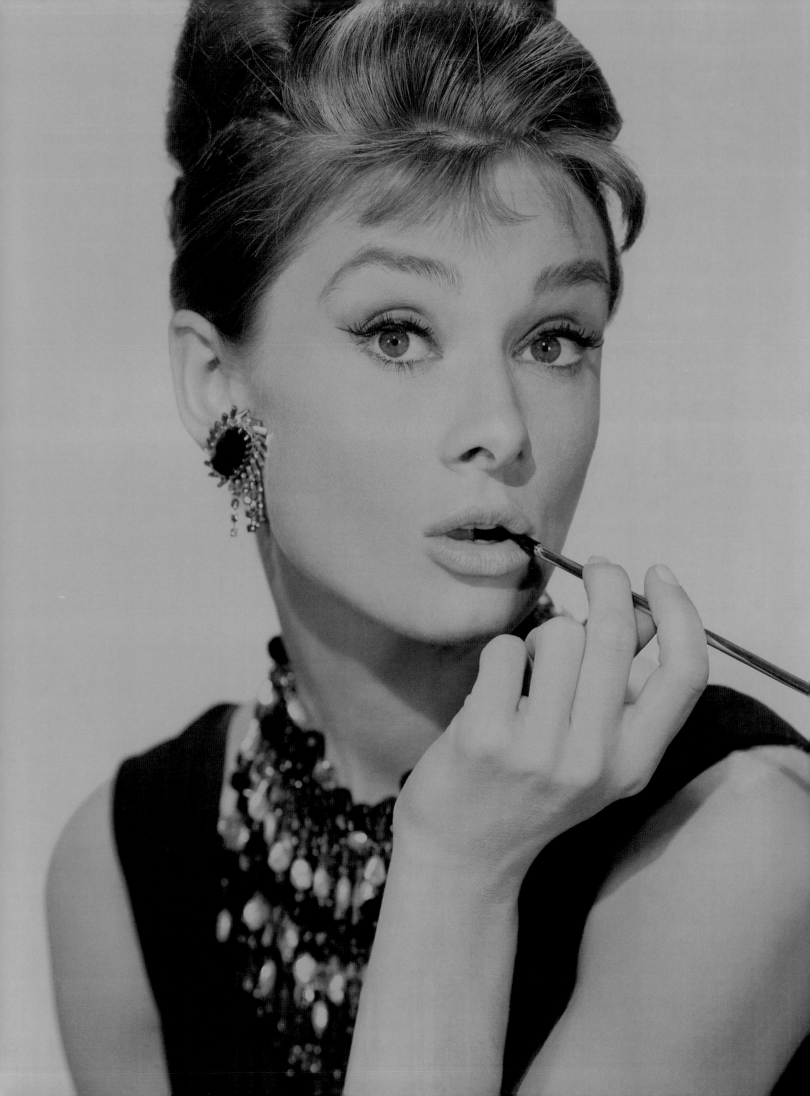

Breakfast at Tiffany's

1961

"There is not a woman alive who does not dream of looking like Audrey Hepburn."

HUBERT DE GIVENCHY (Designer)

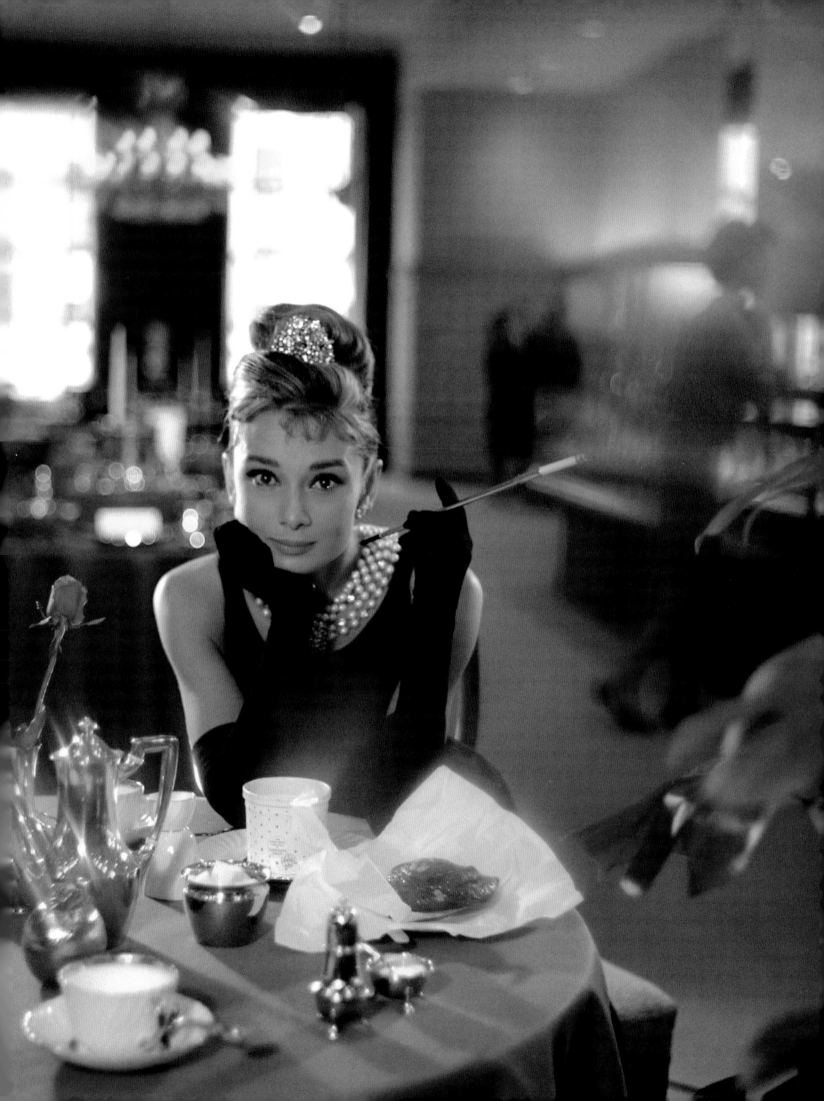

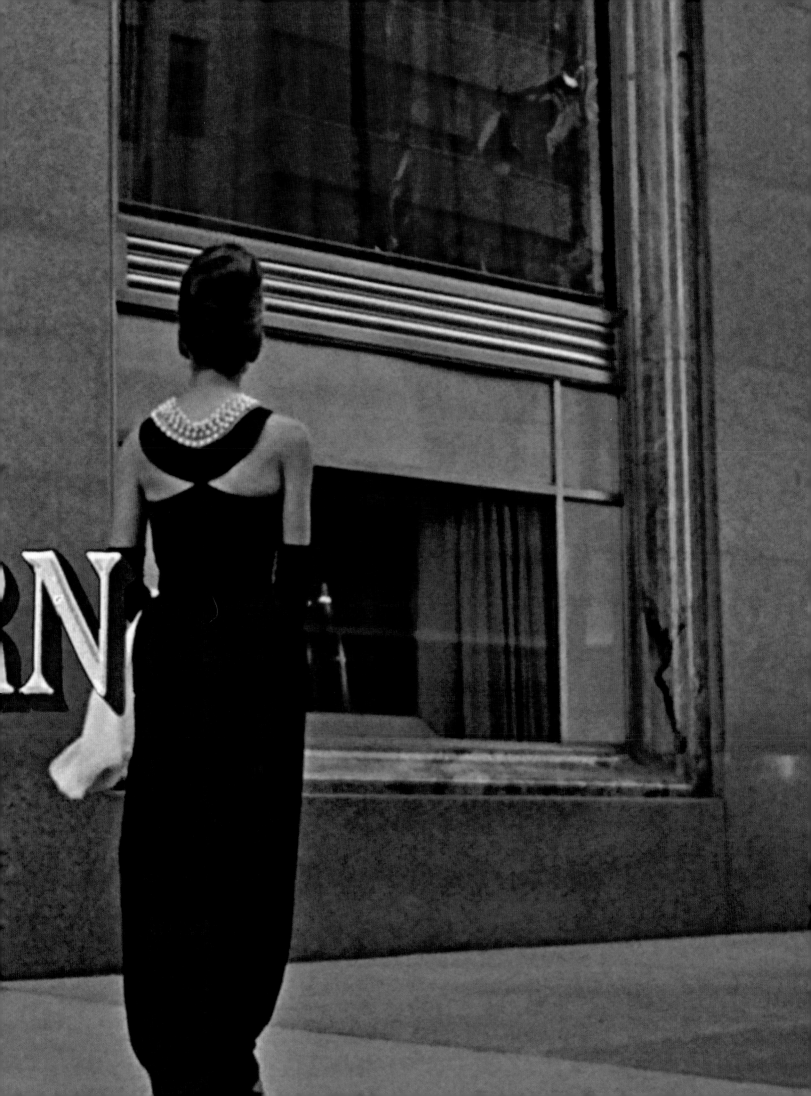

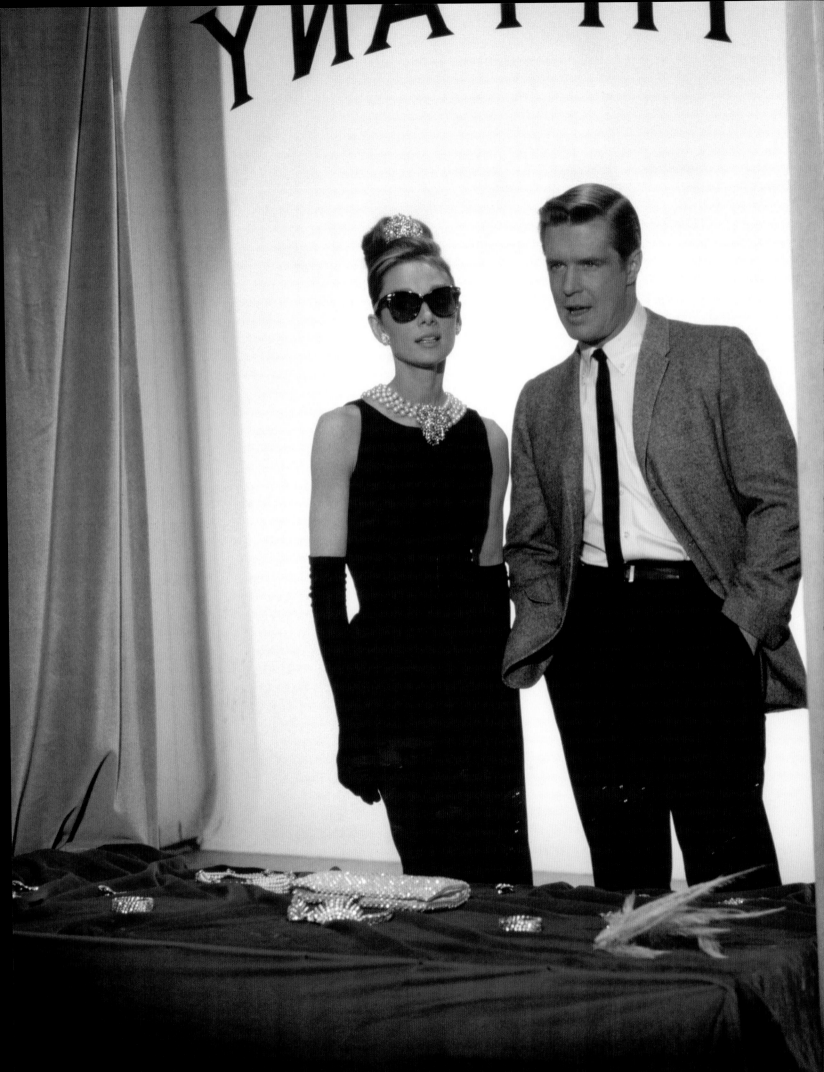

"…she wore a slim cool black dress, black sandals, a pearl choker. For all her chic thinness, she had an almost breakfast-cereal air of health, a soap and lemon cleanness, a rough pink darkening in the cheeks. Her mouth was large, her nose upturned. A pair of dark glasses blotted out her eyes. It was a face beyond childhood, yet this side of belonging to a woman."

Breakfast at Tiffany's, by Truman Capote, 1958

"Anything that was flash to her was not real glamour or chic. There was no pretension."

JOHN LORING
(Design Director Emeritus, Tiffany & Co.)

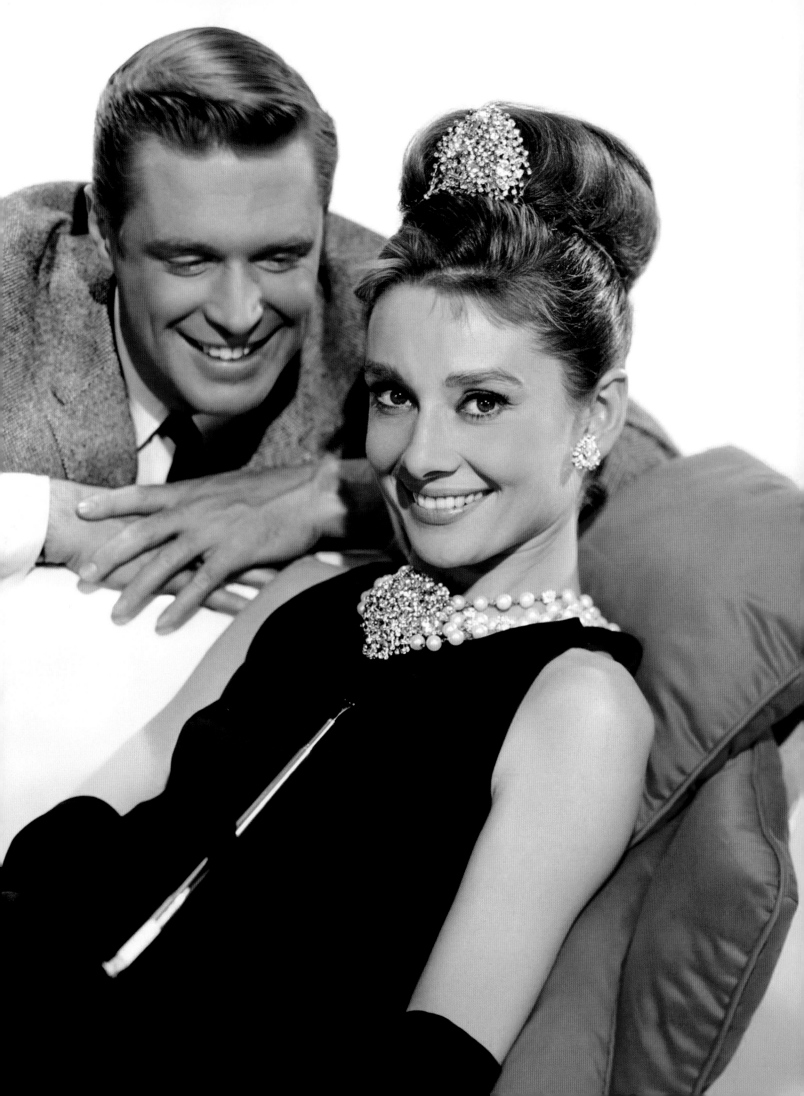

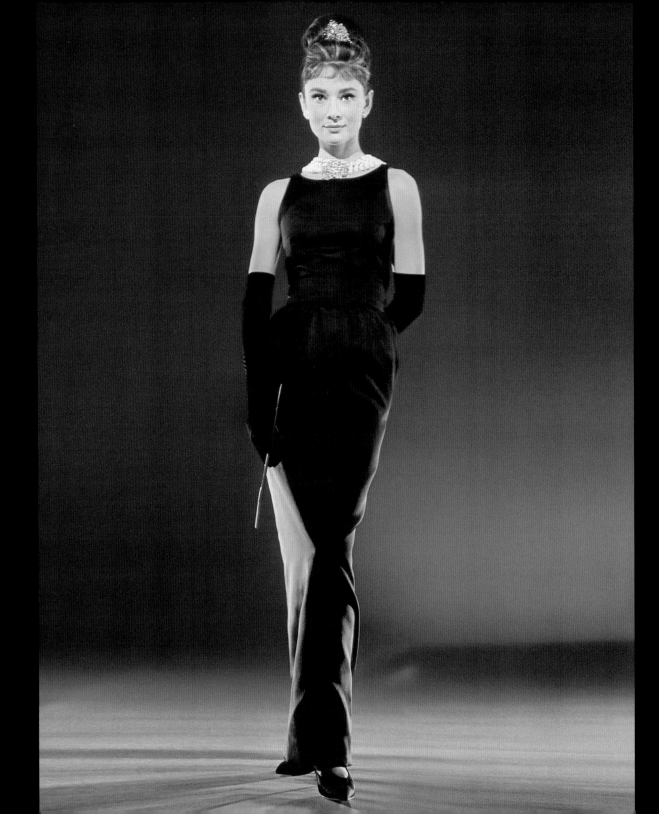

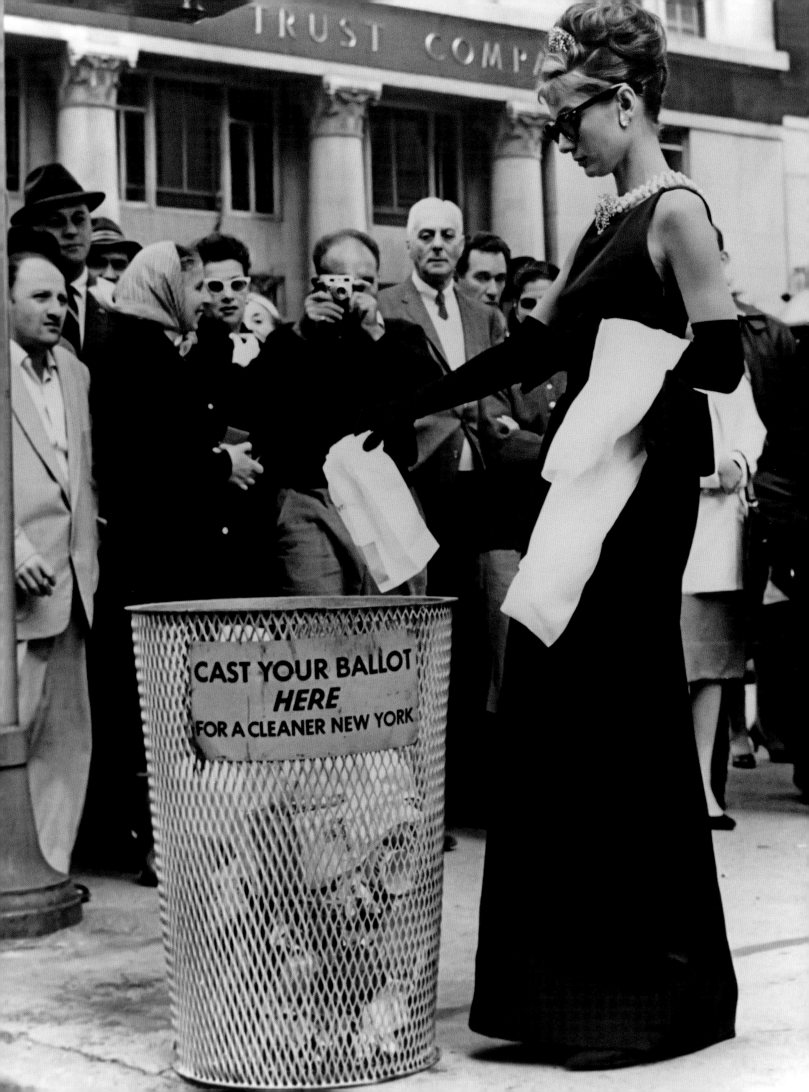

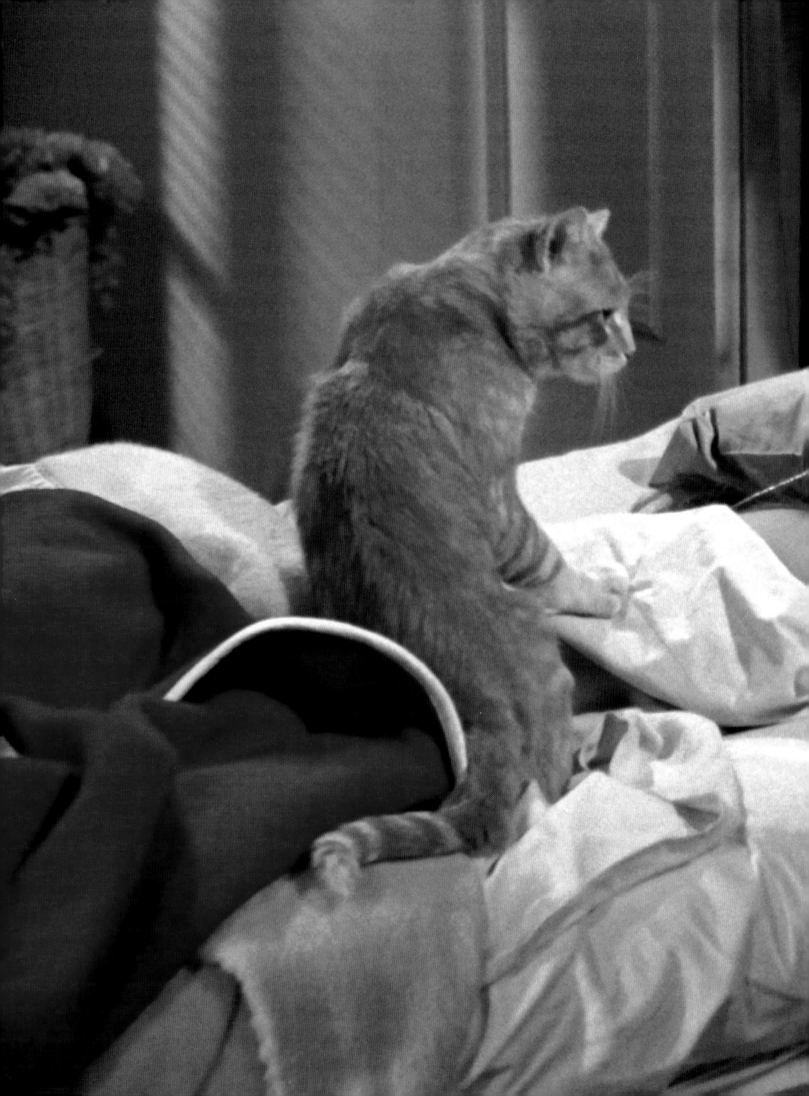

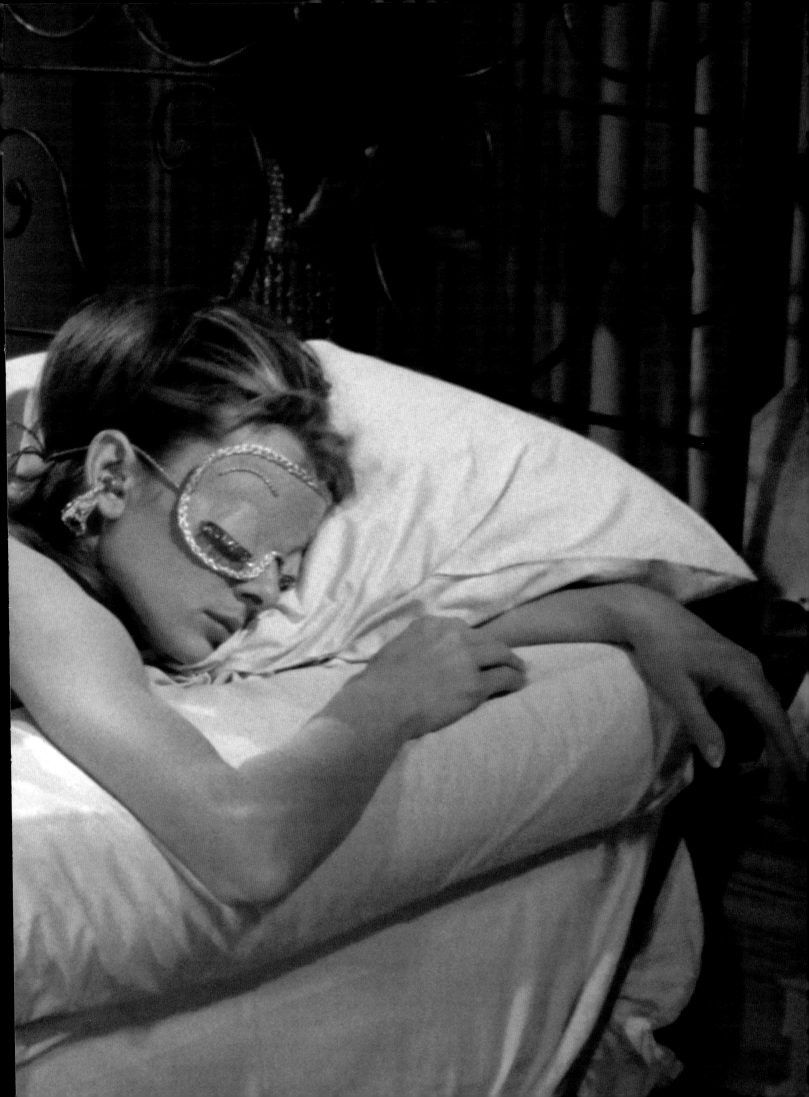

"I was nothing like her, but I felt I could 'act' Holly. I knew the part would be a challenge, but I wanted it anyway. I always wonder if I risked enough on that one. I should have been a little more outrageous. But at the time, as a new mother, I was about as wild as I could be. If only I were a Method player, huh? But the fact is, I didn't really believe in the Method. I believed in good casting. And I'm still not sure about Holly and me…"

AUDREY HEPBURN

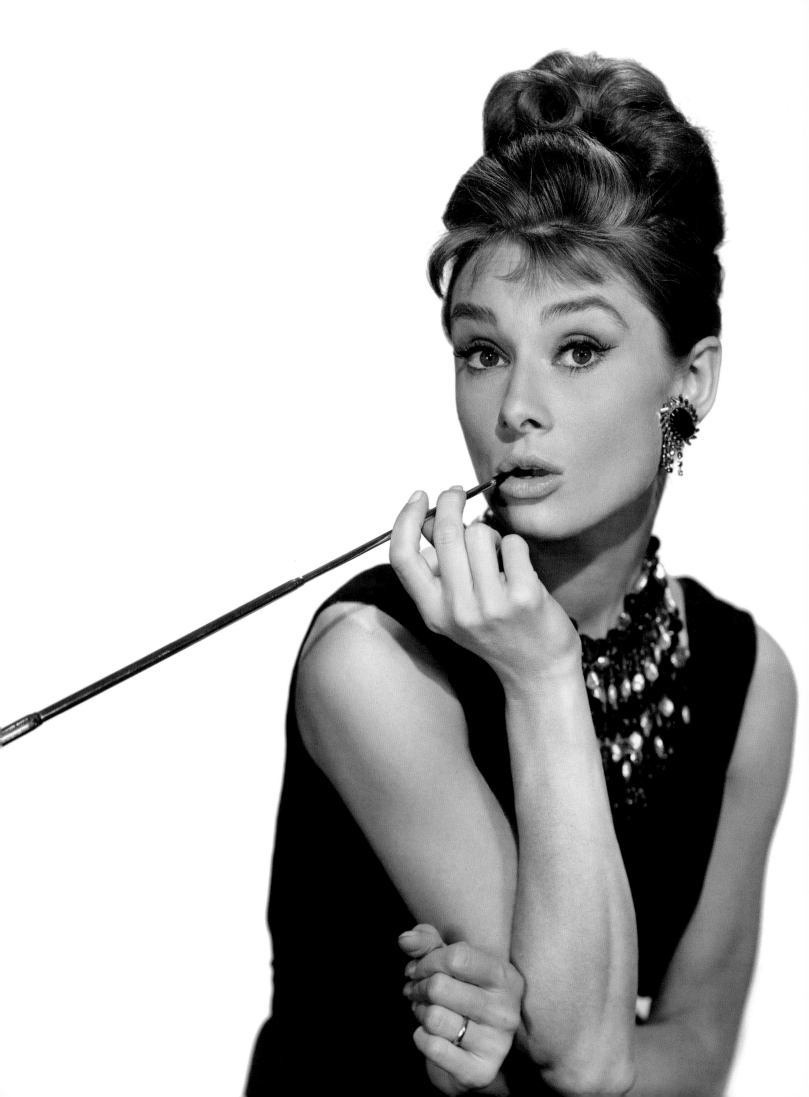

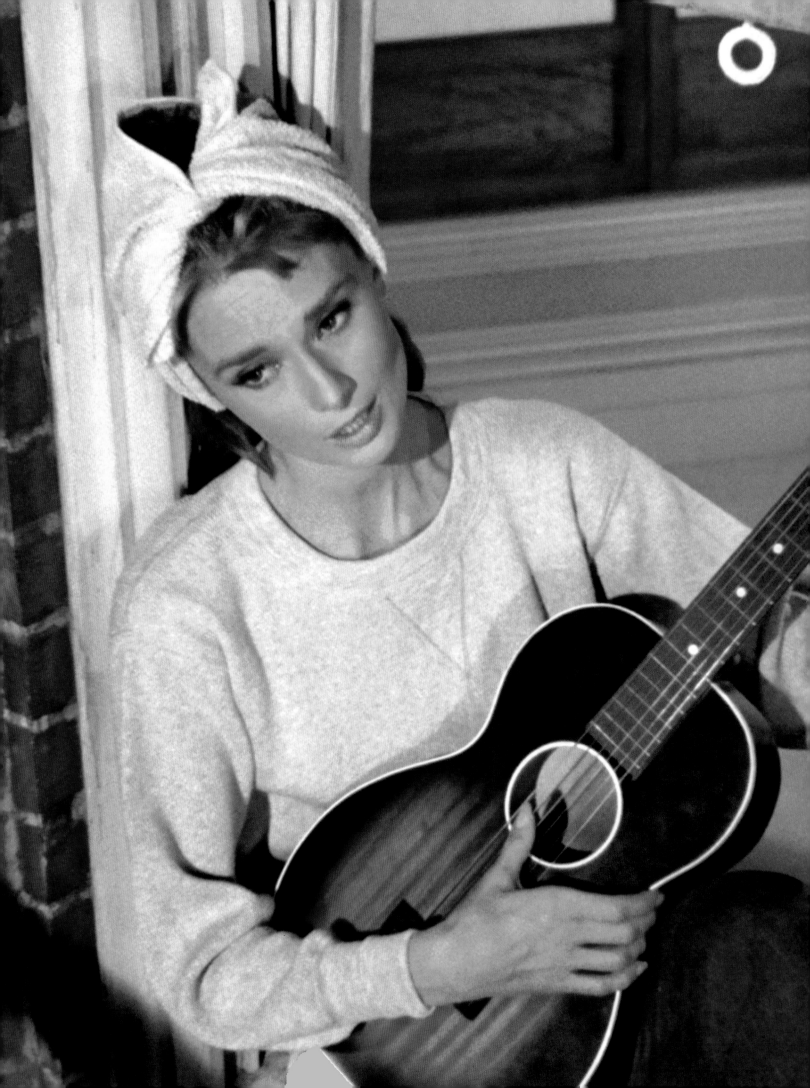

"'Moon River' was written for her. No one else has ever understood it so completely. There have been more than one thousand versions, but hers is unquestionably the greatest."

HENRY MANCINI (Composer, "Moon River")

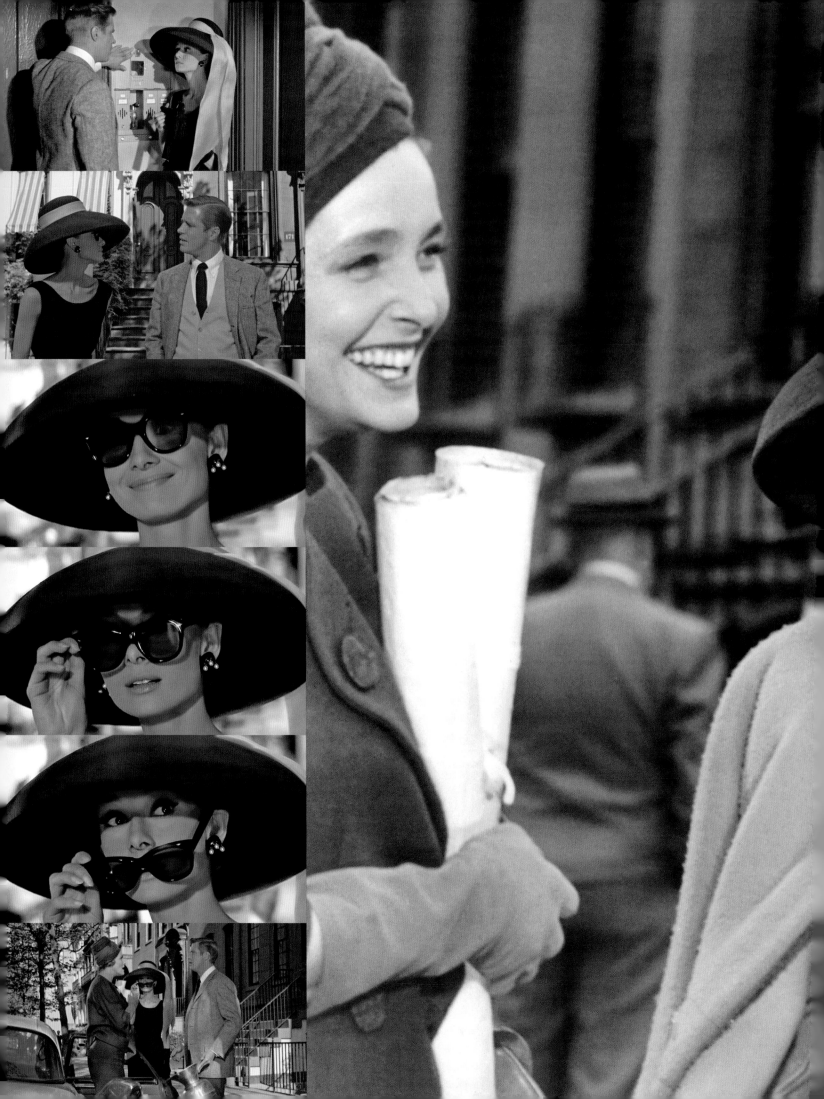

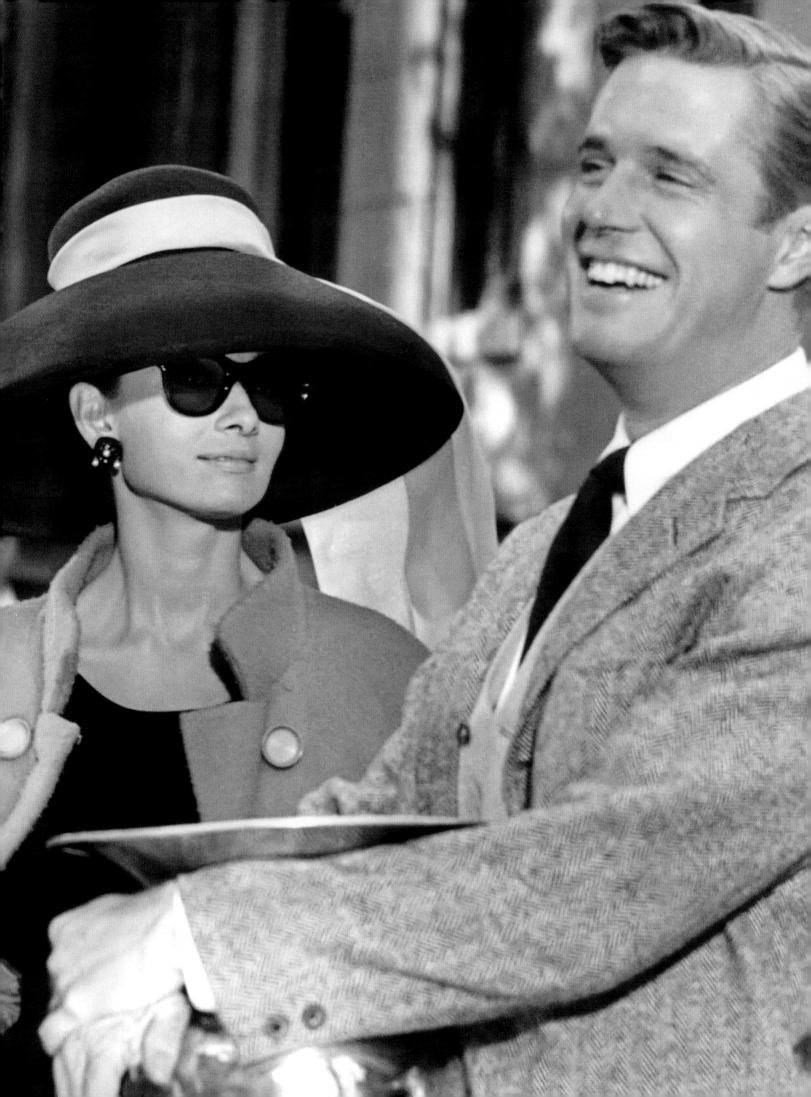

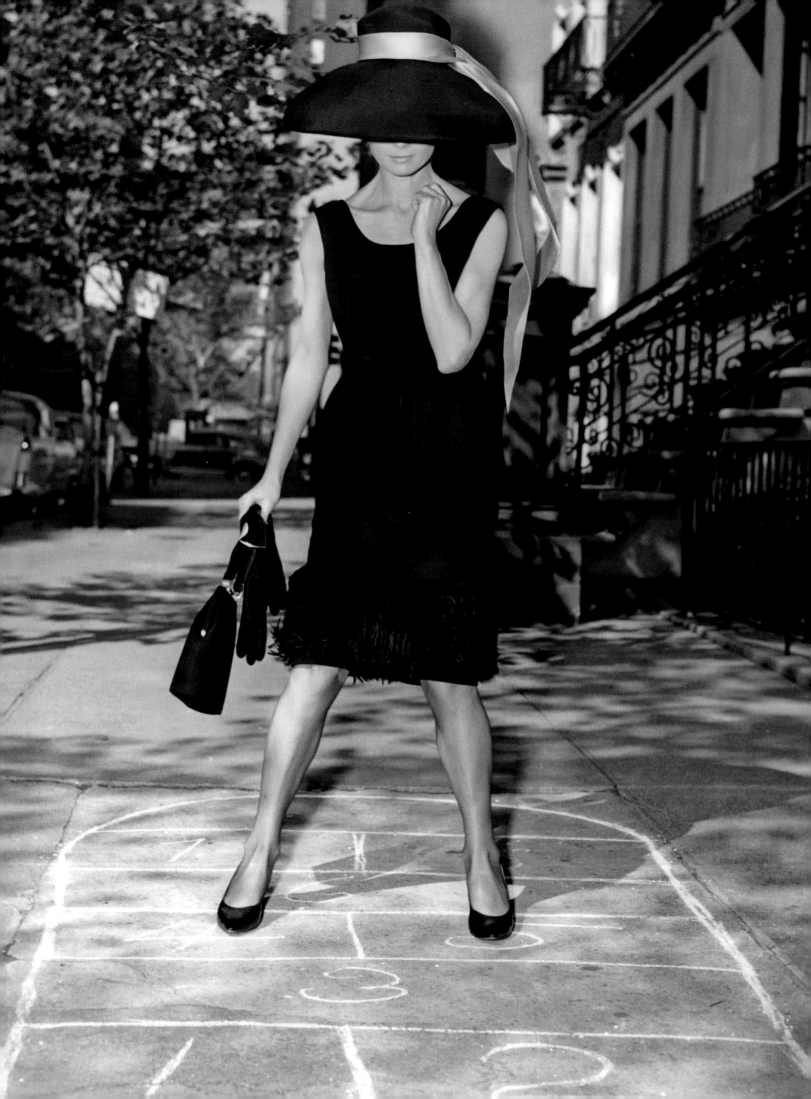

"Above all, it has the overpowering attribute known as Audrey Hepburn, who, despite her normal, startled fawn exterior, now is displaying a fey, comic talent that should enchant Mr. Capote, who created the amoral pixie she portrays, as well as moviegoers meeting her for the first time in the guise of Holly Golightly."

THE NEW YORK TIMES

"How do I look?"

AUDREY HEPBURN as Holly Golightly
(*Breakfast at Tiffany's*, 1961)

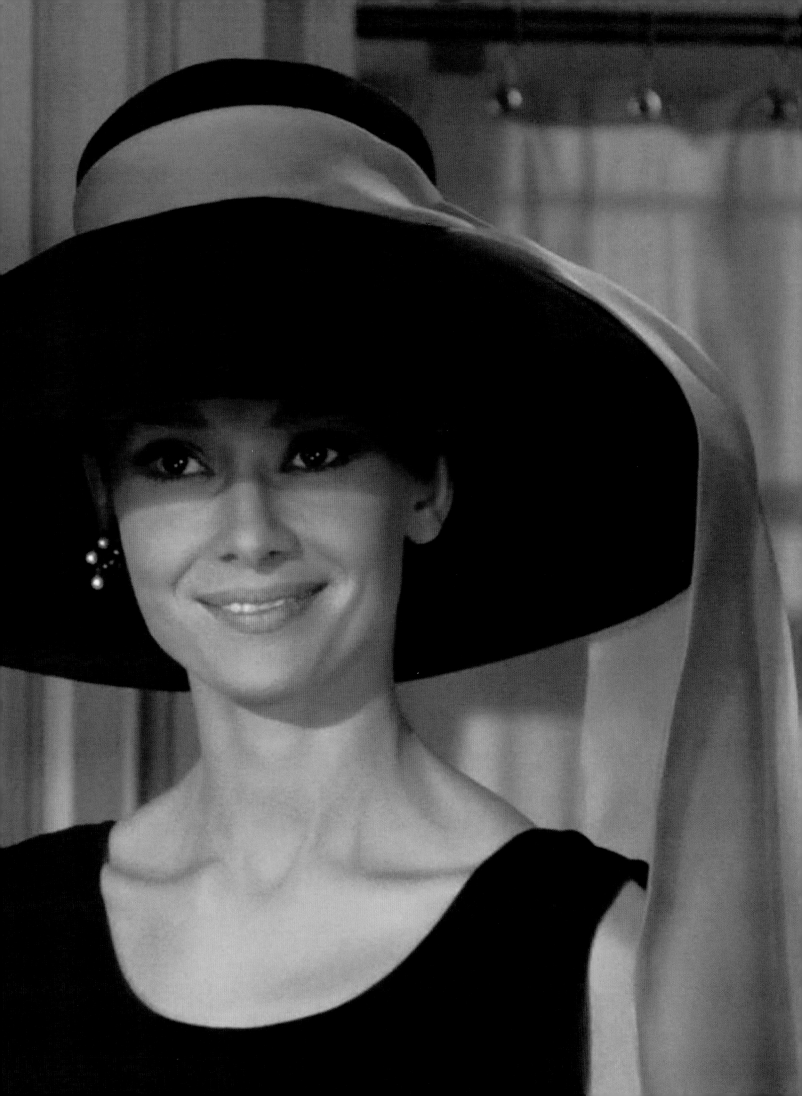

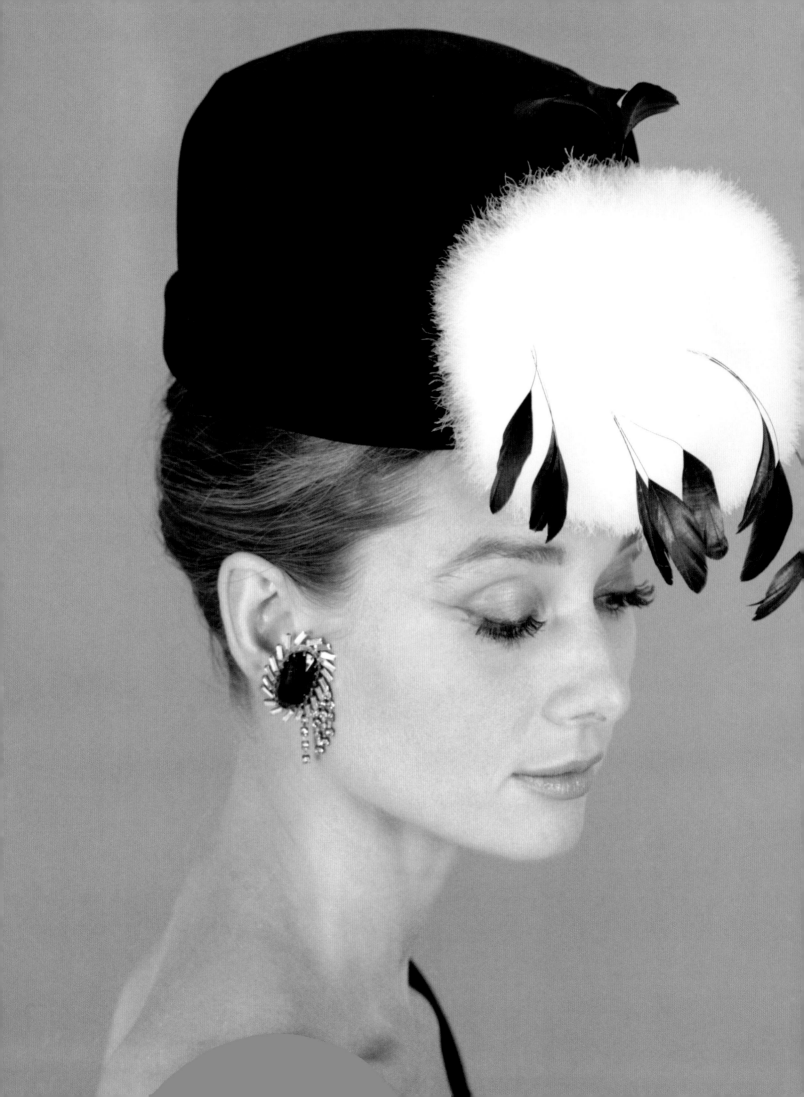

"Audrey could have been a designer herself, she had such perfect taste."

EDITH HEAD (Costume designer)

"There are certain shades of limelight that can wreck a girl's complexion."

AUDREY HEPBURN as Holly Golightly

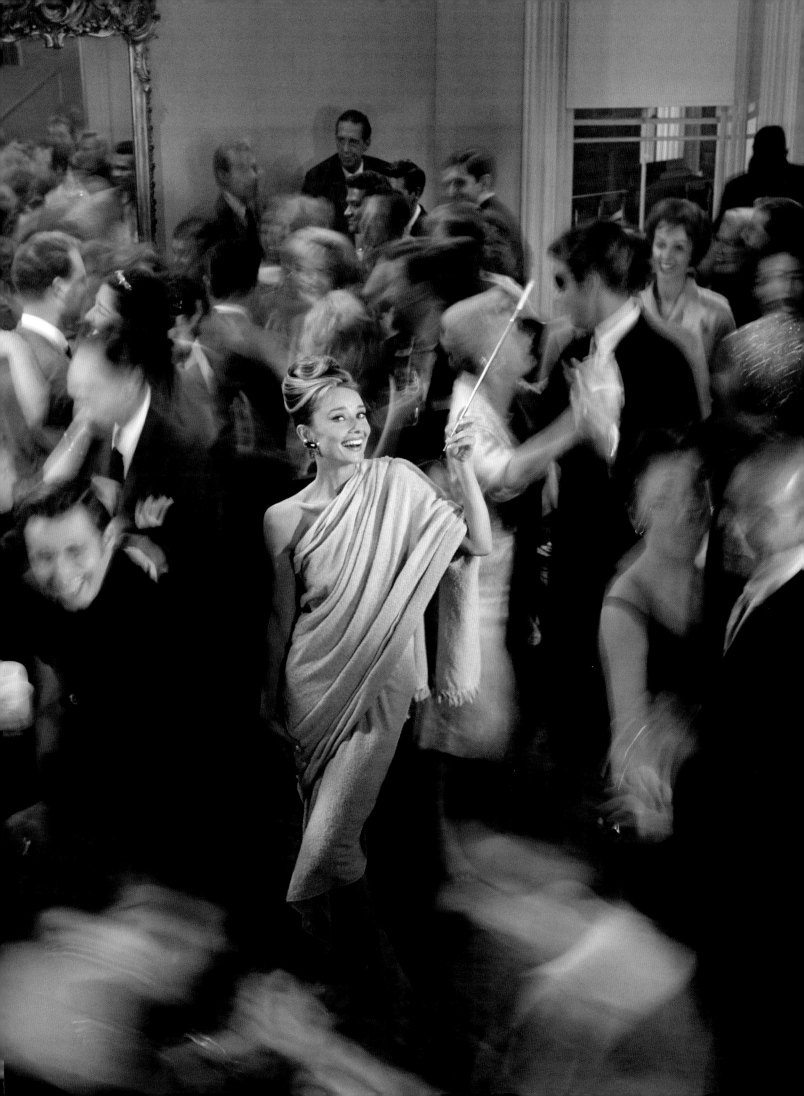

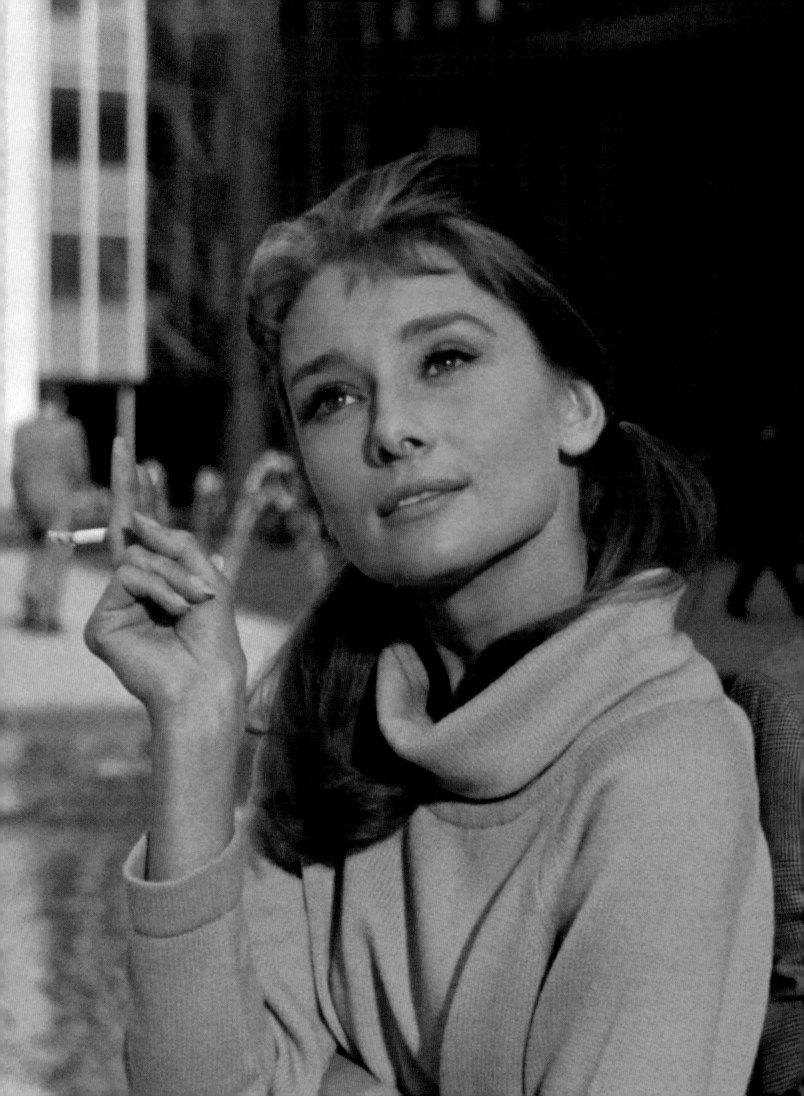

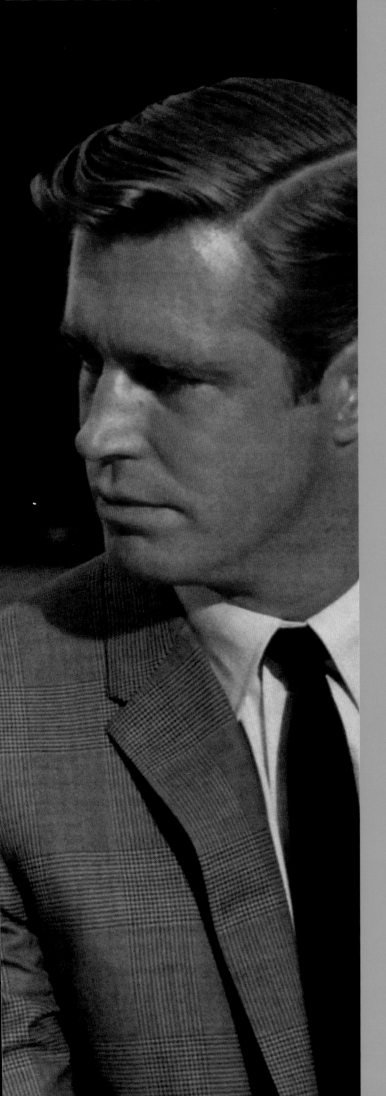

"Oh, I love New York."

AUDREY HEPBURN as Holly Golightly

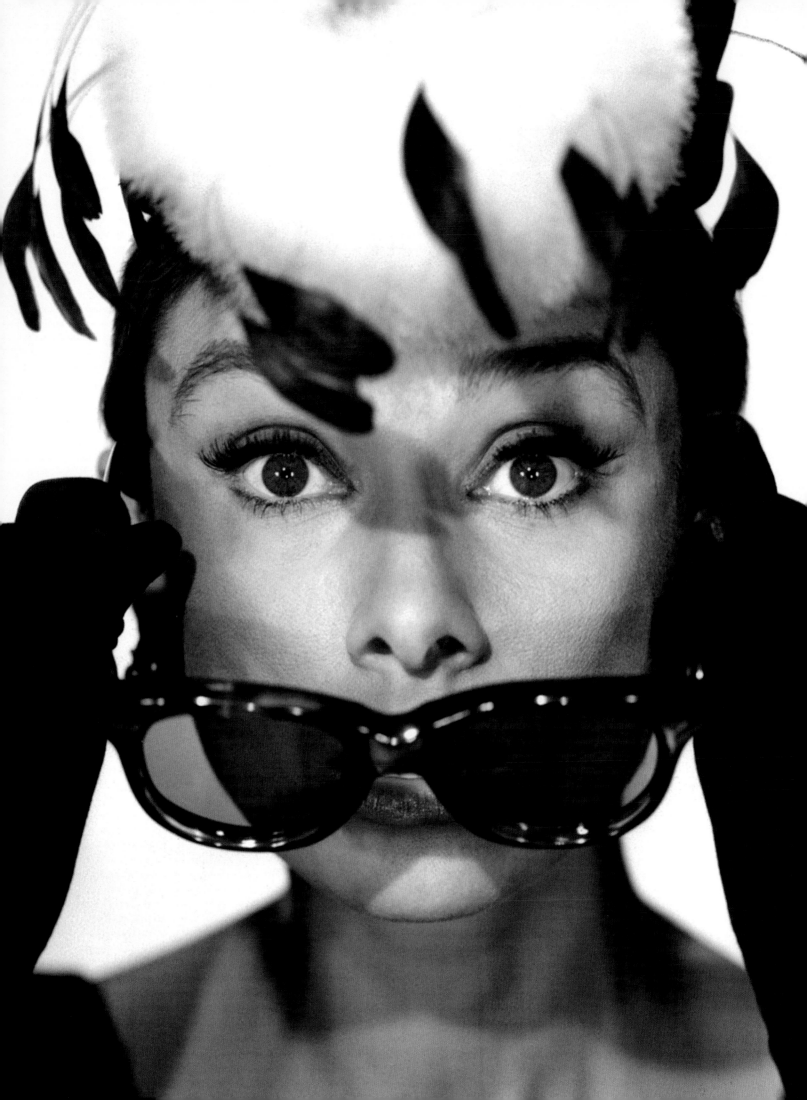

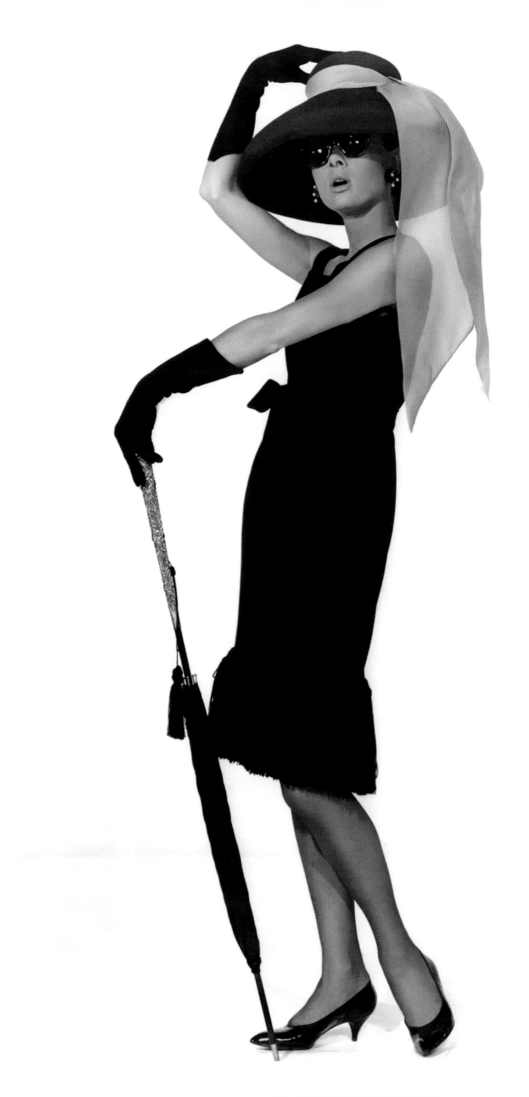

"I couldn't quite fathom that she was real. There were so many paradoxes in that face. Darkness and purity; depth and youth; stillness and animation. She had a fresh look, a beauty that was ethereal."

ANTHONY BEAUCHAMP (Photographer)

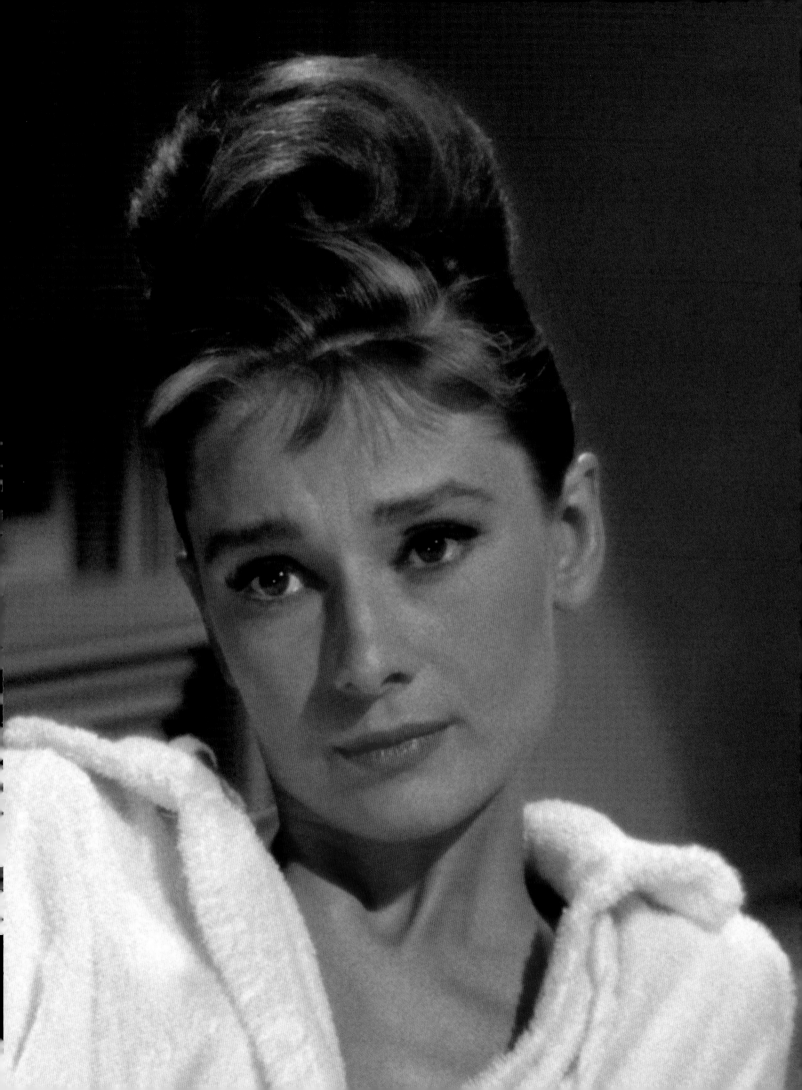

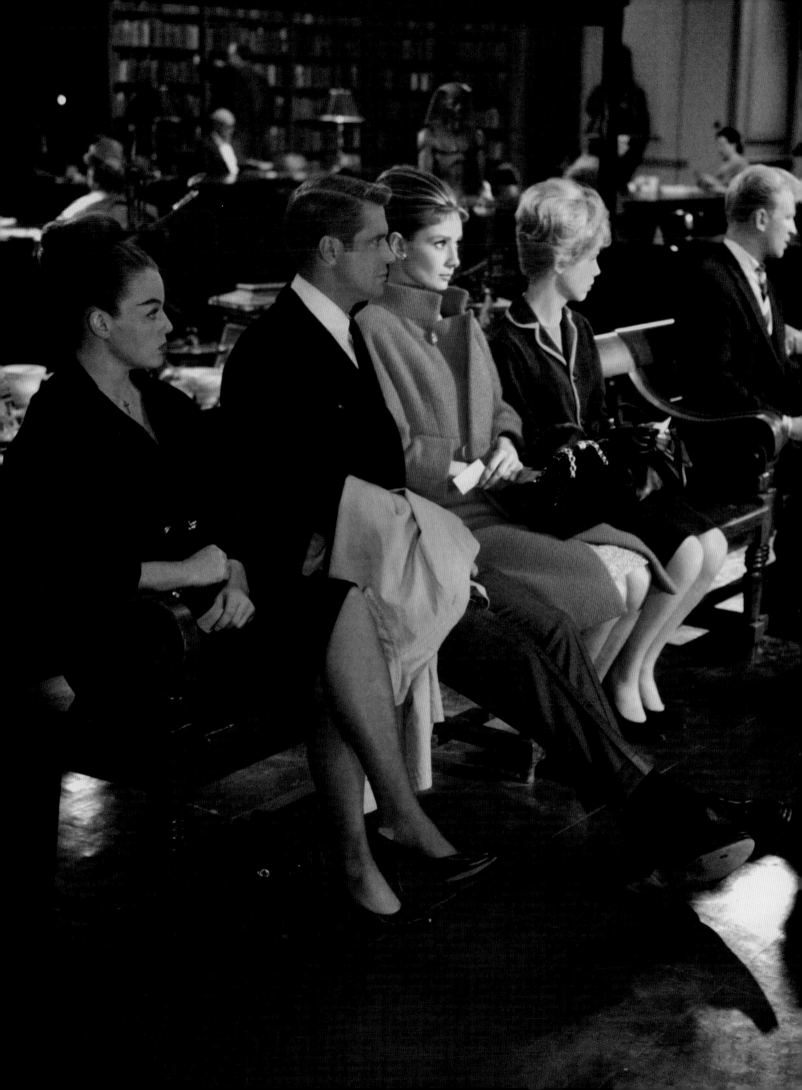

"Hepburn wore clothes better than any other actress ever has; it's an essential part of her persona."

MOLLY HASKELL (Film critic and author)

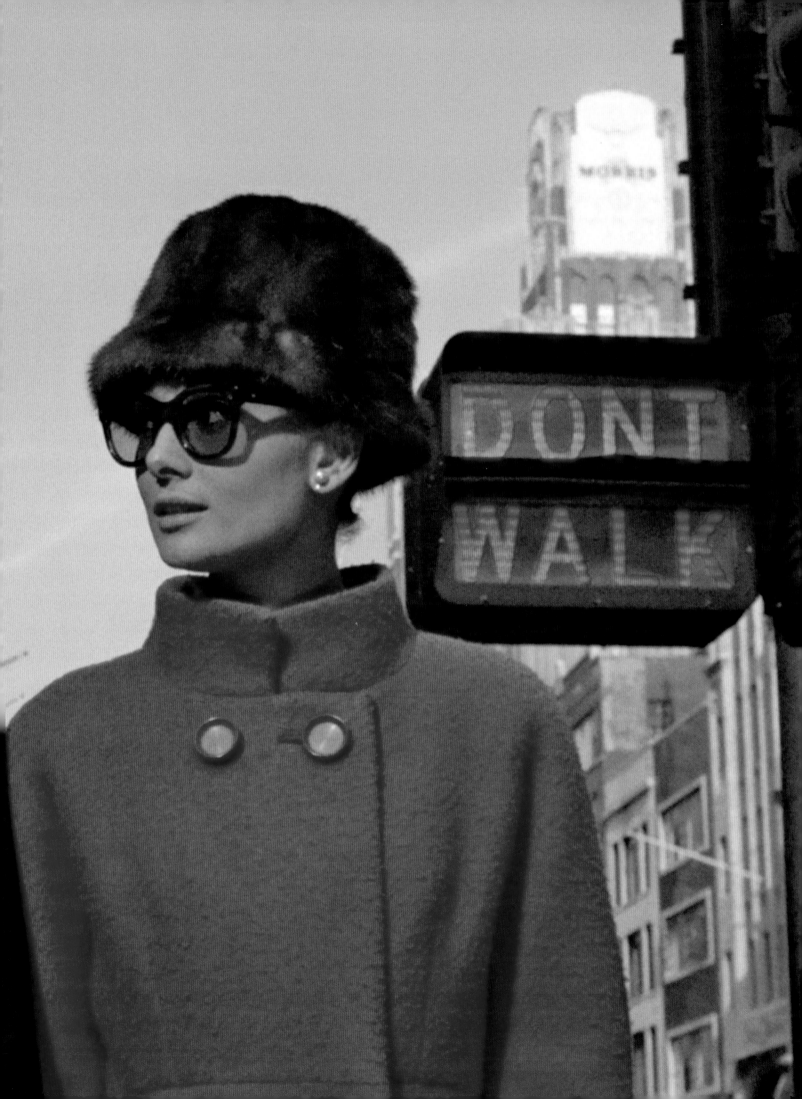

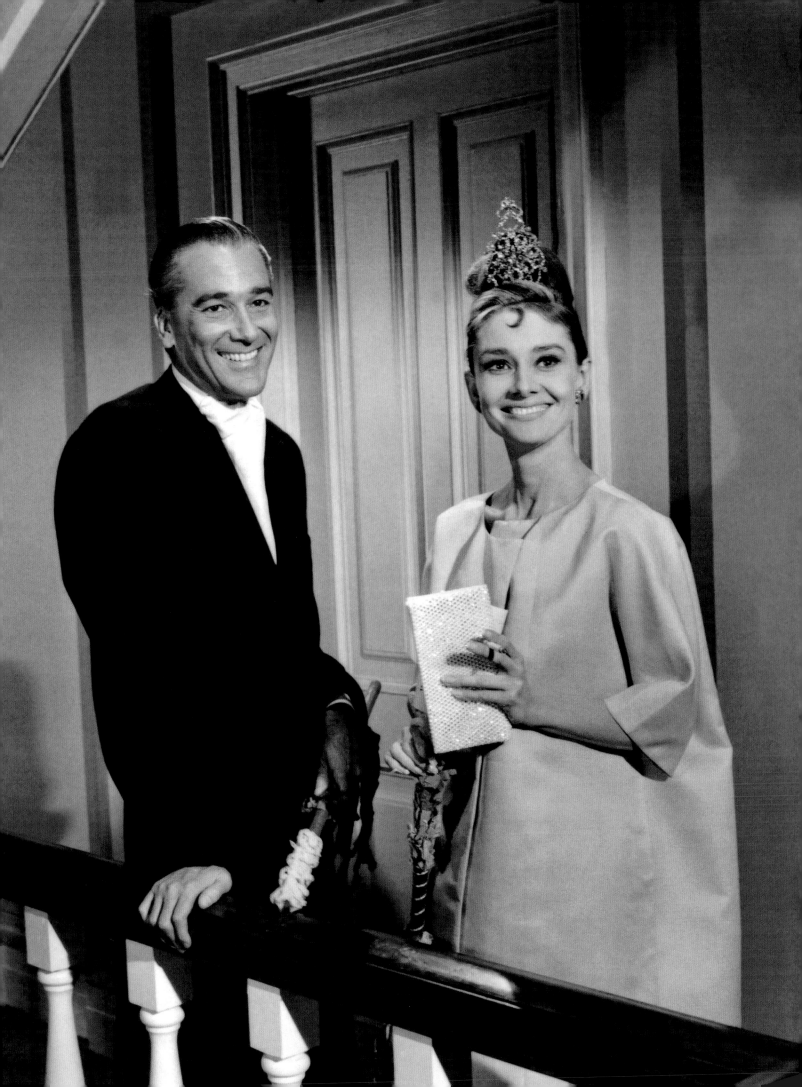

"I was sort of inadvertently thrown in with some of the truly great fashion people in the world, and suddenly I was looking at wardrobe to be approved by Audrey Hepburn. And, of course, I'm not stupid, I'm not going to say 'Well, gee, fellas, I don't really know about those kinds of things.' It gave me an education."

BLAKE EDWARDS (Director, *Breakfast at Tiffany's*, 1961)

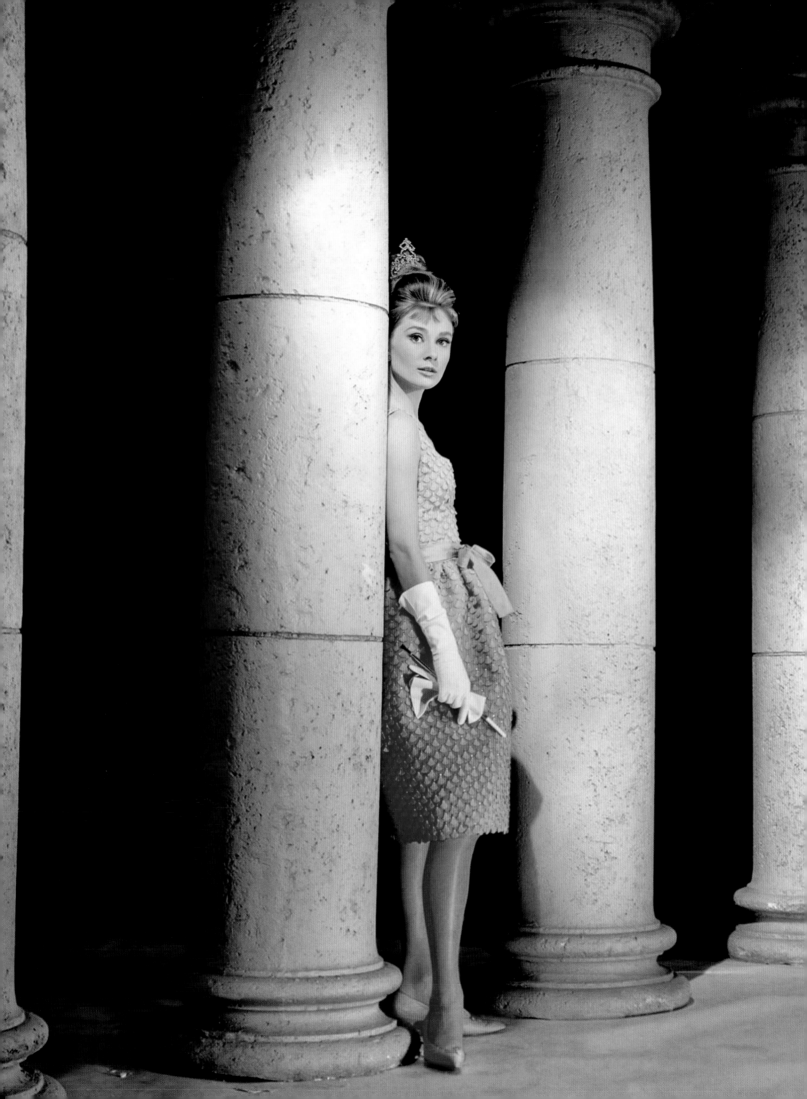

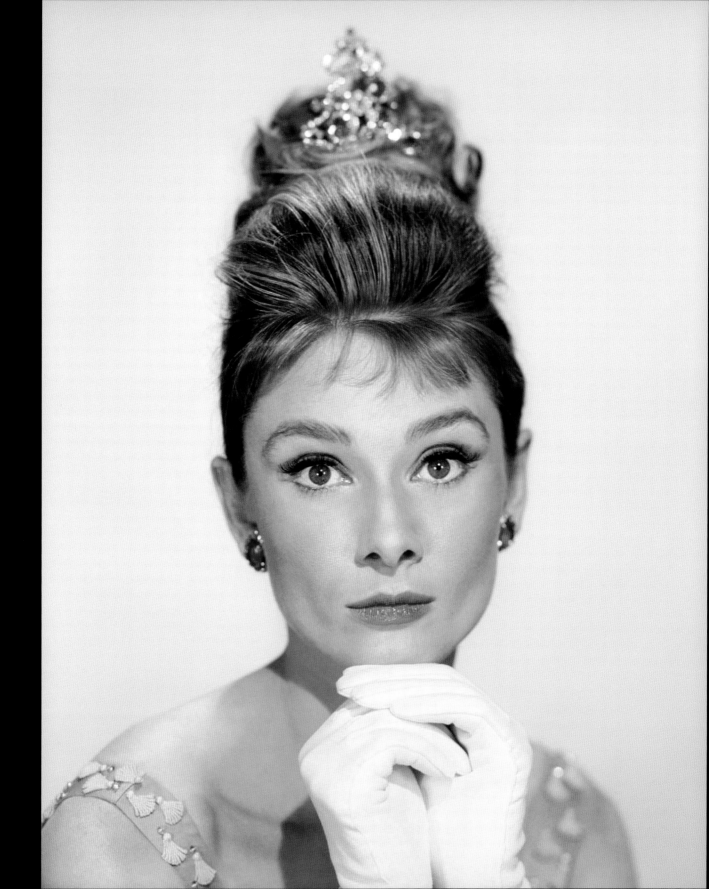

Cinelândia

N.º 218 — DEZEMBRO DE 1961
1.ª QUINZENA - Cr$ 40,00
PARA ADULTOS

DORIS DAY:
Crepúsculo à Vista?

YUL BRYNNER
desafia o deserto

tv magazine

The Cleveland Press
PROGRAM LISTINGS APR. 6-APR. 13

Oscar Night in Hollywood

Audrey Hepburn
"Tiffany's" Jewel

EPOCA

SCANDALO A LONDRA:
TORINO, GENOVA E MILANO
STAVANO PER ESSERE RASE AL SUOLO
DAI BOMBARDIERI INGLESI

A COLORI: VIAGGIO NEL CUORE DELLA TERRA

132 PAGINE

LIFE
INTERNATIONAL

JAPAN'S TROUBLES
WITH NEUTRALISM

SUPERSONIC TRAVEL
London-New York
In 132 Minutes

AUDREY
HEPBURN
In Her
Funniest Role

OCTOBER 9, 1961

DELL
OCT.
25¢

screen stories

THE LOVELIEST
PHONY IN TOWN—
she belonged to nobody
she drank champagne for breakfast!
she stole Halloween masks
AUDREY HEPBURN
stars in
"Breakfast At Tiffany's"

DICK CLARK and
FREDRIC MARCH in
"The Young Doctors"

SPECIAL REPORT ON
NATALIE WOOD and
BOB WAGNER
What happened to
their "Togetherness"?

cinéma 62

N° 63 2 NF
★ FÉVRIER ★

FÉDÉRATION FRANÇAISE DES CINÉ-CLUBS

LE CINÉMA
D'AMATEUR

le cinéma à la TV

DIAMANTS
SUR CANAPÉ

ELLE

Deux
ans après:
L'ensorcelante
Audrey Hepburn
revient

Modèles
bien chauds
pour
froids week-ends

Pour vous
et votre maison
le Blanc
62

The American Weekly The Washington Post

YOUR
WEEK END
A boon or a bore?

MERCY

H. Allen Smith's
LAW
for
LIVING

Audrey Hepburn

VEA y LEA

EN COLORES:
DELACROIX
Sus mejores obras

EL CASO
PASTERNAK

DELTA:
¿Tierra sin destino?

עולם הקולנוע

Q QUICK

Alle lesen:
Johannes Mario Simmel
Bis zur bitteren Neige
Das Protokoll eines wüsten Lebens

Audrey Hepburn

ANNABELLE

Audrey
Hepburn
im neuen
Film

Pariser
Mode
weiblich
beschwingt

So leben
und wohnen
die Stars
in der
Schweiz

Wettbewerb
Gute Ideen
für kleine
Wohnungen!
Wertvolle
Möbel als
Preise!

映画ストーリー

特集

12

NEUES Film
PROGRAMM
Nr. 2603

FRÜHSTÜCK
BEI TIFFANY

L'EUROPEO

SETTIMANALE POLITICO D'ATTUALITÀ

Il secondo
fascicolo
del libro
fotografico

SU CARTA SPECIALE
LE FOTOGRAFIE DI
ROBERT CAPA:
LA GUERRA IN ITALIA

ECCO GLI ERETICI

Il primo servizio sul-
l'Albania '61, il paese
inaccessibile ai gior-
nalisti occidentali

AUDREY HEPBURN

עולם הקולנוע

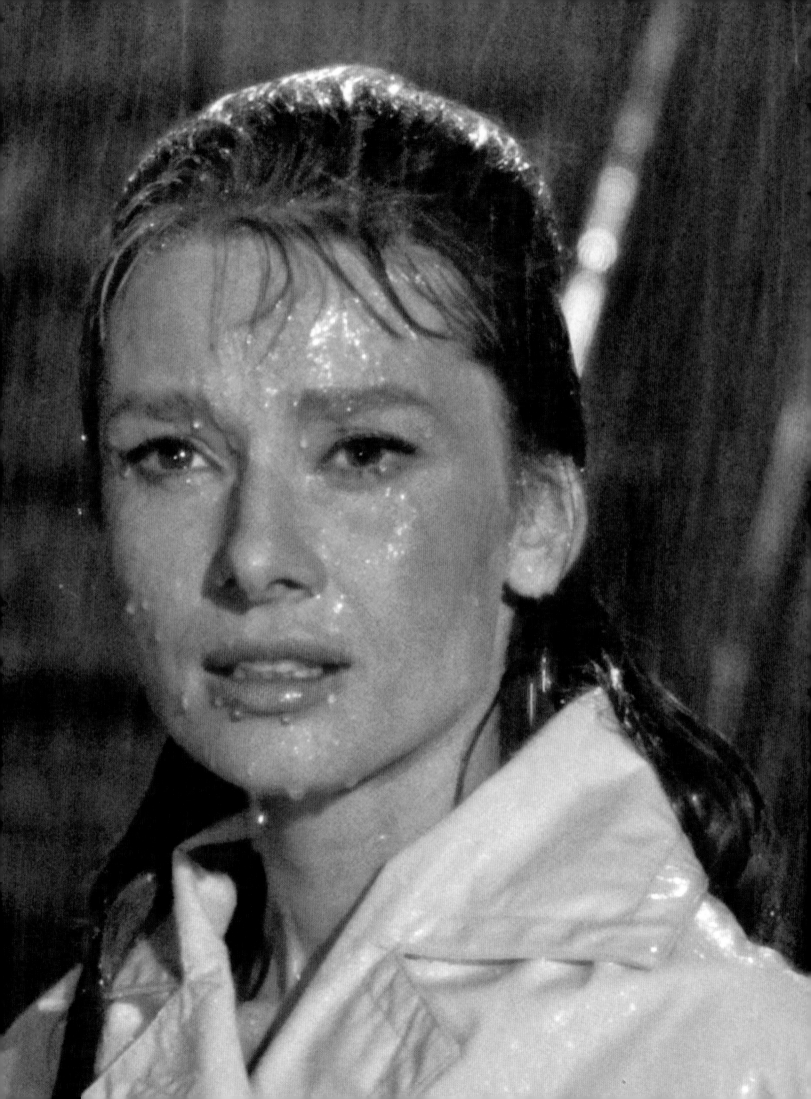

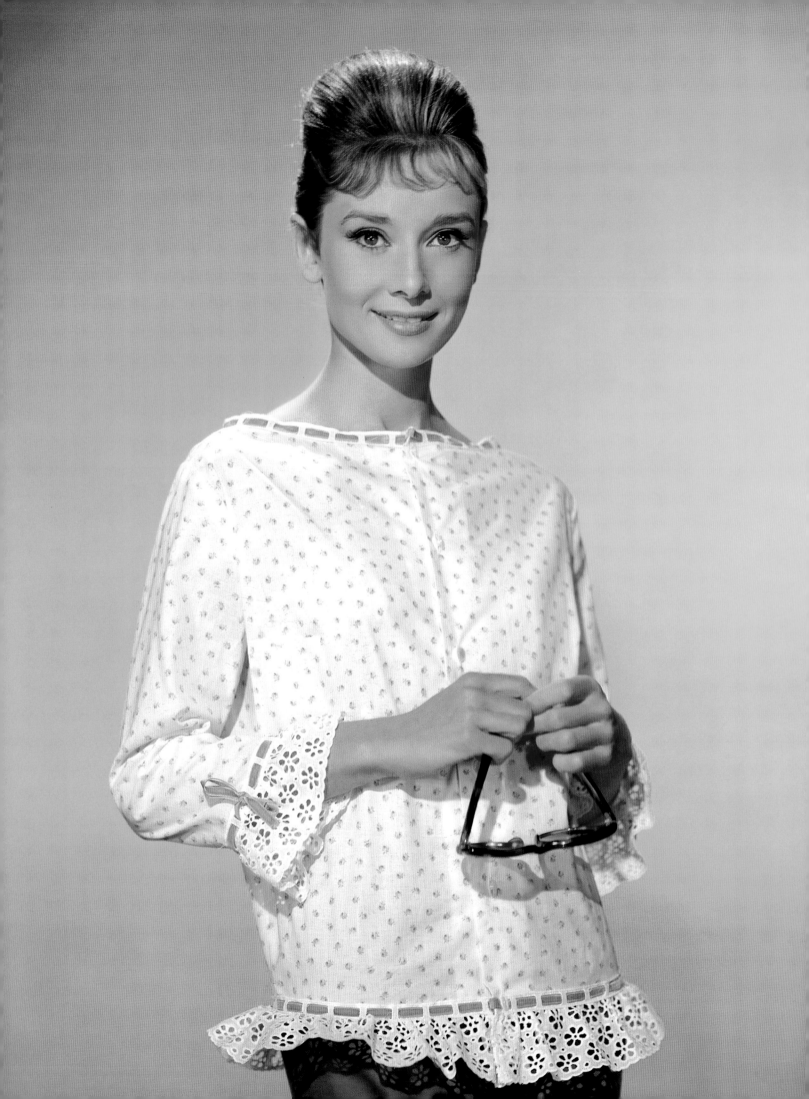

"Audrey and I first met in 1961 at a party that Tony Curtis and Janet Leigh gave for their tenth wedding anniversary. I was just married, knew nobody, and was obviously starstruck by all. Audrey was a *star*. She was an icon. She was amazing looking with the best taste. She was always the same, yet like all bright and intelligent people, often doubted herself. She would say to me, 'My feet are so big and yours are just so much smaller and nicer.' She always felt that her looks were due to makeup. One day she came to see me on her way to the studio, just stood there, with no makeup on . . . looking at me with those big eyes and said, 'You see, no makeup, no eyes and a square face!' None of it was true of course, but from that day on I always called her 'Square' and she would call herself that to me. She was my beloved friend. She was my soul mate. We had no secrets from each other. We laughed and cried together. She was funny. She did everything so well: cooking, decorating her homes. Christmas and Easter were always great. Most of all, she was loving and caring. She was also extremely sensitive, so she suffered more than others."

DORIS BRYNNER (Friend)

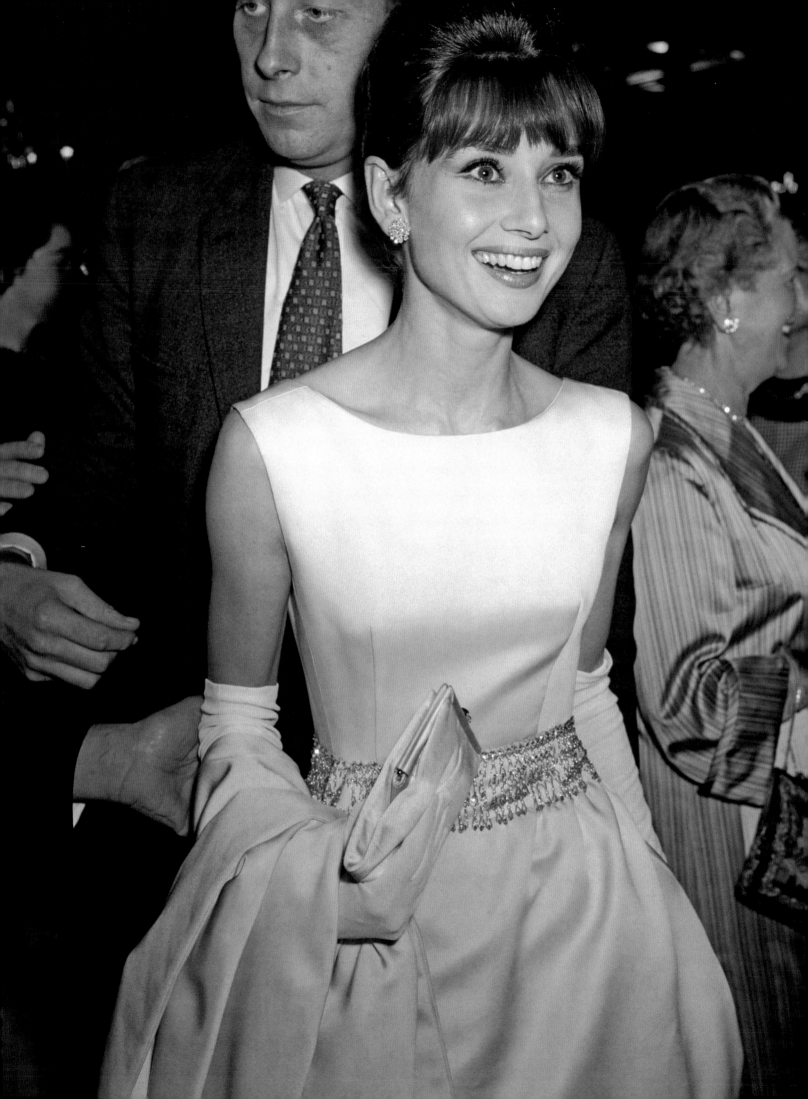

"What a burden she lifted from women. There was proof that looking good need not be synonymous with looking bimbo. Thanks to their first glimpse of Audrey Hepburn in *Roman Holiday,* half a generation of young females stopped stuffing their bras and teetering on stiletto heels."

THE NEW YORK TIMES

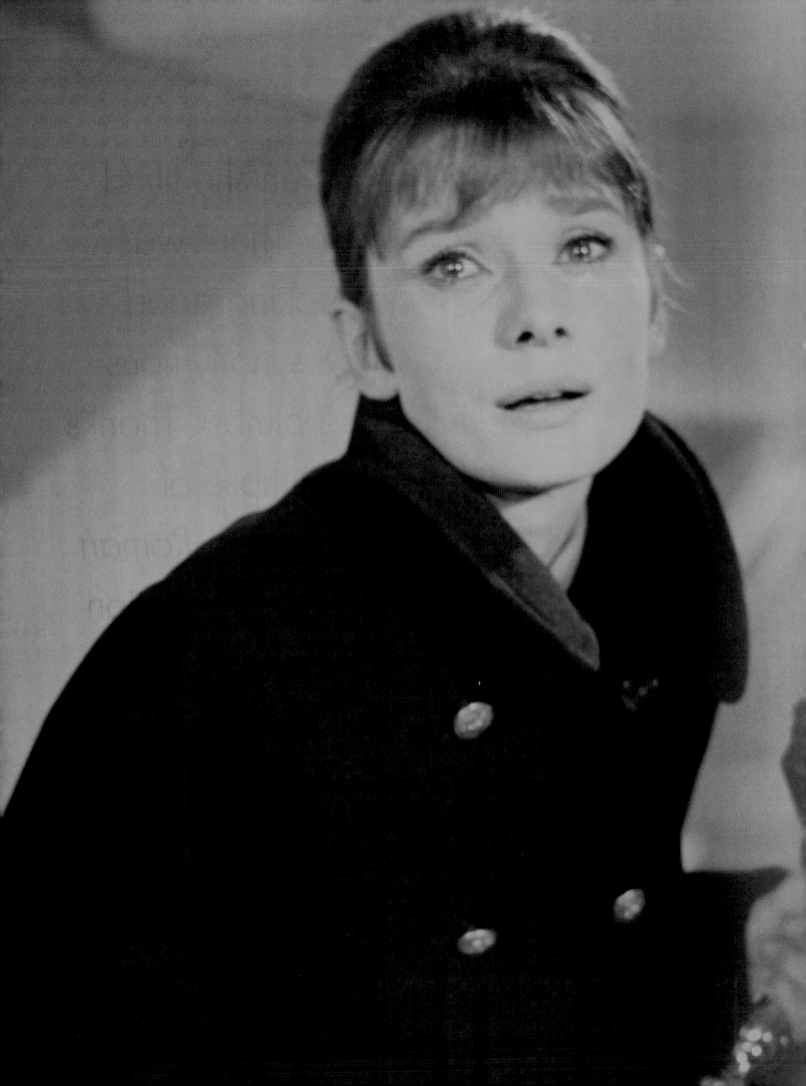

The Children's Hour

1961

"At the time we made the picture, there were not real discussions about homosexuality. It was about a child's accusation. It could have been about anything. So none of us were really aware. We were in the mindset of not understanding what we were basically doing. These days there would be a tremendous outcry, as well there should be. The profundity of this subject was not in the lexicon of our rehearsal period even. Audrey and I never talked about this. Isn't that amazing. Truly amazing."

SHIRLEY MACLAINE (Costar, *The Children's Hour*, 1961)

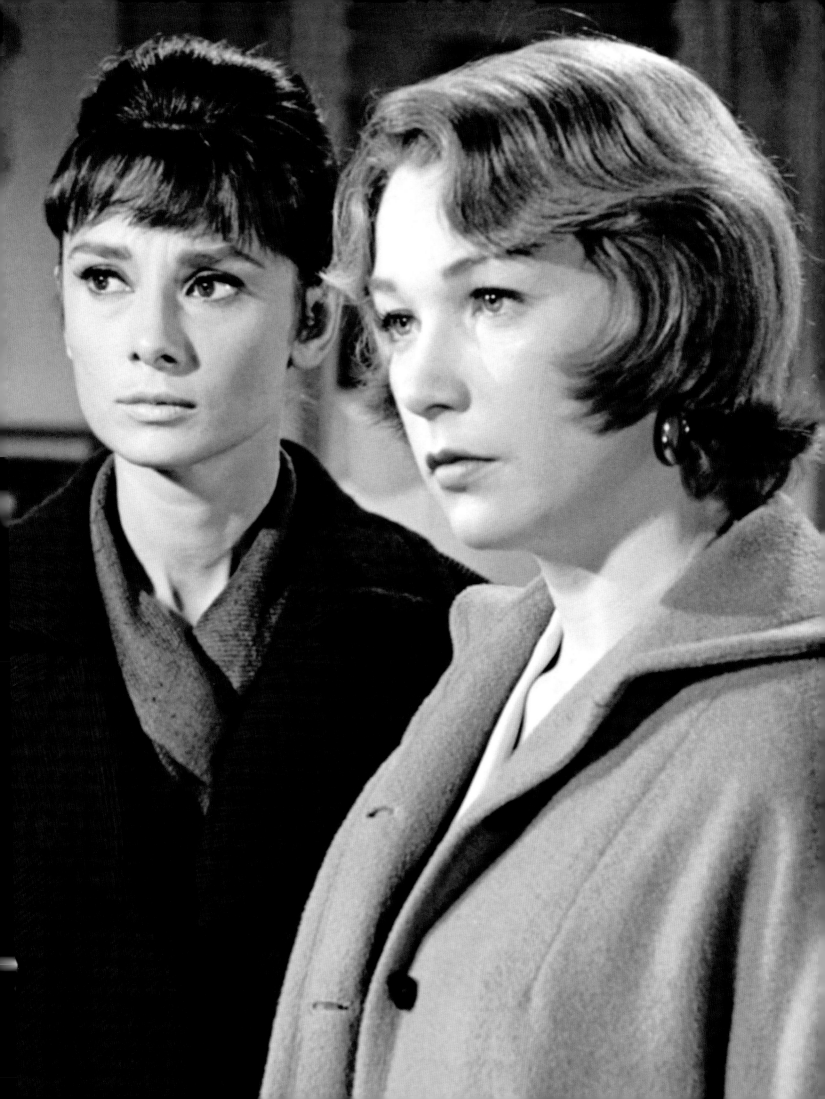

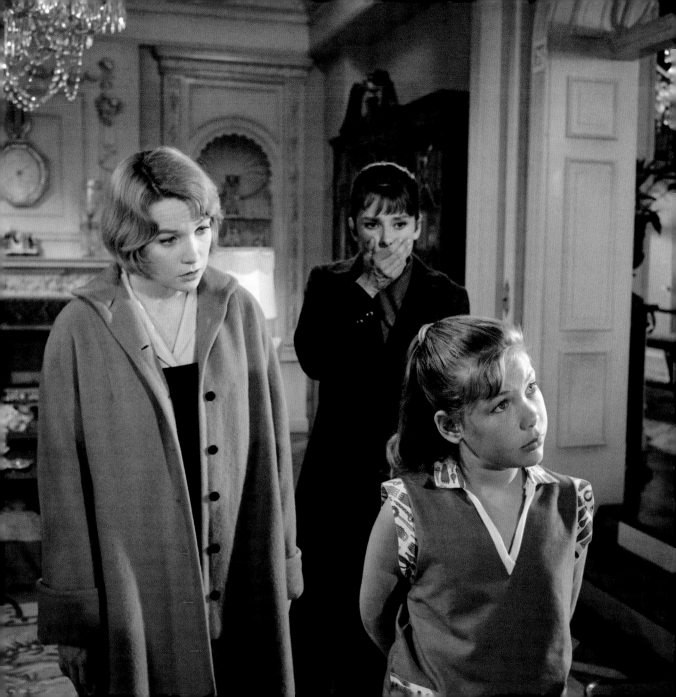

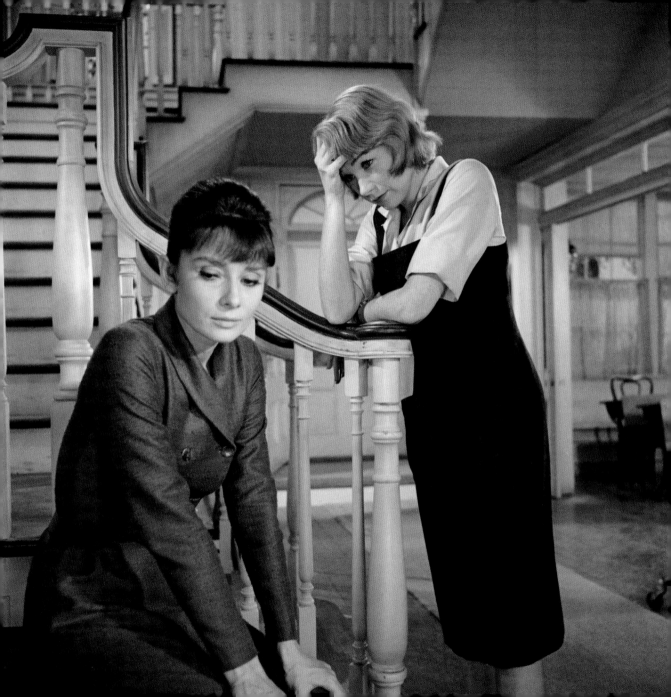

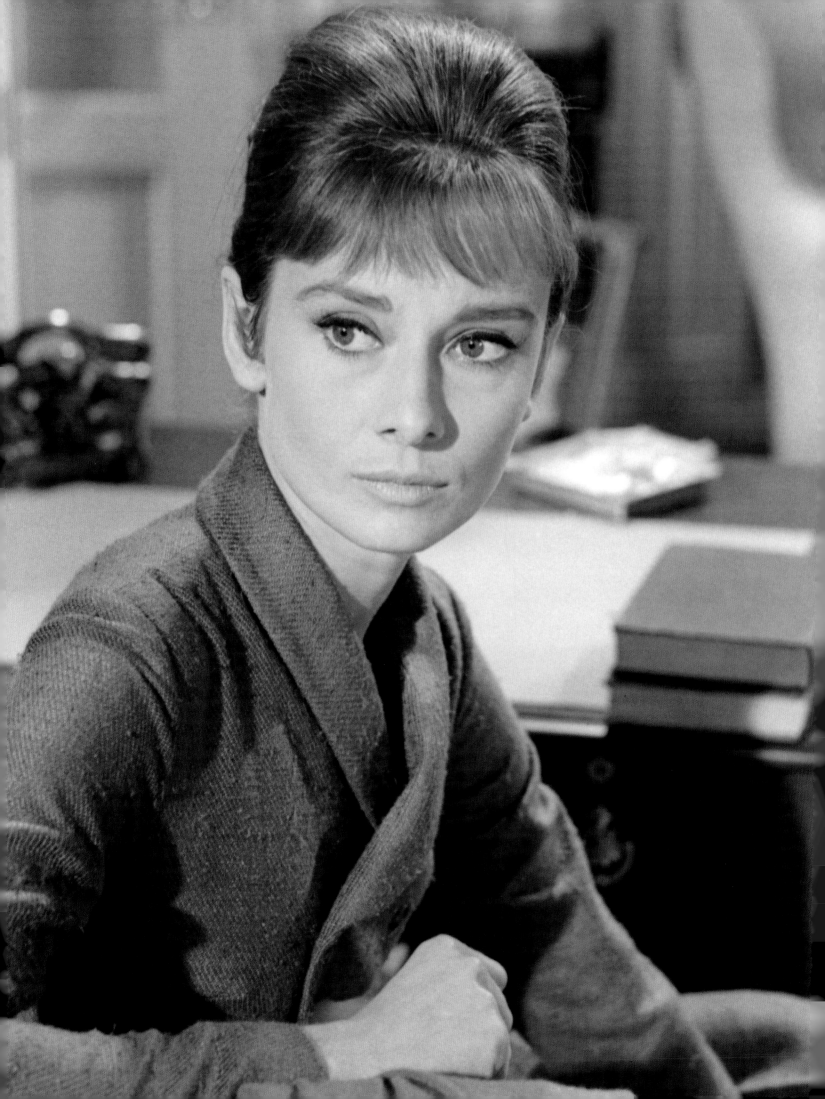

"He was so dear to me. He never made me feel he had to teach me anything. He just said go ahead and do it. Therefore I felt very relaxed. There was no technique that was visible. I was never aware of being put through my paces or that what I did wasn't good enough. He'd say, 'Well, let's just do it again.' He was famous for very many takes, of course. But that was good for me."

AUDREY HEPBURN on William Wyler, director
(*The Children's Hour*, 1961)

Martha:

"No! You've got to know. I've got to tell you. I can't keep it to myself any longer. I'm guilty!"

Karen:

"You're guilty of nothing!"

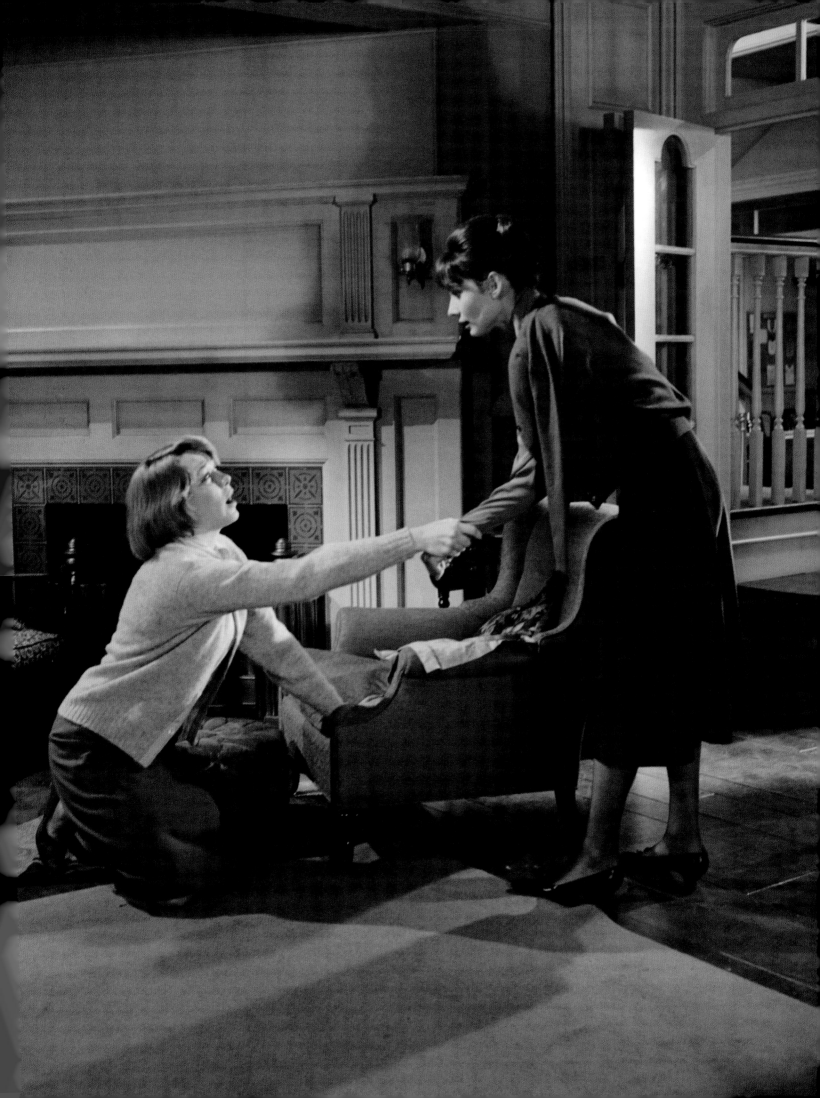

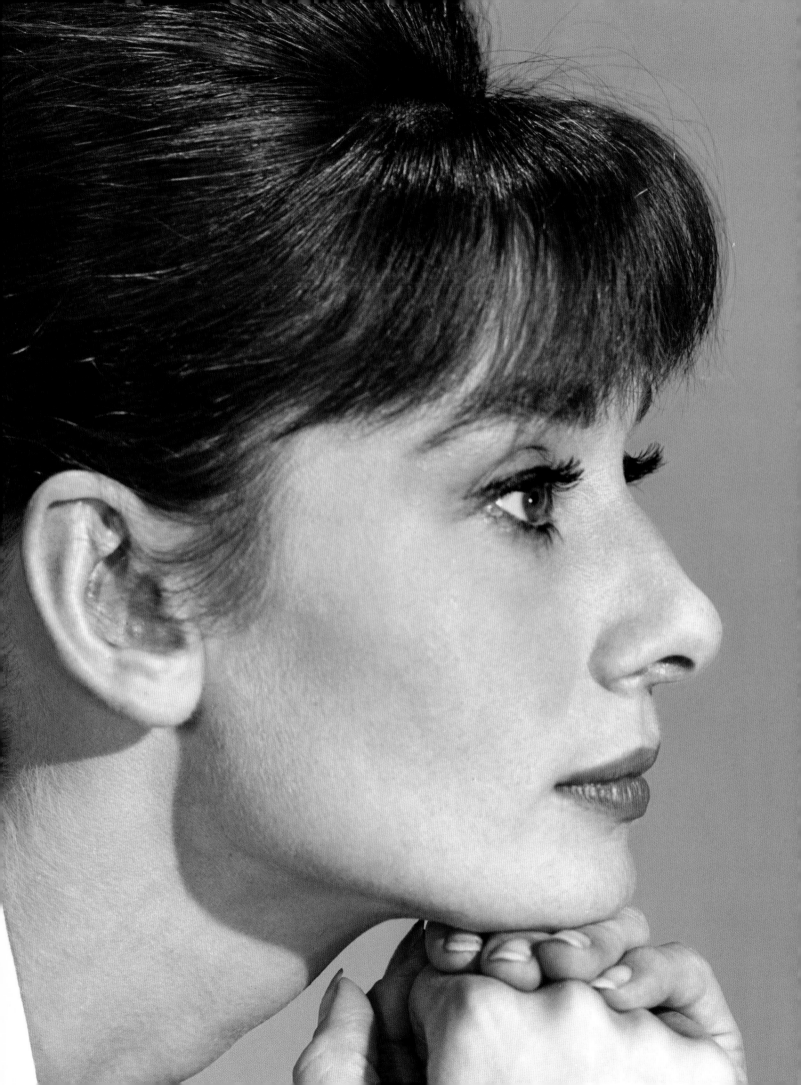

"Audrey was the kind of person who, when she saw someone else suffering, tried to take the pain on herself. She was a healer. She knew how to love. You didn't have to be in constant contact with her to feel you had a friend. We always picked up right where we left off."

SHIRLEY MACLAINE

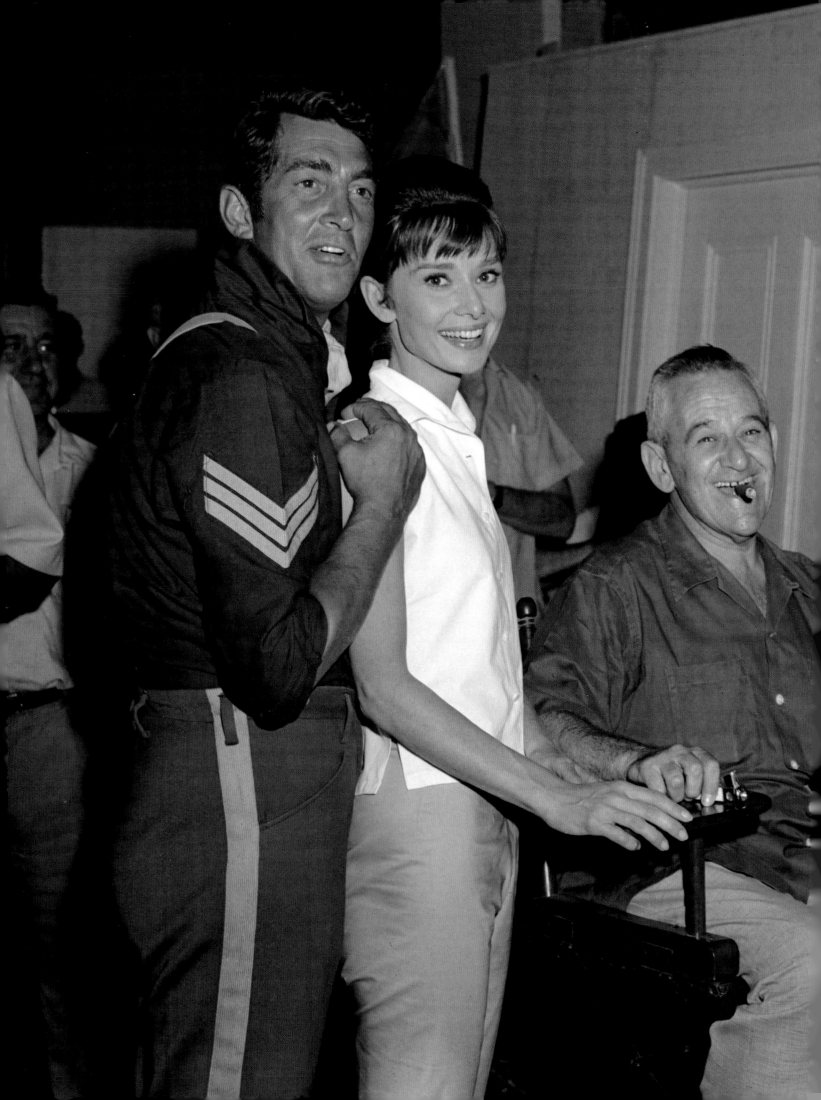

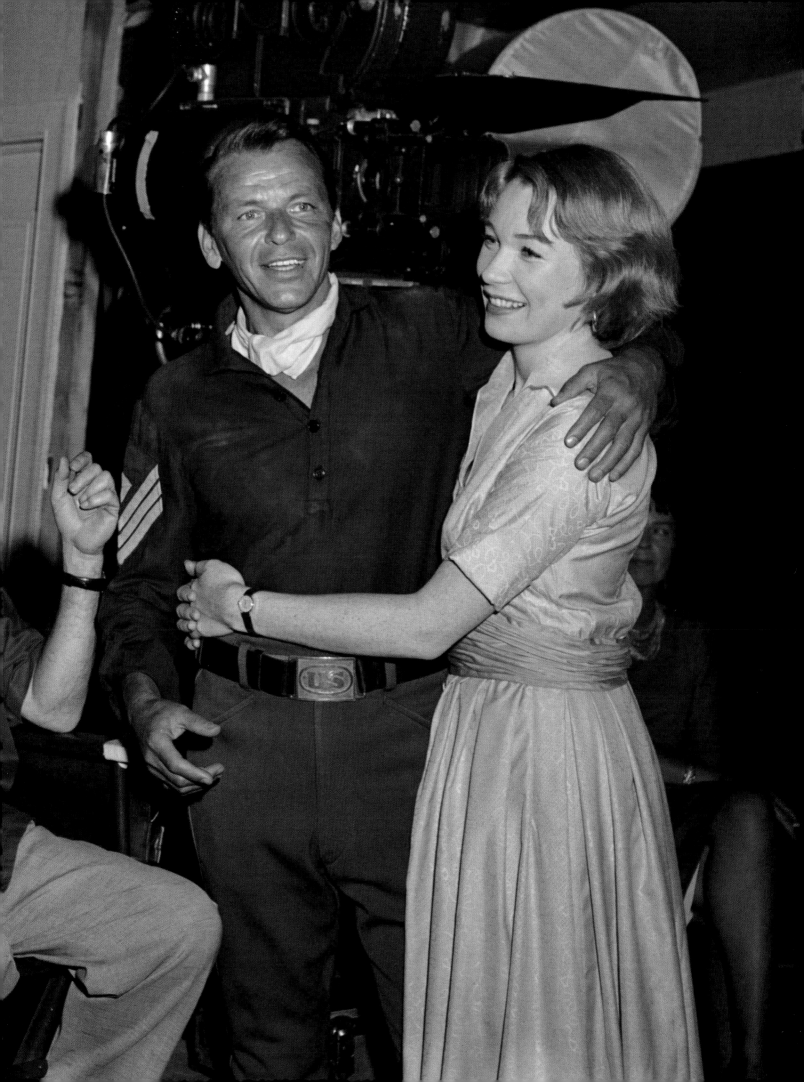

"Audrey and I decided we'd throw a party for the cast and the crew when the picture was finished. We went all out, had it catered by Romanoff's— nothing but the best. In the middle of the party, Audrey sidled up to me, jabbed me with her elbow and said, out of the corner of her mouth, 'Hey, Shirl-Girl, whatya think the bruise is gonna be for this bash?'"

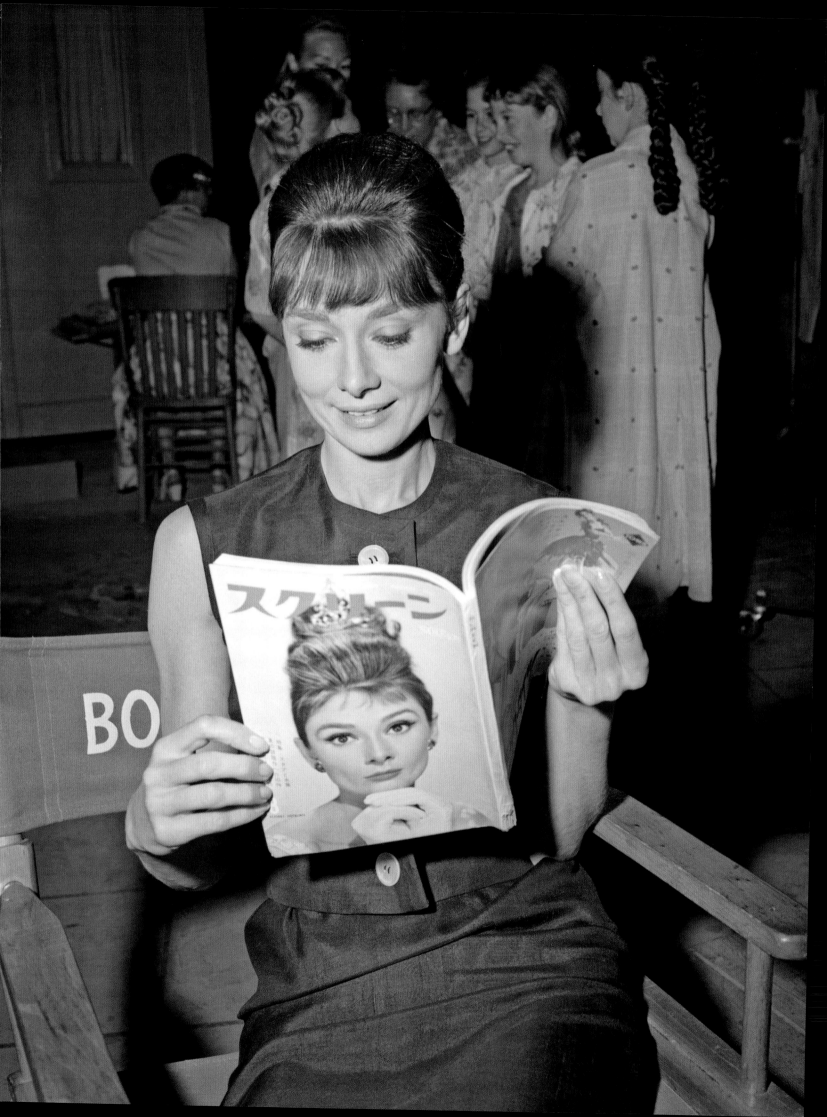

Charade

1963

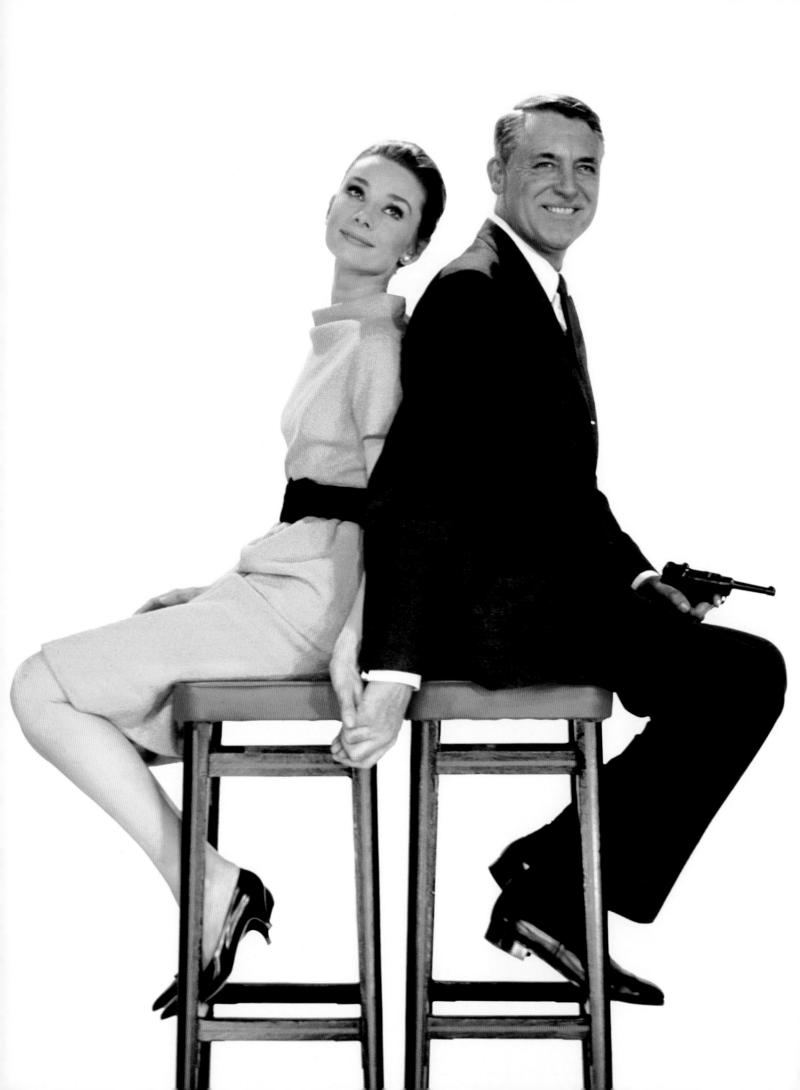

"I think he understood me better than I did myself. He was observant and had a penetrating knowledge of people. He would talk often about relaxing and getting rid of one's fears, which I think he found a way to do. But he never preached. If he helped me, he did it without my knowing, and with a gentleness which made me lose my sense of being intimidated. I had this great affection for him because I knew he understood me. It was an unspoken friendship, which was wonderful. He would open up his arms wide when he saw you, and hug you, and smile, and let you know how he felt about you. While you might not think of it, Cary was a vulnerable man, and he recognized my own vulnerability. We had that in common. There was something mystic about Cary which I've never been able to put my finger on, but I think he had a deep perception of life. He said one thing very important to me one day when I was probably twitching and being nervous. We were sitting next to each other waiting for the next shot. And he laid his hand on my two hands and said, 'You've got to learn to like yourself a little more.' I've often thought about that."

AUDREY HEPBURN on Cary Grant (Costar, *Charade*, 1963)

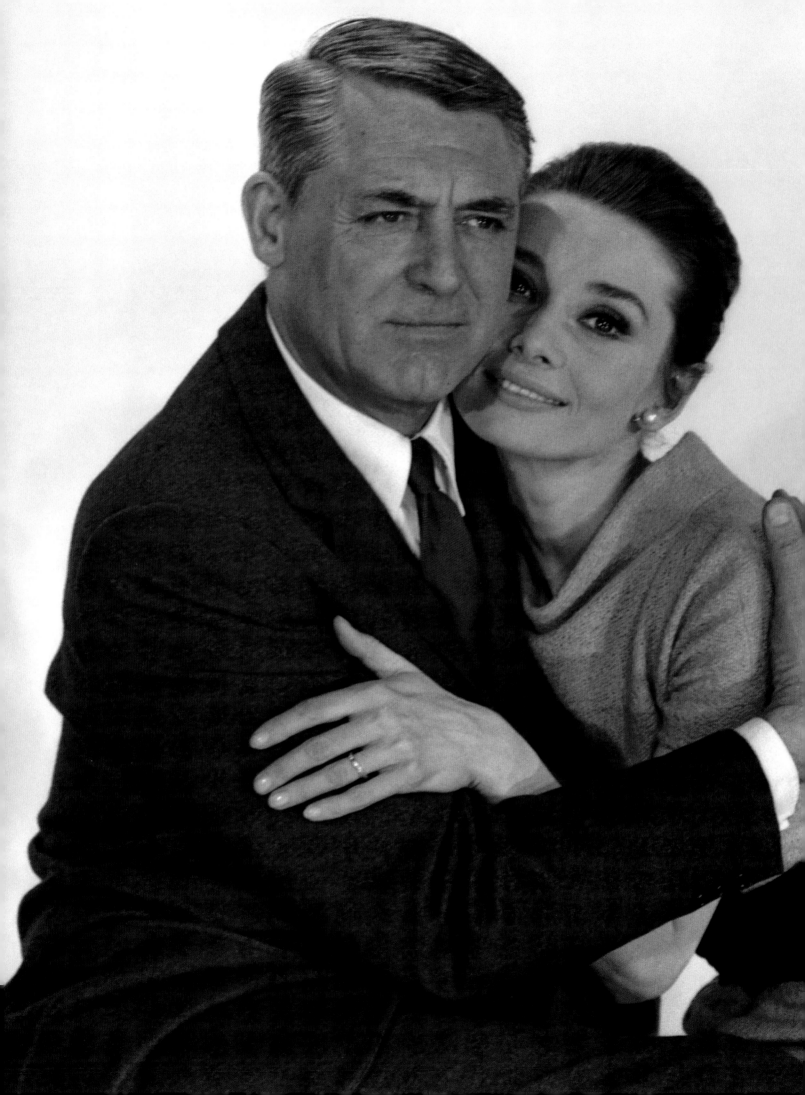

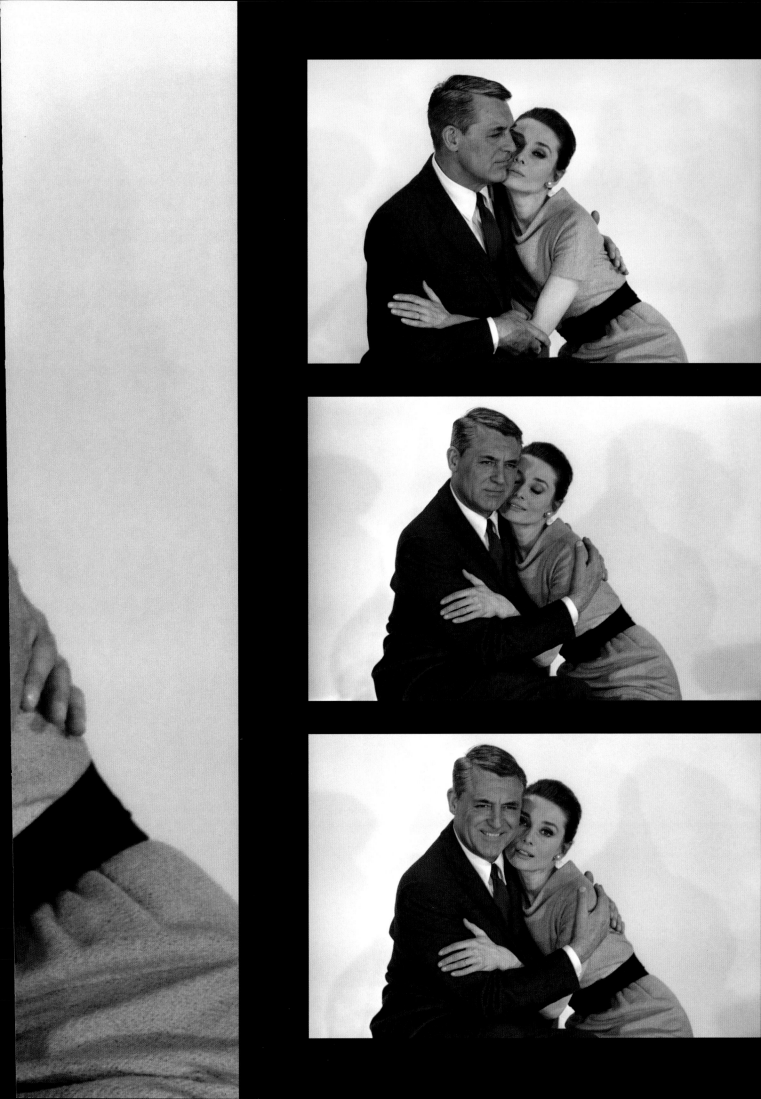

"She looks so pure. She doesn't wear jewels or furs like the rest of us, and half the time her only makeup is around those huge eyes of hers."

AUDREY WILDER (Wife of Billy Wilder)

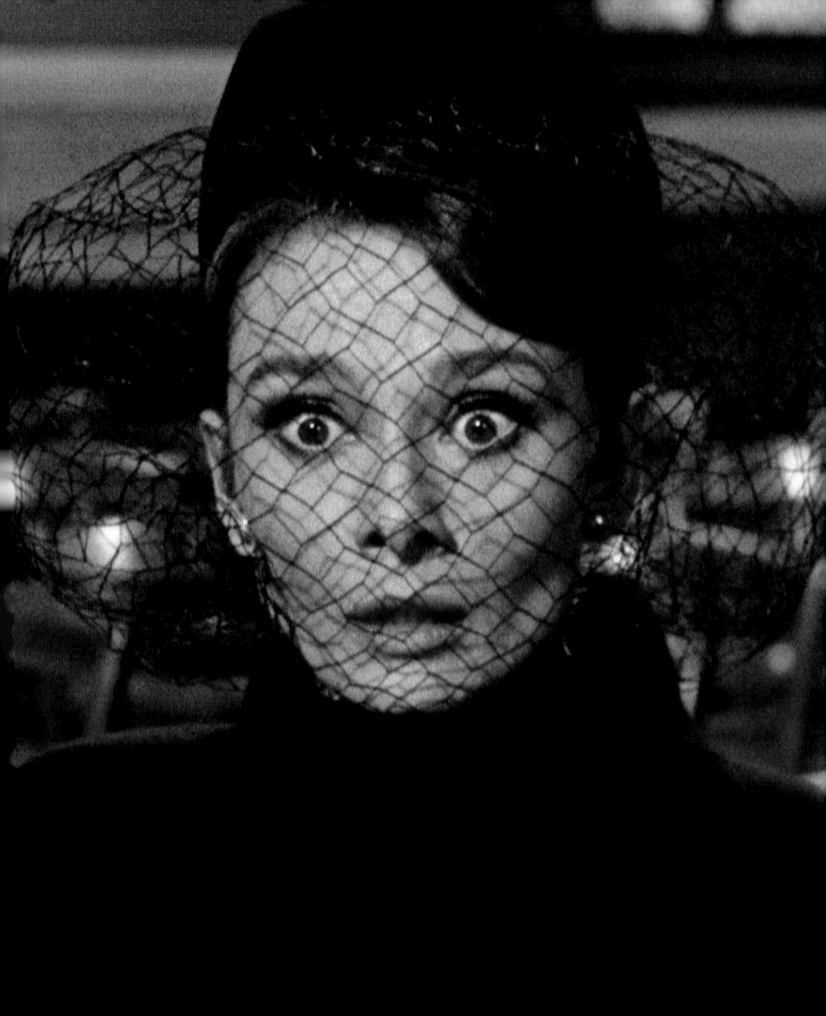

"Hepburn is cheerfully committed to a mood of how-nuts-can-you-be in an obviously comforting assortment of expensive Givenchy costumes."

THE NEW YORK TIMES

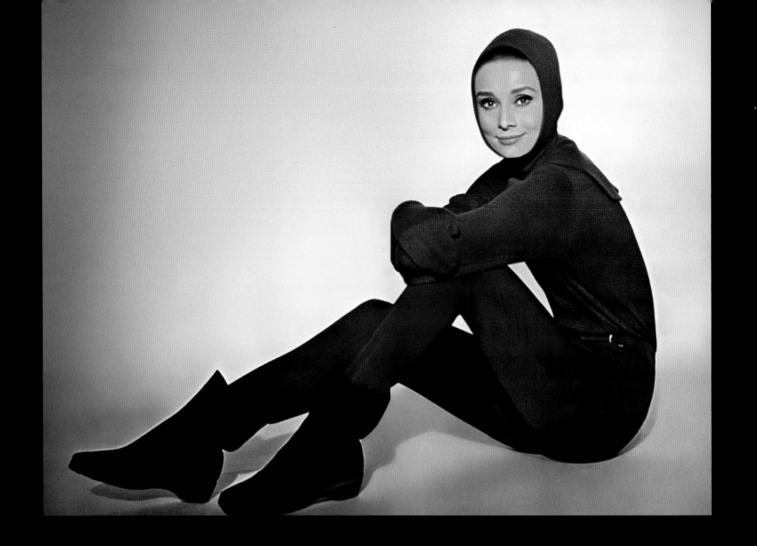

"John [Mercer] got very poetic when it came to writing for Audrey. There was a scene in *Charade* where the *Bateau Mouche* sails down the Seine and the [offscreen] chorus comes in. The phrase in the lyric 'sad little serenade' was inspired by Audrey, and I think *Charade* is the best work John and I ever did together."

HENRY MANCINI (Composer, *Charade*, 1963)

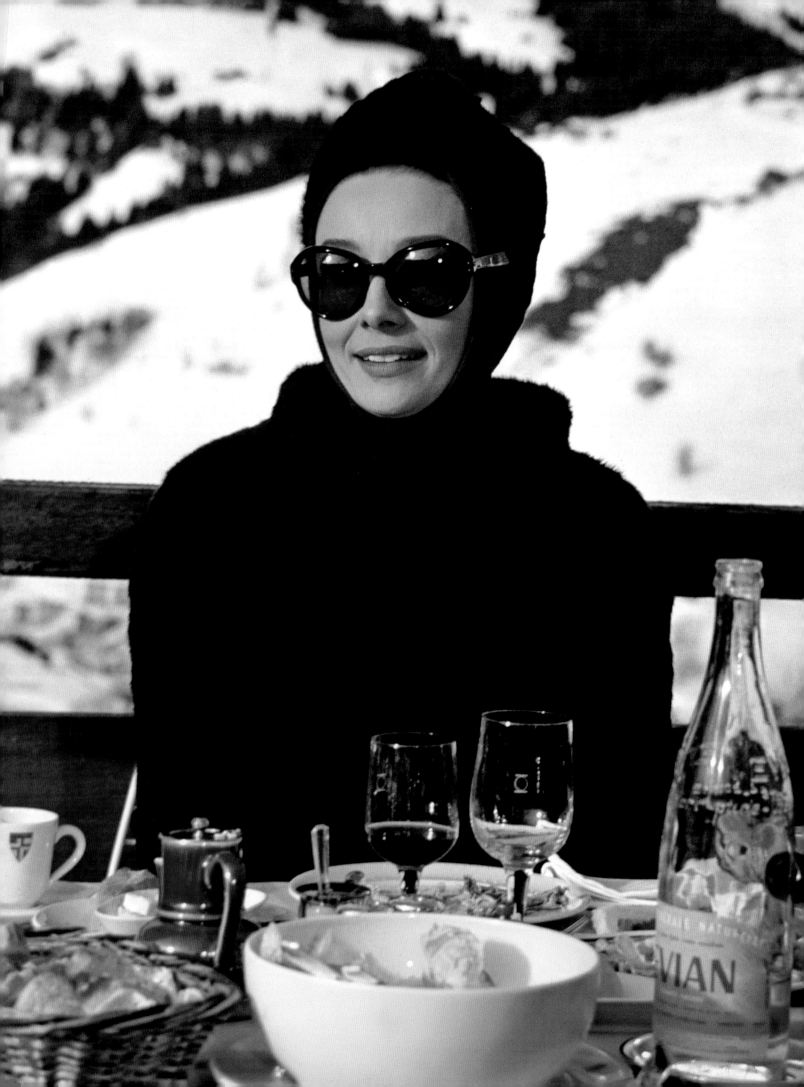

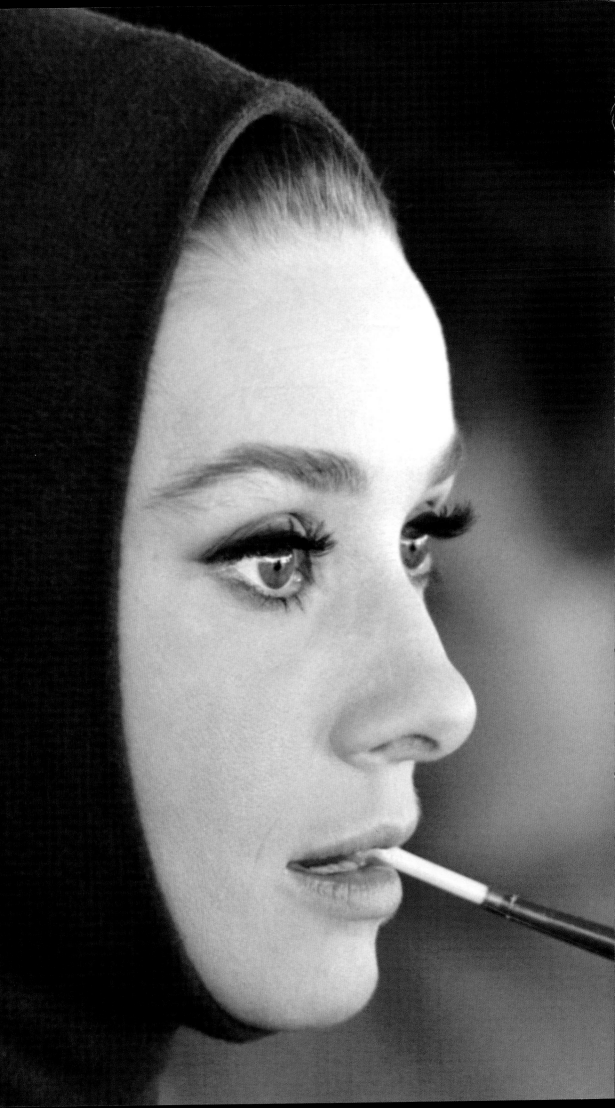

"The extraordinary mystique of hers made you think she lived on rose petals and listened to nothing but Mozart, but it wasn't true. She was quite funny and ribald. She could tell a dirty joke."

ANDRE PREVIN (Conductor and composer)

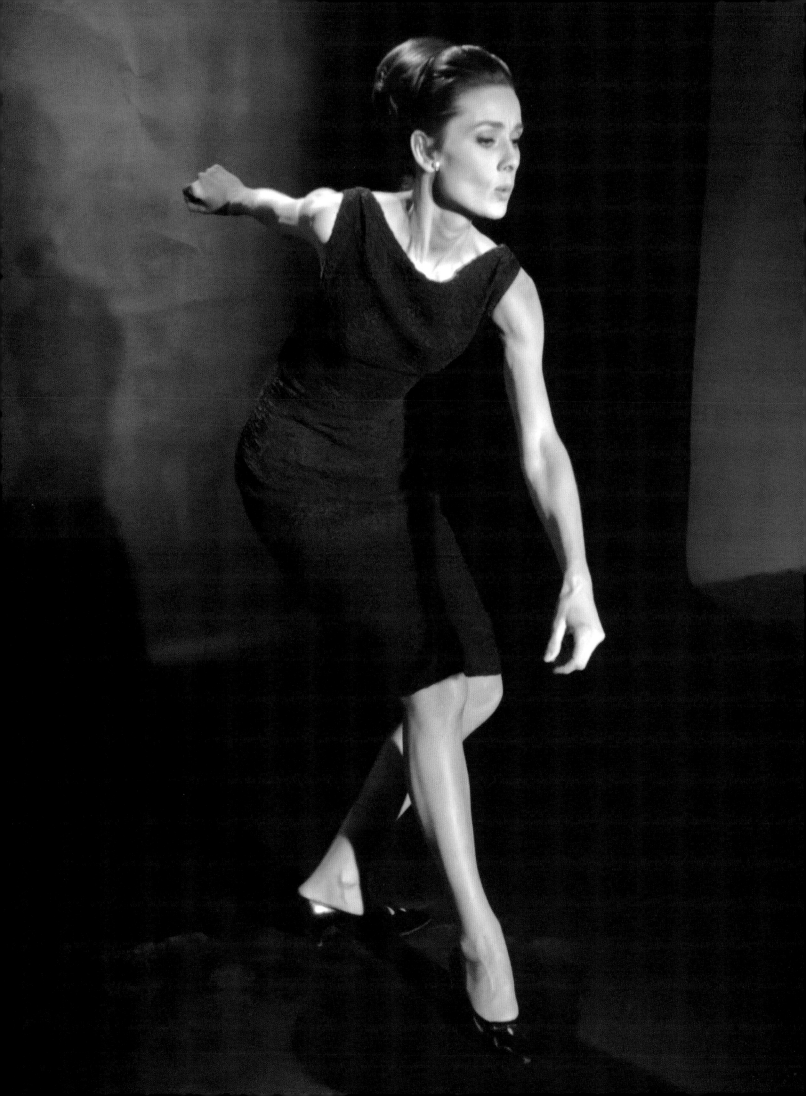

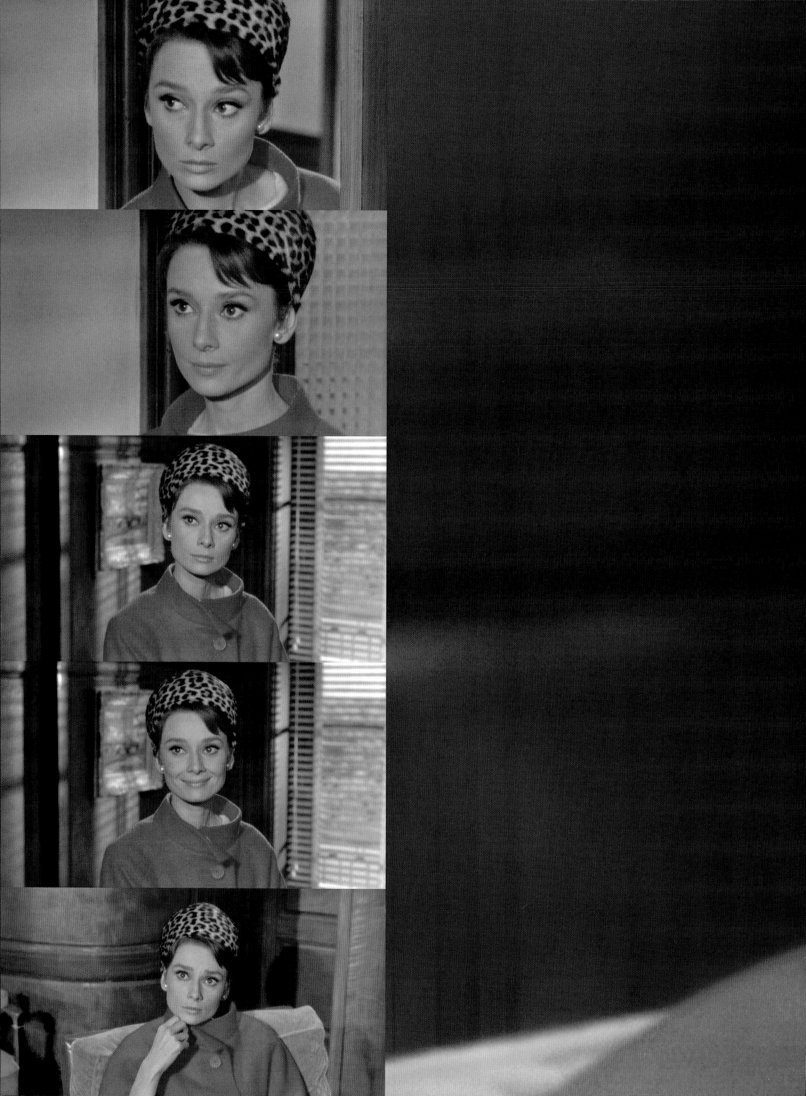

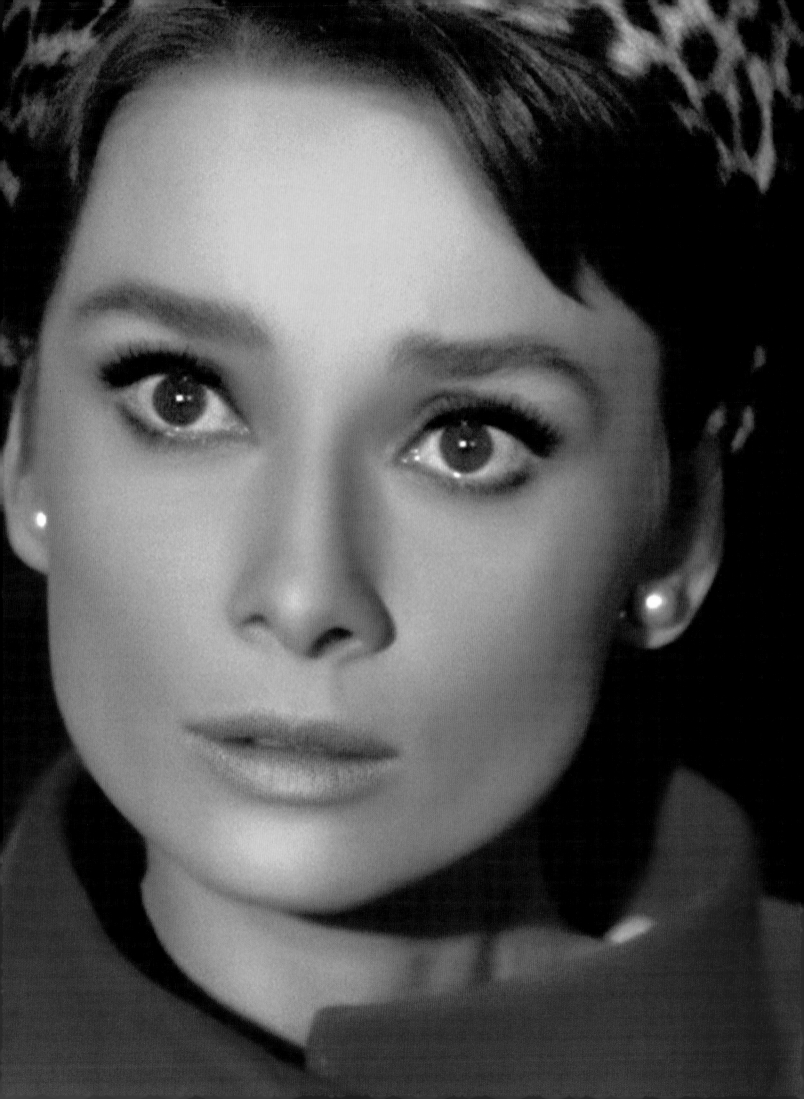

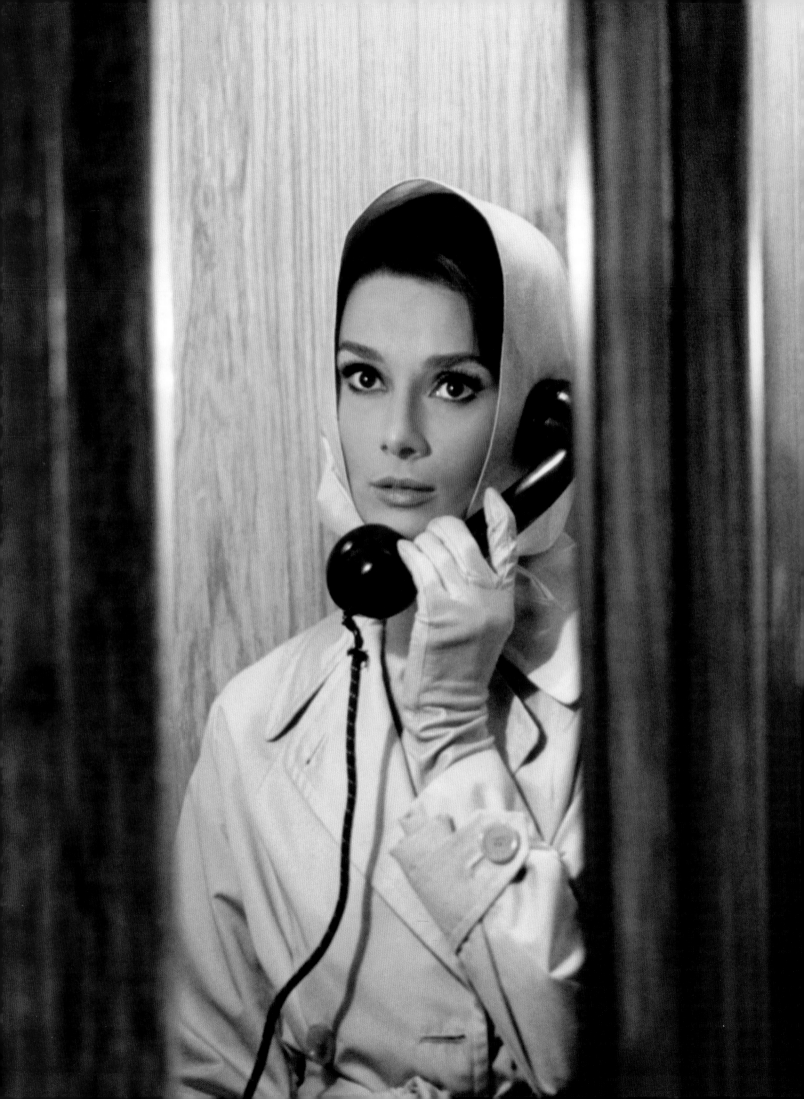

"The first time I saw Audrey Hepburn was in *Roman Holiday*. There have only been a few firsts in my life that have rattled me so much—the first time I saw Fred Astaire, the first time I saw Marlon Brando. It was obvious to me that she was going to join a group into which a few artists are admitted."

STANLEY DONEN (Director, *Charade*, 1963)

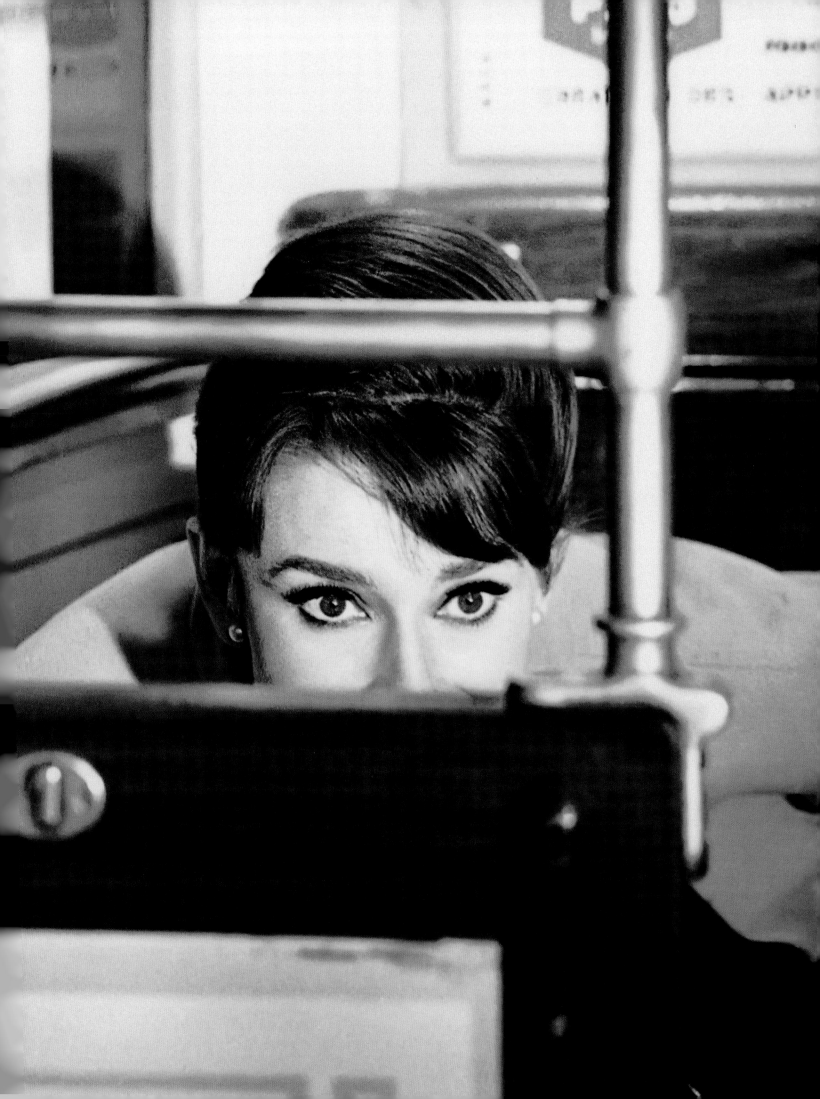

"I used to break Audrey up a lot, just by saying our lines. Cary always wanted to know if I could tell him any jokes. He liked to collect them. Audrey I distinctly remember cracking up when I asked her if she was saving her money."

WALTER MATTHAU (Costar, *Charade*, 1963)

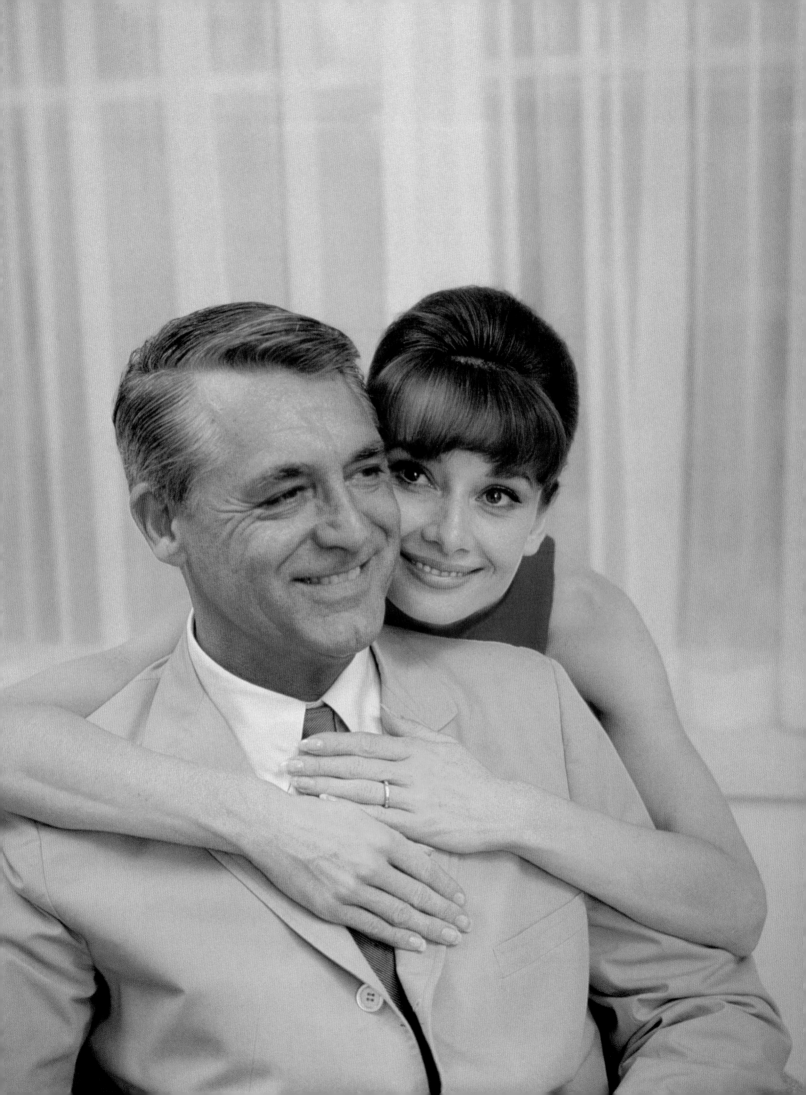

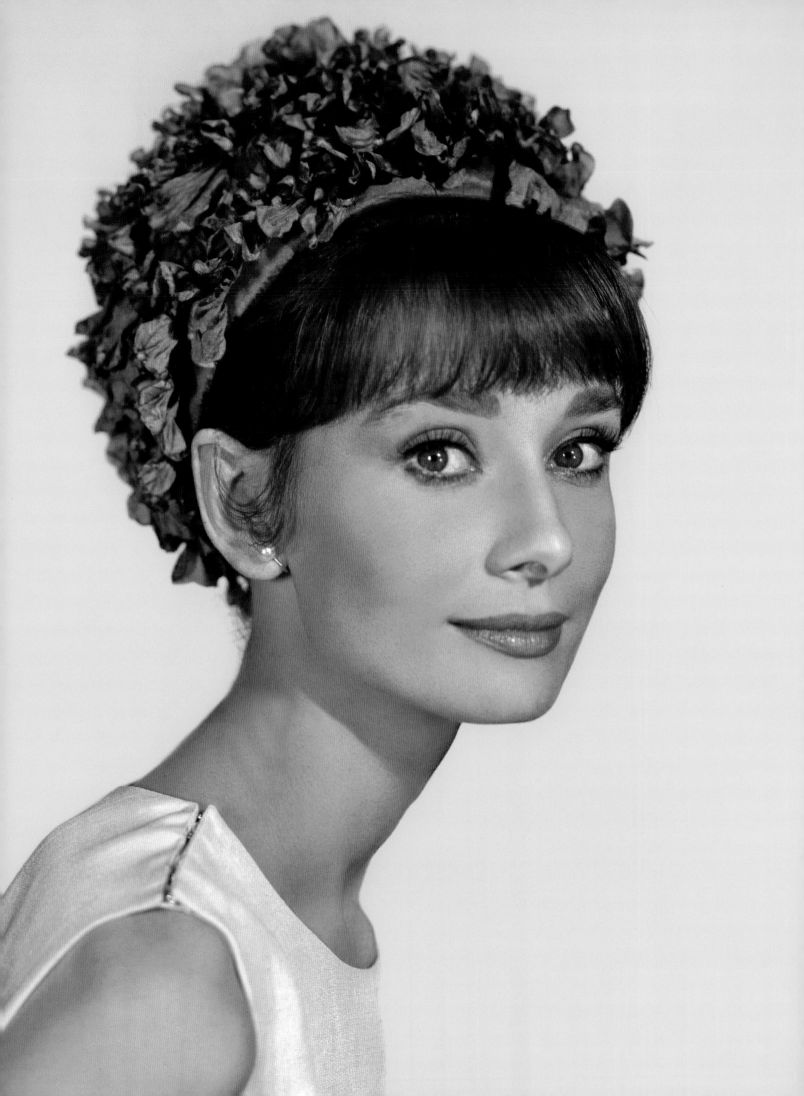

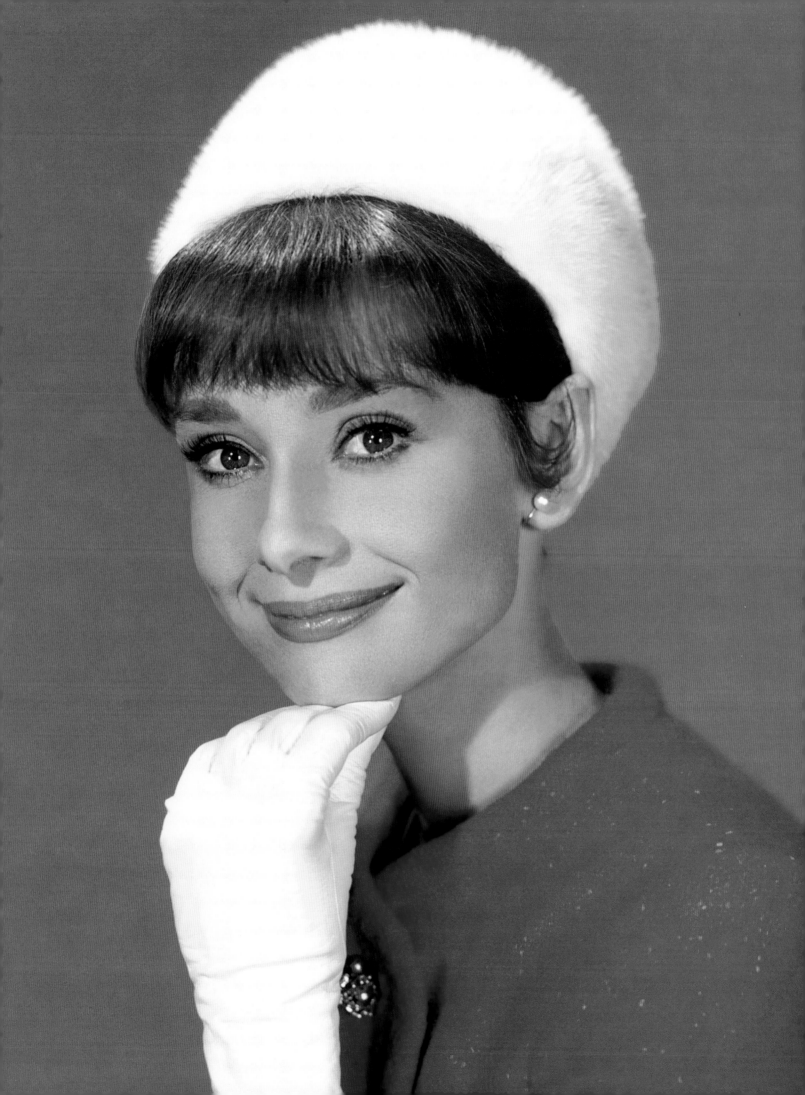

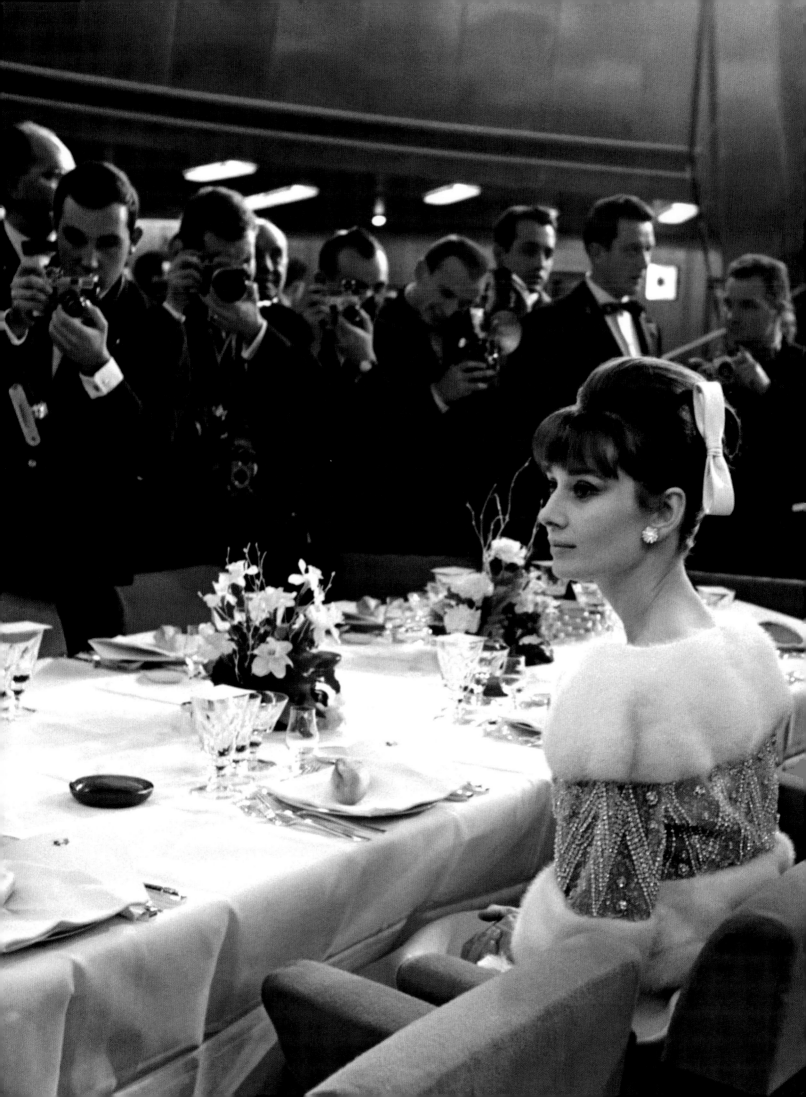

Paris When It Sizzles

It Sizzles

1964

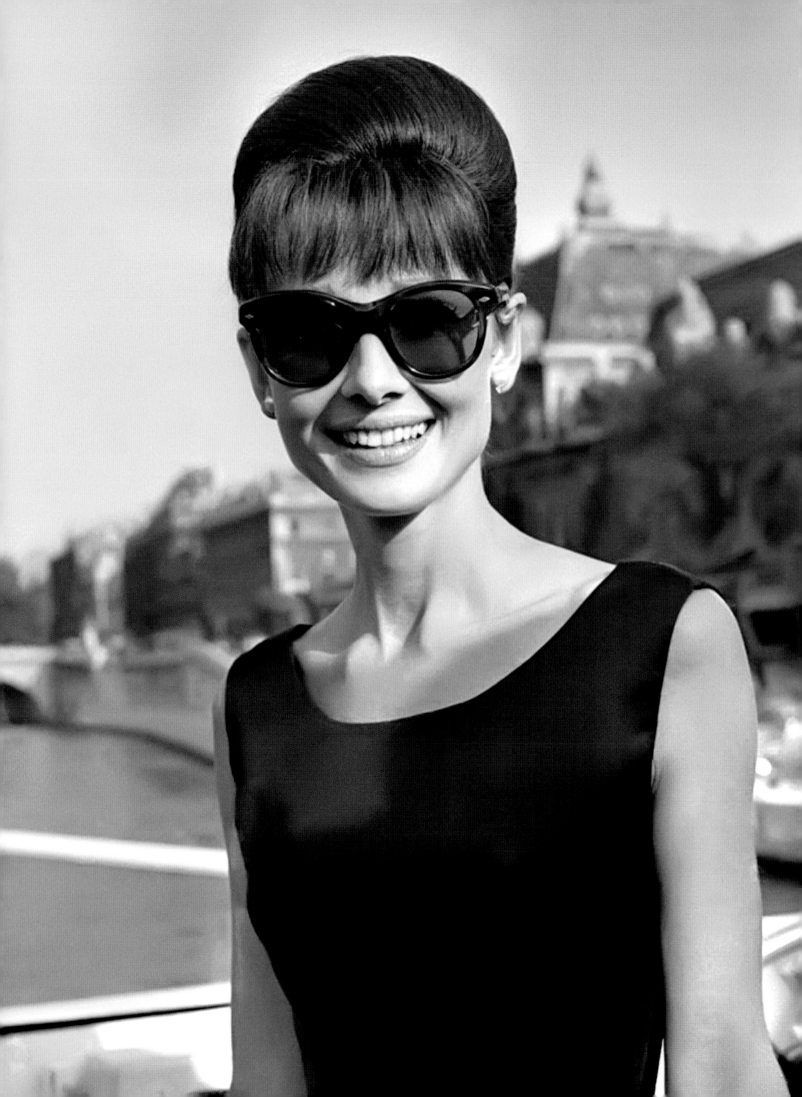

"She was the last Hollywood actress whose presence as the star of a film always sold tickets and made the studios great profits. They understood that it was the actual *personality* of the actor that made the role a success. Therefore, stars of the time were never asked to go to acting classes to change the type of person they were so that film critics would think it was 'good acting'. . . . She became a great friend of George Cukor's after *My Fair Lady* and would very often stay at his house when she came to Hollywood, just a few minutes away from the very small house Katharine Hepburn lived in on his property. They both liked her a lot . . . I once went to a small party at her apartment in Rome. She was sweet and charming and instantly made someone feel at ease. Though she was one of the few movie stars I ever met who looked exactly in the flesh like she did on screen, there was a humility about her that never made you feel you were in the presence of one of the last superb artists of the golden years of the great Hollywood studio system."

PAUL MORRISSEY (Producer, writer, and director)

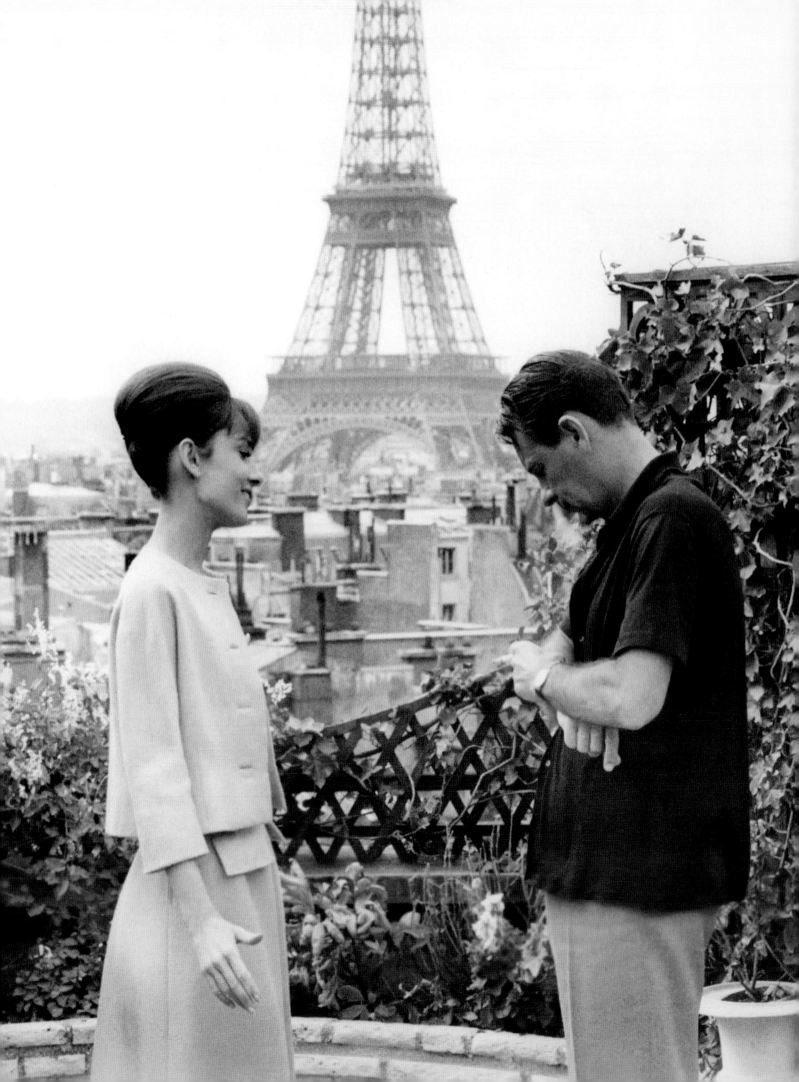

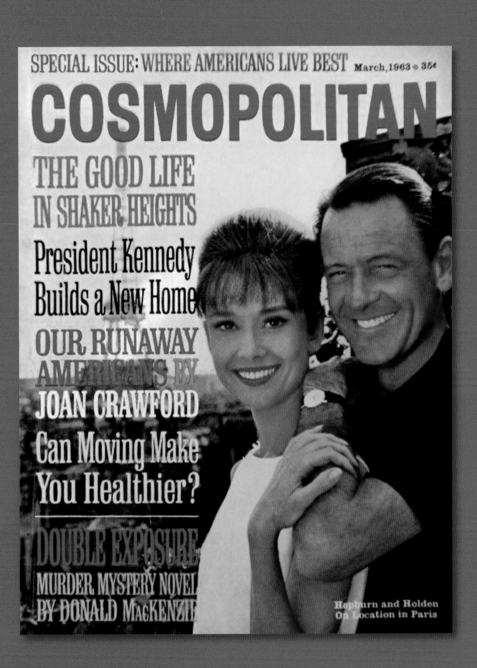

SPECIAL ISSUE: WHERE AMERICANS LIVE BEST March, 1963 ● 35¢

COSMOPOLITAN

**THE GOOD LIFE
IN SHAKER HEIGHTS**

**President Kennedy
Builds a New Home**

**OUR RUNAWAY
AMERICANS BY
JOAN CRAWFORD**

**Can Moving Make
You Healthier?**

**DOUBLE EXPOSURE
MURDER MYSTERY NOVEL
BY DONALD MacKENZIE**

Hepburn and Holden
On Location in Paris

"As a child, I was taught that it was bad manners to bring attention to yourself, and to never, ever make a spectacle of yourself…all of which I've earned a living doing."

AUDREY HEPBURN

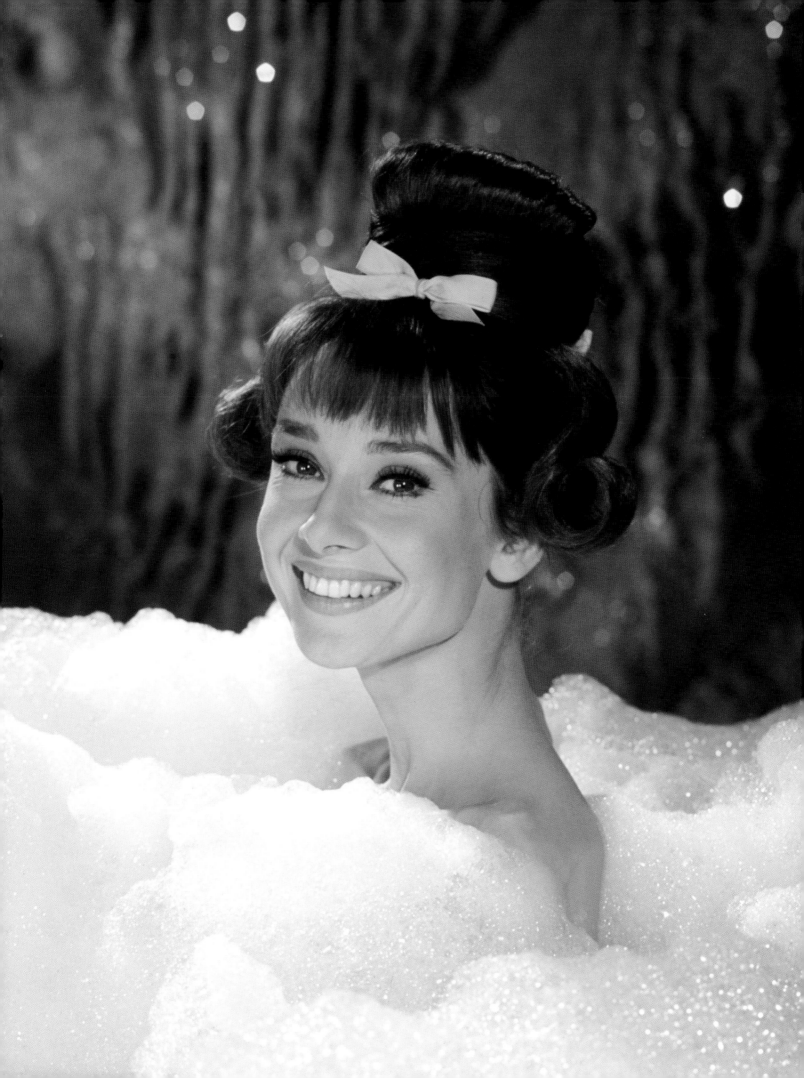

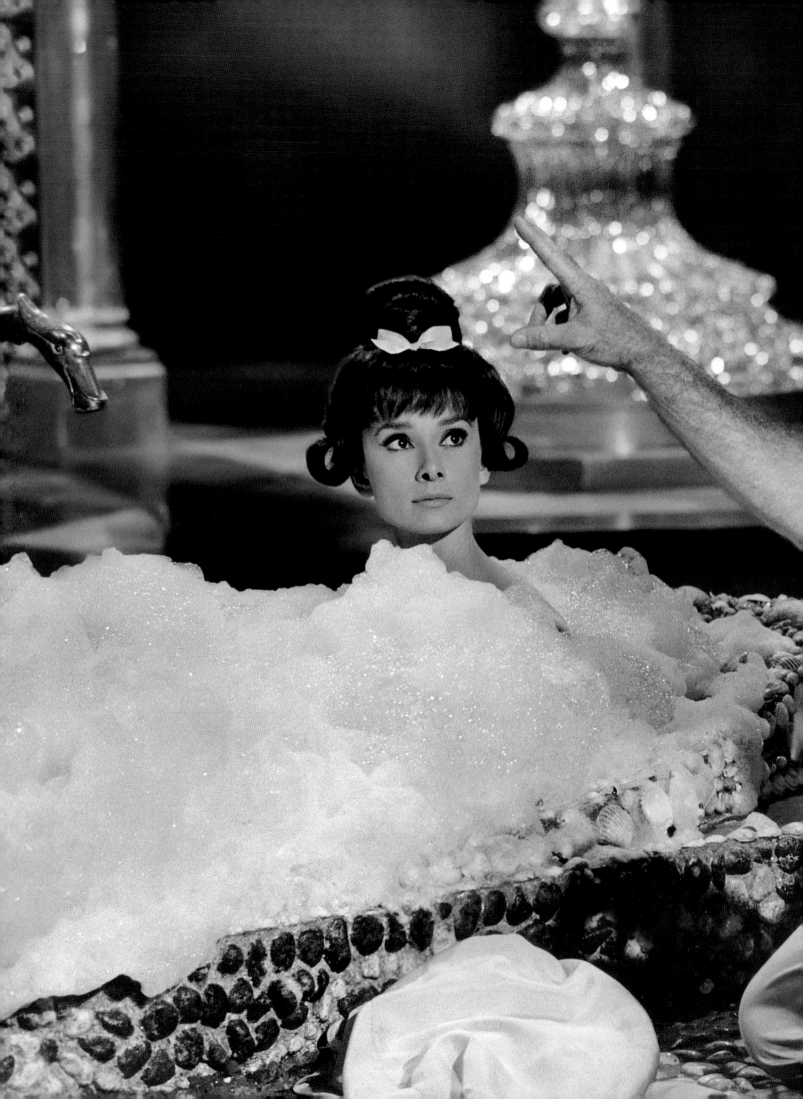

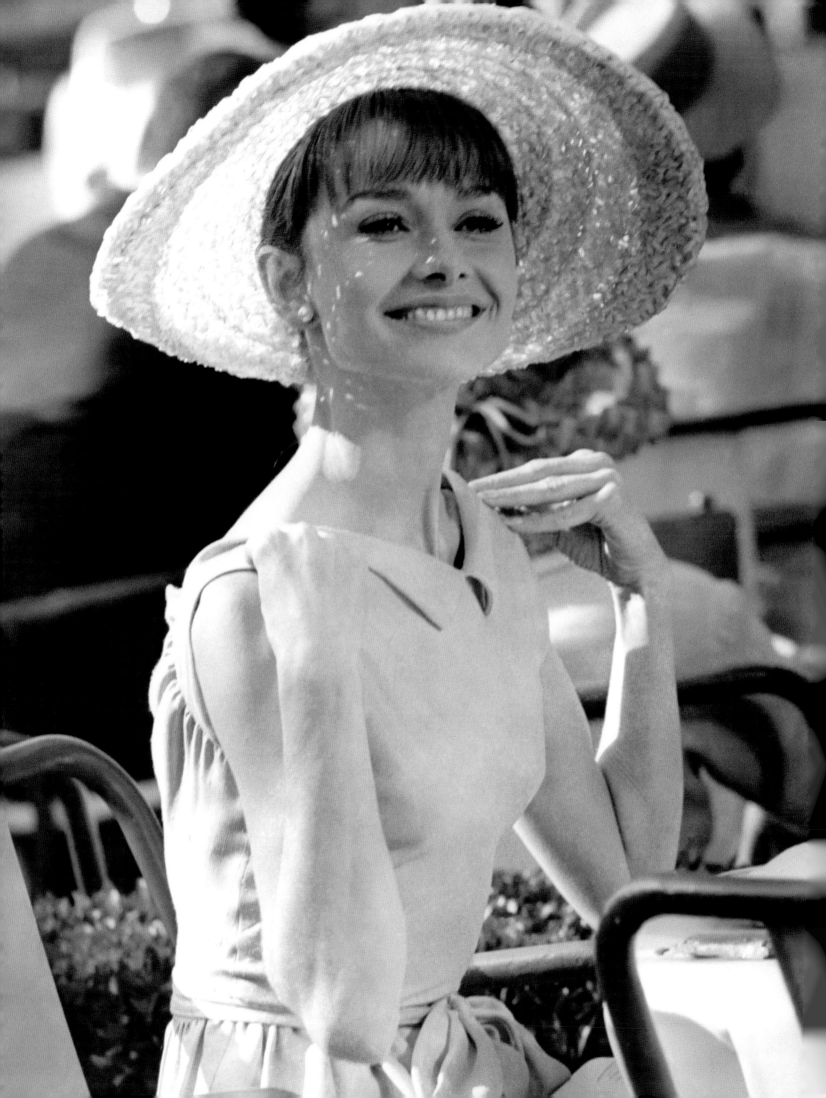

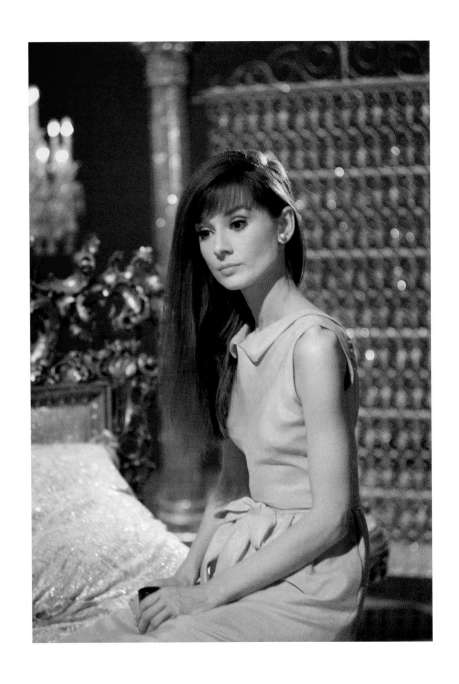

"Audrey was meek, gentle, and ethereal, understated both in her life and in her work. She walked among us with a light pace, as if she didn't want to be noticed."

SOPHIA LOREN

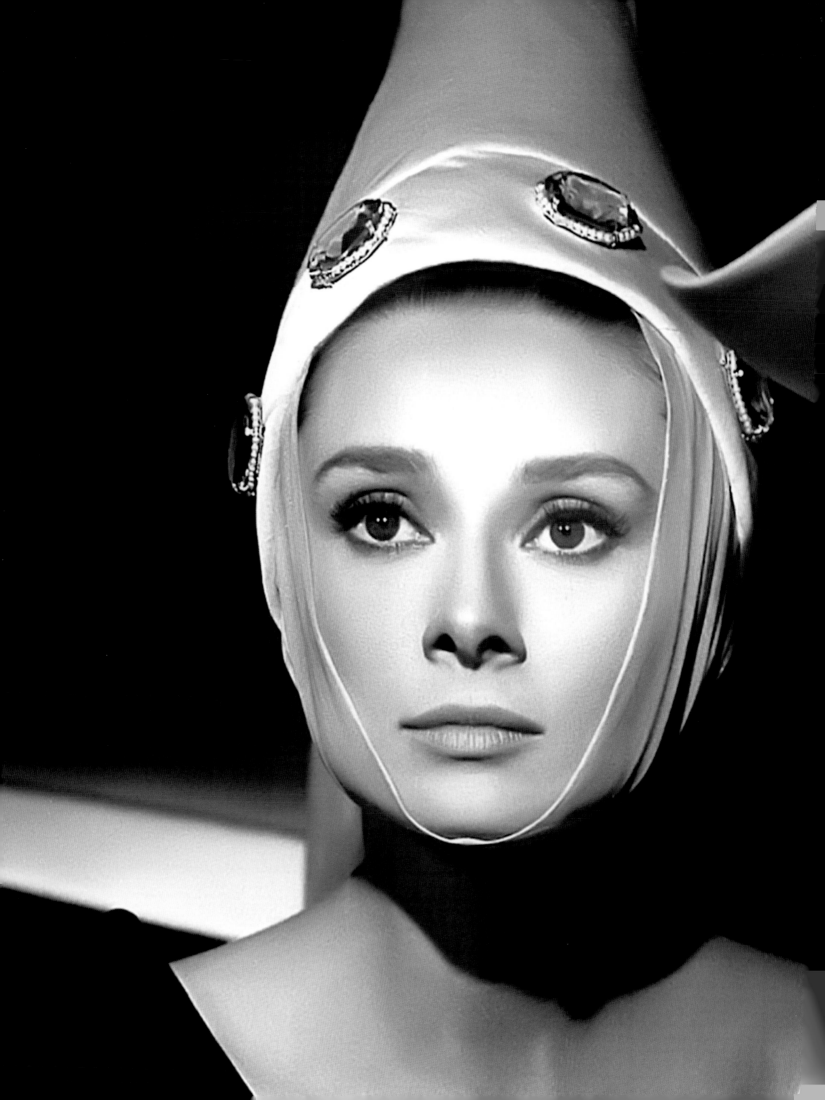

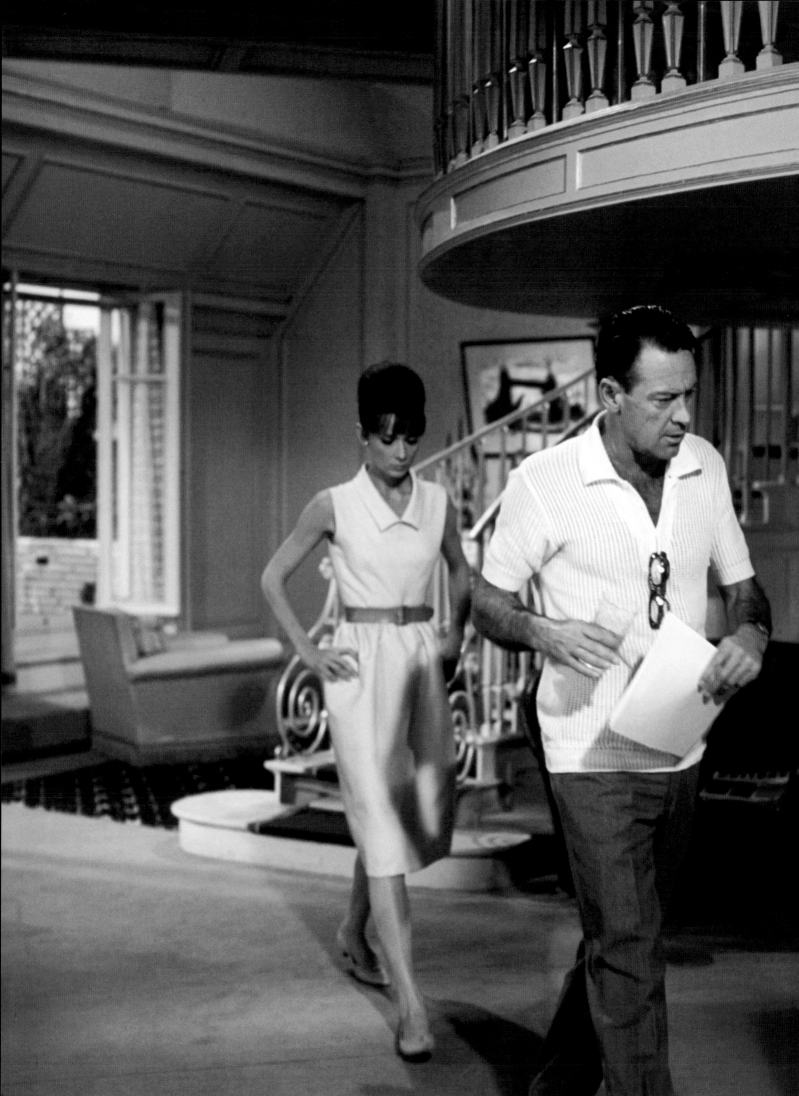

"Before I even met Audrey, I had a crush on her, and after I met her, just a day later, I felt as if we were old friends... Most men who worked with her felt both fatherly or brotherly about her, while harboring romantic feelings about her...She was the love of my life."

WILLIAM HOLDEN
(Costar, *Paris When It Sizzles*, 1964)

"No one in the profession was ever jealous of her. No one ever disputed her title as 'The Best' in romantic comedies. Courageous, stoical even, her sense of duty amazed her colleagues; she was always on time, ever ready with her script on the movie set. No one ever saw her throw a tantrum, or the shadow of a movie-star caprice. She was moved to this code of perfect behavior by the most touching modesty. According to her, she had just been lucky to be singled out for a fabulous career. She tried forever to measure up to what she thought she ought to be."

LESLIE CARON (Actress)

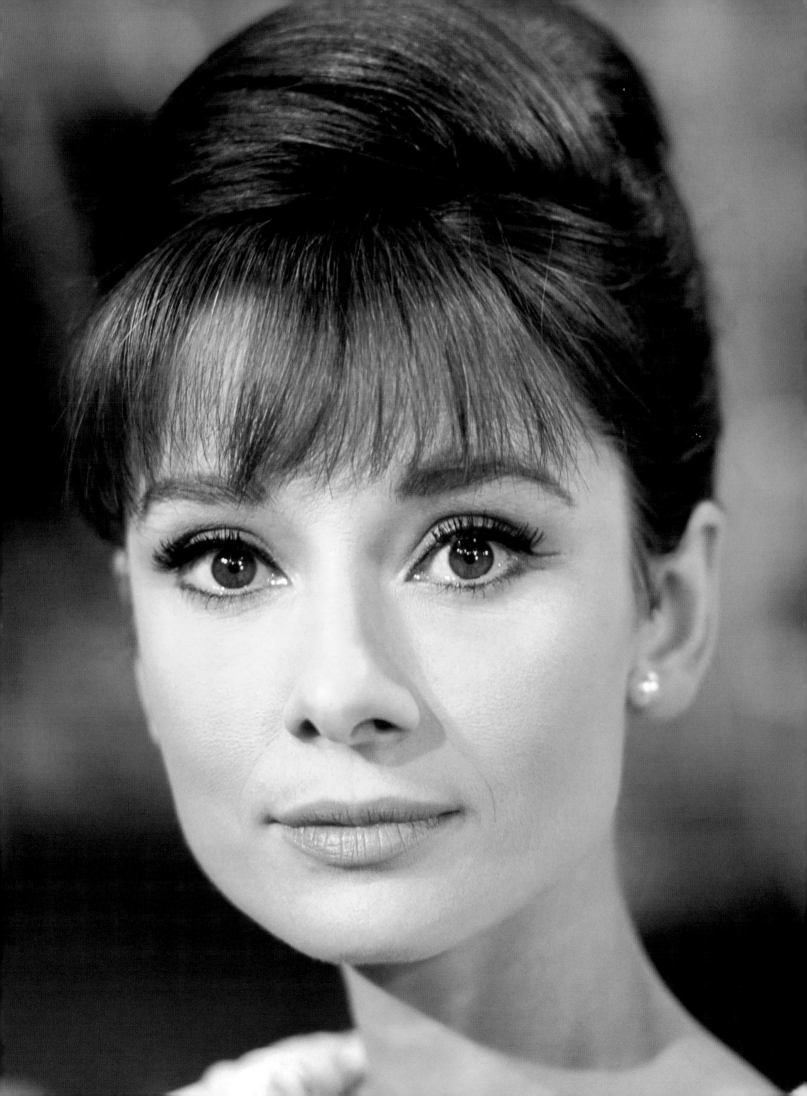

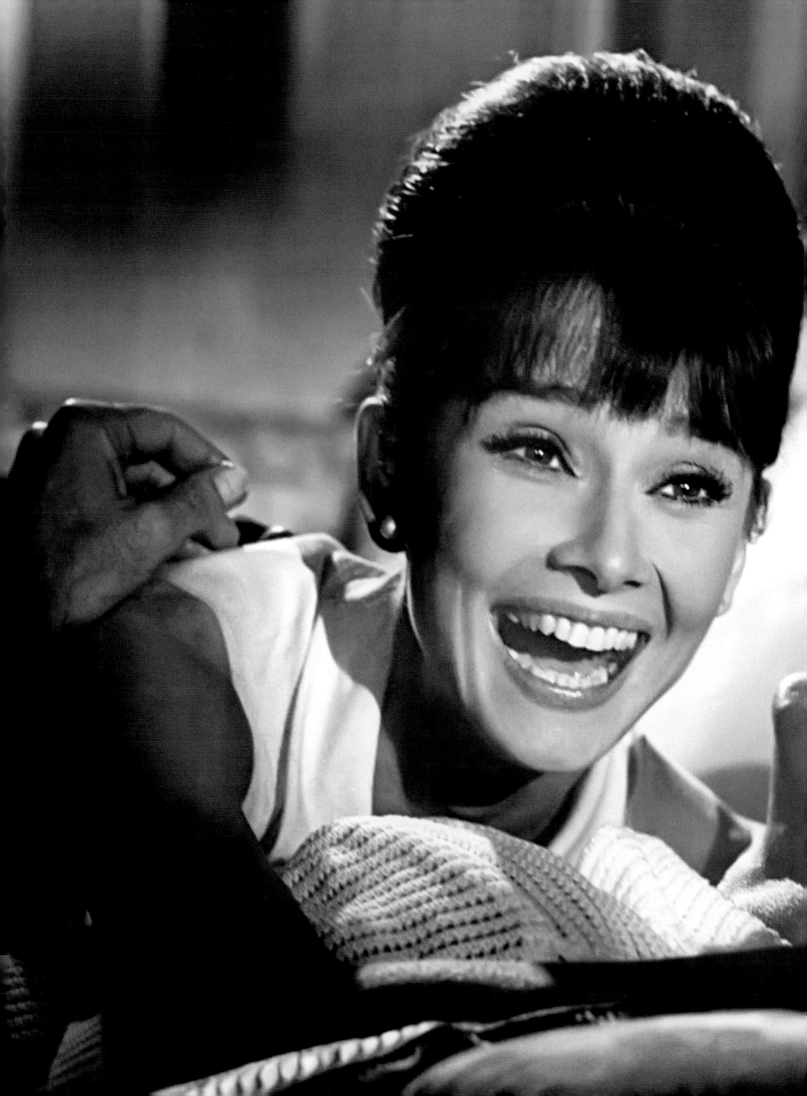

"First I realized that I had a mom, and she was a pretty great mom. And then I realized she was was an actress and she was involved with films. It was only much later that I realized how much she was appreciated worldwide... I think people love her for the right reasons and I think she was deserving of that love."

SEAN HEPBURN FERRER (Son of Audrey Hepburn)

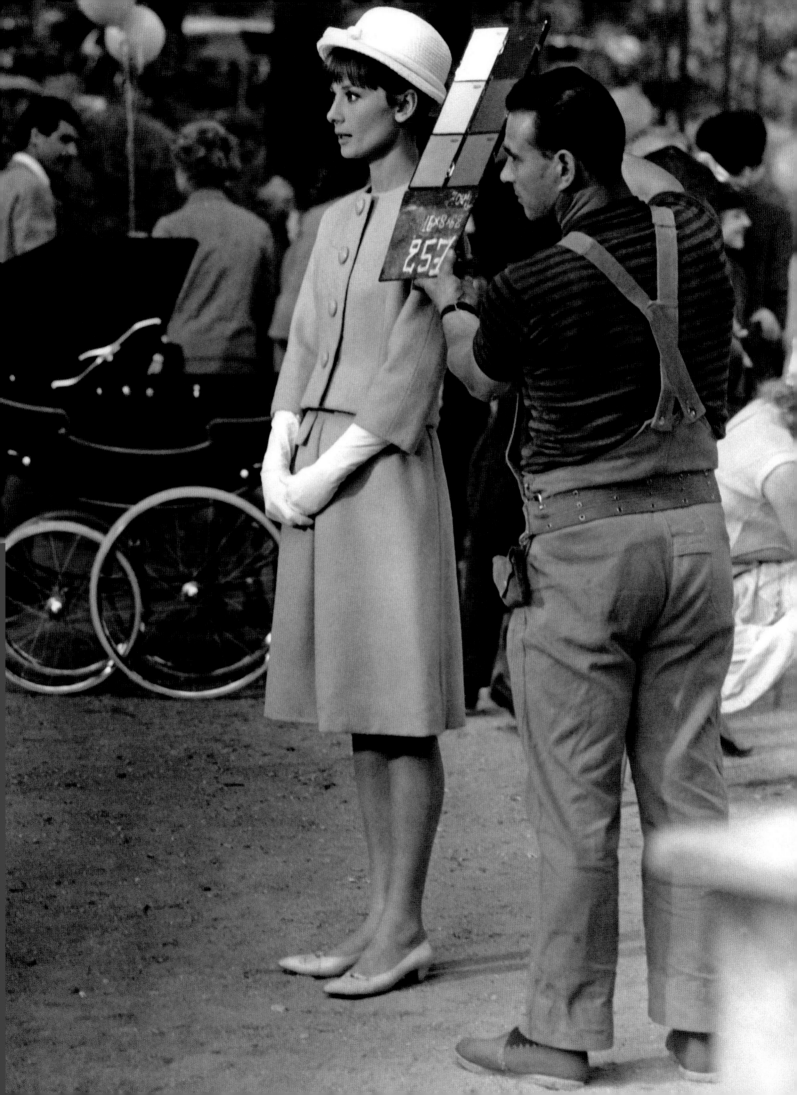

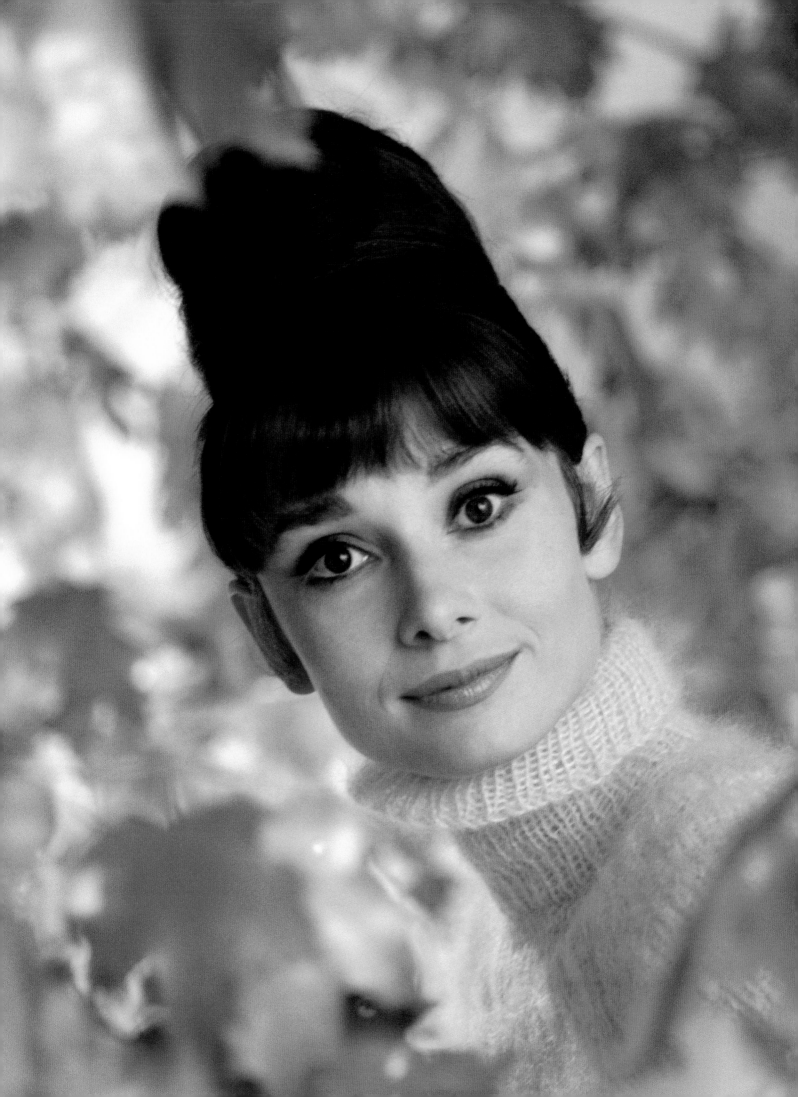

"I can take long walks, as I understand Greta Garbo does, and no one interferes with my thoughts and tranquillity. Come to think of it, the other day I was on Fifth Avenue in New York and I saw a woman who could very well have been Garbo; I was a bit tempted to go up to her, but then I thought, 'My God, practice what you preach! If it is her, you'll be intruding—just the thing you don't like yourself.'"

AUDREY HEPBURN

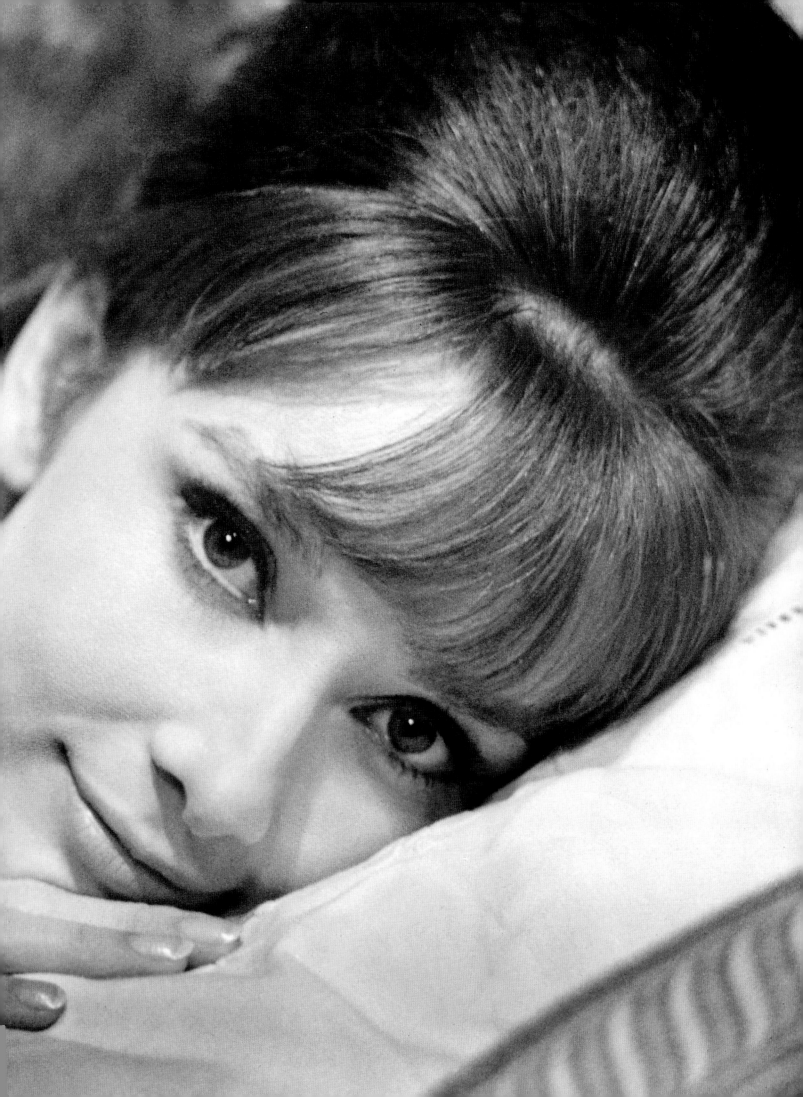

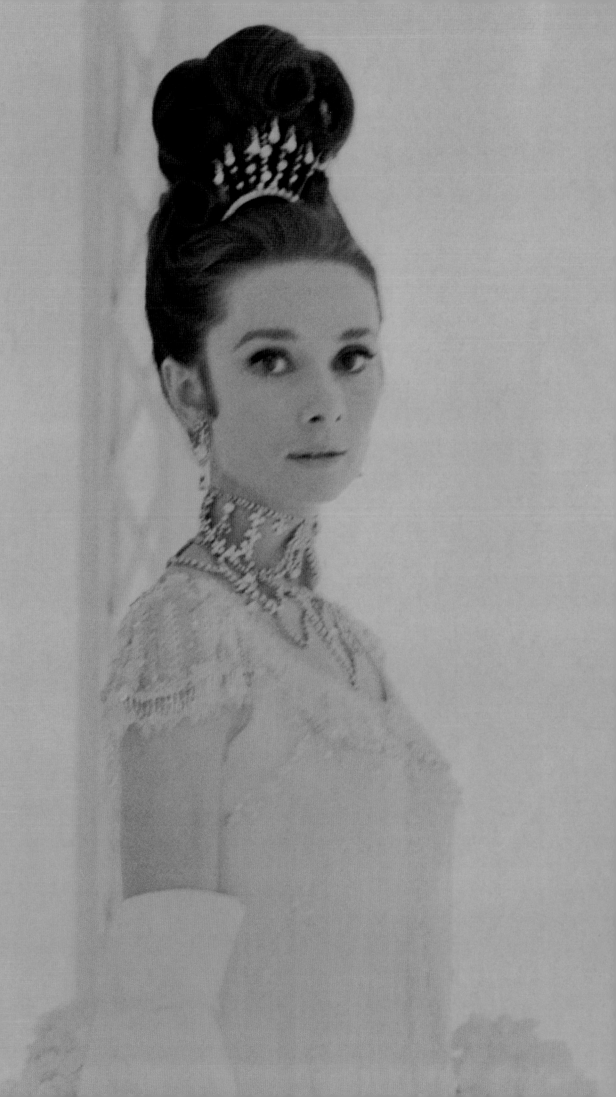

My Fair Lady

1964

"The difference between a lady and a flower girl is not how she behaves, but how she is treated."

AUDREY HEPBURN as Eliza Doolittle
(*My Fair Lady*, 1964)

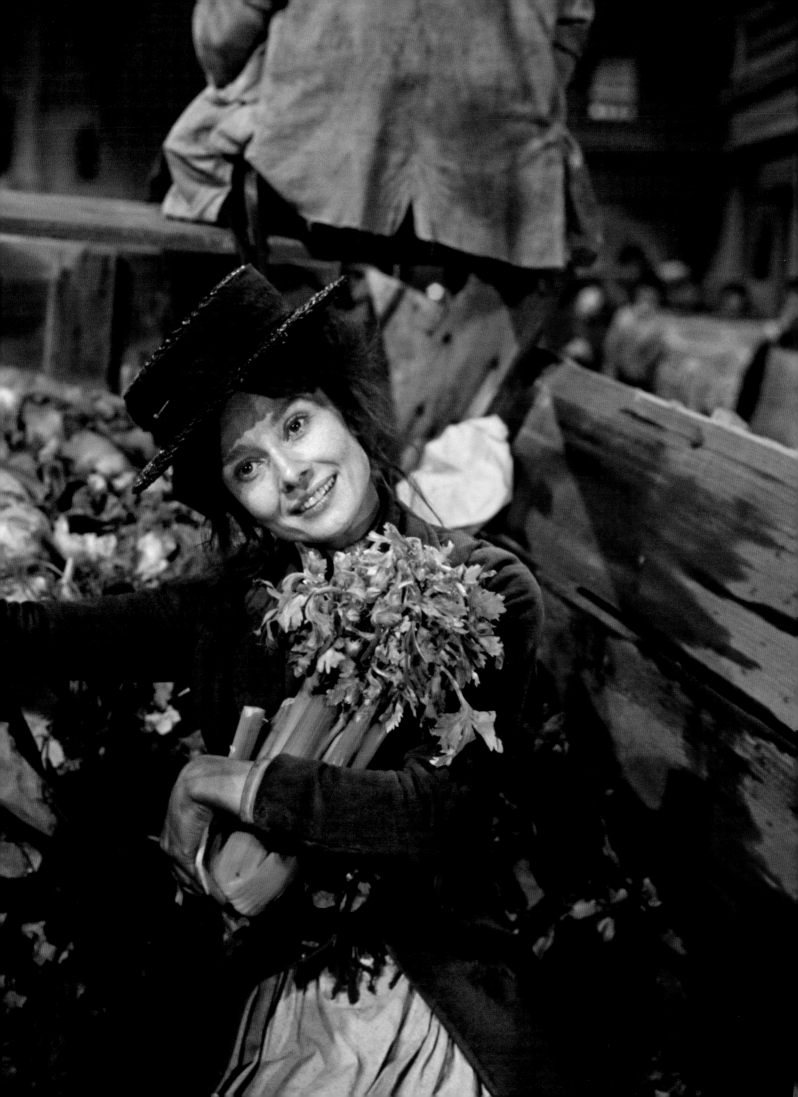

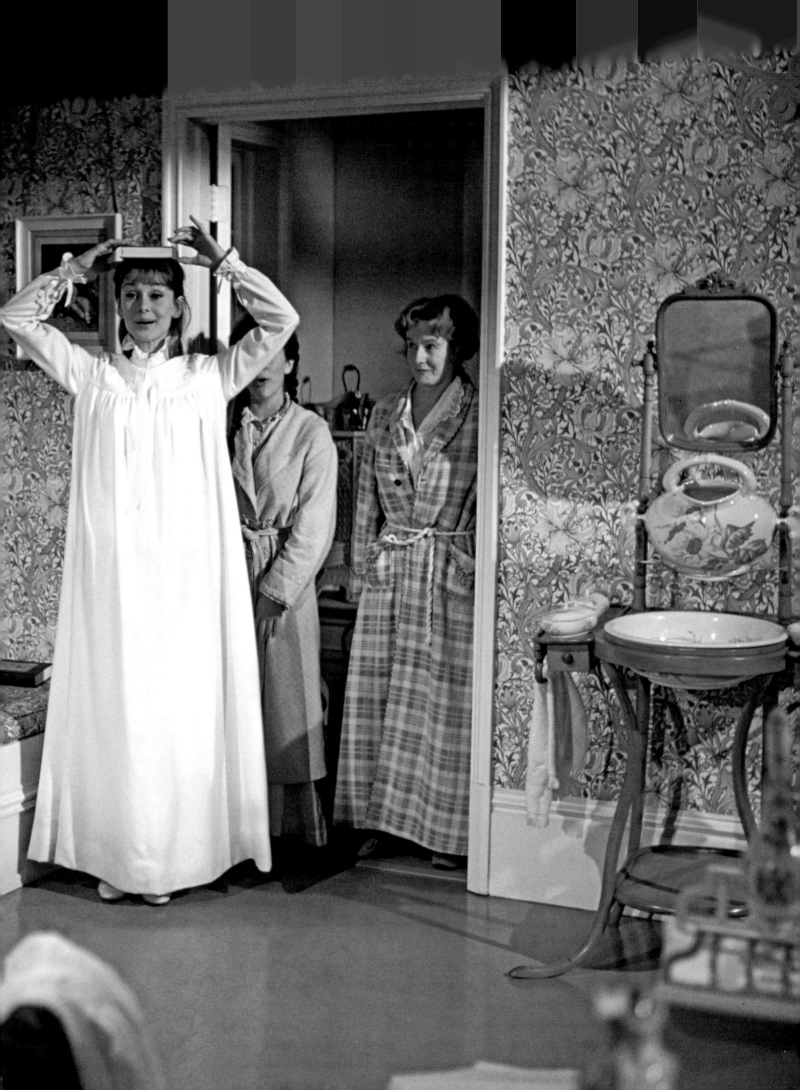

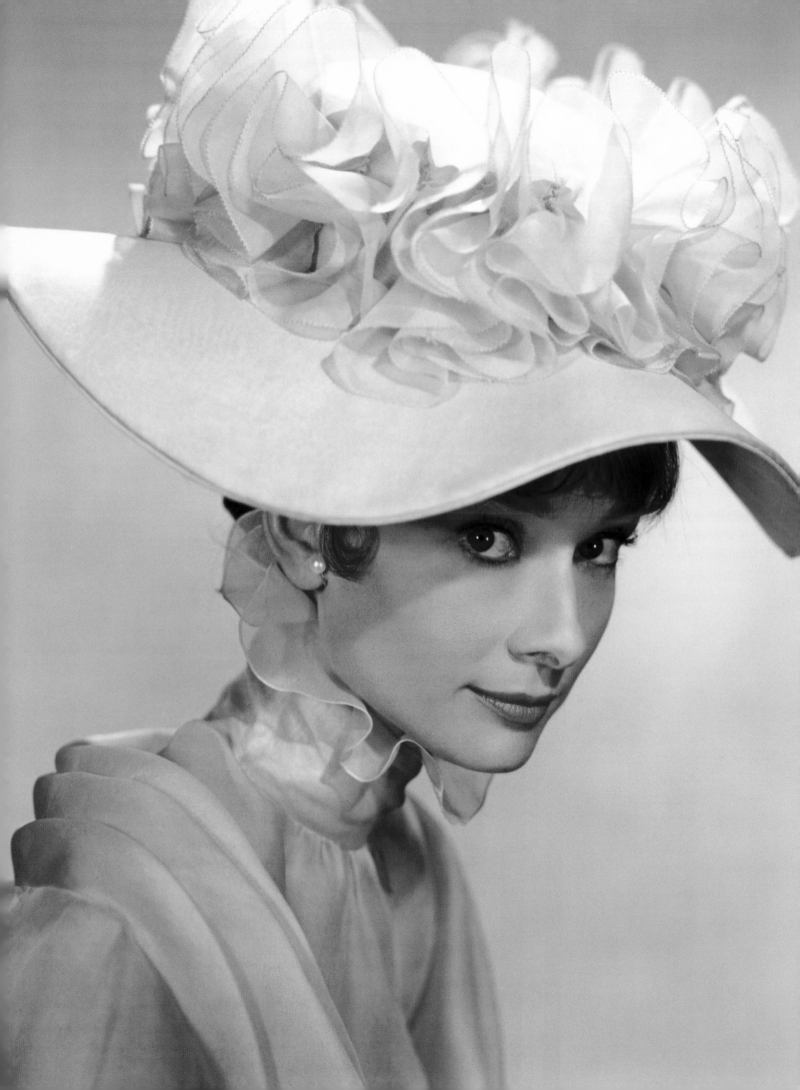

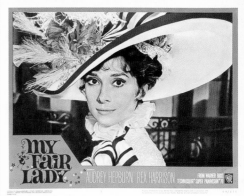

"The happiest thing about it is that Audrey Hepburn superbly justifies the decision of Jack Warner to get her to play the title role."

THE NEW YORK TIMES

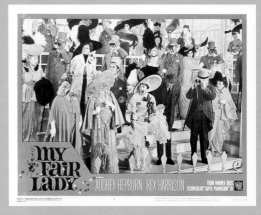

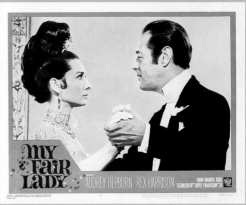

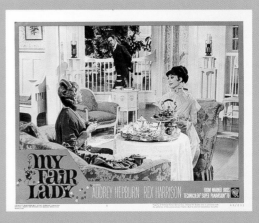

"In the middle of the crowd of race-goers Audrey appeared to be tested in her ballroom dress and coiffure. Never has she more lived up to her name, and never was her allure more obvious than now as she smiled radiantly or shyly, flickered her eyelids, lowered her lashes, blinked, did all the tricks of allure with enormous assurance. She gyrated in front of the camera while two hundred extras watched. She was vastly entertained that some of them were scrutinizing her through their race glasses."

CECIL BEATON (Photographer)

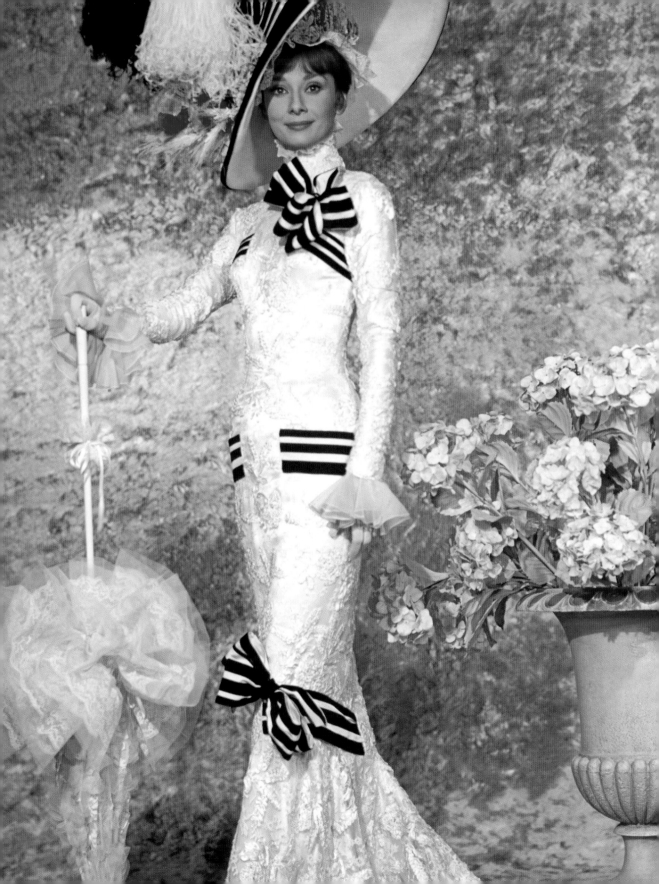

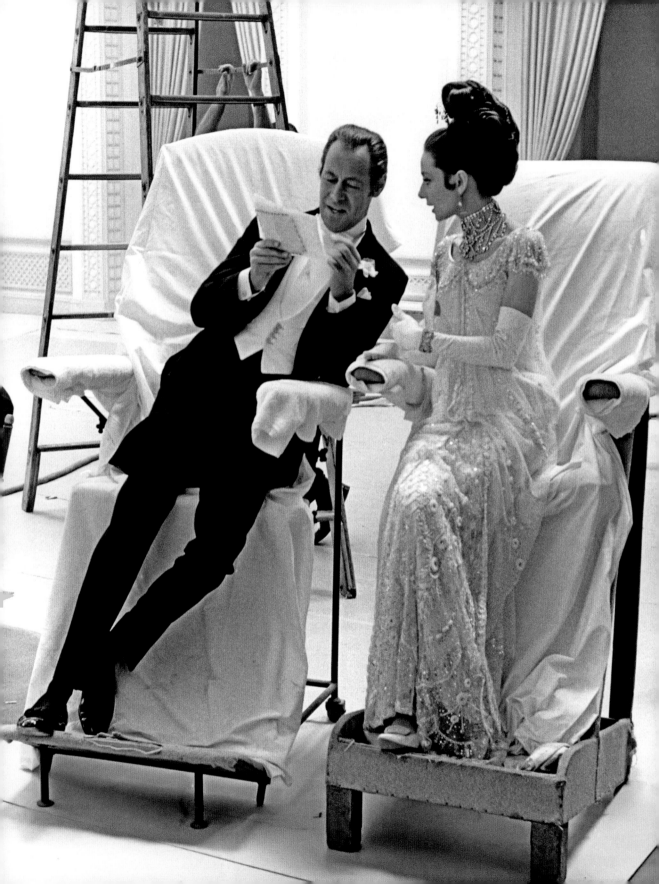

"Audrey Hepburn was playing Eliza Doolittle, partly because she was one of the now rare actresses who could command a million dollars for each picture. [Director George] Cukor was not backward in pointing out to me how lucky I was to be acting with a million-dollar girl. It was in no way Audrey's design that she, and not Julie Andrews, was chosen for the film role; it was the luck of the draw and she had a tough time over it. There are very few similarities between the two girls, except that they both have extraordinary charm. She is a very gentle and sweet person, and we get on very well. She was terribly thin, and in the habit of eating only raw vegetables, which I always thought could not give her enough energy."

REX HARRISON (Costar, *My Fair Lady*, 1964)

"No one can doubt that Audrey Hepburn's appearance succeeds because it embodies the spirit of today. Audrey Hepburn has enormous heron's eyes and dark eye-brows slanted towards the Far East. Her facial features show character rather than prettiness: the bridge of the nose seems almost too narrow to carry its length, which bares into a globular tip with nostrils startlingly like a duck's bill. Her mouth is wide, with a cleft under the lower lip too deep for classical beauty, and the delicate chin appears even smaller by contrast with the exaggerated width of her jaw bones. Seen at the full, the outline of her face is perhaps too square; yet she intuitively tilts her head with a restless and perky asymmetry. She is like a portrait by Modigliani where the various distortions are not only interesting in themselves but make a completely satisfying composite."

CECIL BEATON

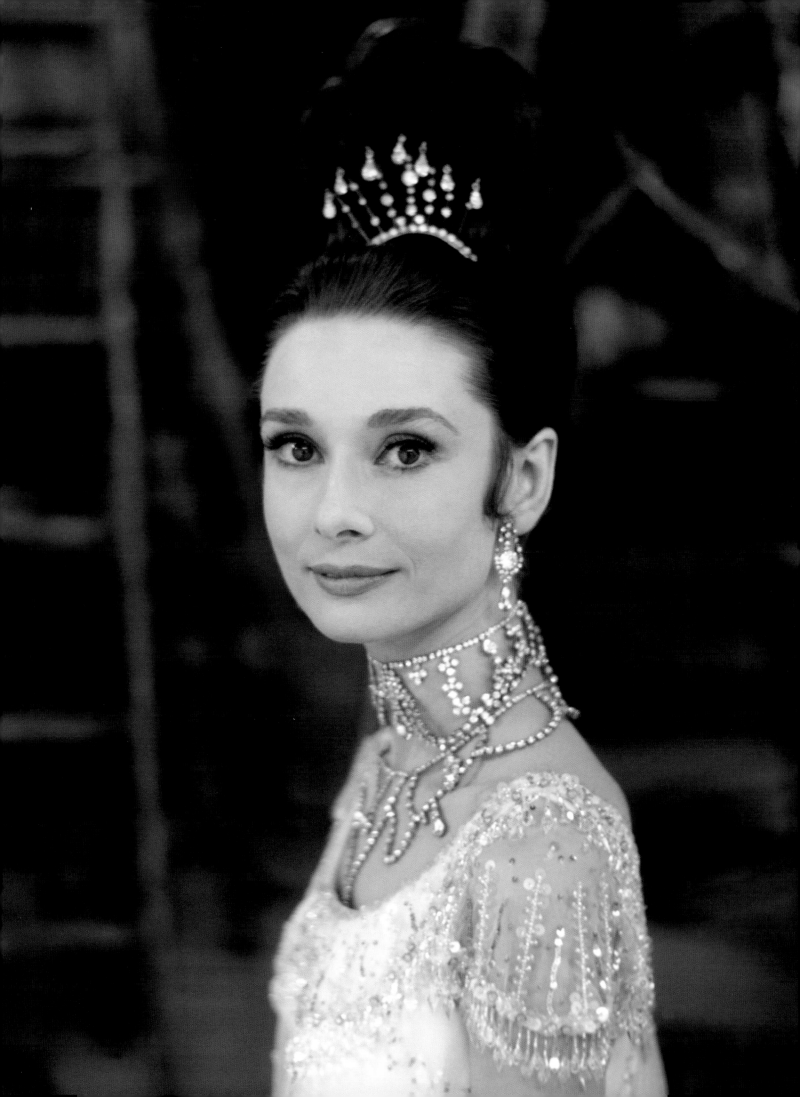

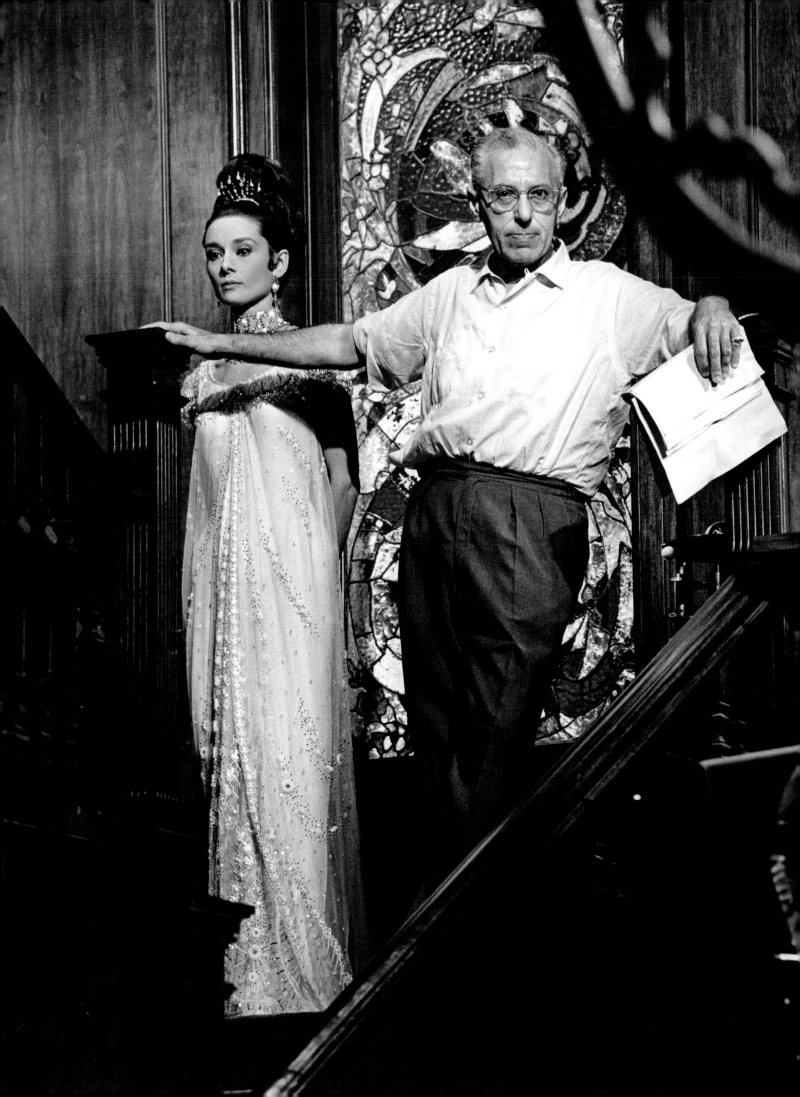

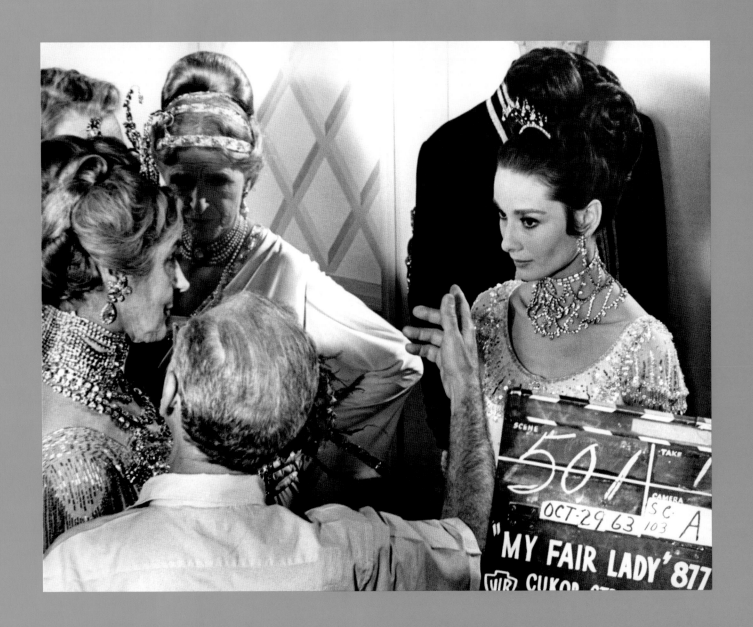

"I think *My Fair Lady* is a charming picture… Audrey plays with a great deal of power in it. She's a hard worker… extremely intelligent, inventive, modest… and funny. To work with her you wouldn't think she was this great star. She's tactful… the most endearing creature in the world."

GEORGE CUKOR (Director, *My Fair Lady*, 1964)

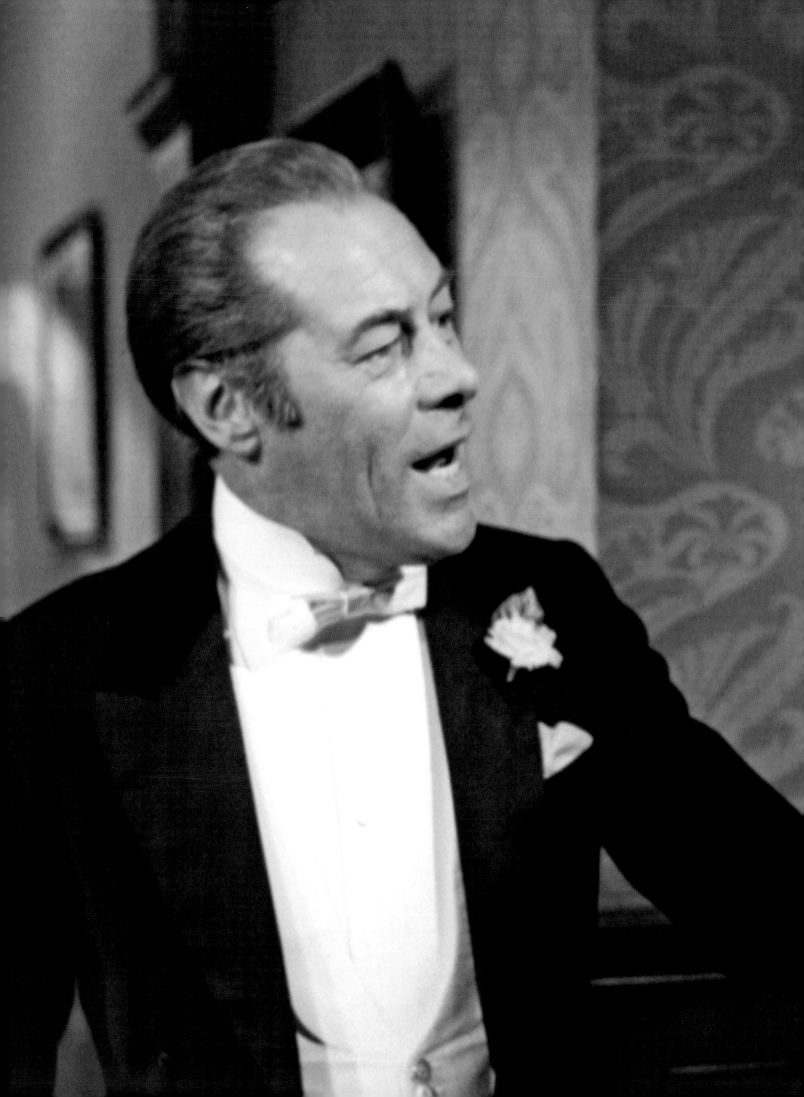

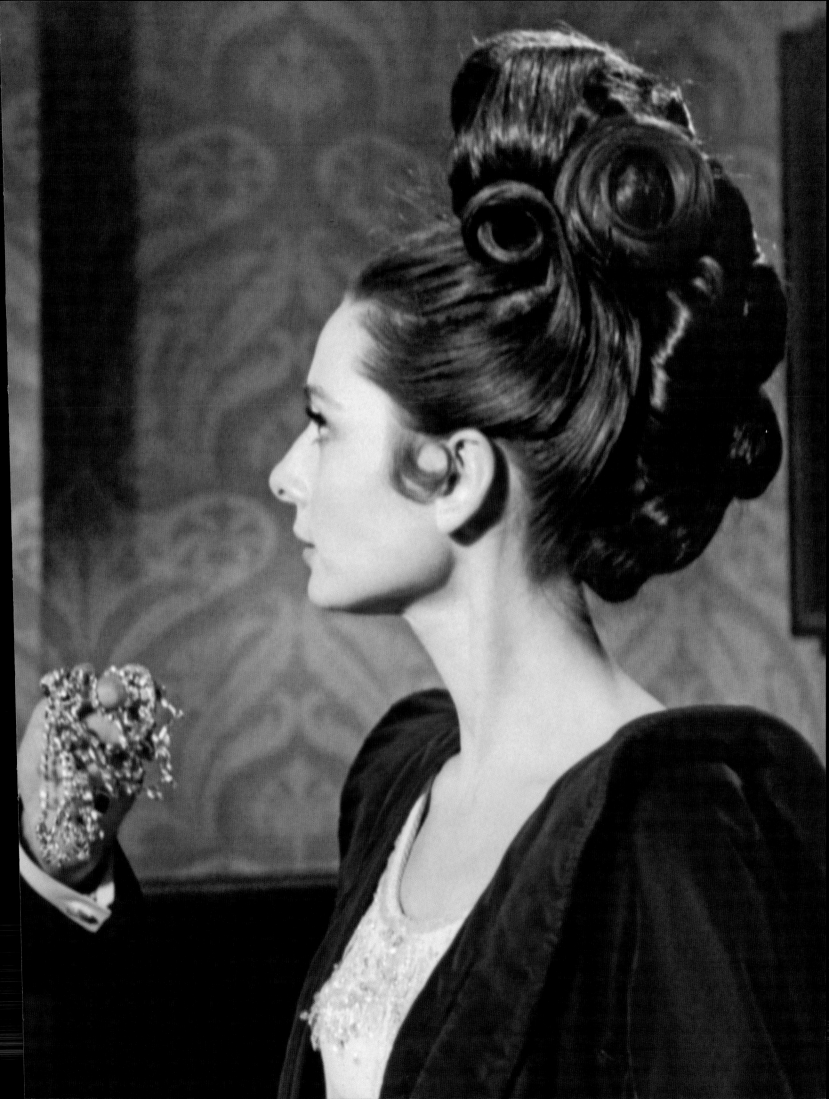

"I lack self-confidence.
I don't know whether I
shall ever get it. Perhaps
it is better to be unsure
of yourself, as I am.
But it is very tiring."

AUDREY HEPBURN

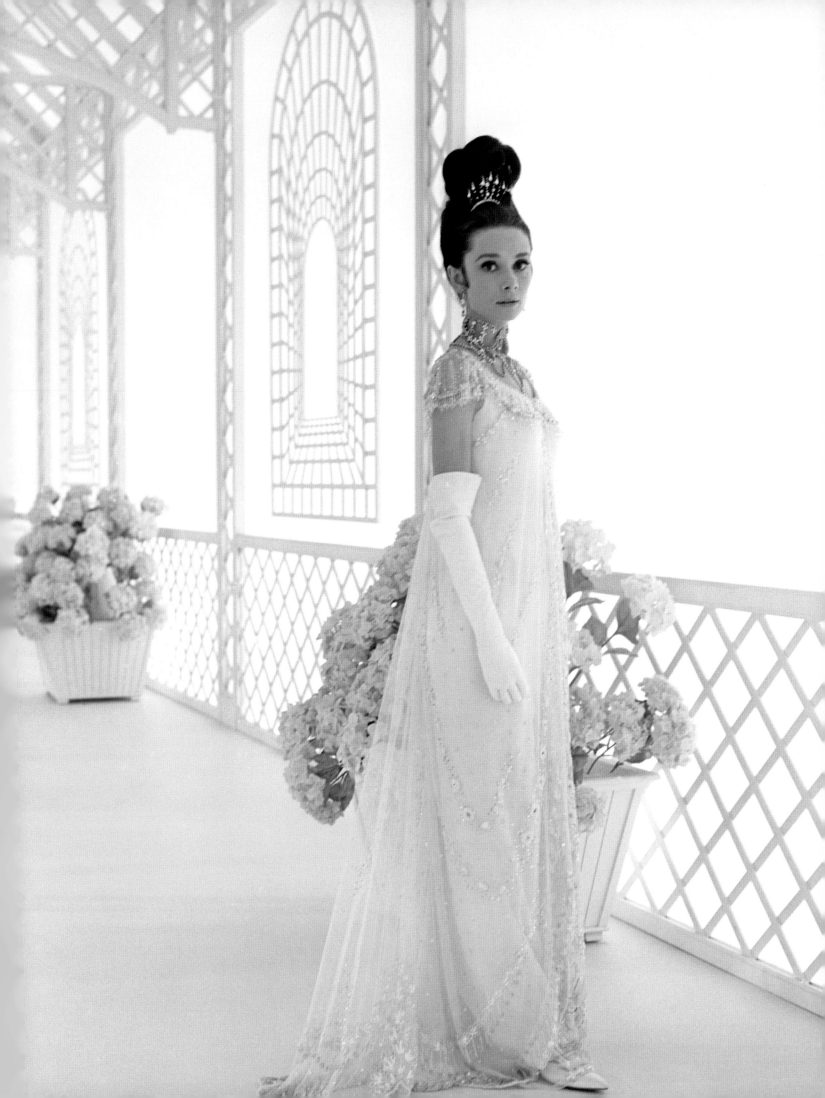

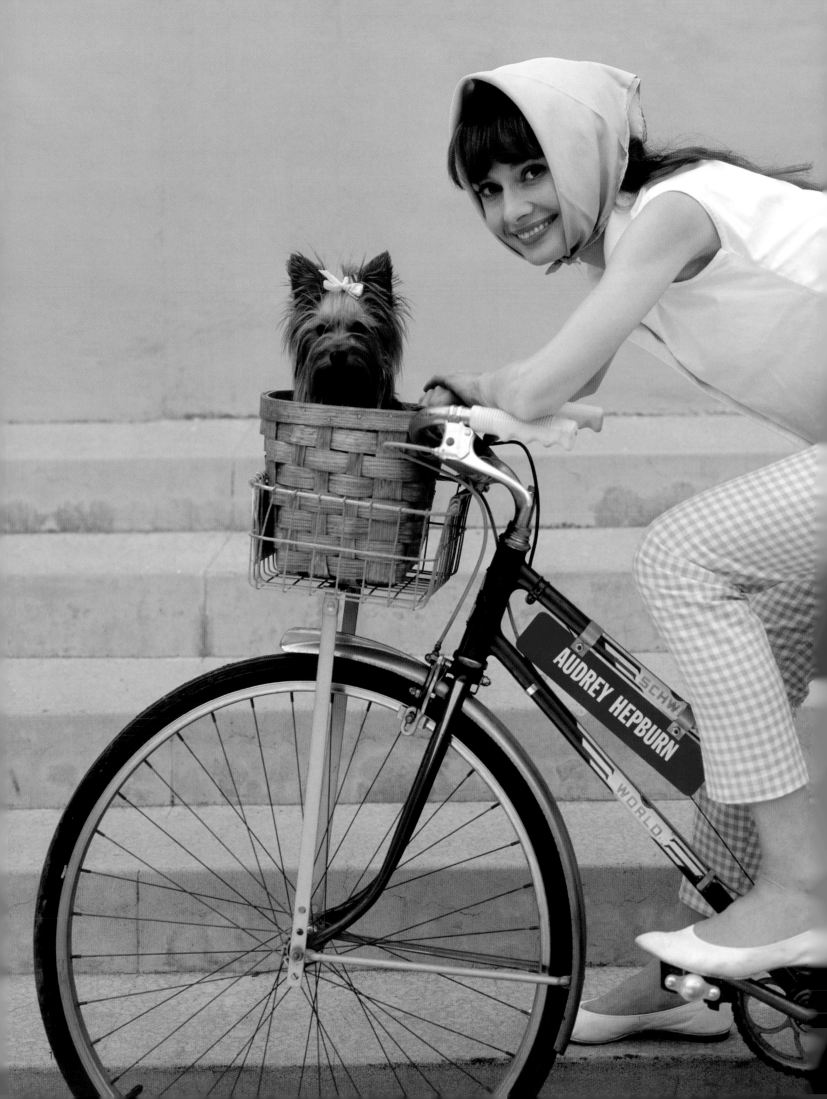

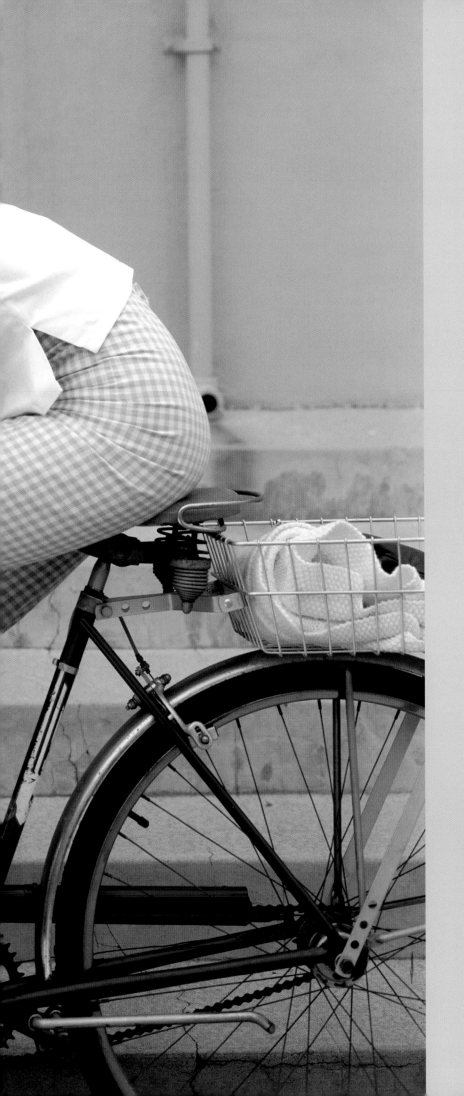

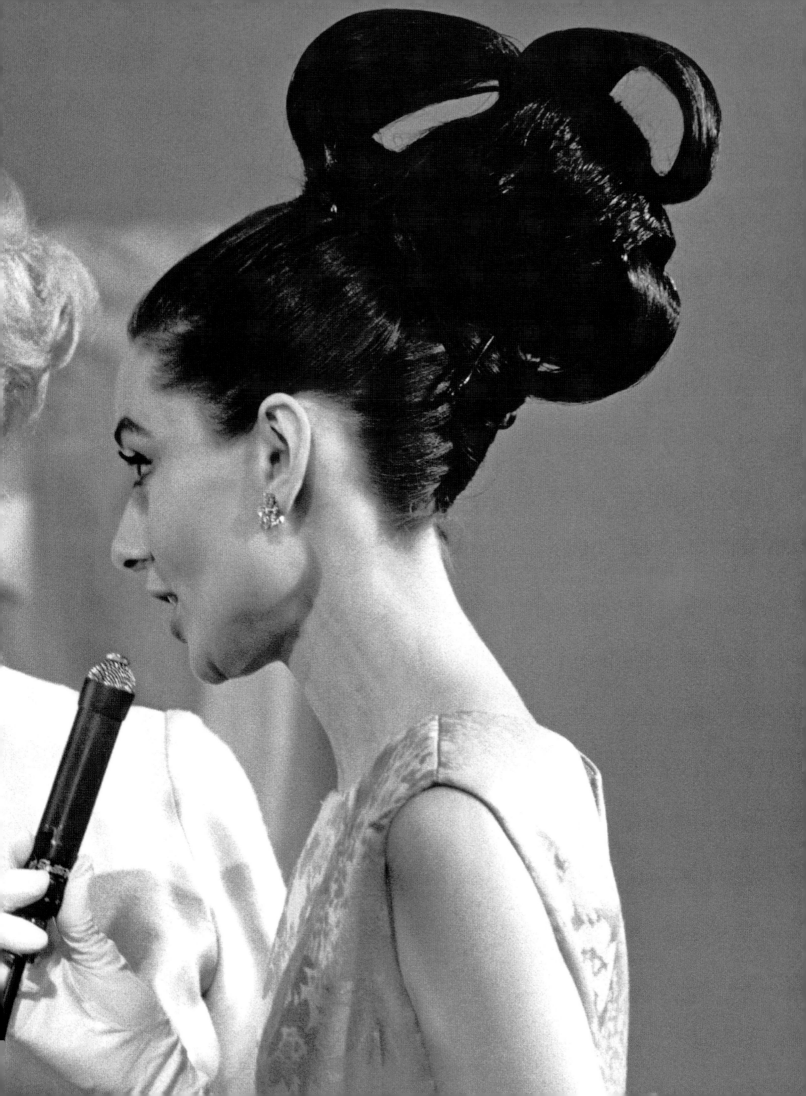

"Audrey was a lady with an elegance and charm that was unsurpassed, except by her love for underprivileged children all over the world."

ELIZABETH TAYLOR

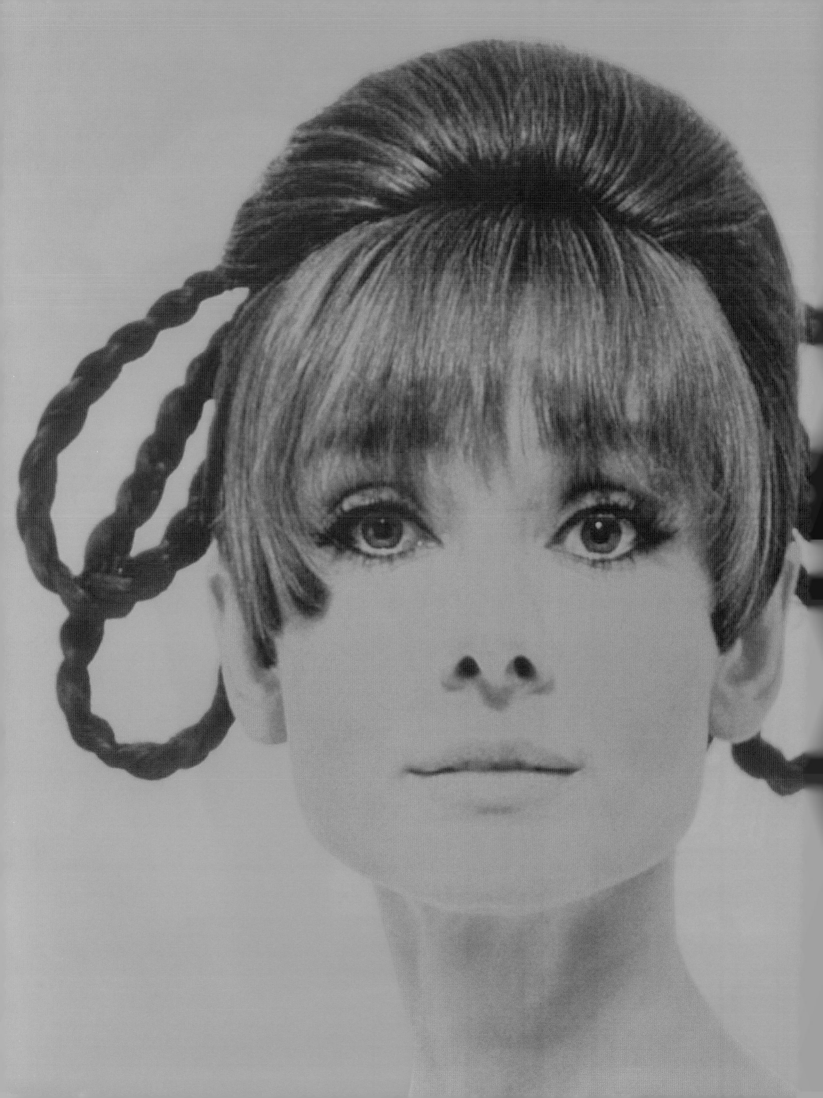

Fashion

1962–1966

"I am, and forever will be, devastated by the gift of Audrey Hepburn before my camera. I cannot lift her to greater heights. She is already there. I can only record. I cannot interpret her. There is no going further than who she is. She has achieved in herself her ultimate portrait."

RICHARD AVEDON (Photographer)

Audrey Hepburn, dress by Yves Saint Laurent, Paris studio, July 1962 © The Richard Avedon Foundation.

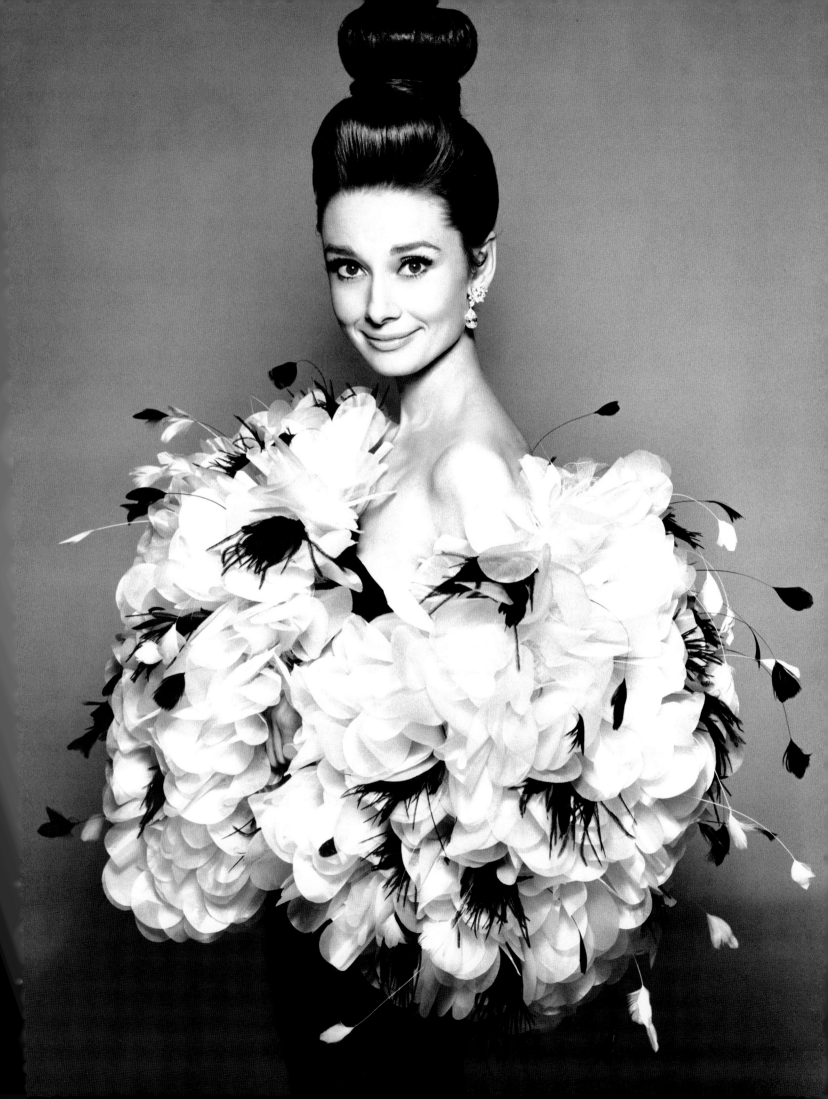

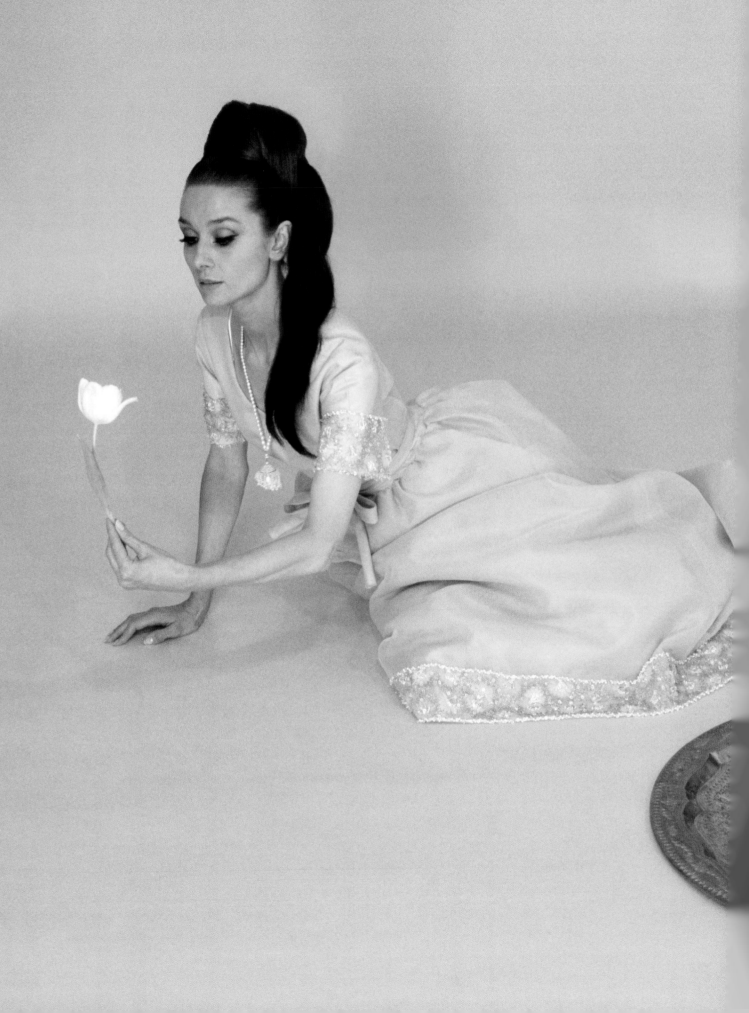

"I believe in pink.

"I believe that laughing is the best calorie burner.

"I believe in kissing, kissing a lot.

"I believe in being strong when everything seems to be going wrong.

"I believe that happy girls are the prettiest girls.

"I believe that tomorrow is another day and I believe in miracles."

AUDREY HEPBURN

151

"The imprint of Miss Hepburn is absolutely, totally present. Like it or not, she will be the most important look of the twentieth century."

MANOLO BLAHNIK (Designer)

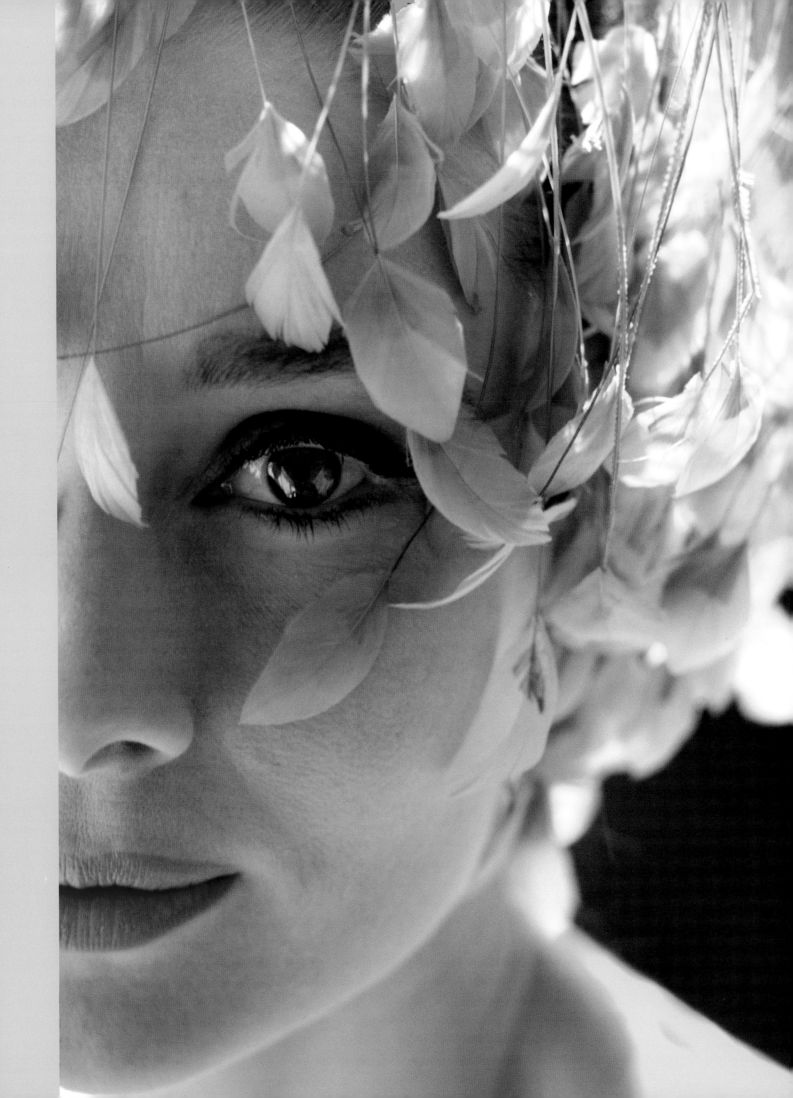

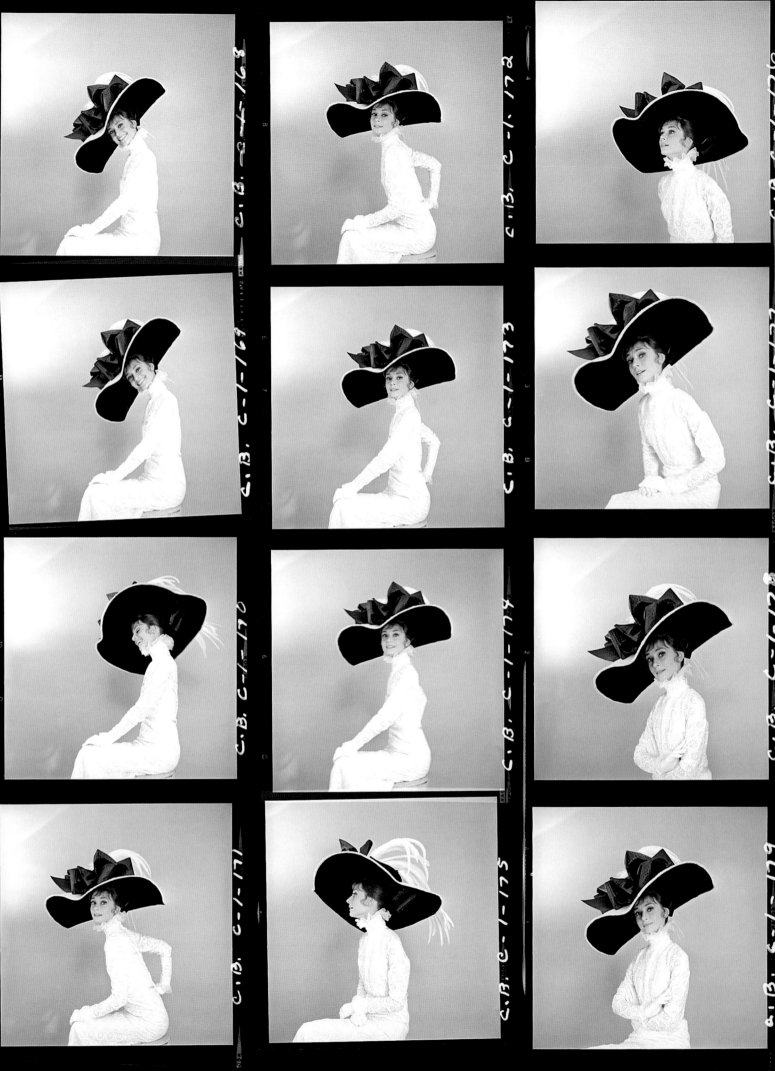

"As a result of her enormous success, Audrey Hepburn has already acquired the extra incandescent glow that comes as a result of being acclaimed, admired, and loved. Yet while developing her radiance, she has too much innate candor to take on that gloss of artificiality Hollywood is apt to demand of its queens."

"In film after film, Audrey wore clothes with such talent and flair that she created a style, which in turn had a major impact on fashion. Her chic, her youth, her bearing, and her silhouette grew ever more celebrated, enveloping me in a kind of aura or radiance that I could never have hoped for. The Hepburn style had been born, and it lives today."

HUBERT DE GIVENCHY

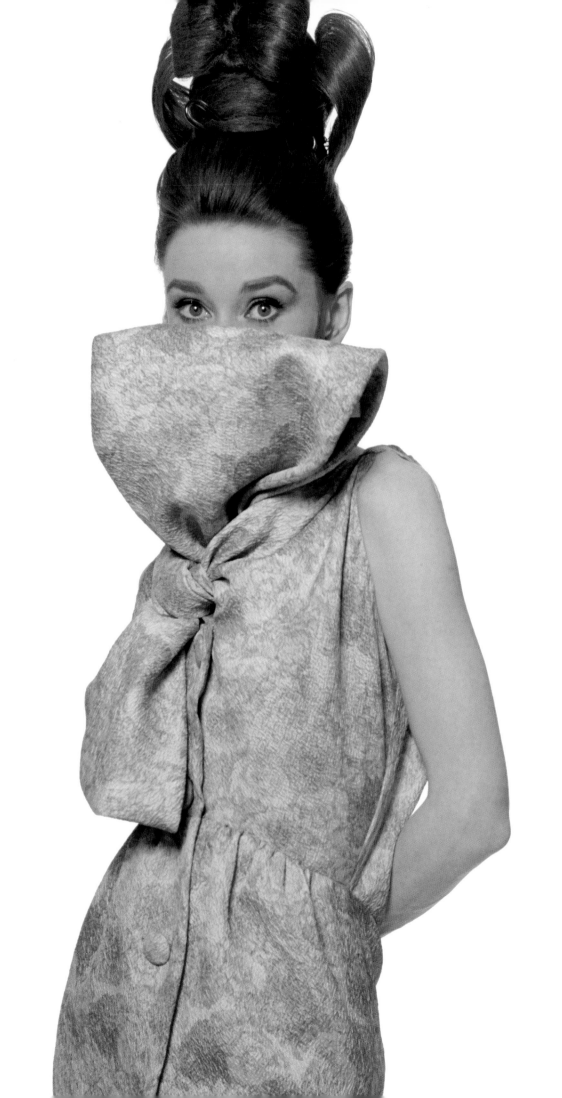

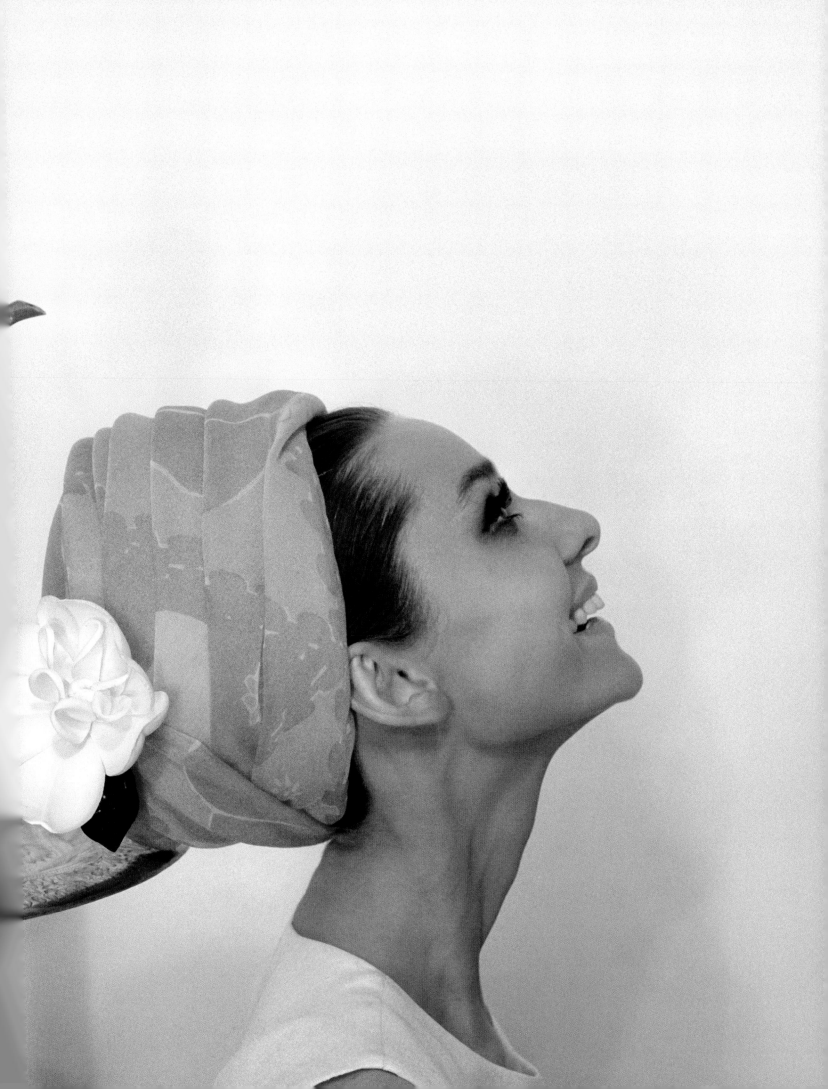

"Style is a word we use often and for a multitude of purposes. In the case of my mother, Audrey Hepburn, it was the extension of an inner beauty held up by a life of discipline, respect for the other and hope in humanity. If the lines were pure and elegant it was because she believed in the power of simplicity. If there was timelessness it was because she believed in quality, and if she still is an icon of style today, it is because once she found her look she stayed with it throughout her life. She didn't go with the trends, didn't reinvent herself every season. She loved fashion but kept it as a tool to compliment her look."

SEAN HEPBURN FERRER

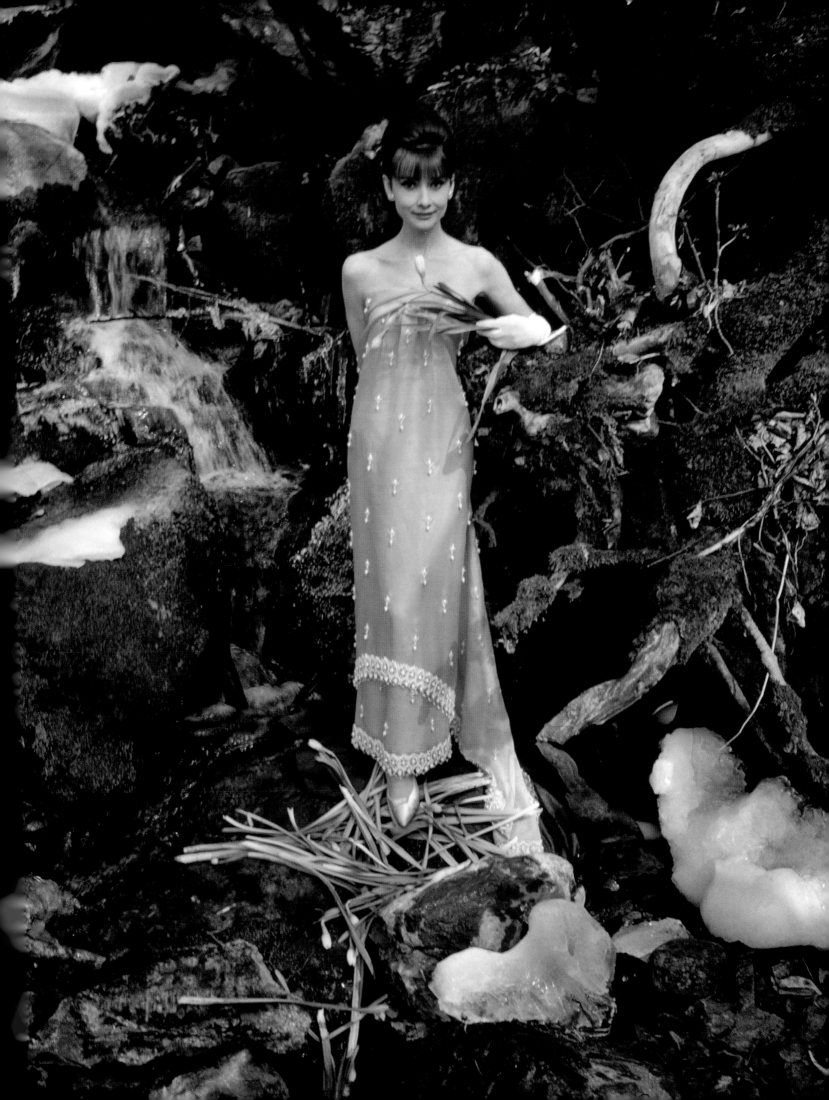

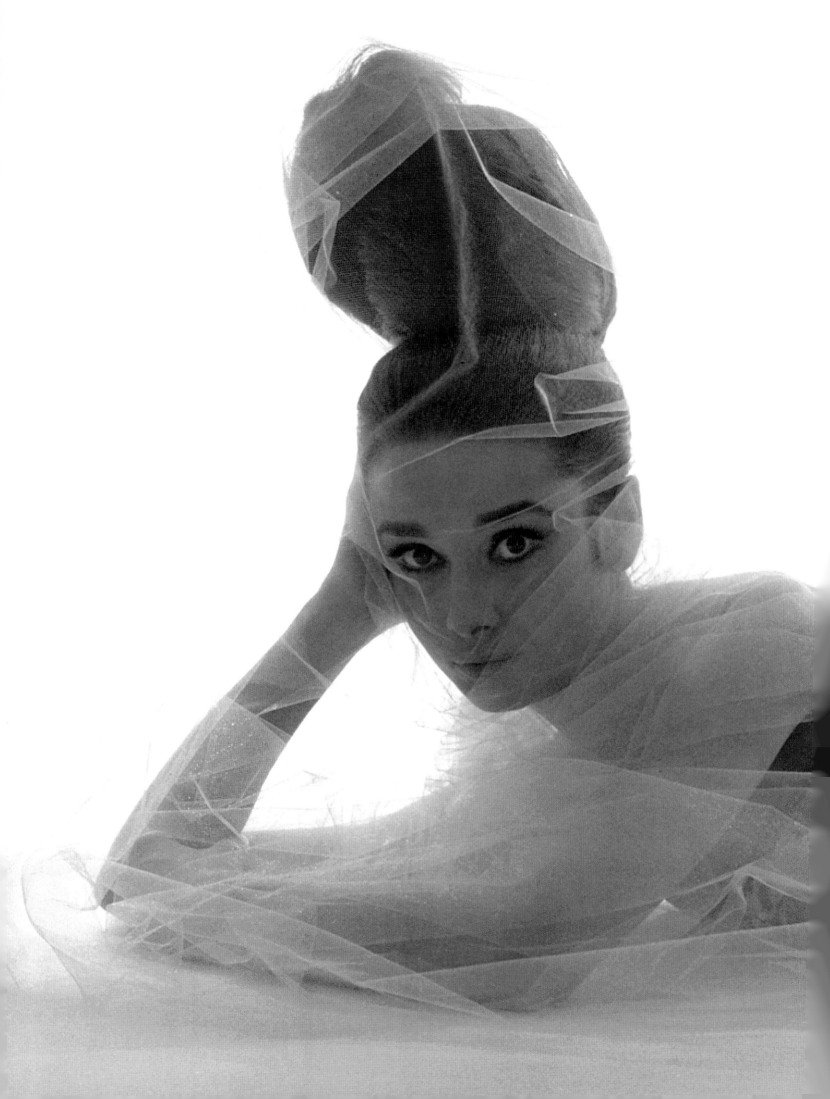

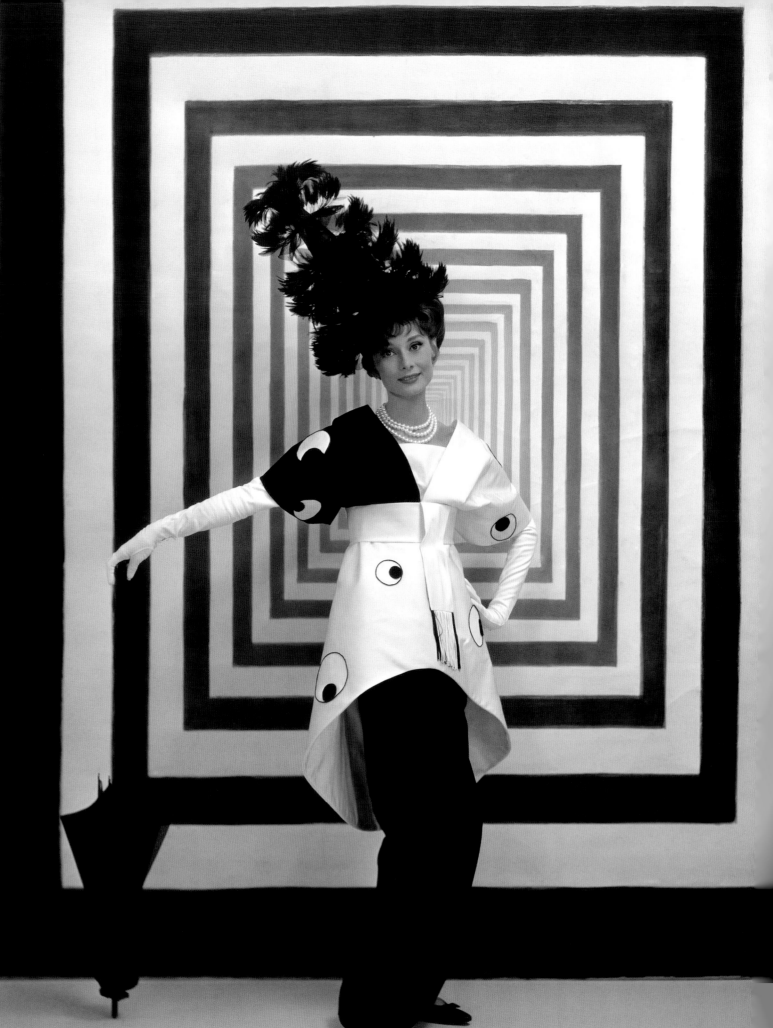

"People associate me with a time when movies were pleasant, when women wore pretty dresses in films and you heard beautiful music.
I always love it when people write me and say 'I was having a rotten time, and I walked into a cinema and saw one of your movies, and it made such a difference.'"

"I am not beautiful. My mother once called me the 'ugly duckling.' But, listed separately, I have a few good features."

AUDREY HEPBURN

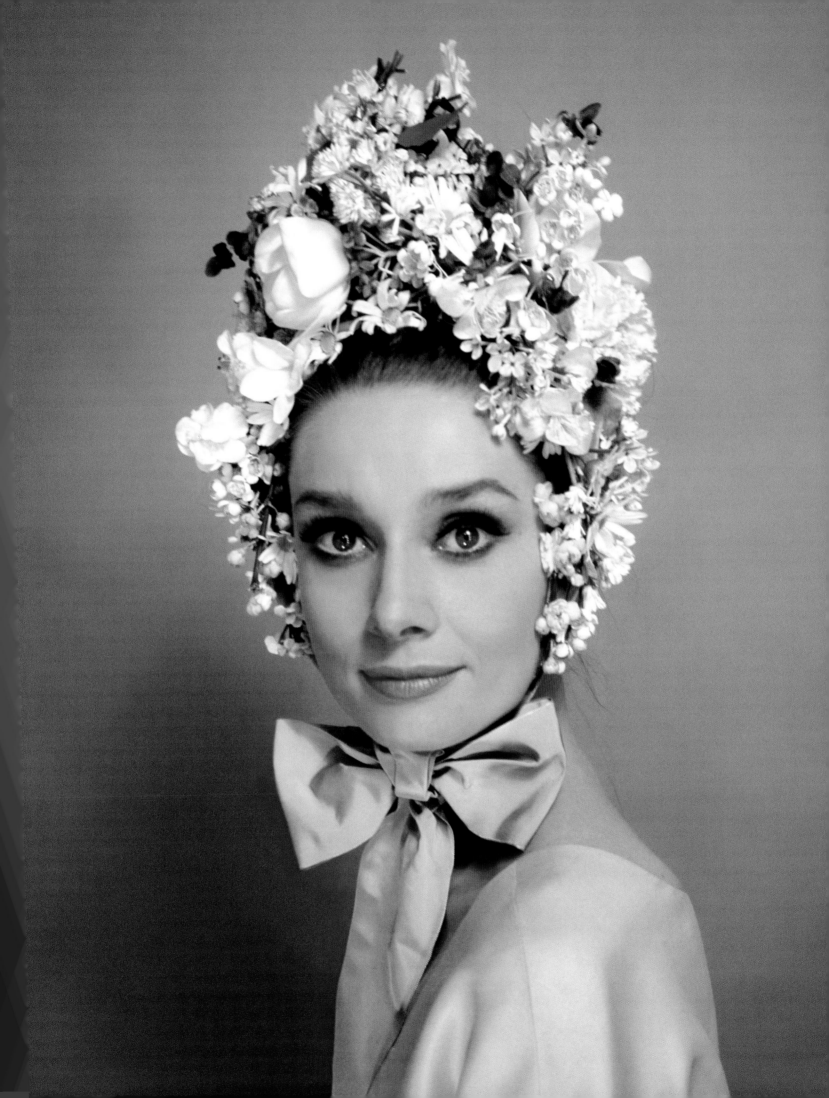

"Gazelles have elegance—and Audrey Hepburn, magnificently."

DIANA VREELAND (Editor in Chief, *Vogue*, 1963–1971)

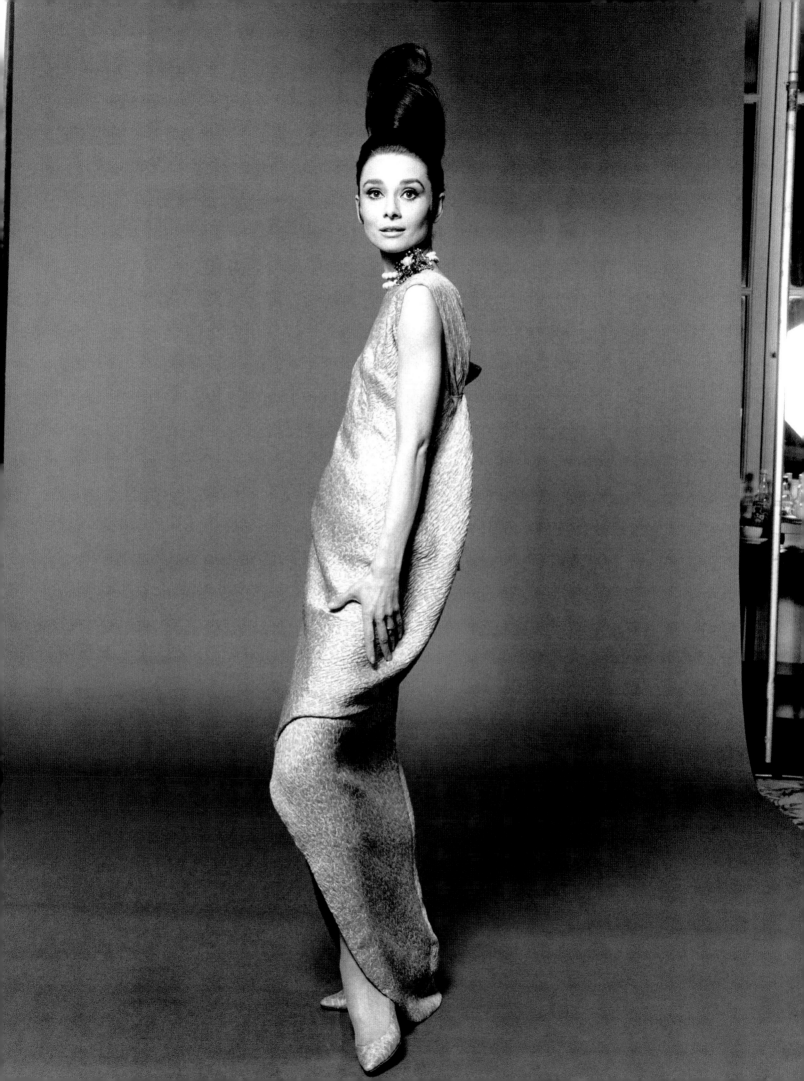

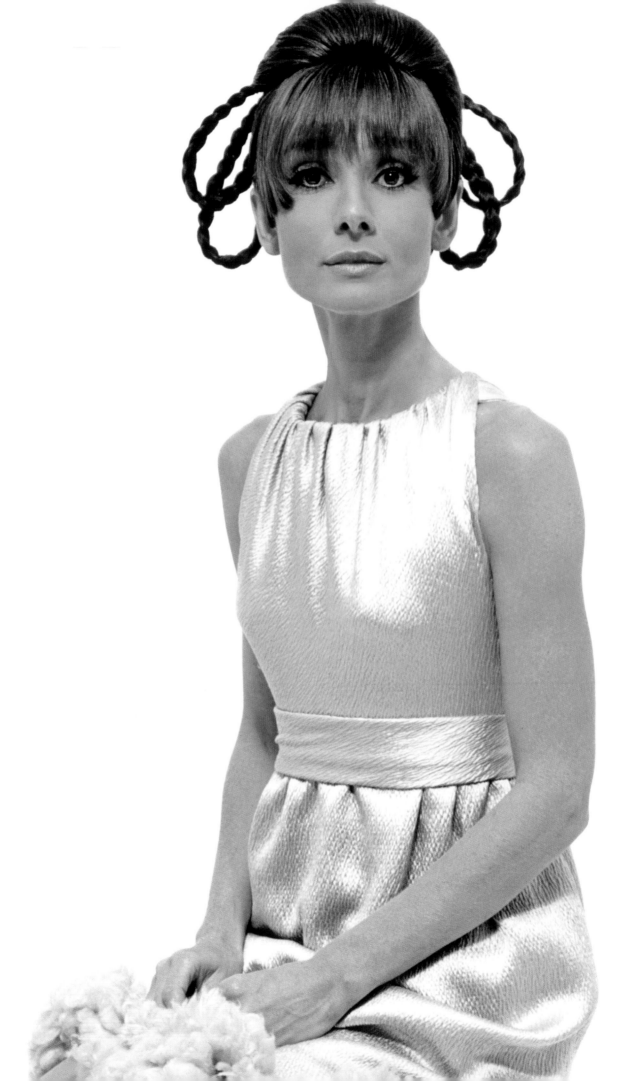

"What was consistent about her was always that less is more."

GRACE MIRABELLA (Editor in Chief, *Vogue*, 1971–1988)

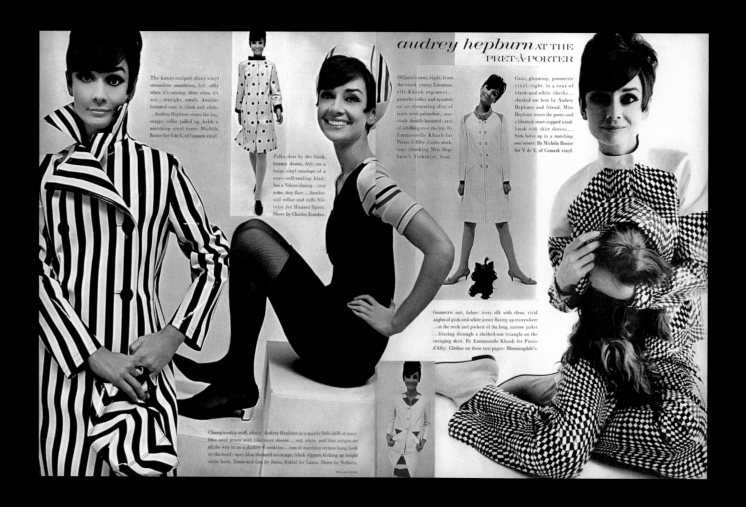

"Like ninety percent of the planet I was in love with Audrey. It didn't go very far, but it went a bit."

WILLIAM KLEIN (Photographer)

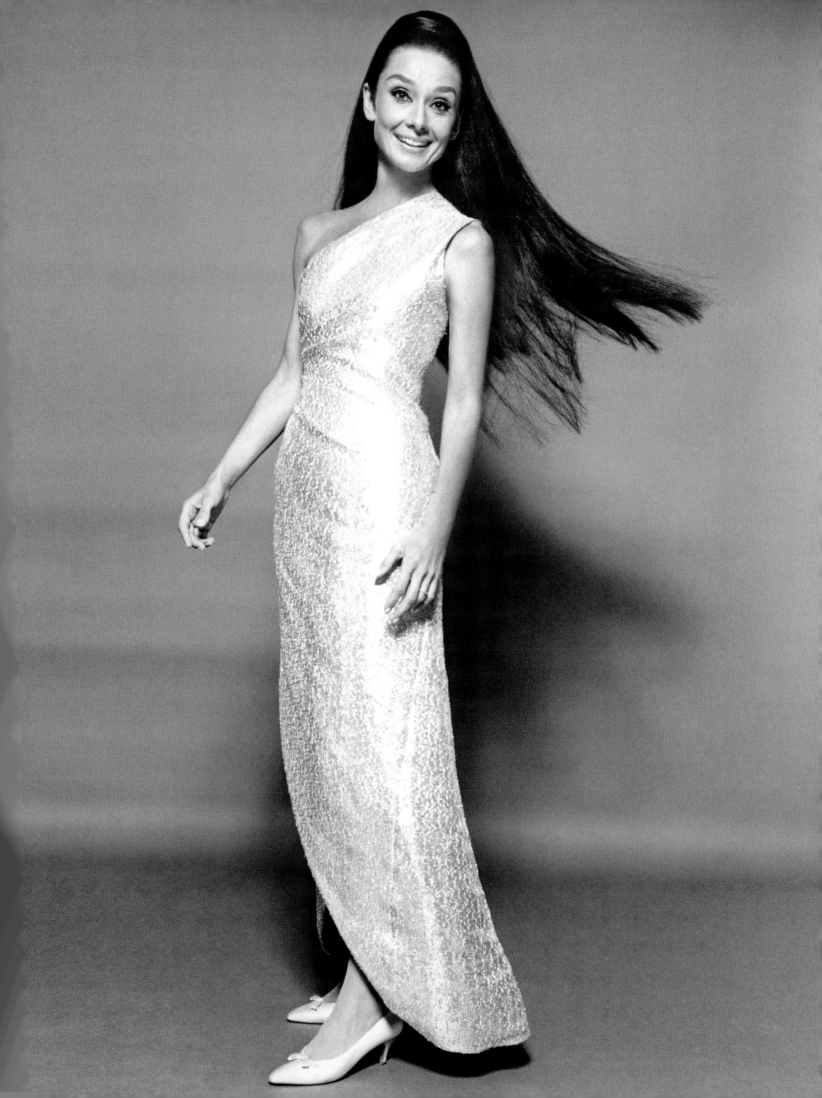

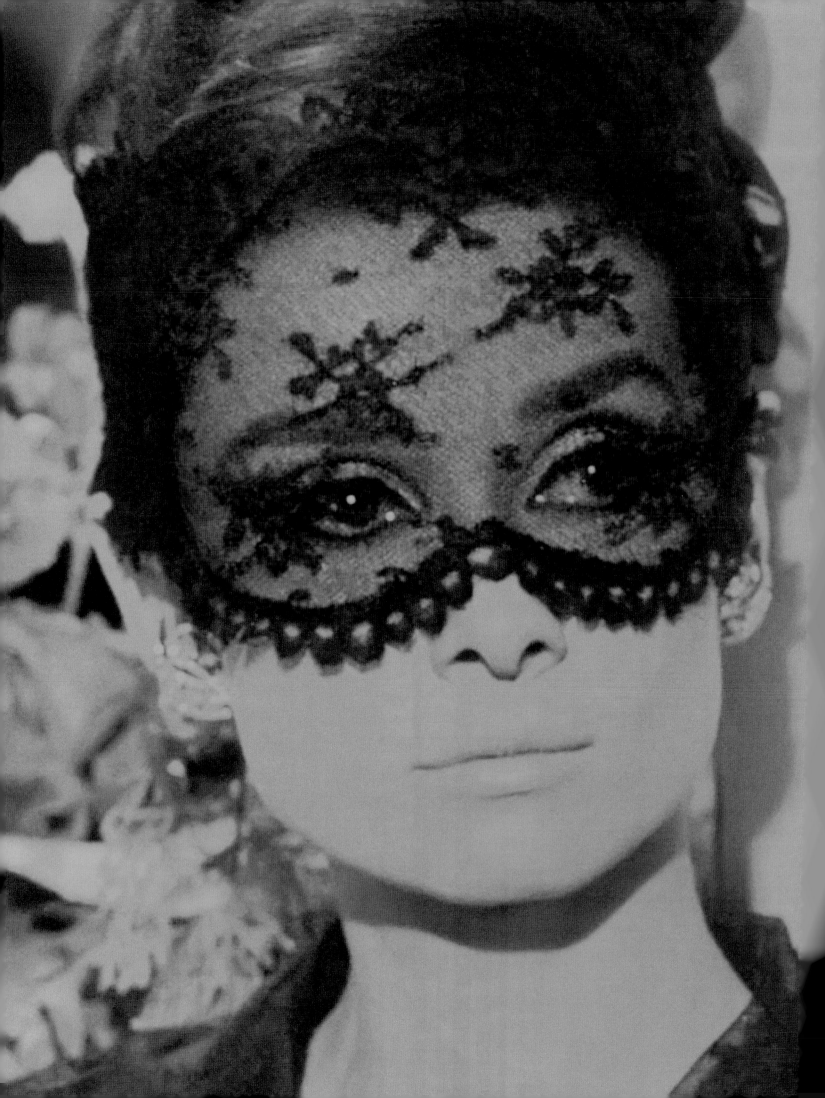

How to Steal a Million

1966

"Ethereal, radiant, trusting, doe-eyed, swan-necked, polyglot Audrey Hepburn. I came to Paris, bought new strobe lights, and she let me experiment with them for the first time. (The result was interestingly harsh.) She also pretended to like the charm I bought her in a souvenir shop. (I should have gone to Cartier, but I didn't know better.) Gracious, ritzy Audrey Hepburn."

DOUGLAS KIRKLAND (Photographer)

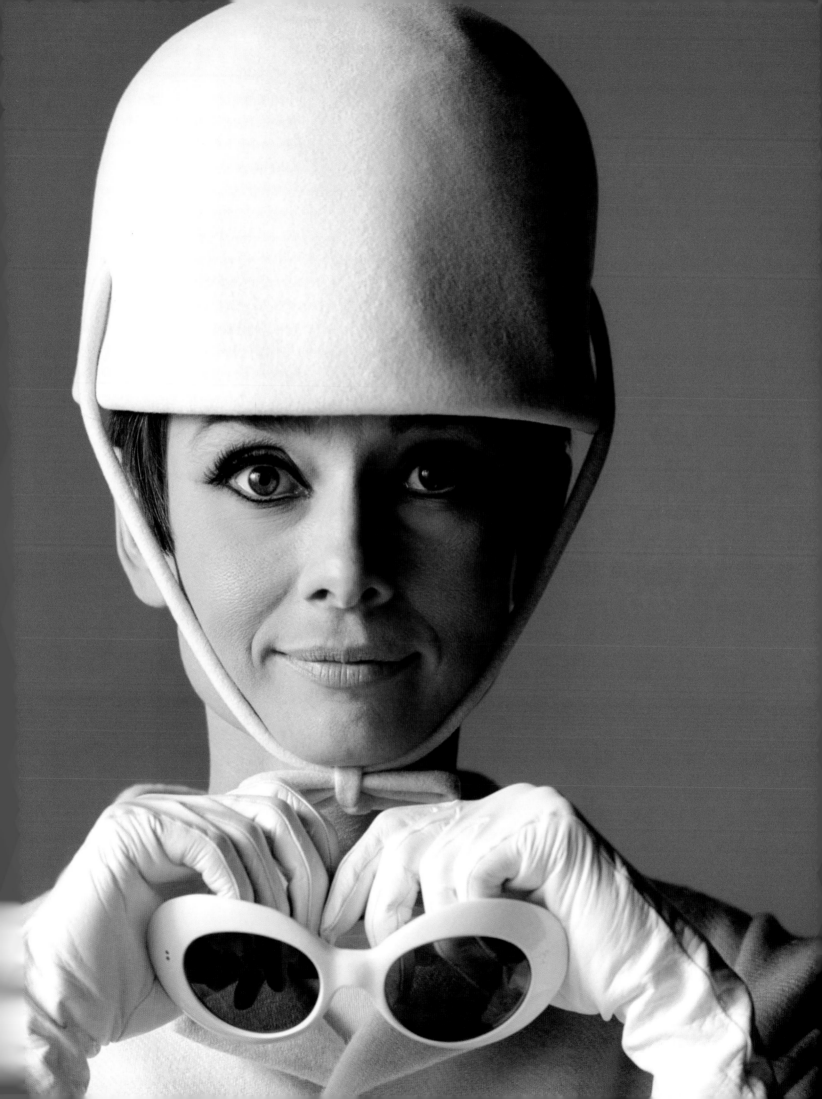

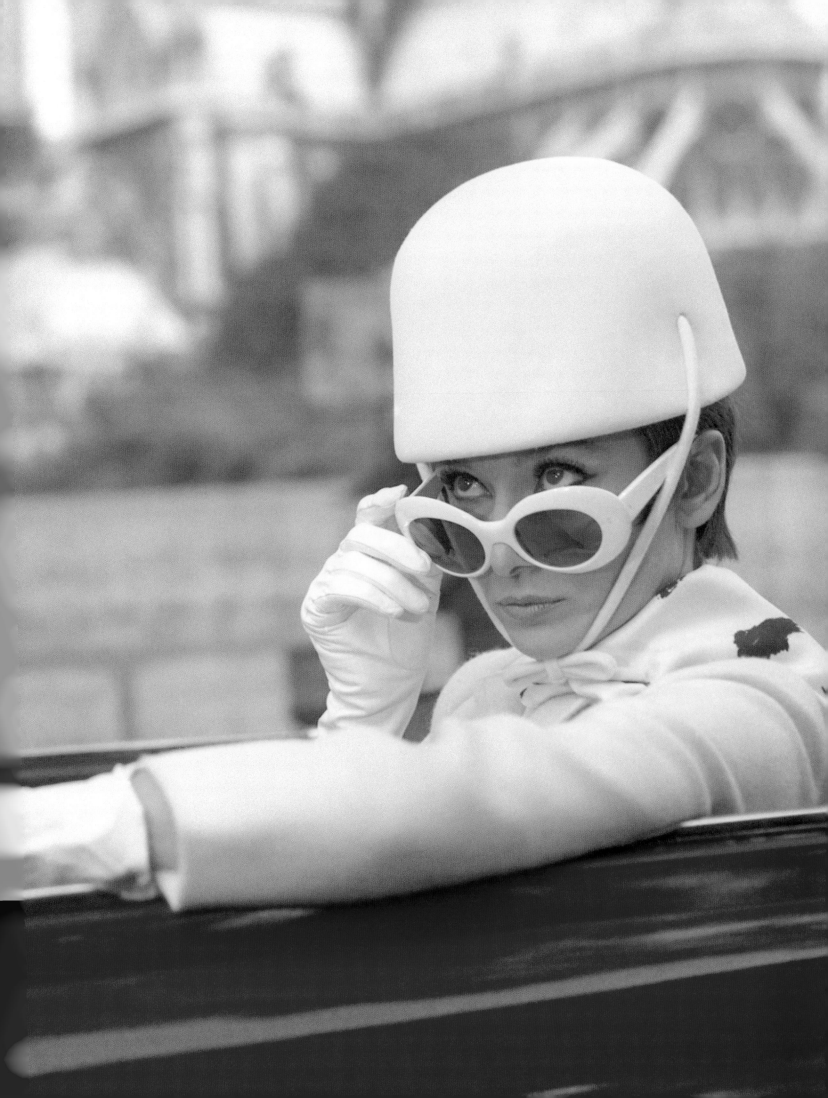

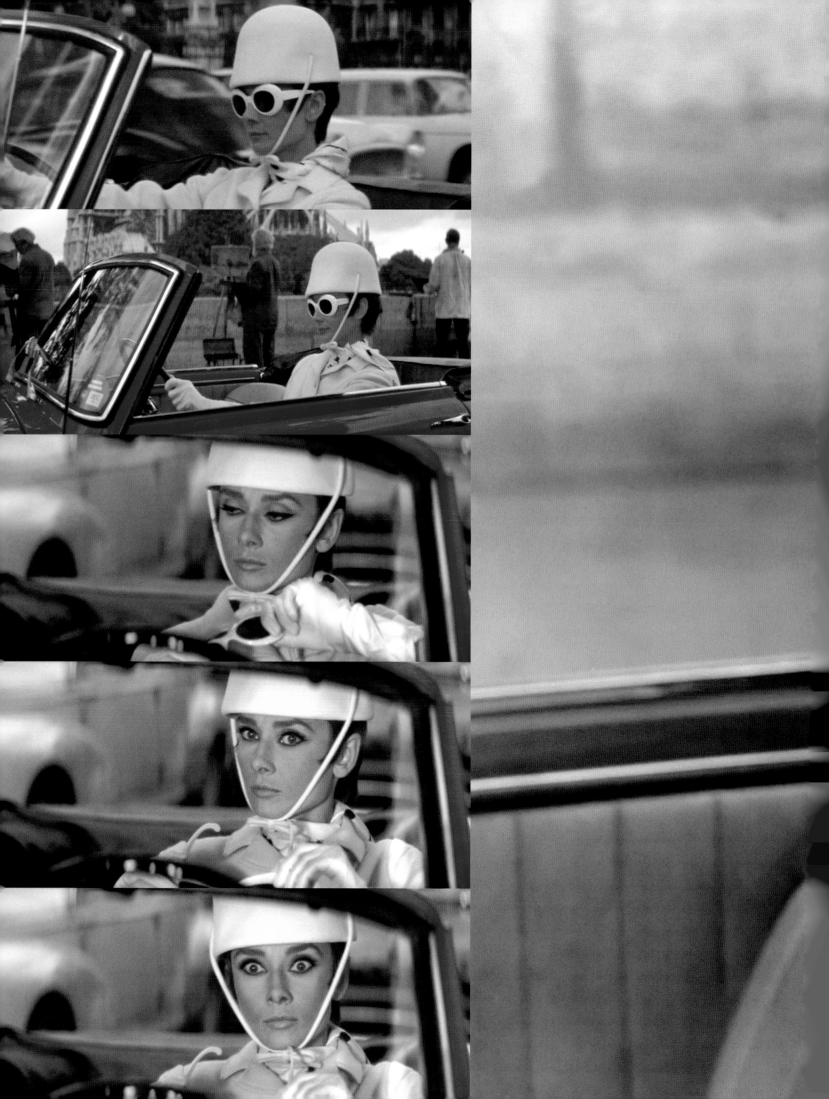

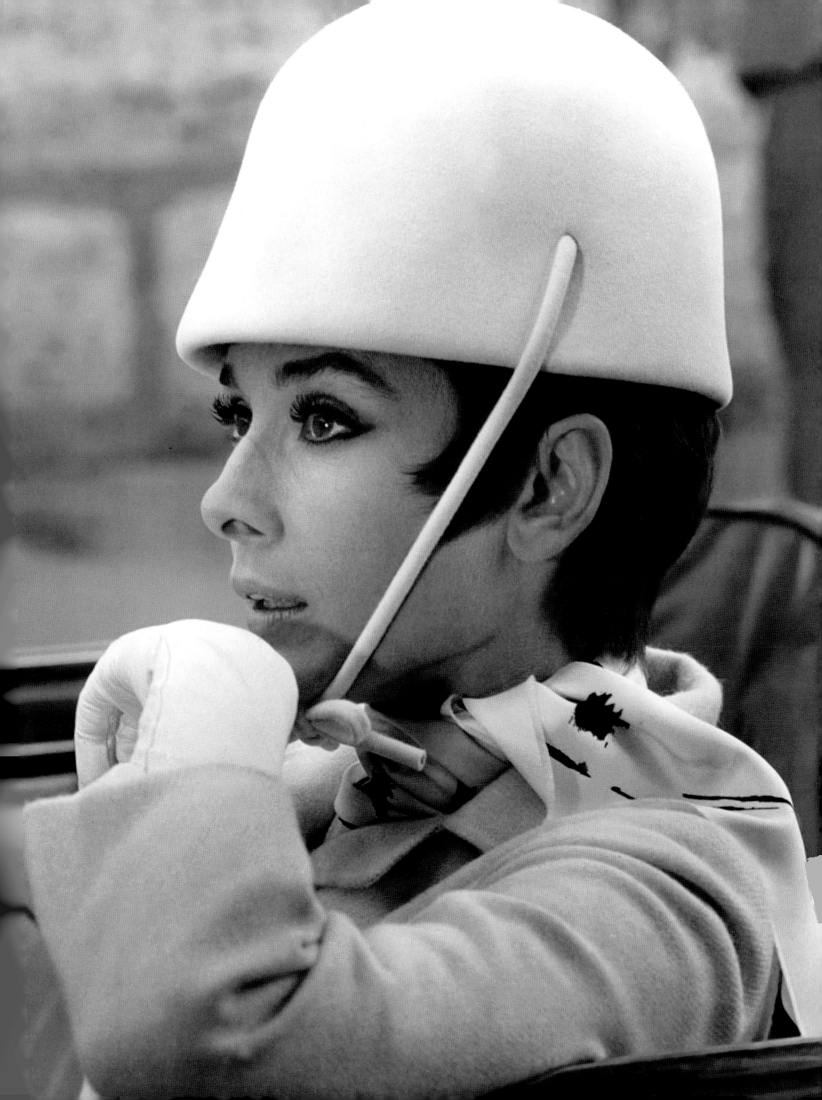

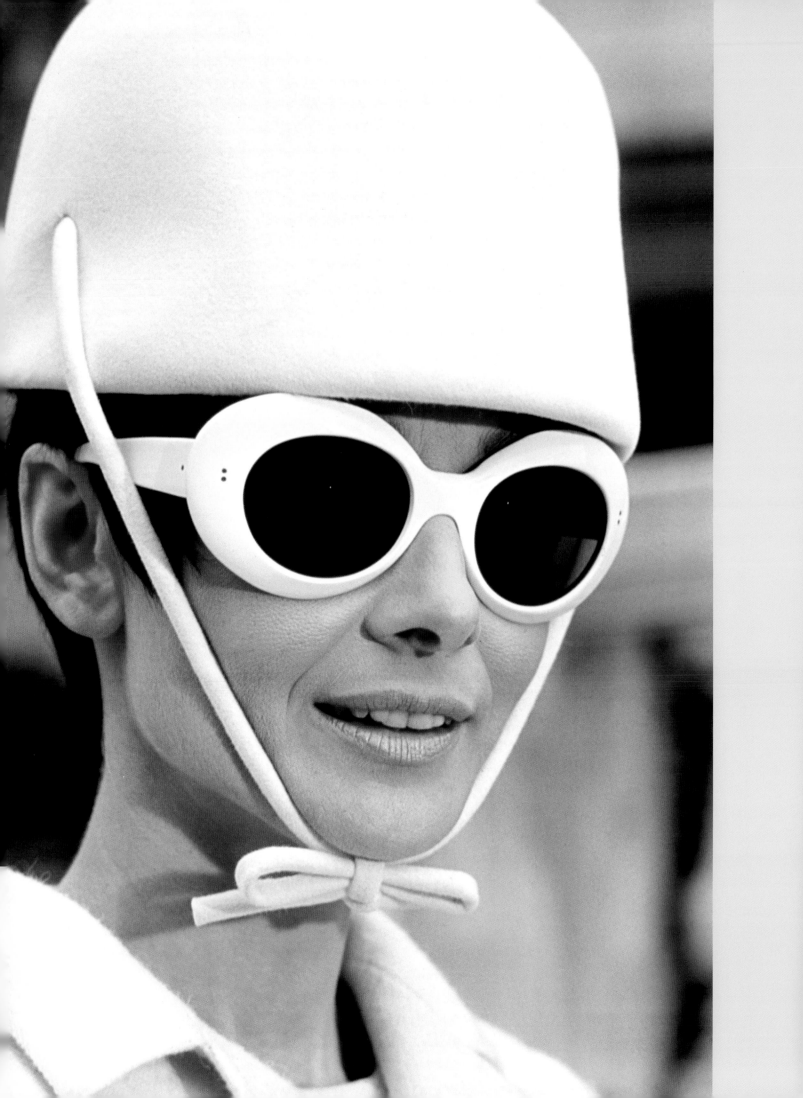

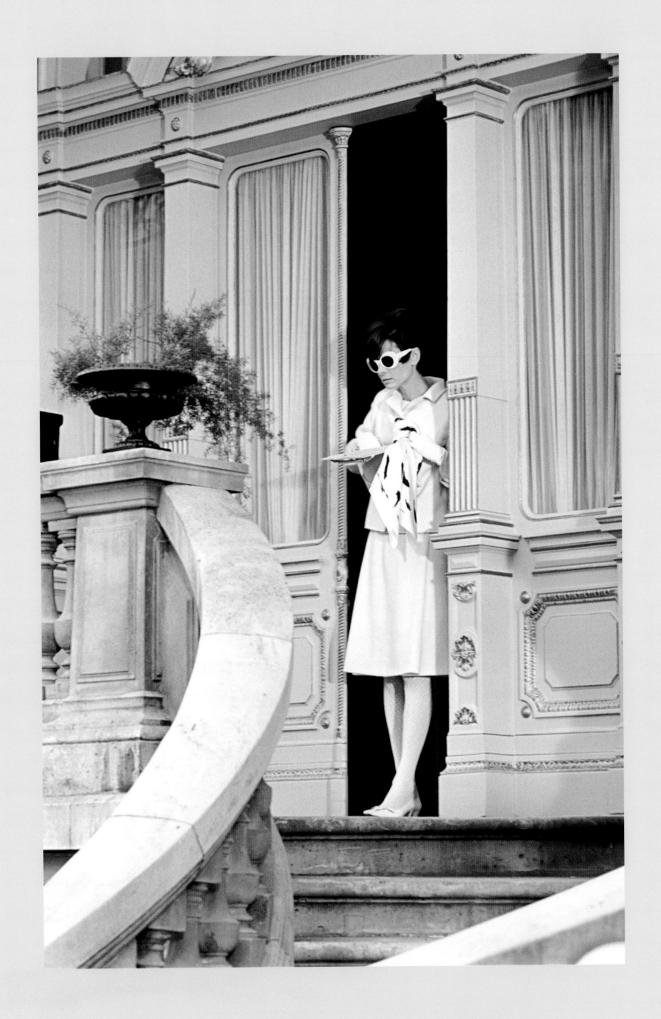

"I love people who make me laugh. I honestly think it's the thing I like most, to laugh. It cures a multitude of ills. It's probably the most important thing in a person."

AUDREY HEPBURN

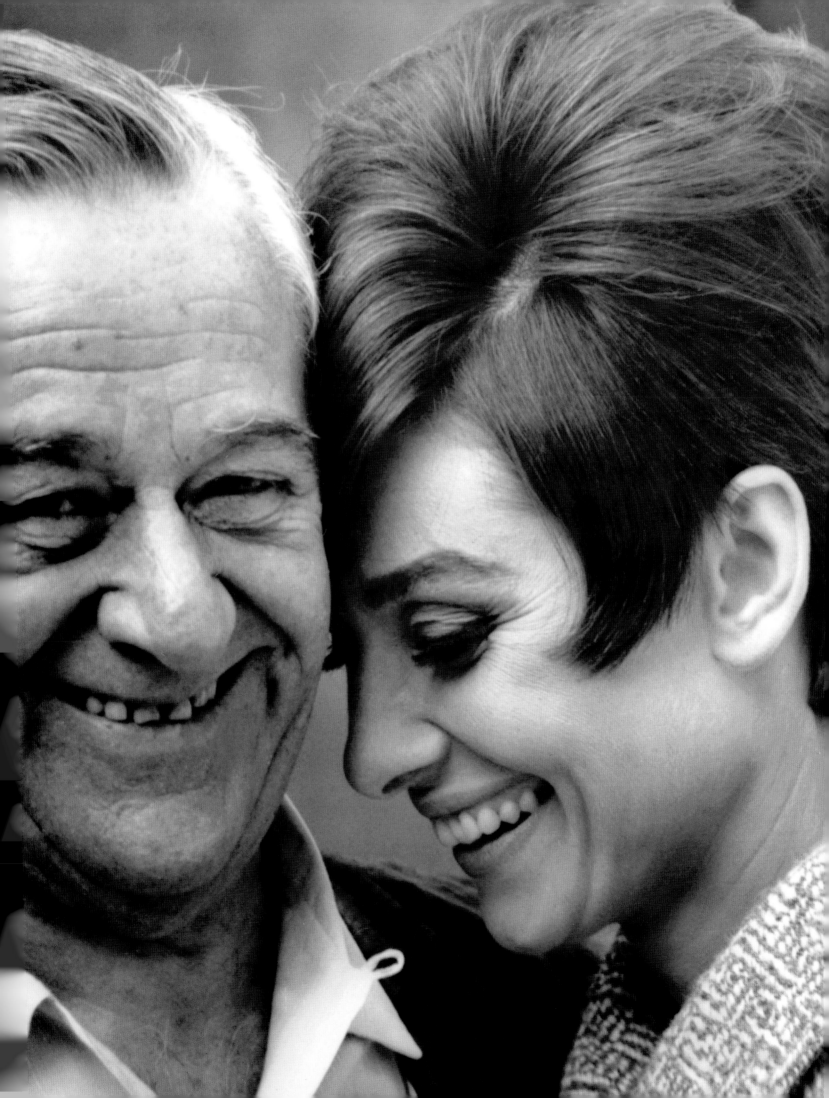

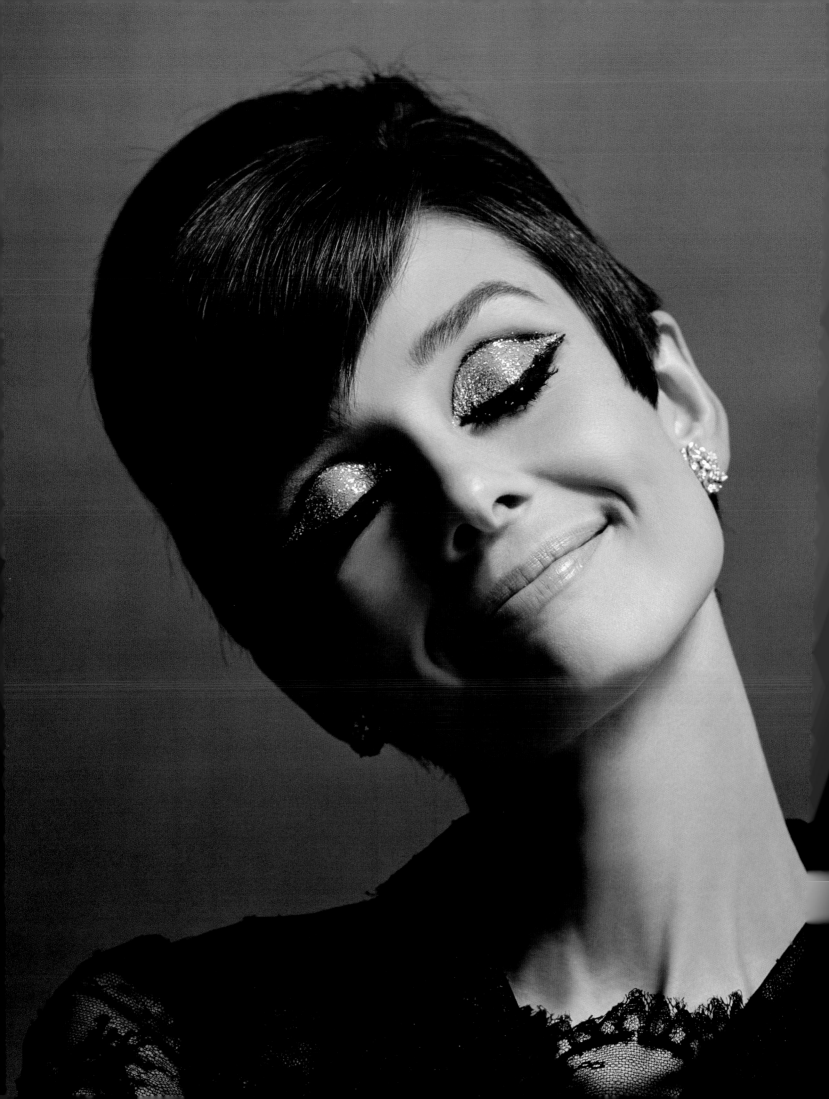

"She shared her joy
with friends, but
kept her unhappy
moments to herself."

HUBERT DE GIVENCHY

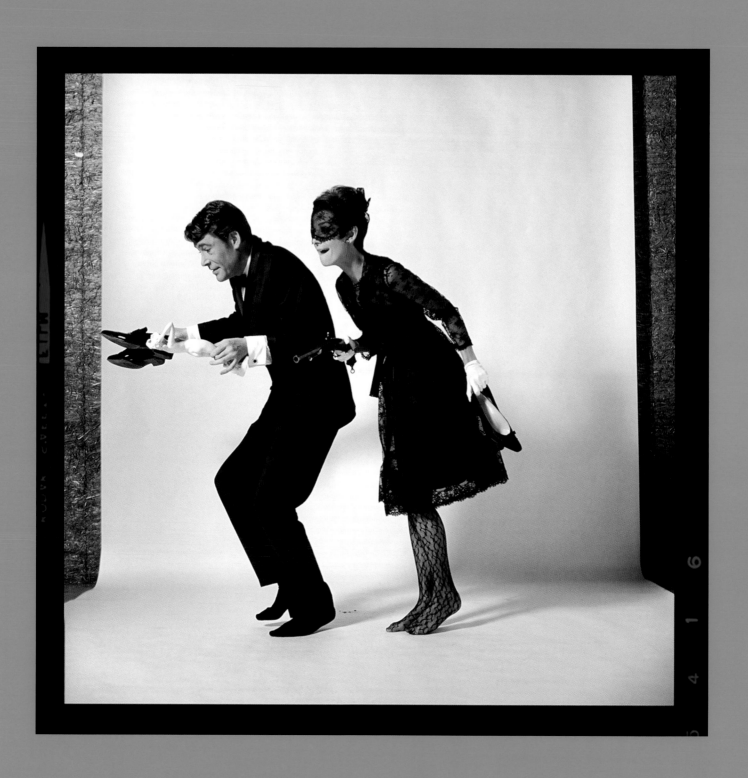

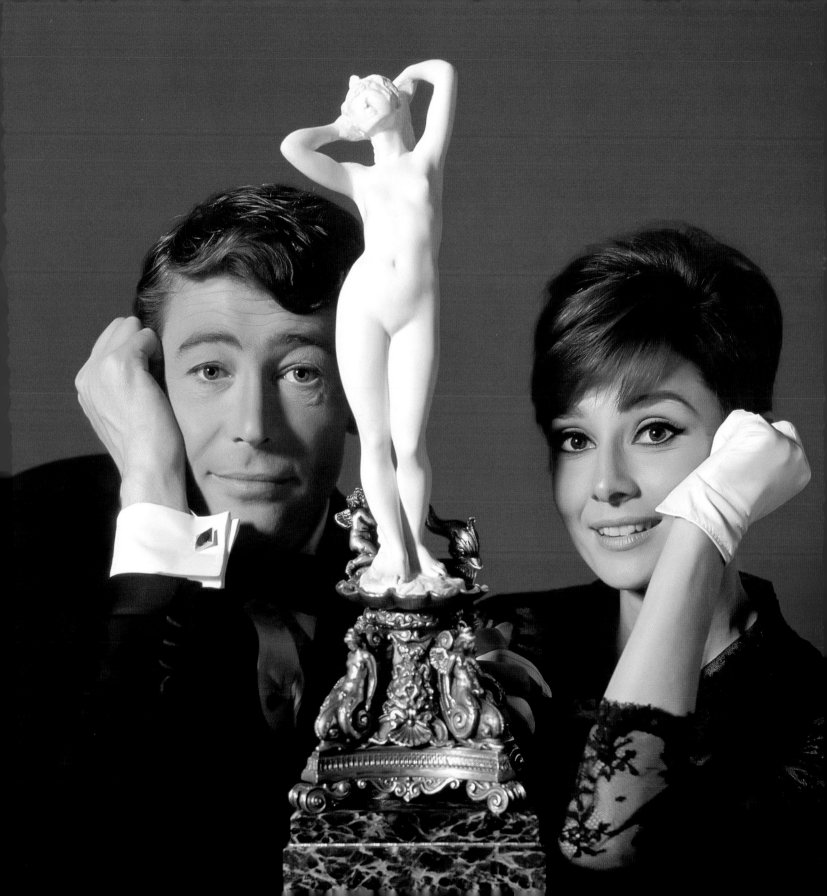

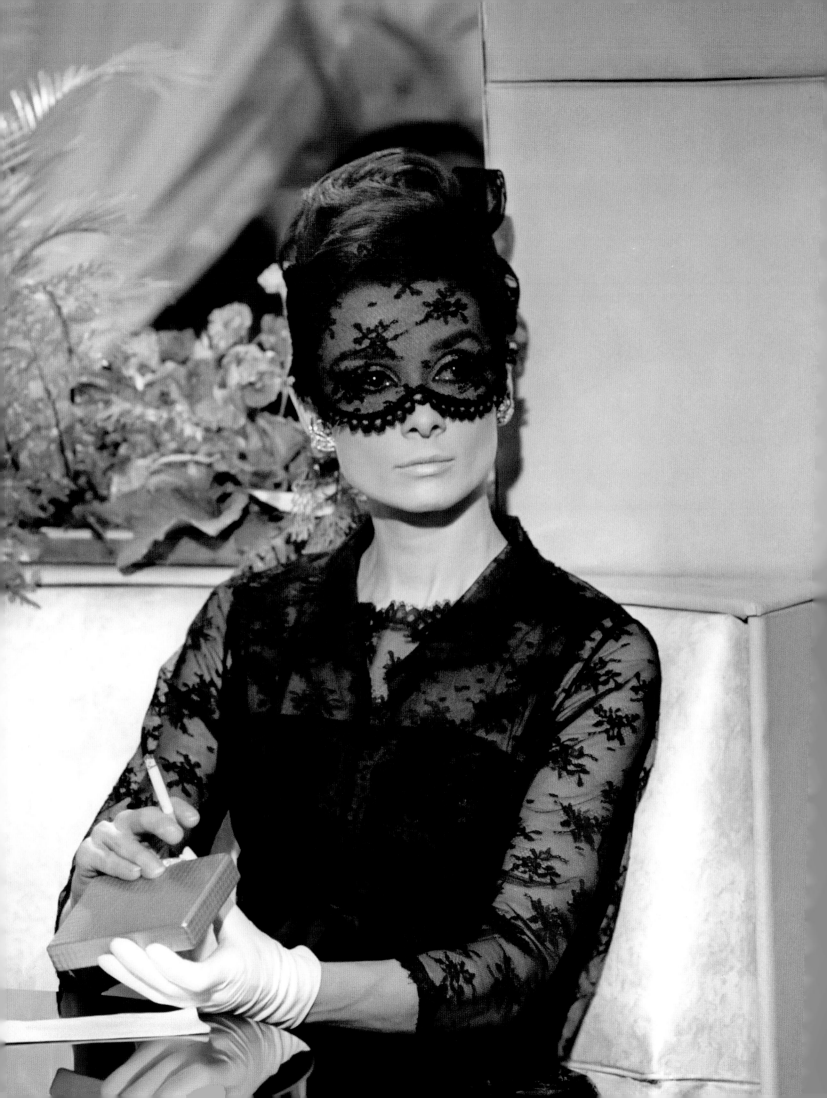

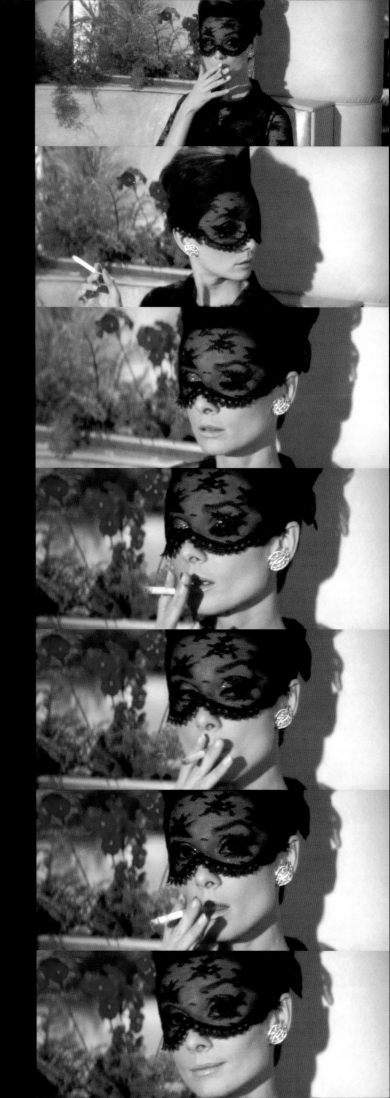

"At the bar at the Ritz, with the veil—that's one of the great moments in fashion in the movies."

TIM GUNN (Fashion consultant)

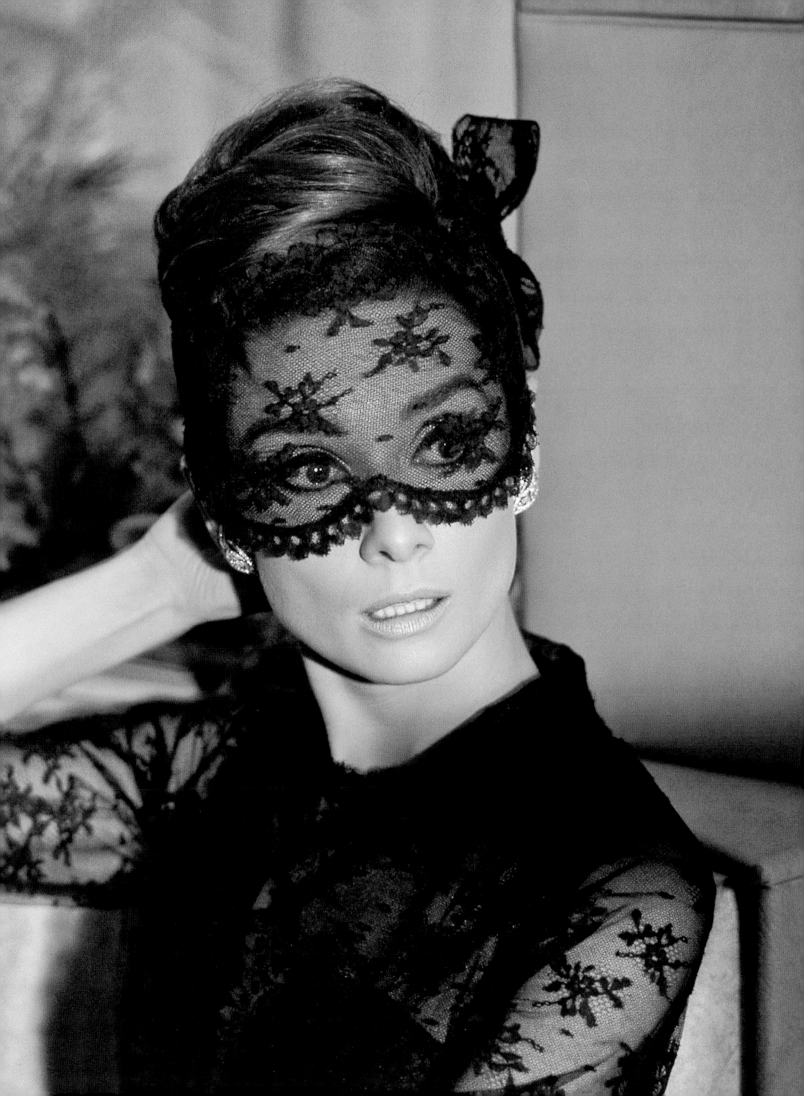

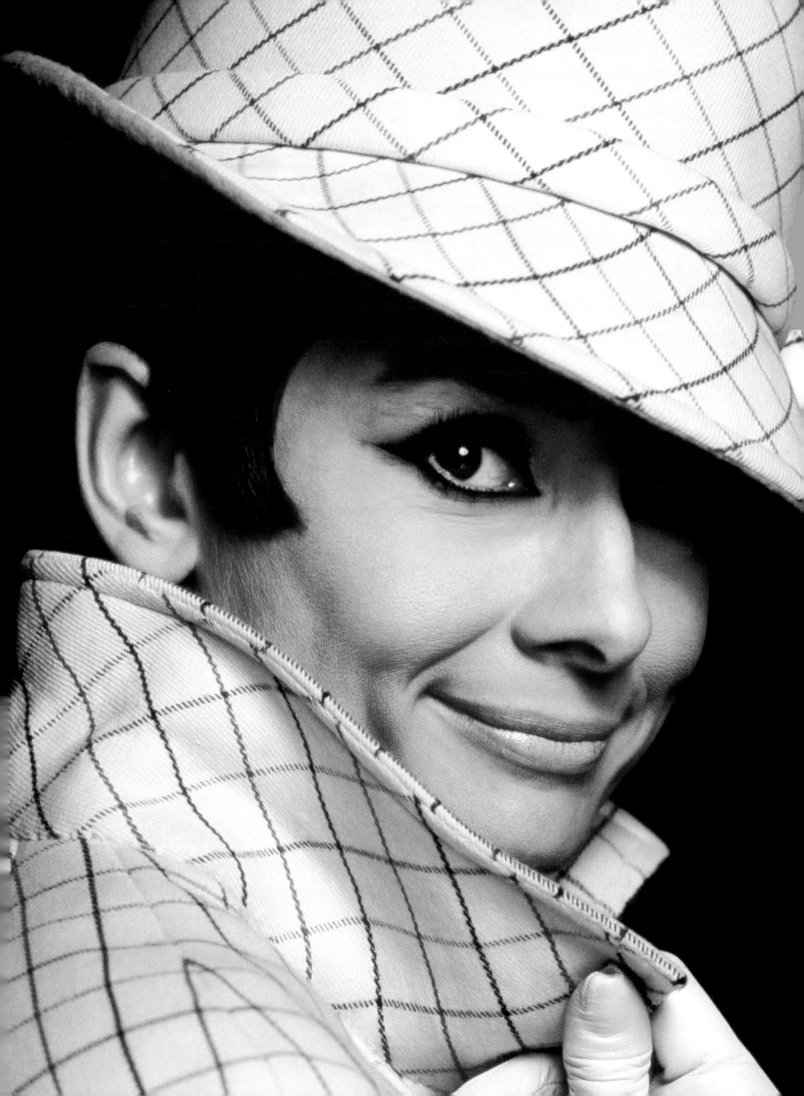

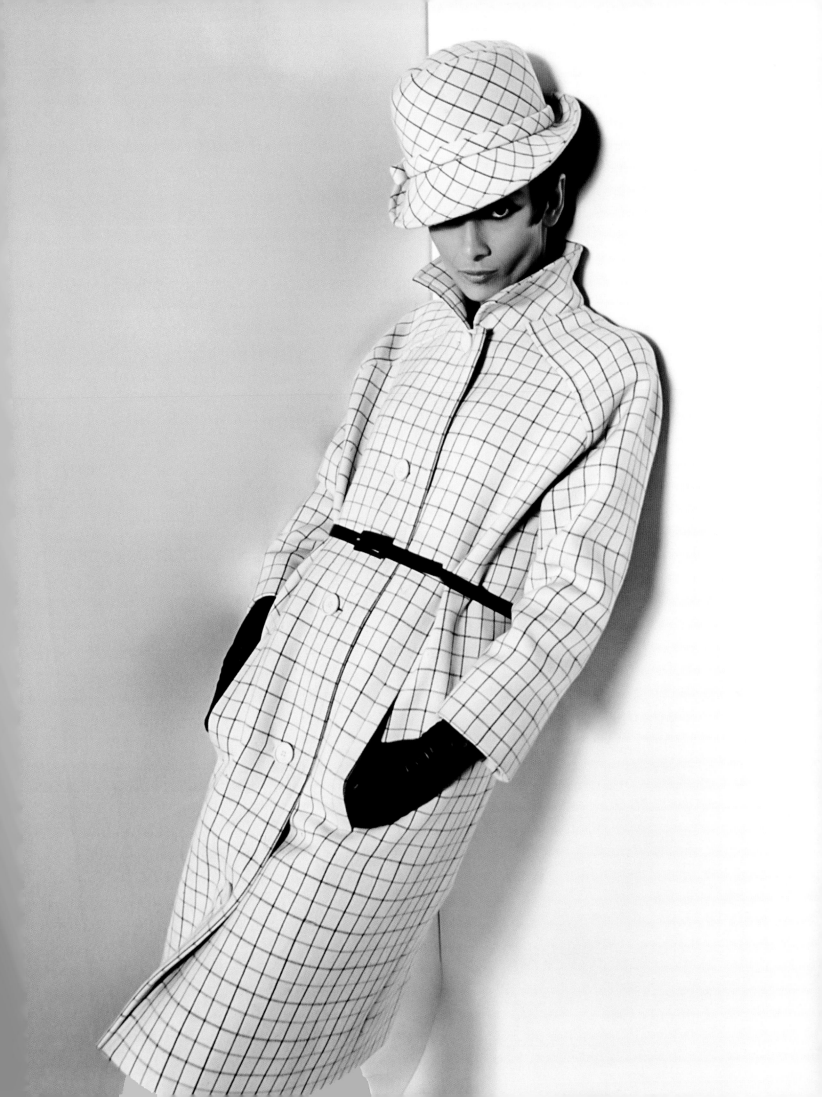

quite tall. She looked at

me and smiled and said,

'I'll take my shoes off.' I

said, 'I love you, I love

you.' She took her shoes

off and played the scene."

ELI WALLACH (Costar, *How to Steal a Million*, 1966)

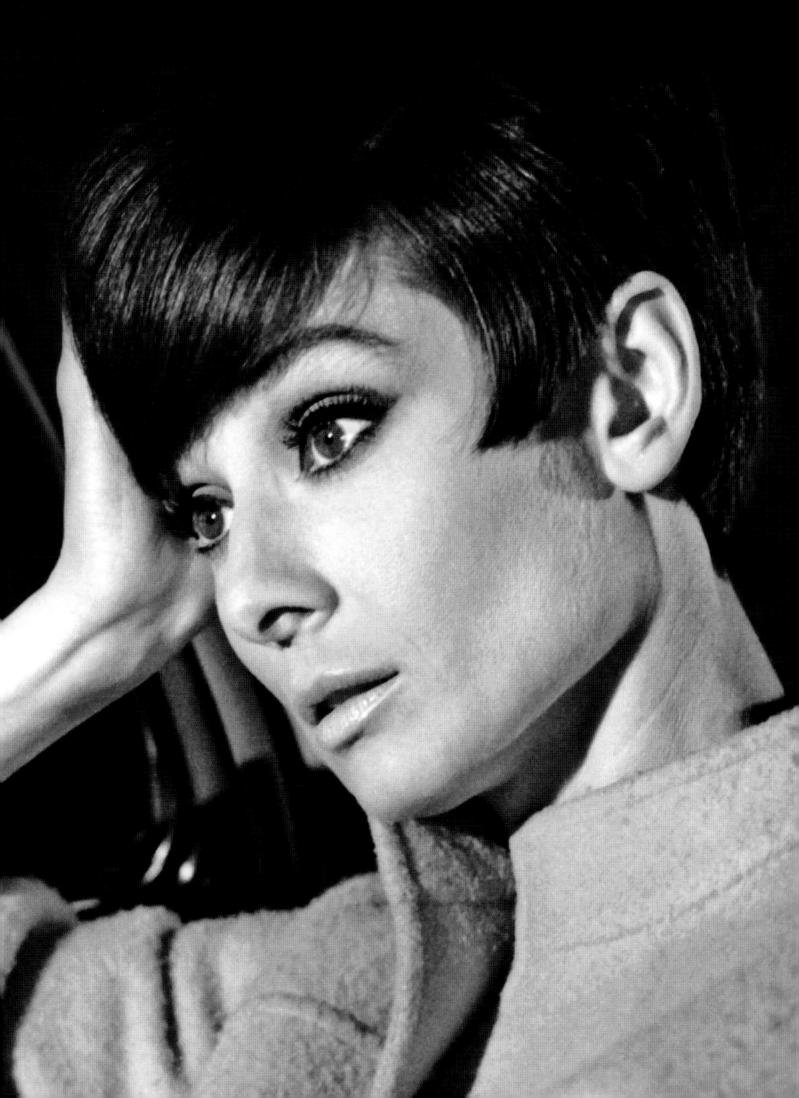

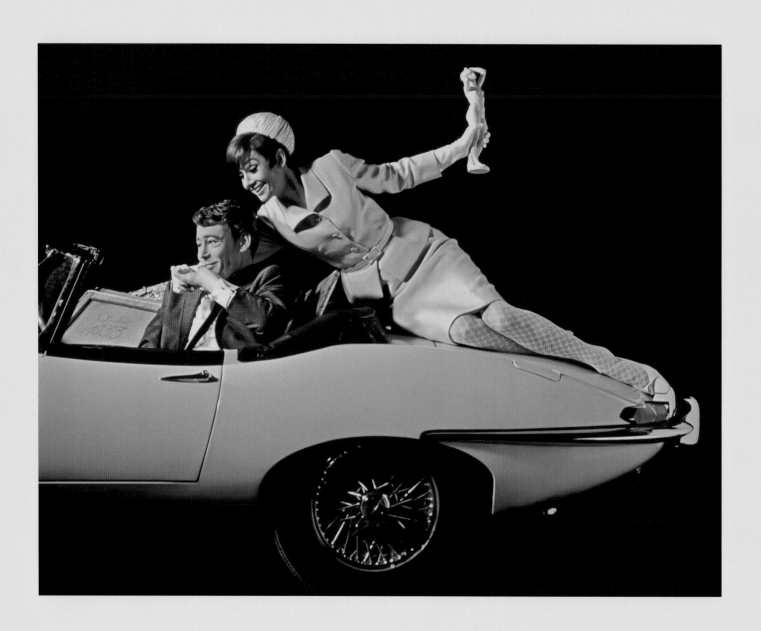

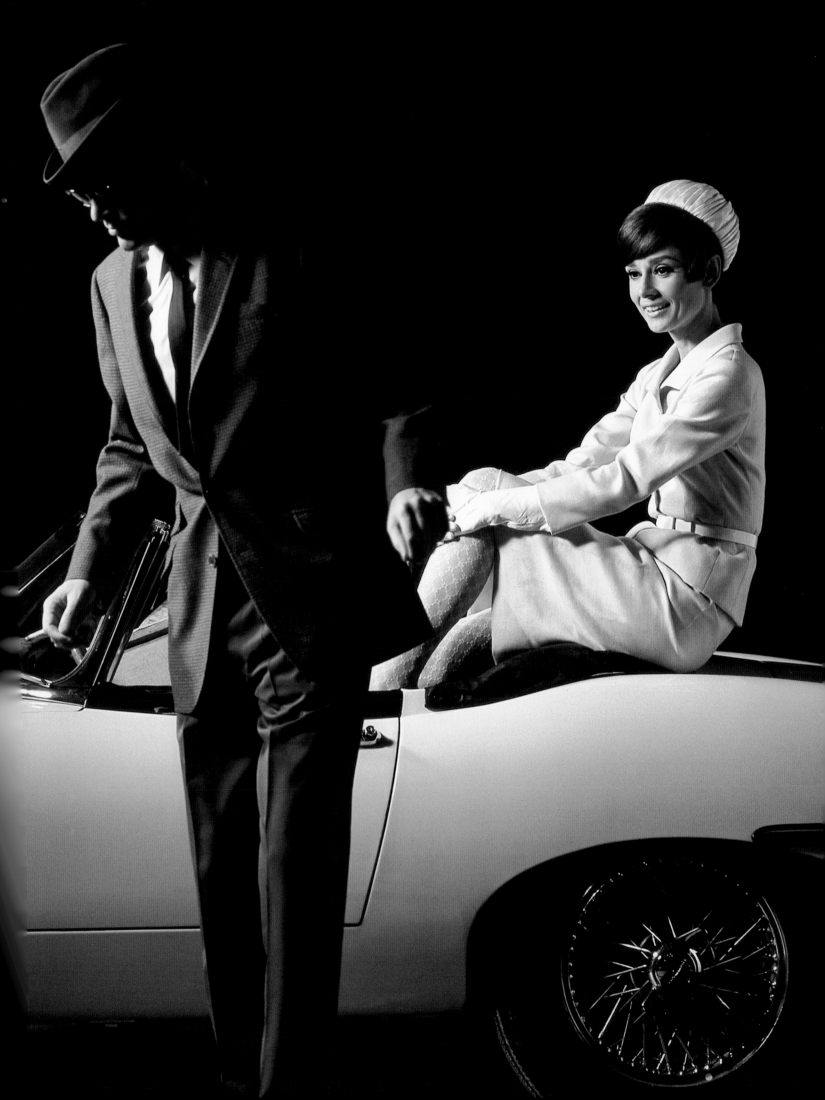

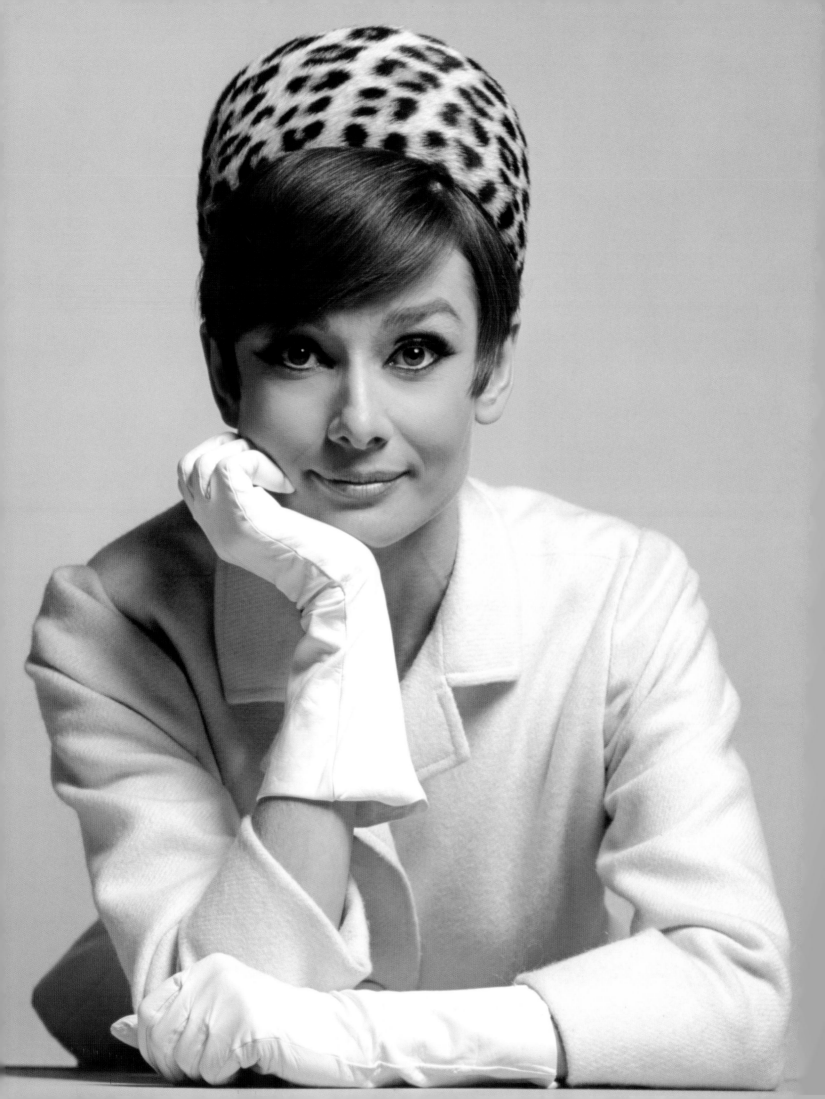

"We were filming an exterior in Paris and the weather…became very, very cold indeed. Audrey had to walk across the street, get into a waiting car and drive off, but the poor child had turned bright blue with cold. The light was going and the shot was needed. I pulled Audrey into the caravan and gave her a shot of brandy. She went all roses and cream, bounced out of the caravan, radiated towards the motor car, hopped into it and drove off, taking with her five great big lamps [being used to light the scene], the trimmers of which had flung themselves on the cobbles out of the way."

PETER O'TOOLE (Costar, *How to Steal a Million*, 1966)

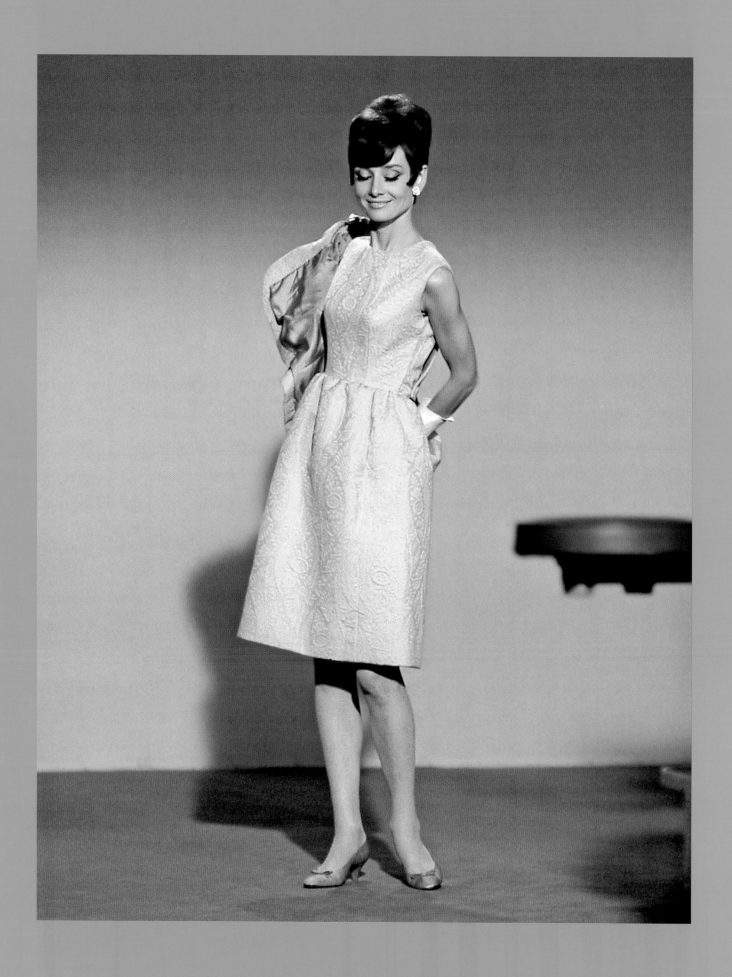

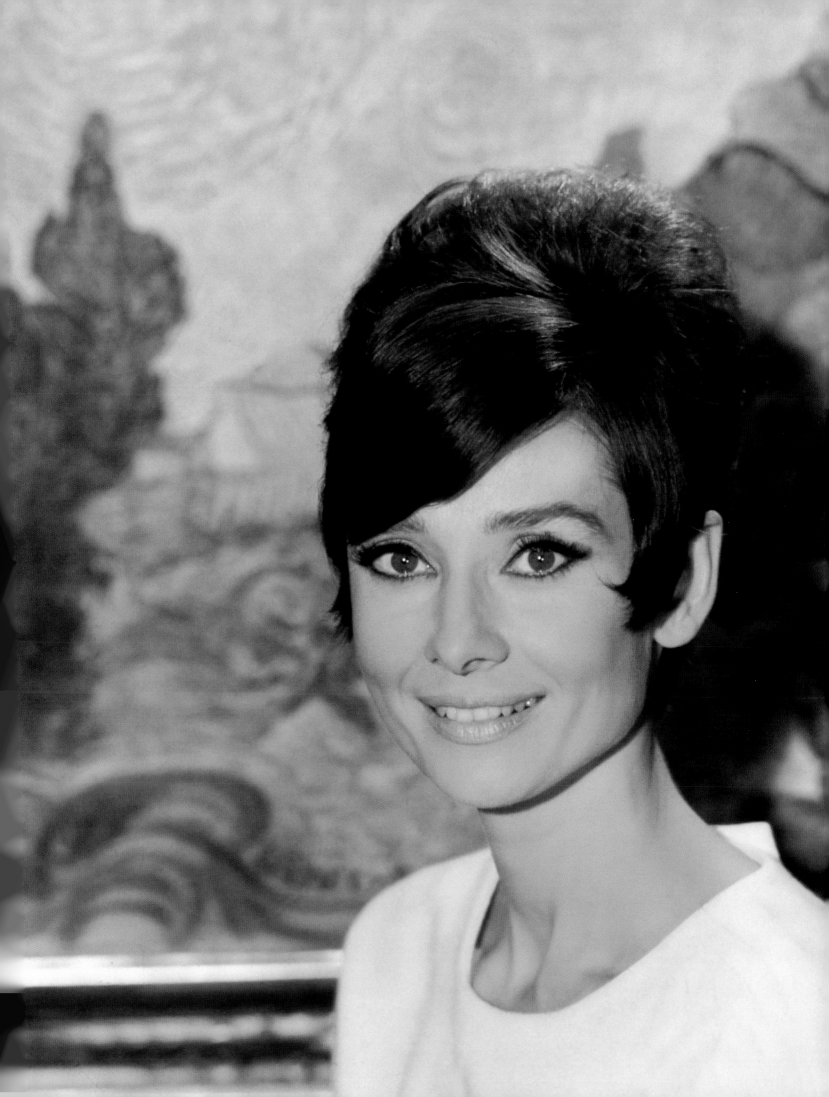

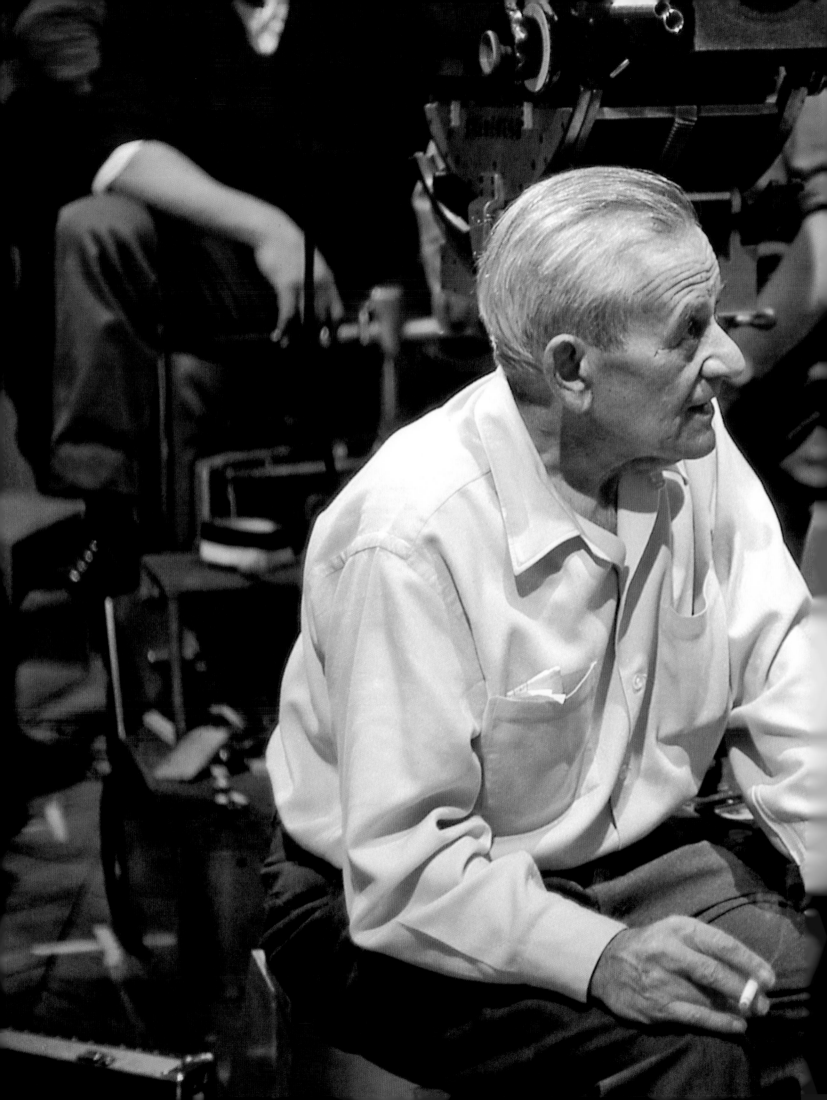

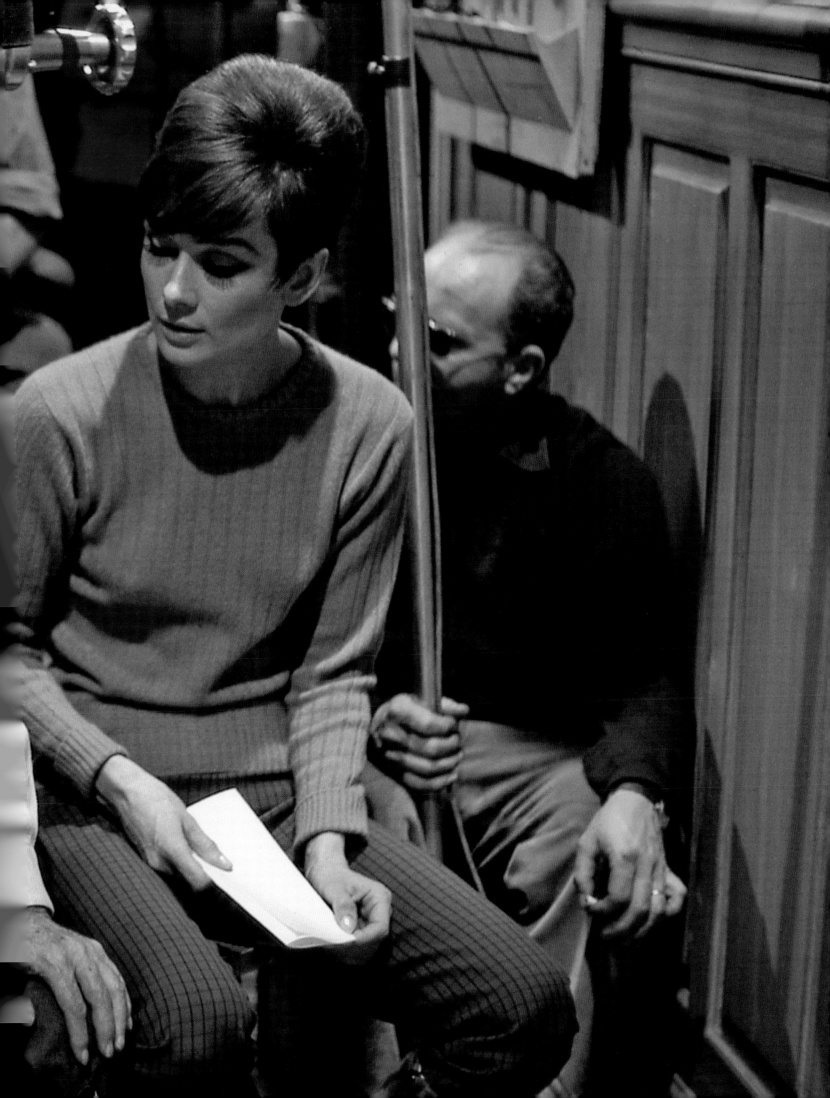

"Audrey Hepburn was in life the exquisite person she represented on screen… Her ability to convey tenderness, a young-puppy kind of joy, a tomboyish mischief, was not what you'd expect from such an elegant and distinguished young lady… She could have afforded to be standoffish; but no, to the contrary, Audrey gave you her heart as if to make you forget her great looks. That rare combination of sweetness and beauty is, I think, what endeared her to the whole world."

LESLIE CARON

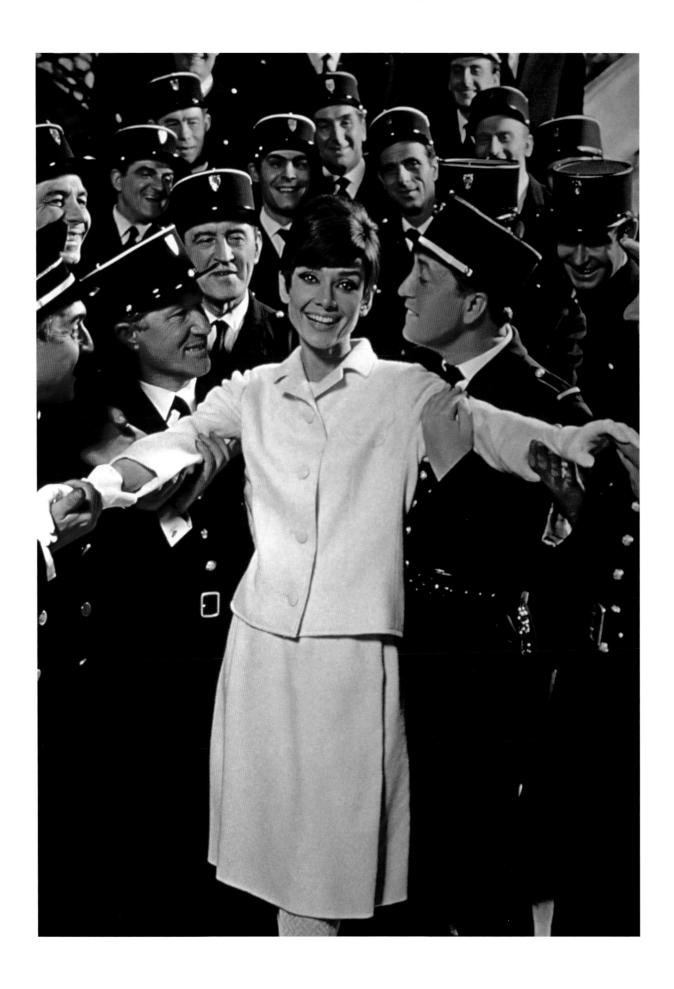

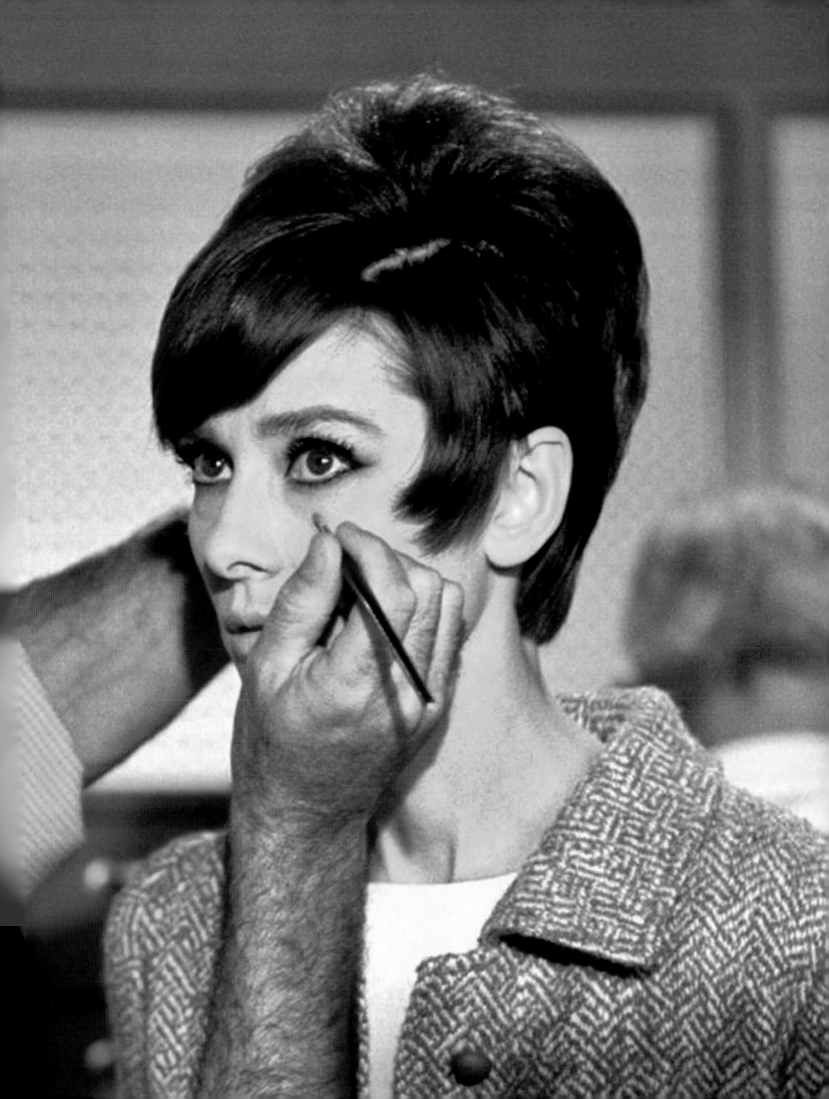

ロードショー

感じる洋画雑誌　*Roadshow・Movie・Music・Fashion & TV*

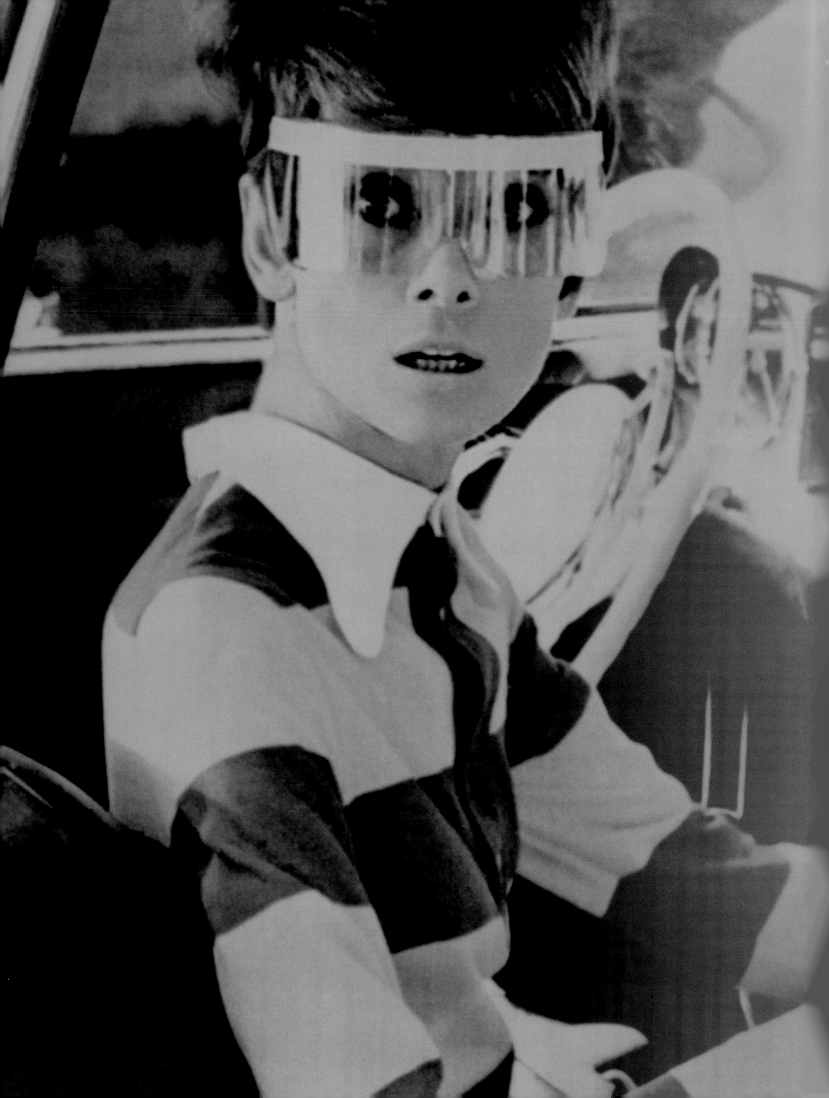

Two for the Road

1967

"It was extremely sophisticated, both in its exploration of the various stages of the man's and woman's infatuation with one another and in the way the story played itself out backward and forward in time."

AUDREY HEPBURN

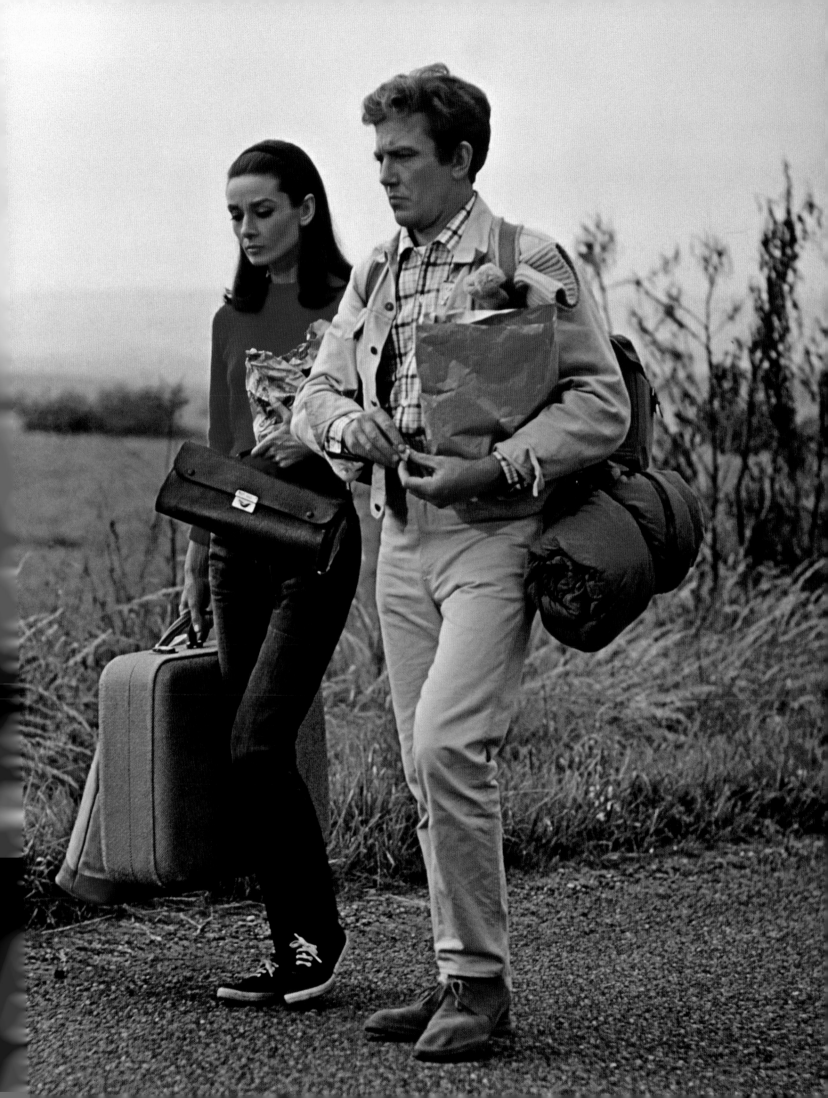

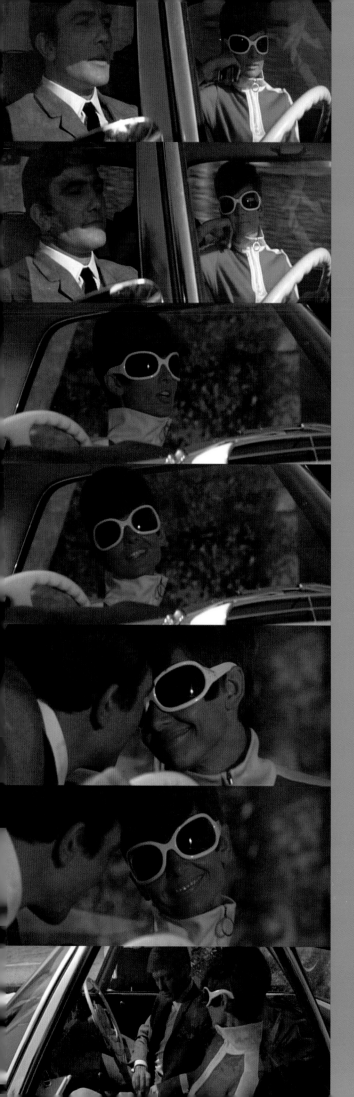

"I remember hearing her give Stanley [Donen] eight different readings of the words, 'Hello, darling.' Number six, she thought, was the right one. Always needed to be perfect, that was Audrey."

FREDERIC RAPHAEL
(Screenwriter, *Two for the Road*, 1967)

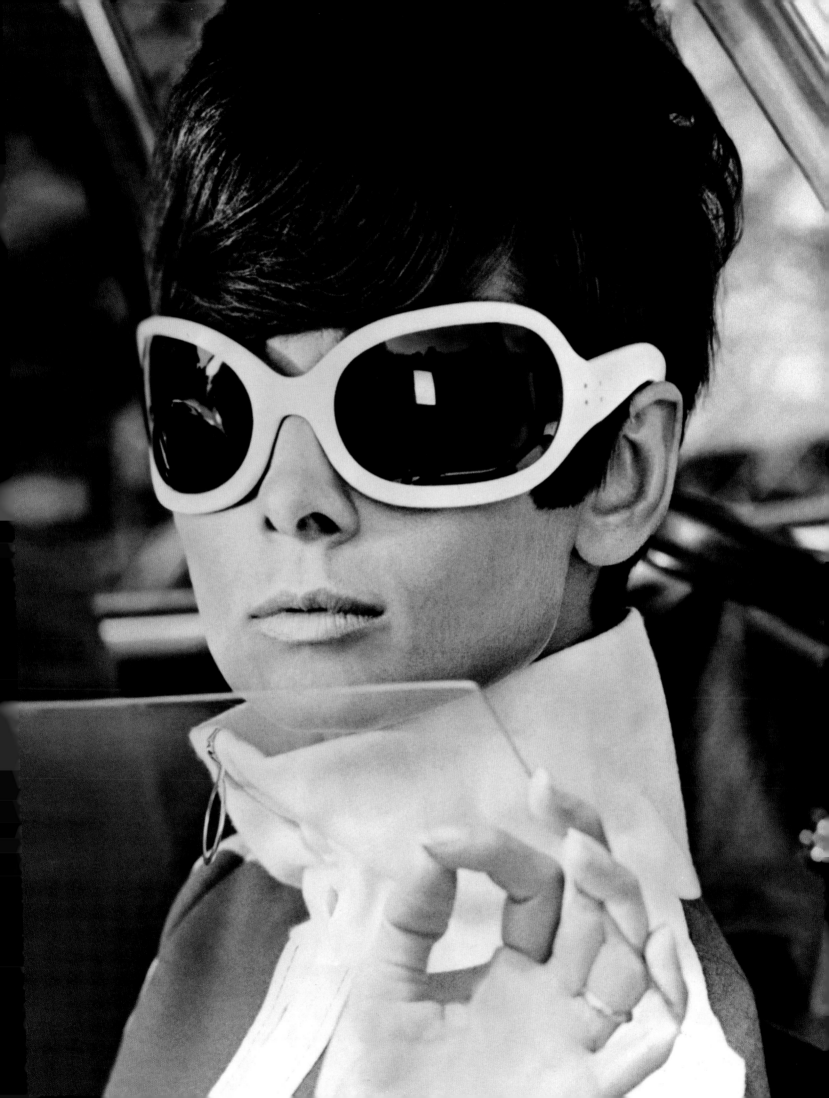

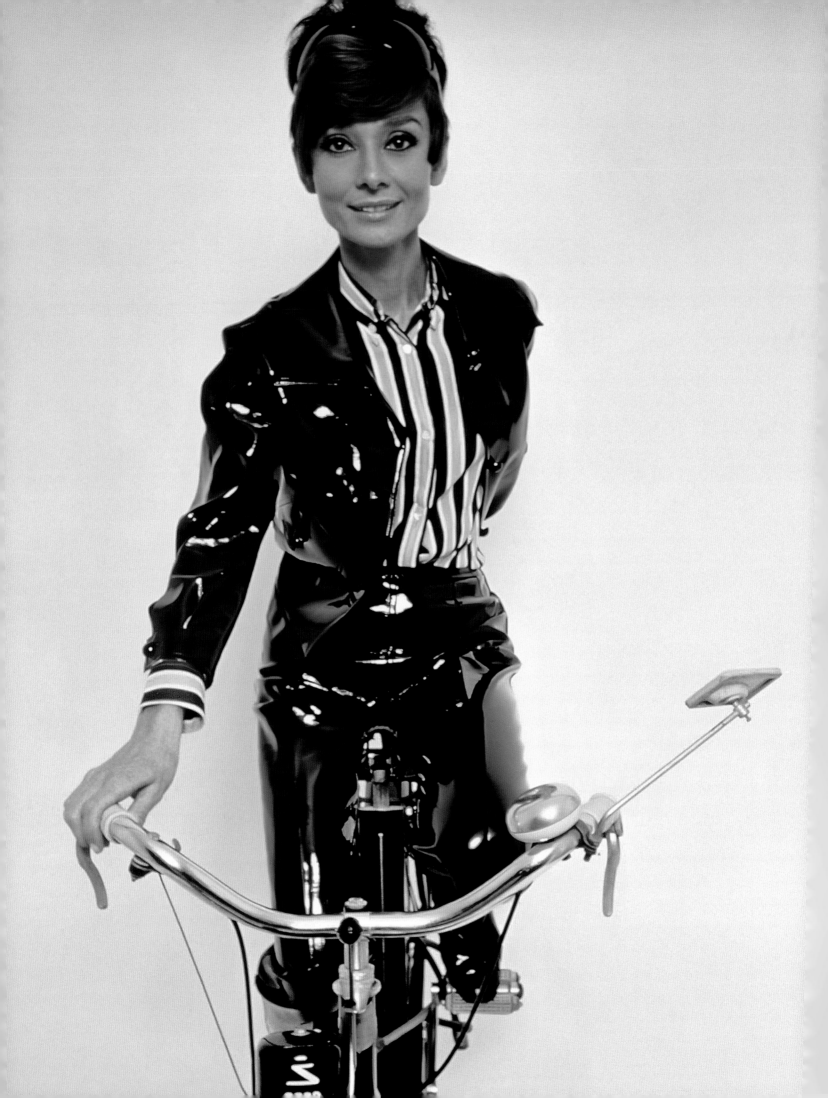

"Playing a love scene with a woman as sexy as Audrey, you sometimes get to the edge where make-believe and reality are blurred, all that staring into each other's eyes— you pick up vibes that are decidedly not fantasy."

ALBERT FINNEY (Costar, *Two for the Road*, 1967)

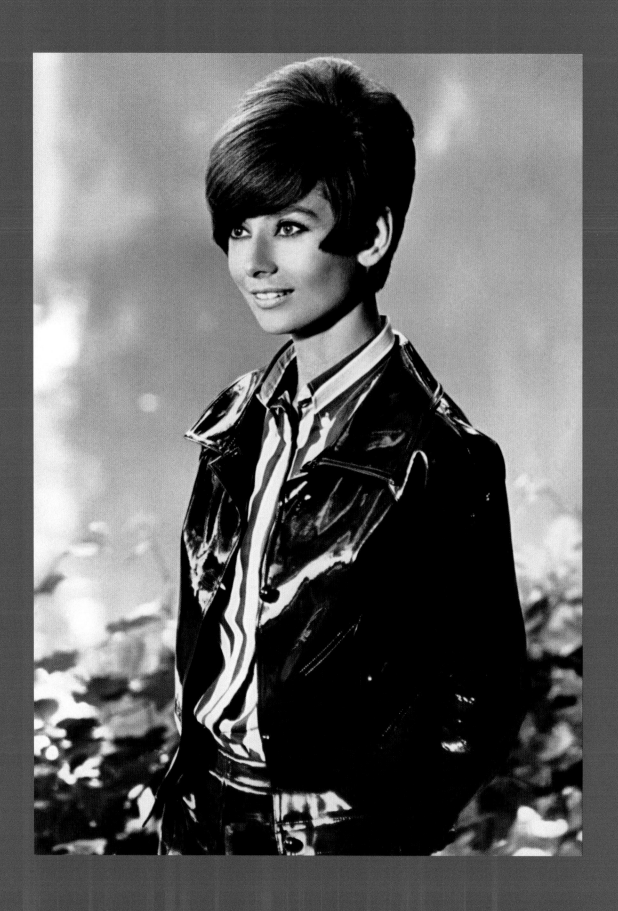

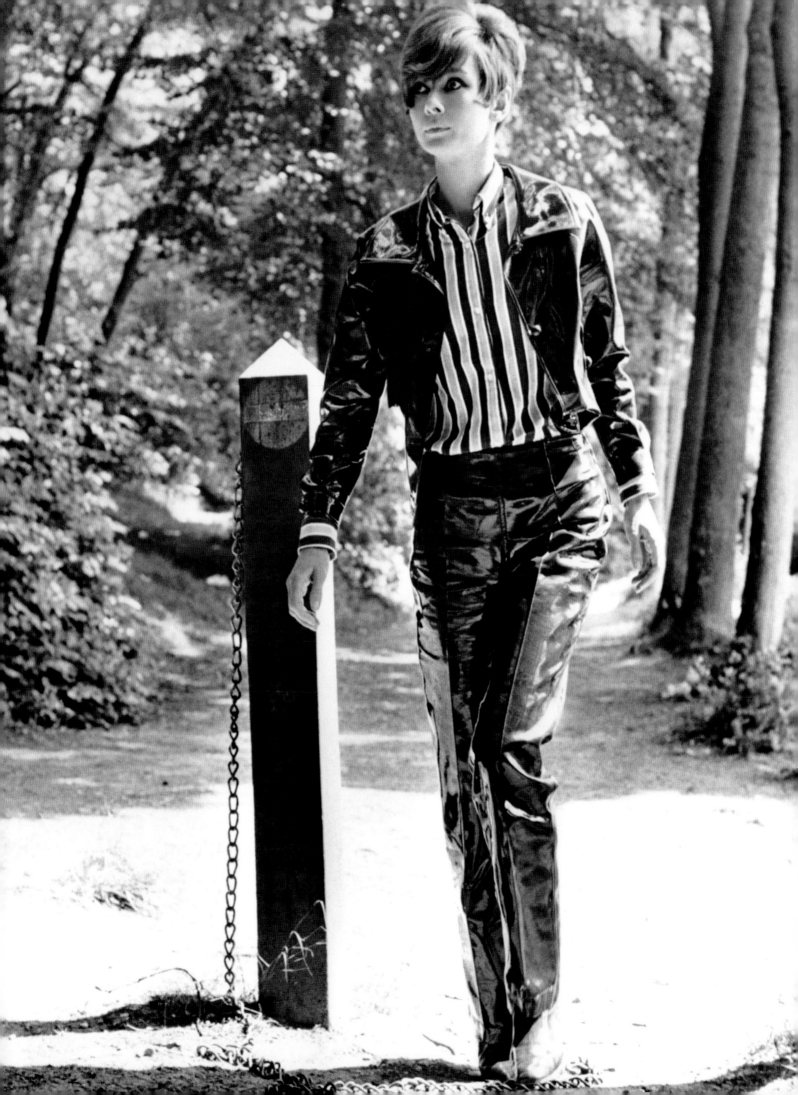

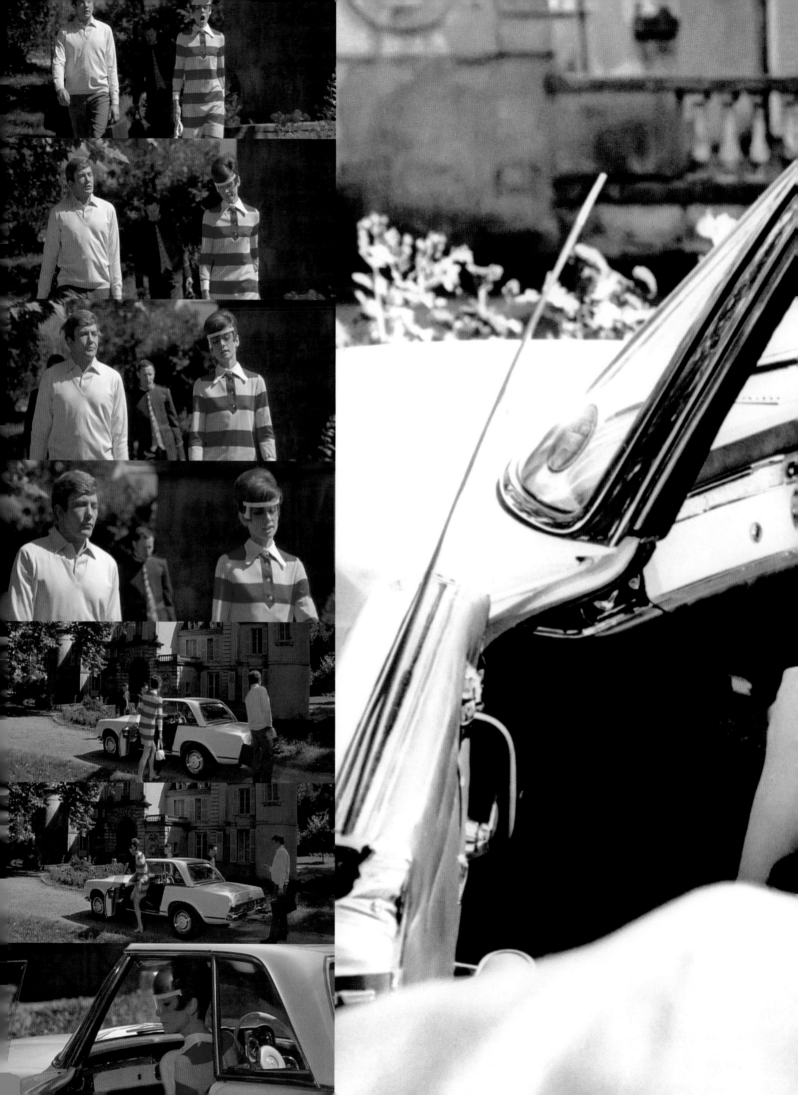

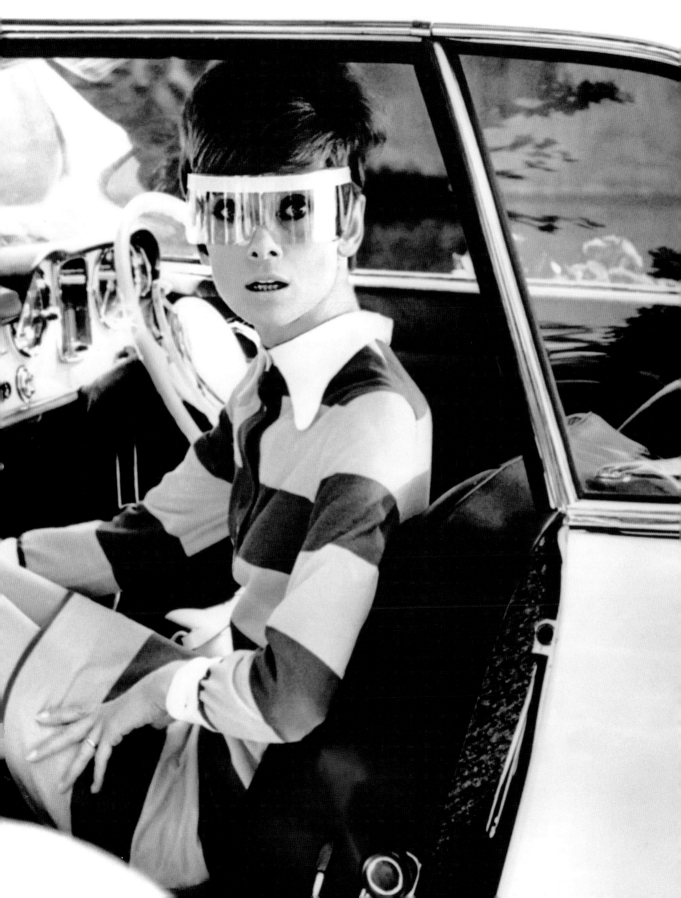

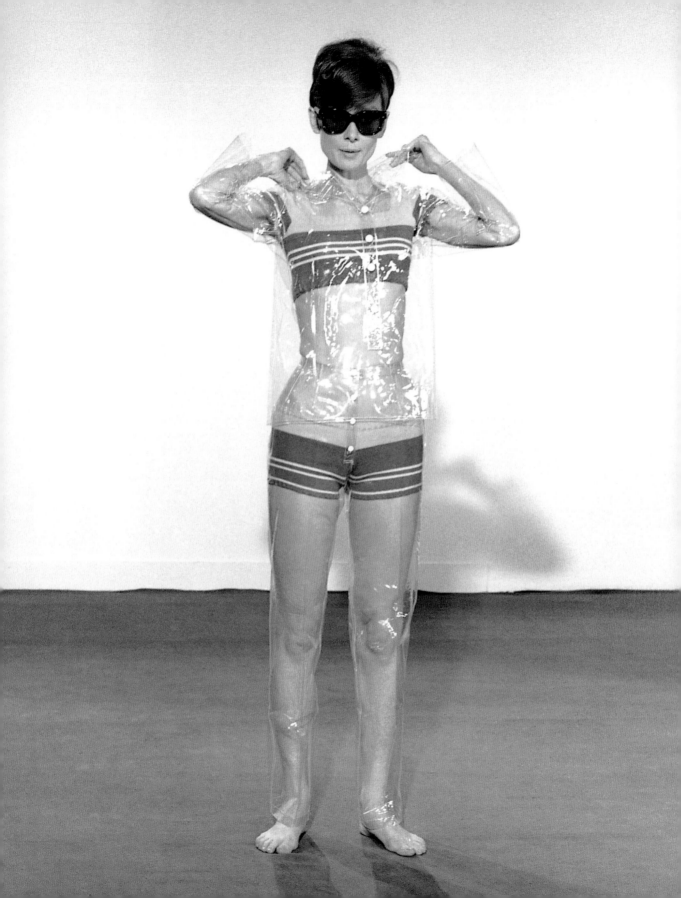

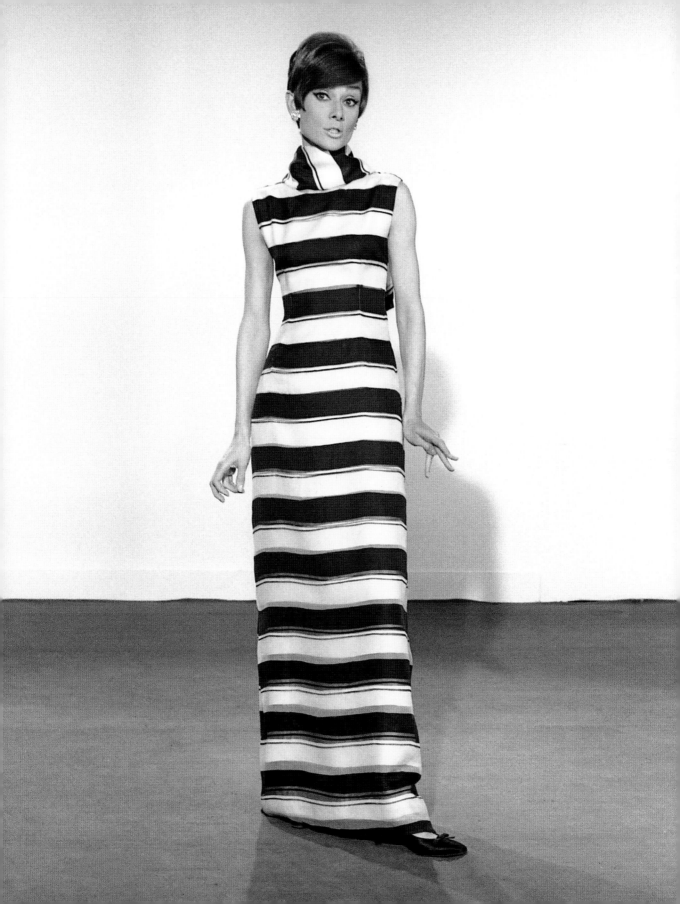

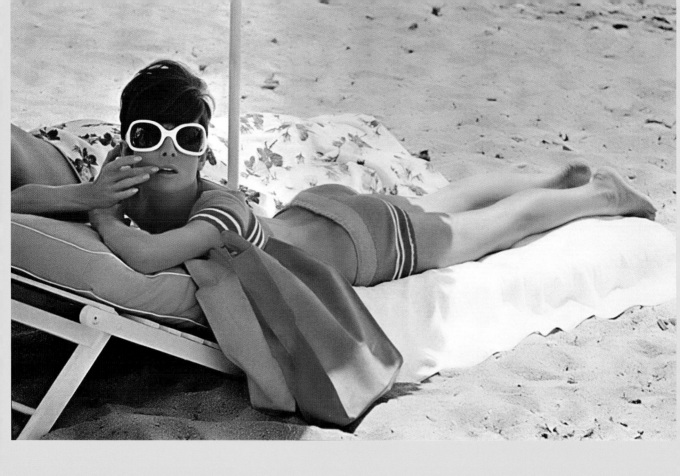

"Stanley is a master moviemaker. His knowledge of film is boundless... As a director, Stanley has time and again generously provided insecure actors such as myself the reassurance and courage they need to give him their absolute best."

AUDREY HEPBURN, on Stanley Donen, director (*Two for the Road*, 1967)

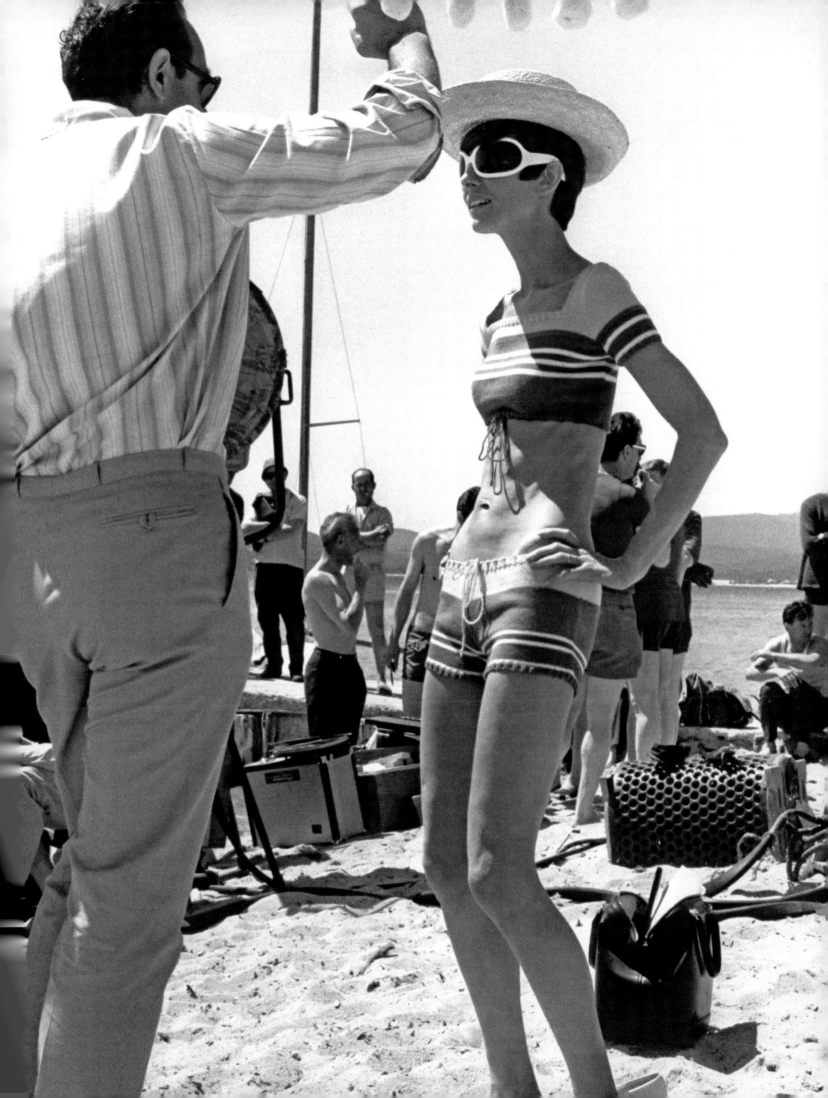

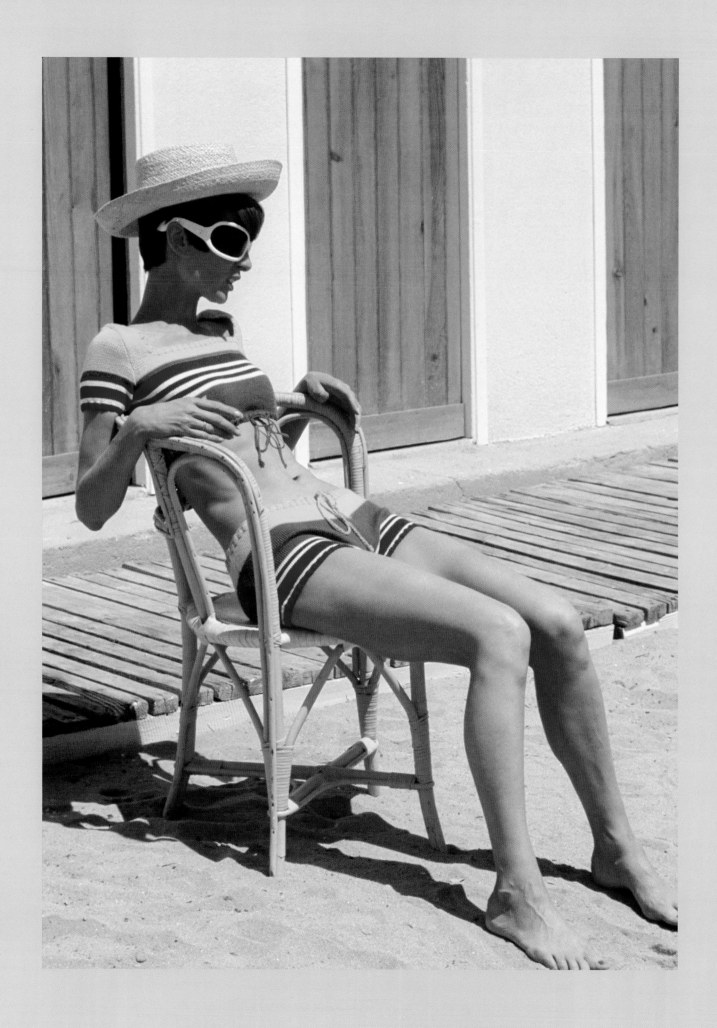

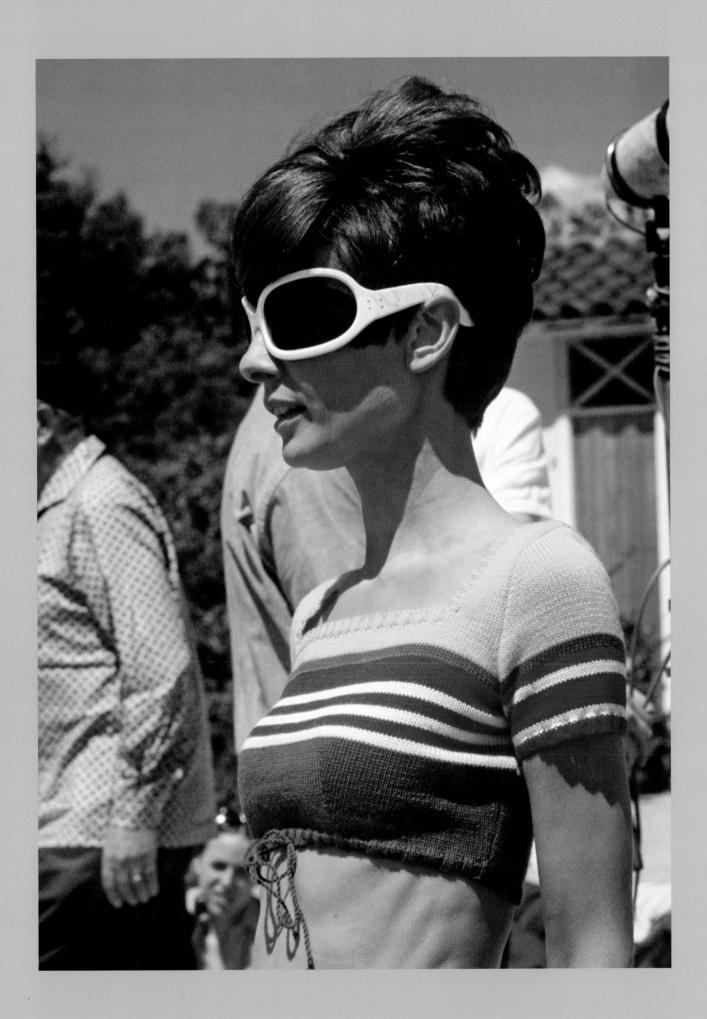

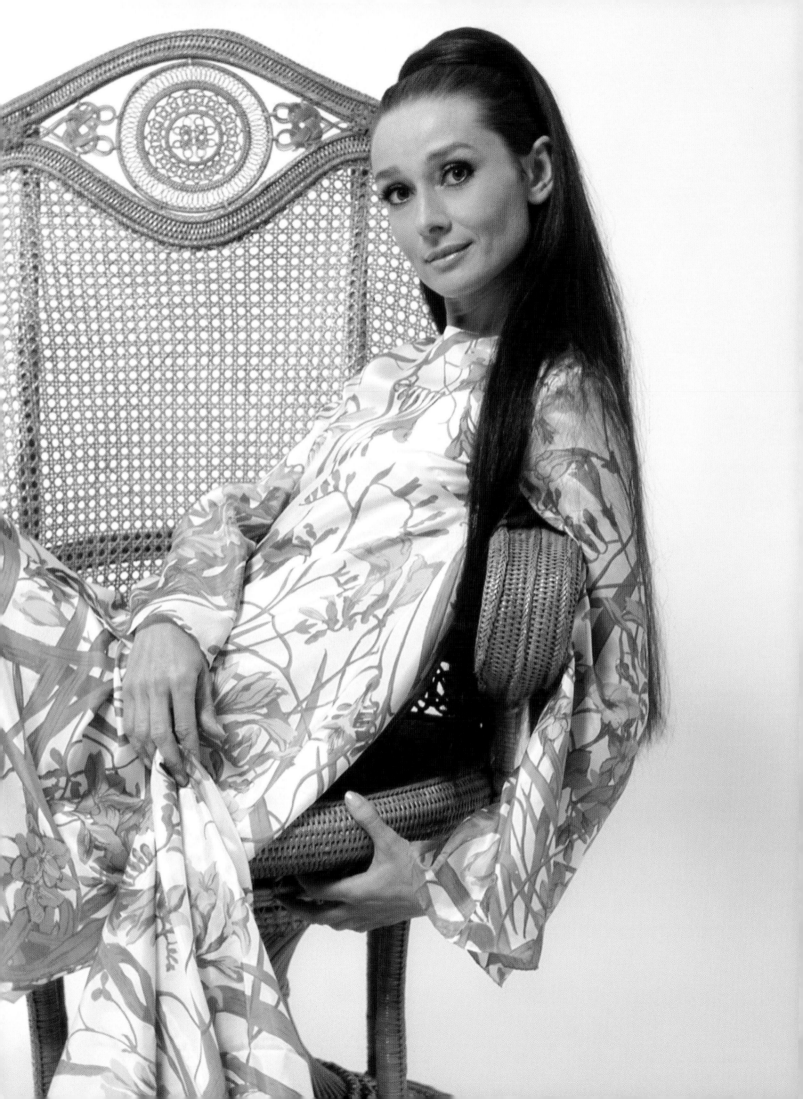

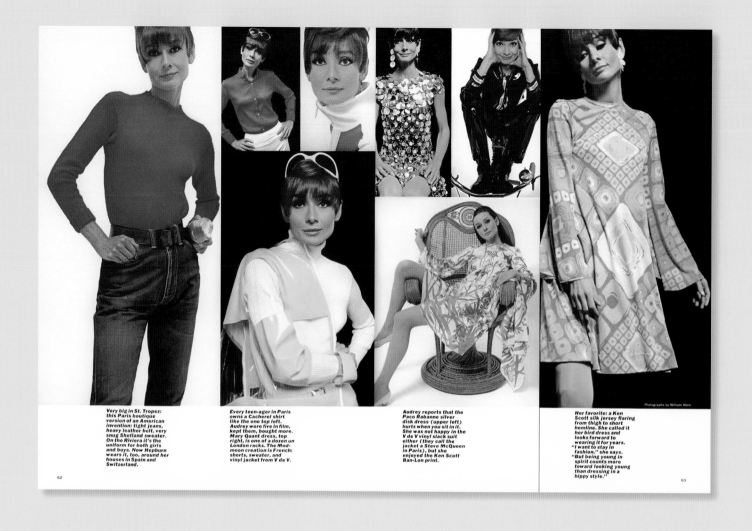

Very big in St. Tropez: this Paris boutique version of an American invention: tight jeans, heavy leather belt, very snug Shetland sweater. On the Riviera it's the uniform for both girls and boys. Now Hepburn wears it, too, around her houses in Spain and Switzerland.

Every teen-ager in Paris owns a Cacherel shirt like the one top left. Audrey wore five in film, kept them, bought more. Mary Quant dress, top right, is one of a dozen on London racks. The Moon-moon creation is French: shorts, sweater, and vinyl jacket from V de V.

Audrey reports that the Paco Rabanne silver disk dress (upper left) hurts when you sit in it. She was not happy in the V de V vinyl slack suit either (they call the jacket a Steve McQueen in Paris), but she enjoyed the Ken Scott Ban-Lon print.

Her favorite: a Ken Scott silk jersey flaring from thigh to short hemline. She called it her bird dress and looks forward to wearing it for years. "I want to stay in fashion," she says. "But being young in spirit counts more toward looking young than dressing in a hippy style."

62 63

"*Two for the Road* is a MOD fashion fest and proves that there's nothing Audrey Hepburn can't wear to perfection. She veers from her usual 'Givenchy chic' ensembles of previous films to a younger, up-to-the-minute look. As Joanna, she sizzles in classic sportswear and the trends of 1966–67, including a boldly striped rugby dress by Mary Quant with a wraparound visor, a skinny black PVC pantsuit by V de V, and a silver Paco Rabanne dress of metal discs with matching earrings. She looks fantastic in everything—her slim dancer's figure is a dream for any designer."

TRINA TURK (Designer)

232

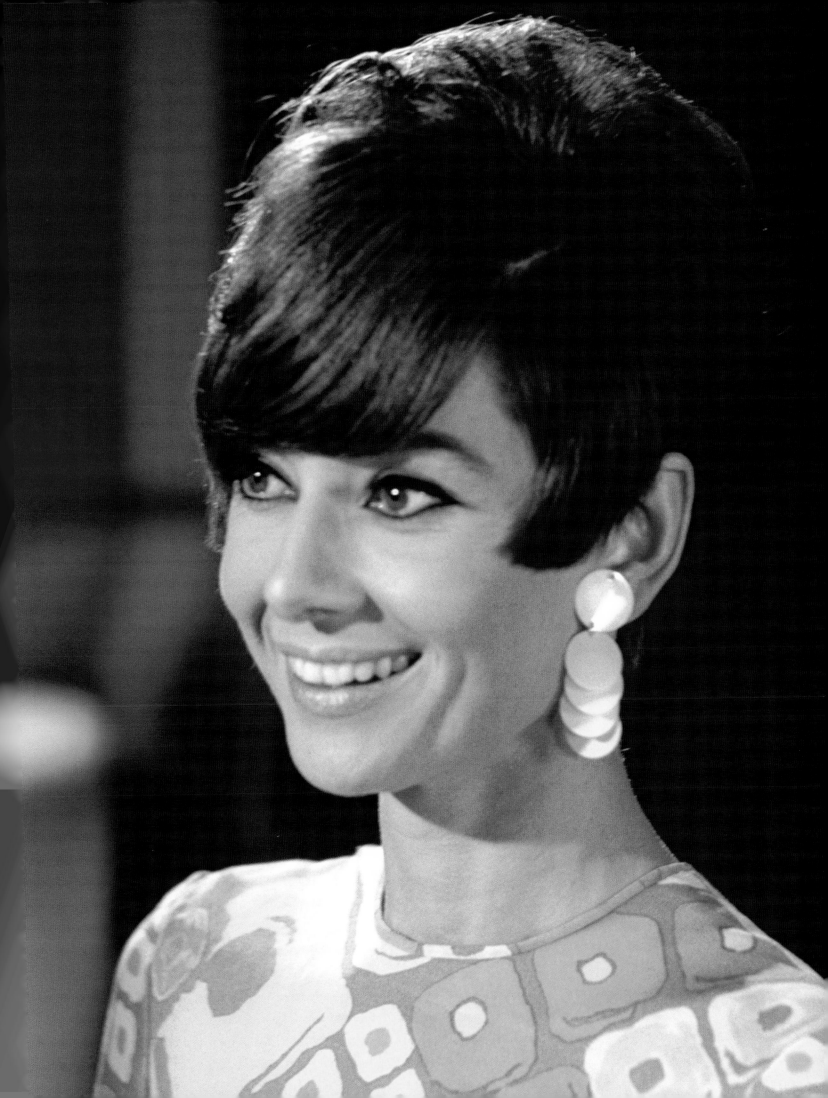

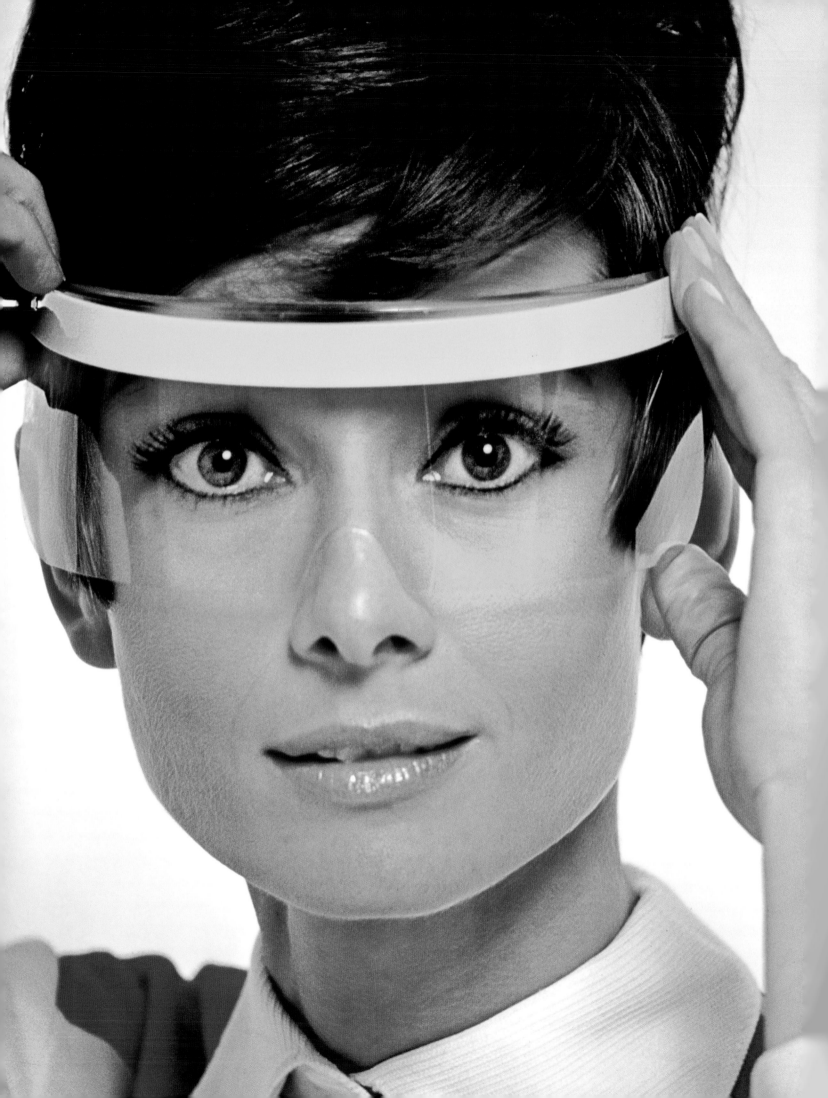

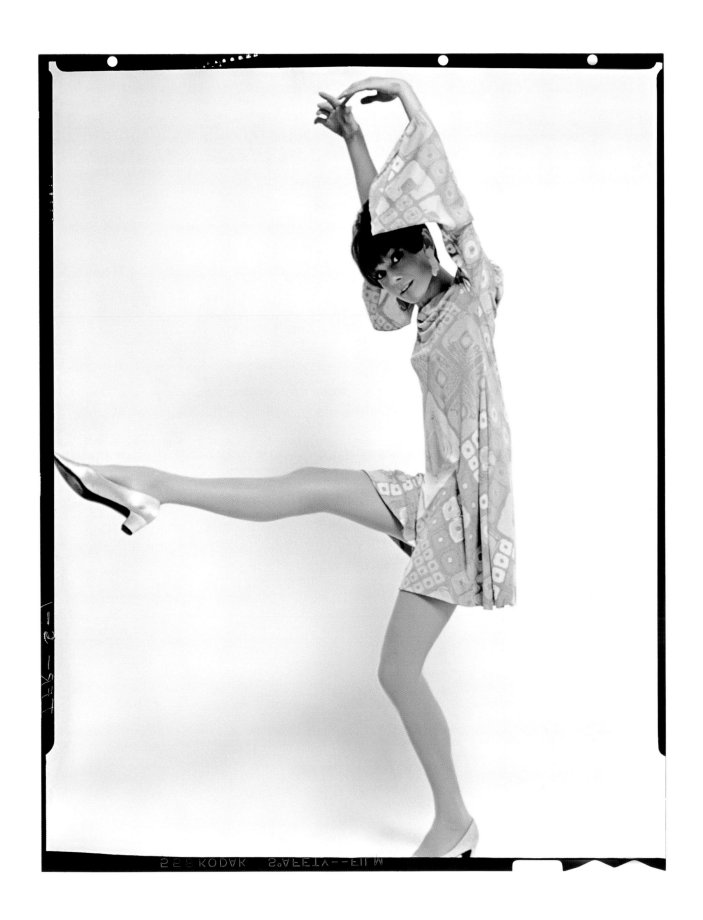

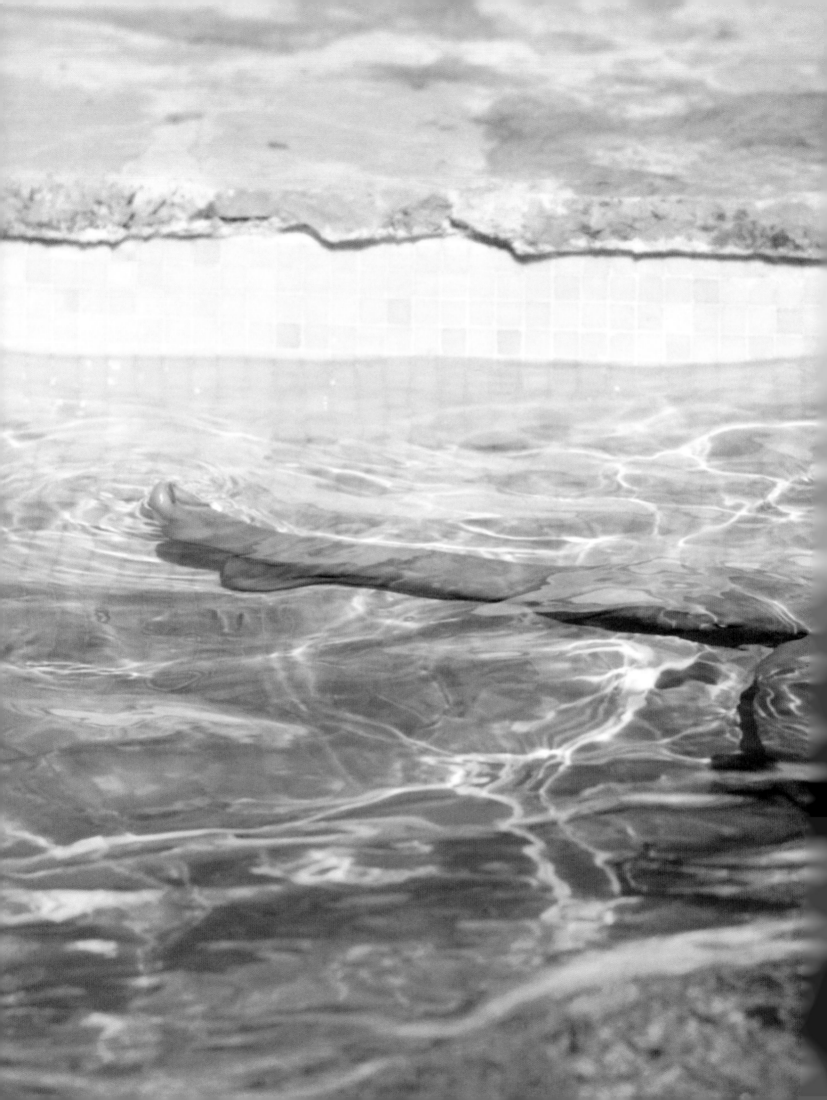

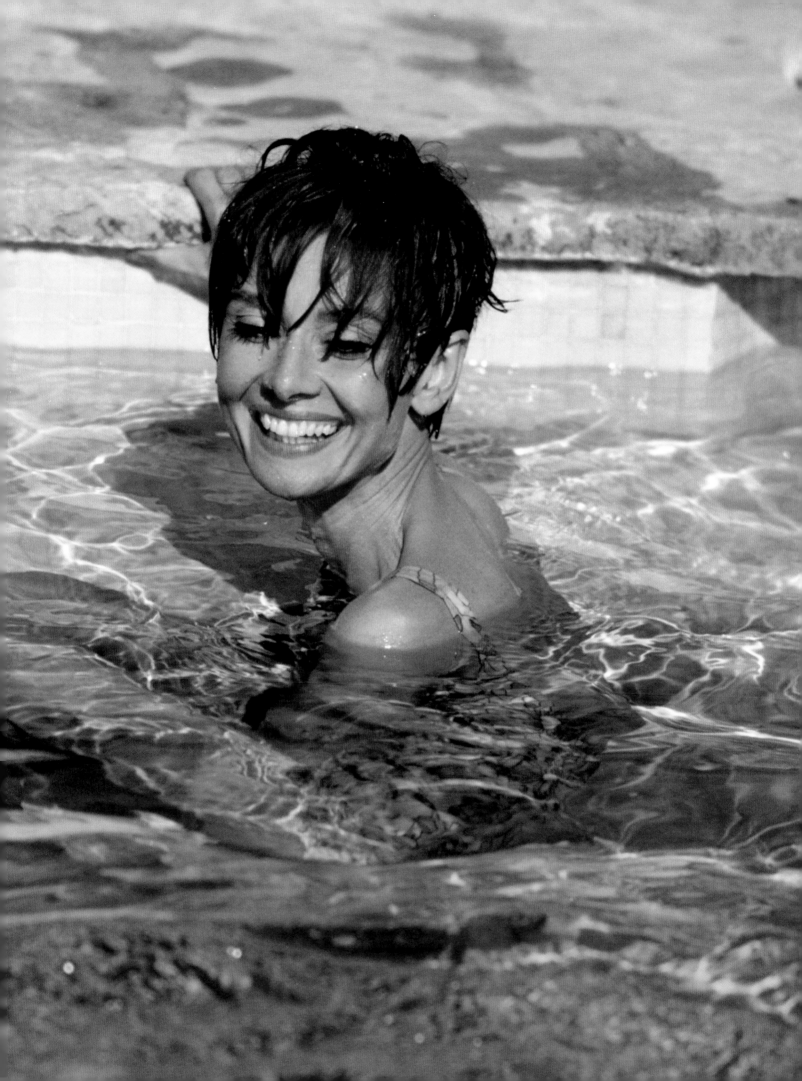

"You're really an eyeful, Audrey."

ALBERT FINNEY

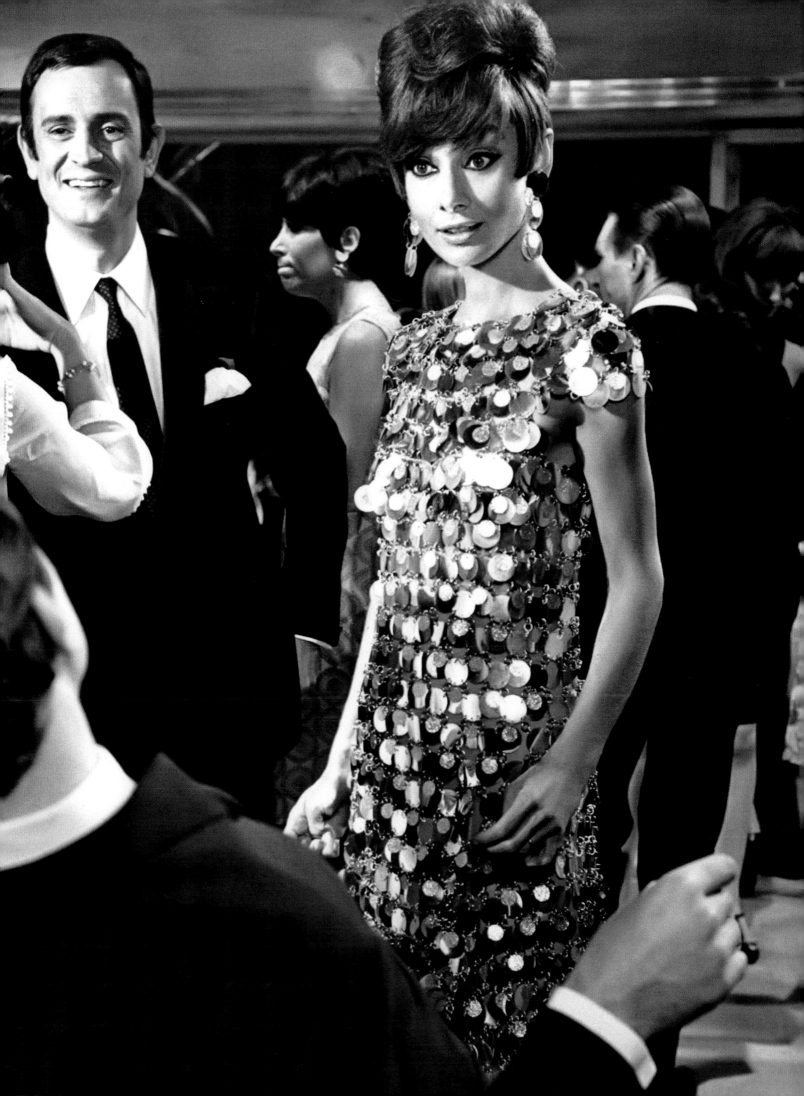

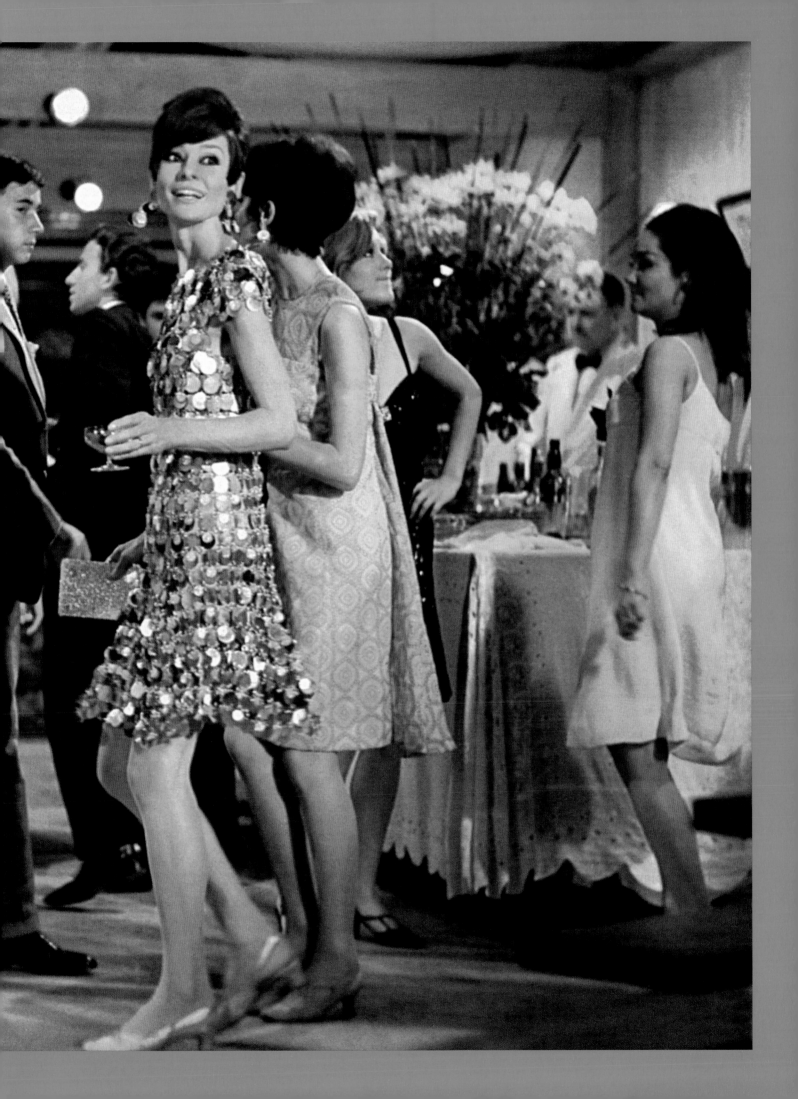

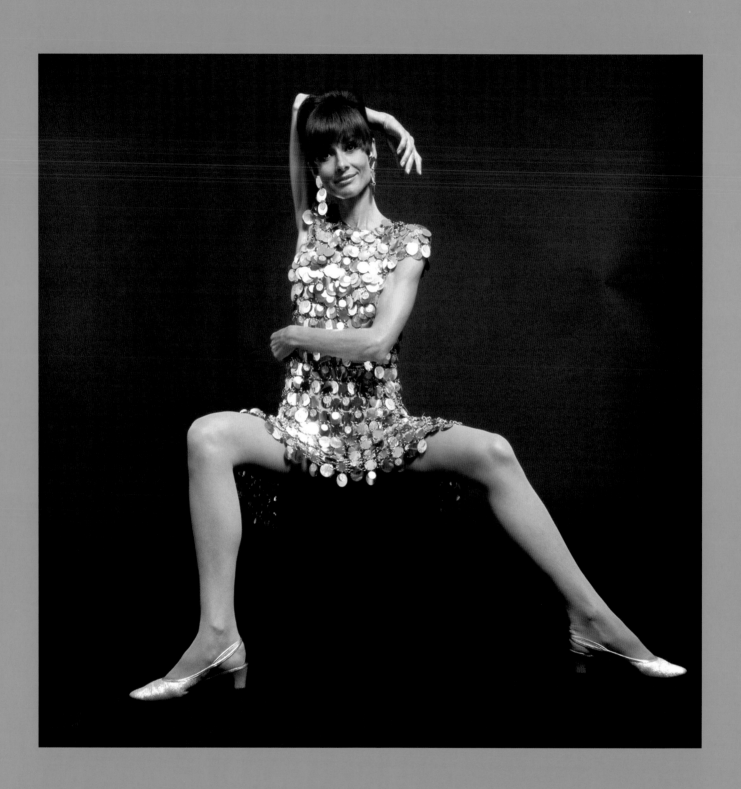

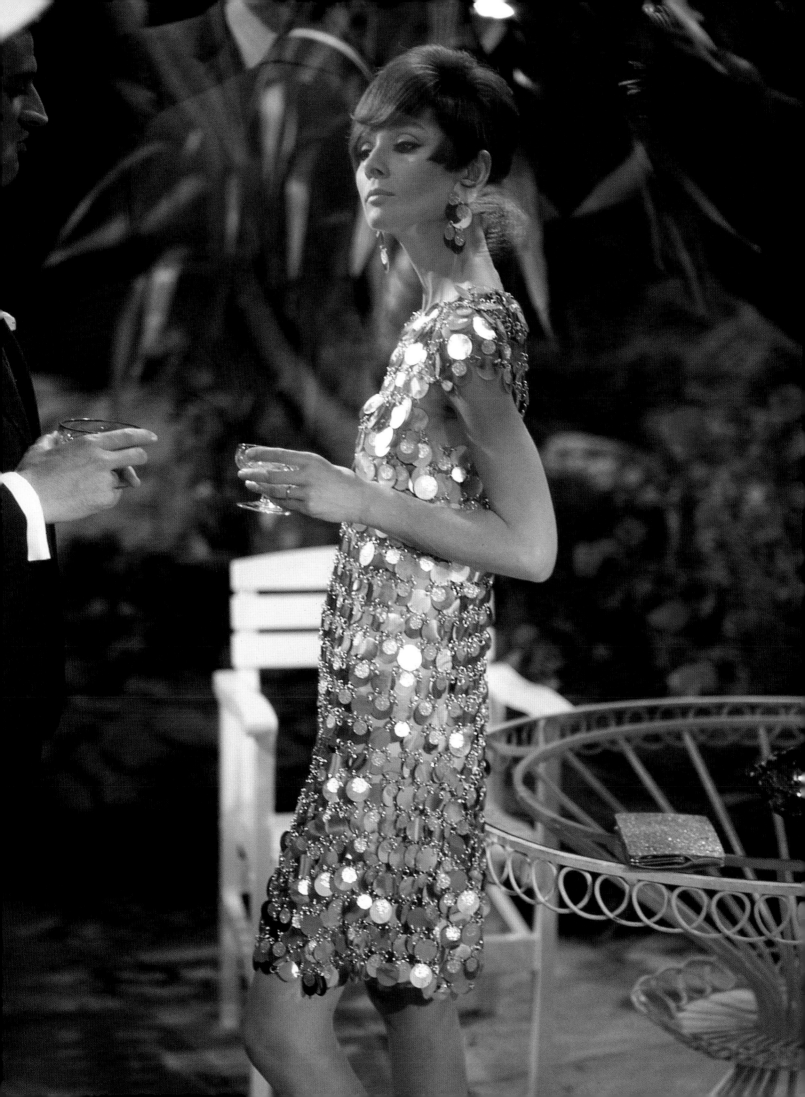

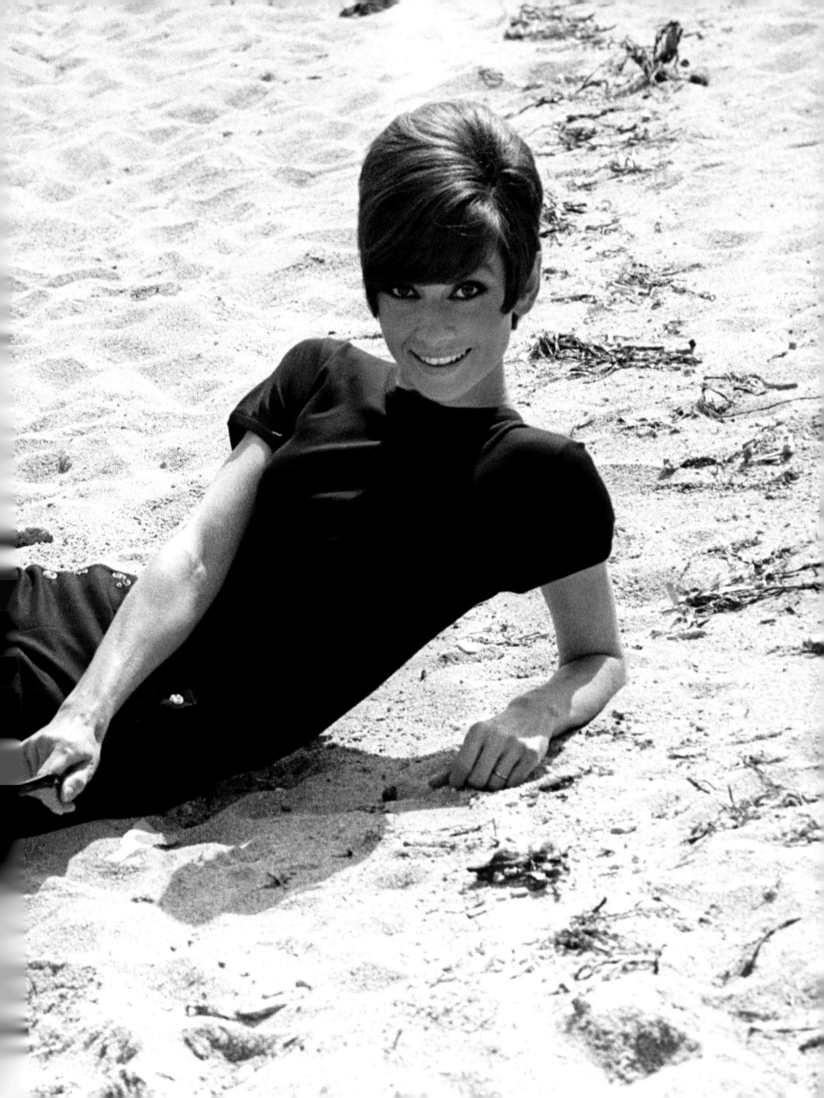

"In film after film, Audrey wore clothes with such talent and flair that she created a style, which in turn had a major impact on fashion. Her chic, her youth, her bearing, and her silhouette grew ever more celebrated, enveloping me in a kind of aura or radiance that I could never have hoped for. The Hepburn style had been born, and it lives today."

HUBERT DE GIVENCHY

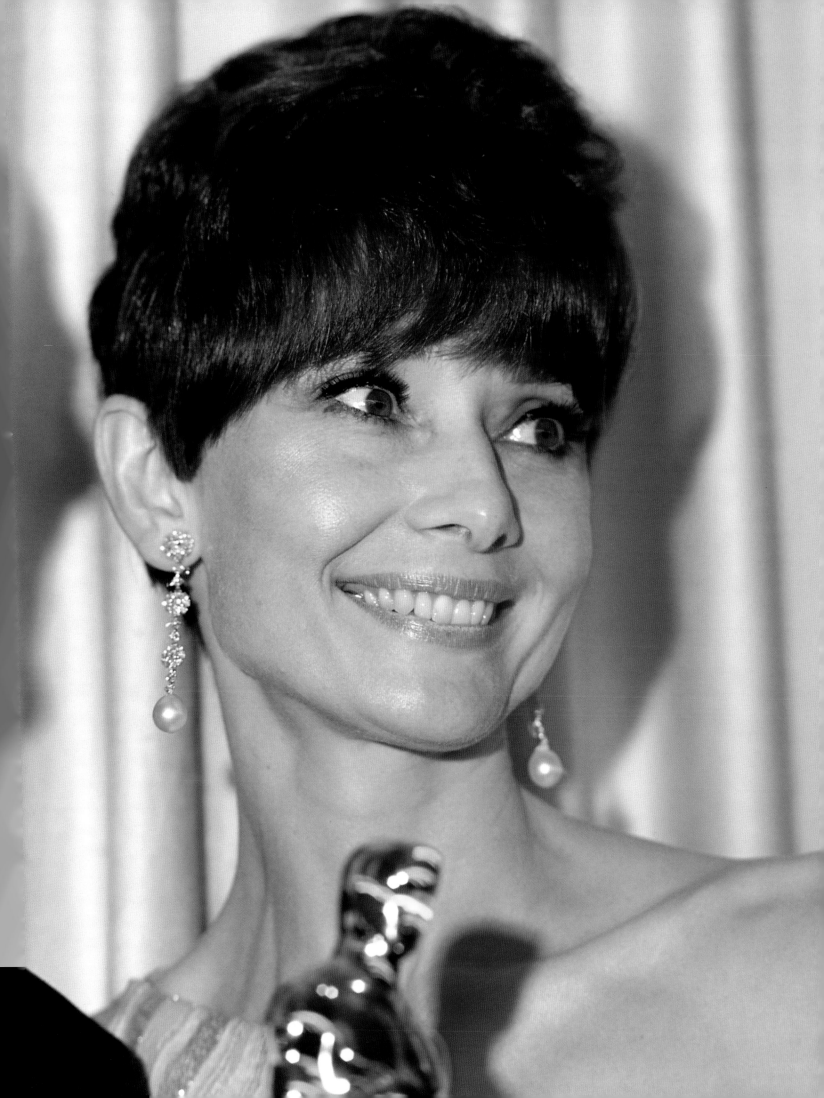

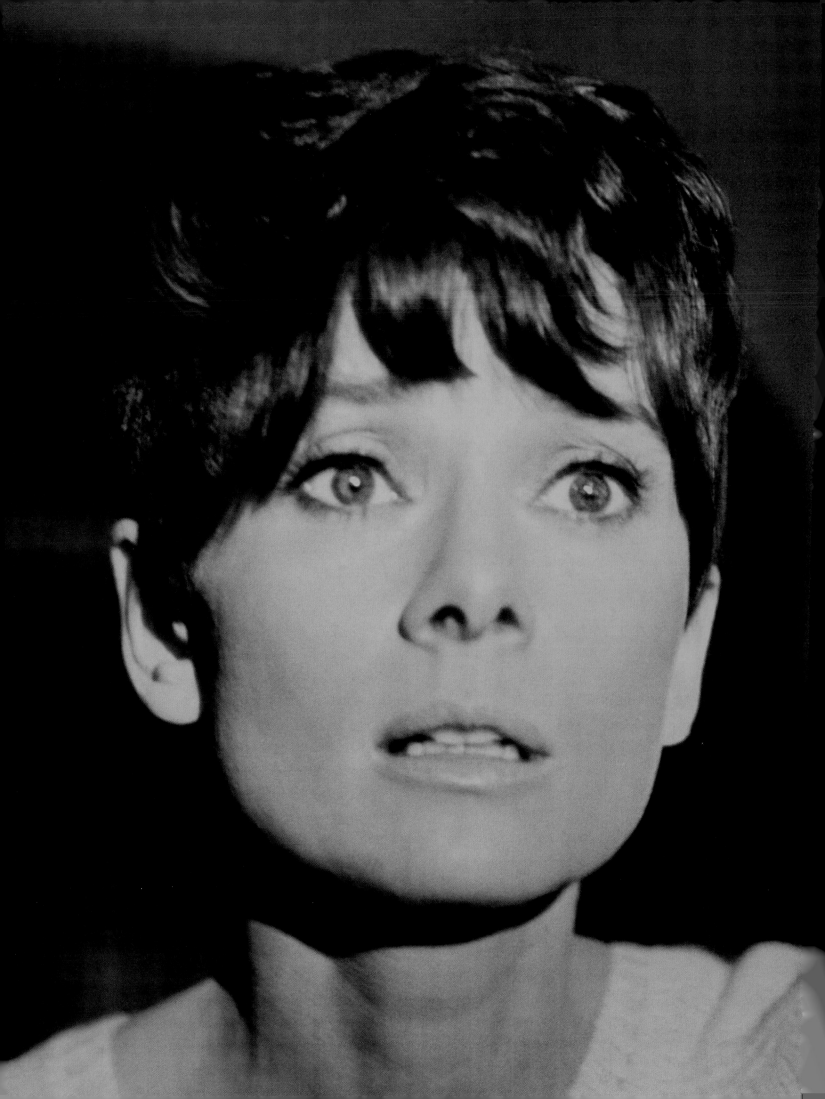

Wait Until Dark

1967

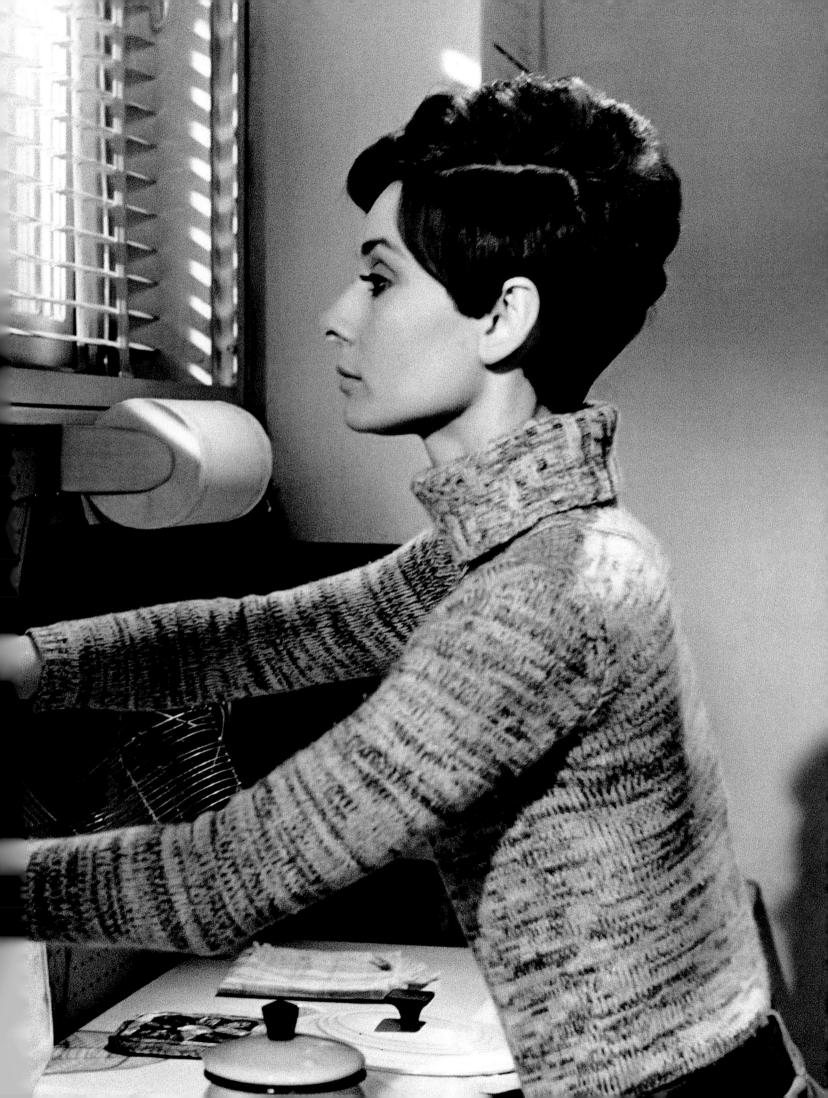

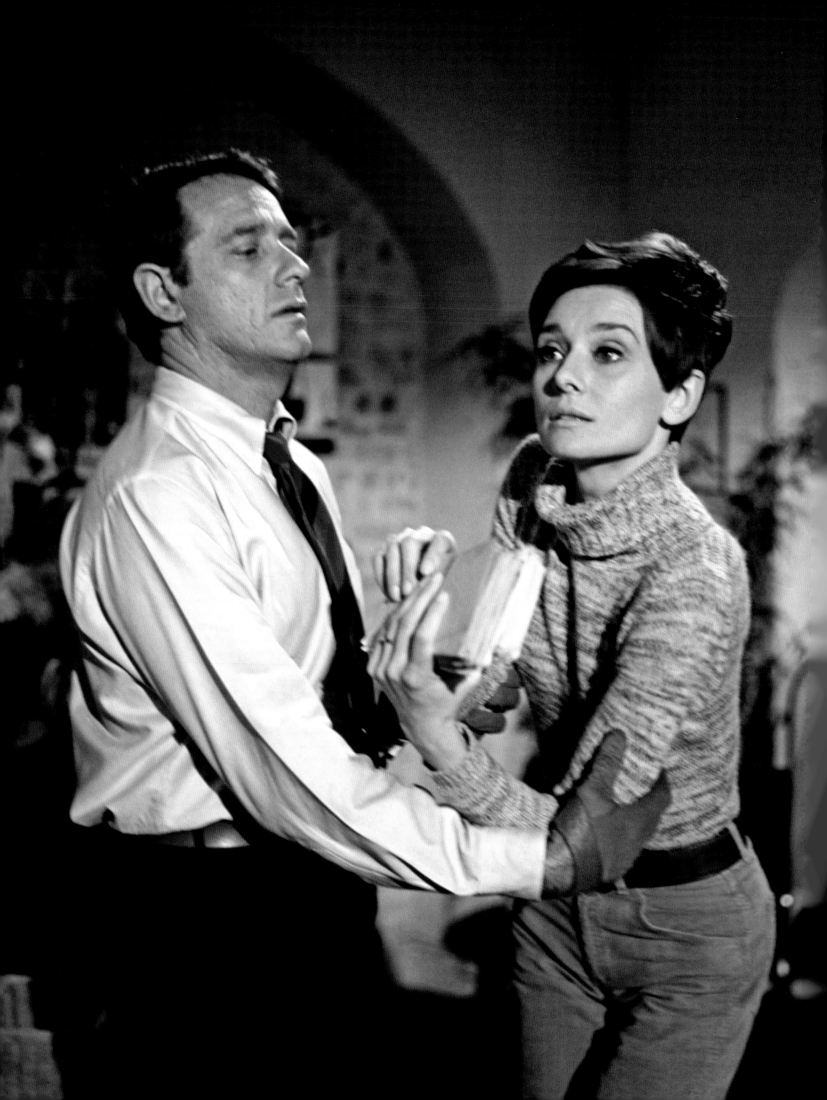

"But the sweetness with which Miss Hepburn plays the poignant role, the quickness with which she changes and the skill with which she manifests terror attract sympathy and anxiety to her and give her genuine solidity in the final scenes."

THE NEW YORK TIMES

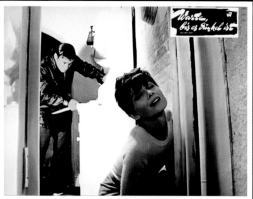

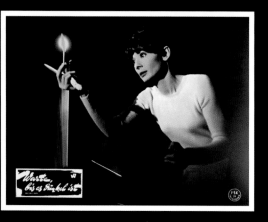

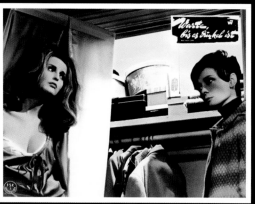

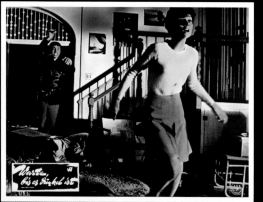

"I'm the only person alive who has attacked Audrey Hepburn."

ALAN ARKIN (Costar, *Wait Until Dark*, 1967)

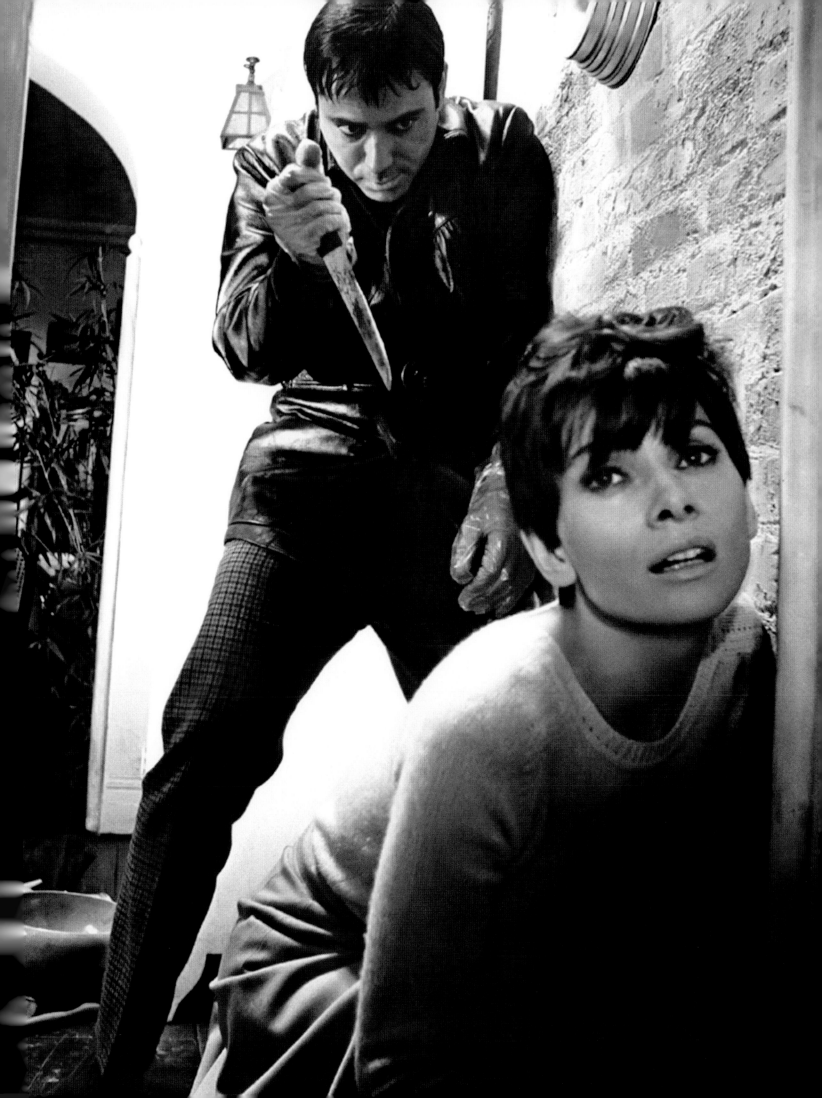

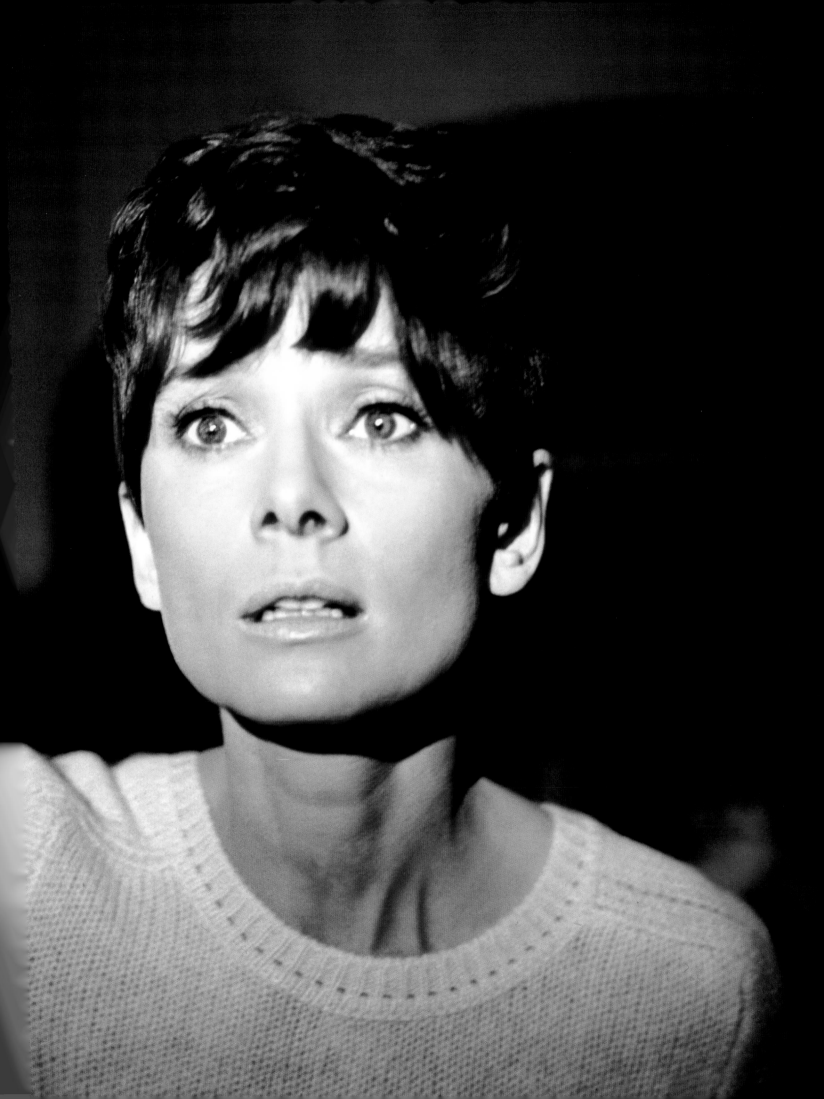

"She used to surprise my friends with how casual she was. They expected something incredible and instead found just a nice person."

LUCA DOTTI (Son of Audrey Hepburn)

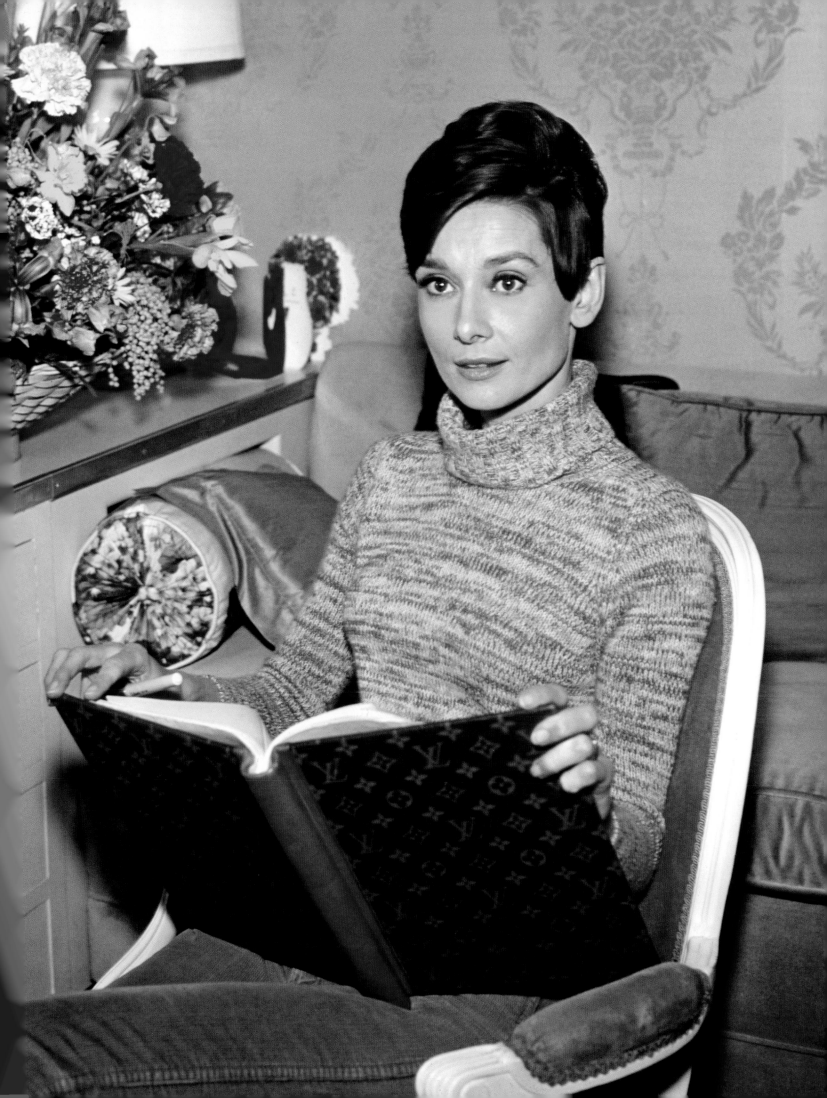

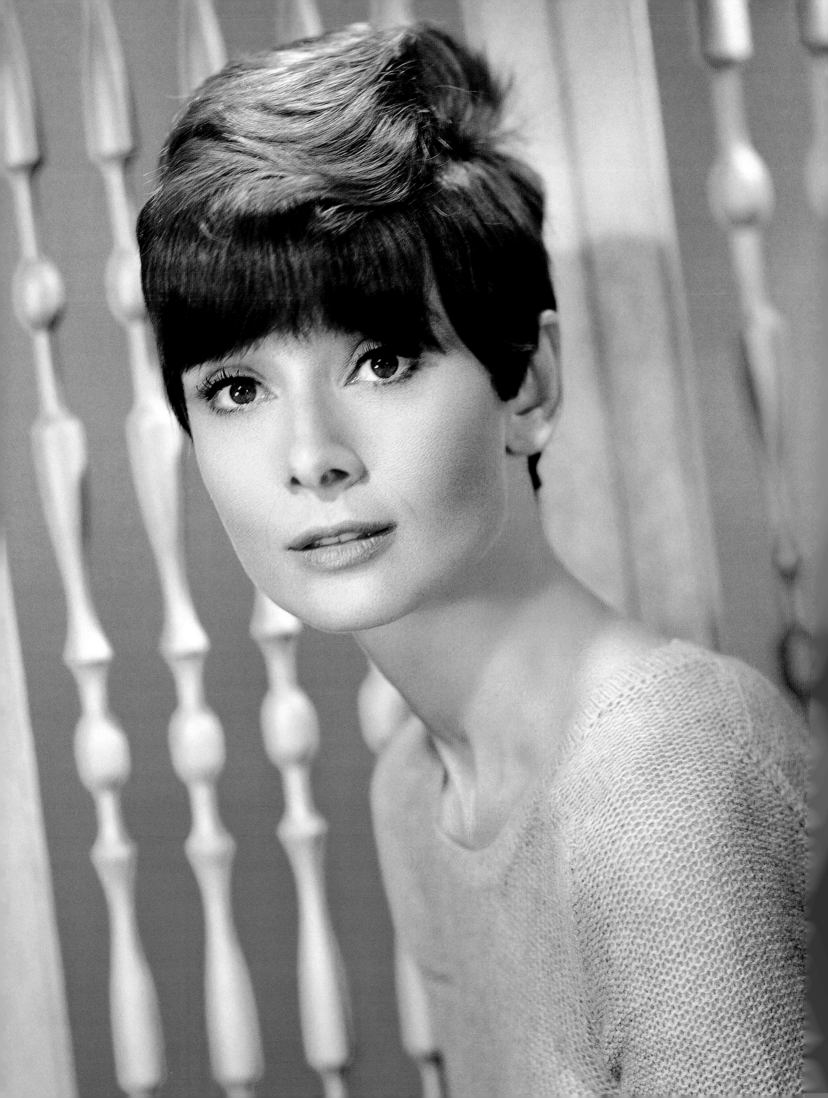

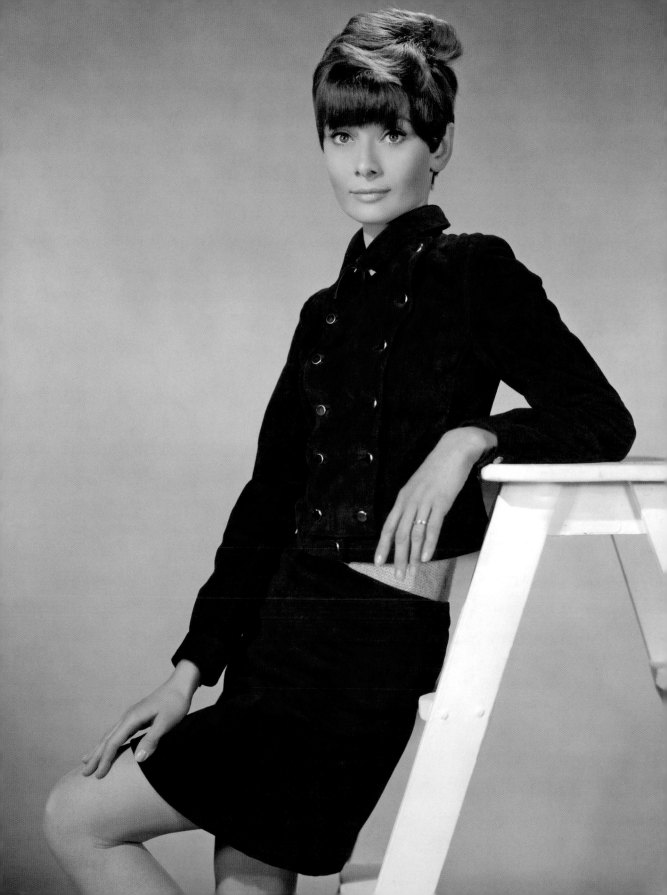

"For beautiful eyes, look for the good in others; for beautiful lips, speak only words of kindness; and for poise, walk with the knowledge that you are never alone."

AUDREY HEPBURN

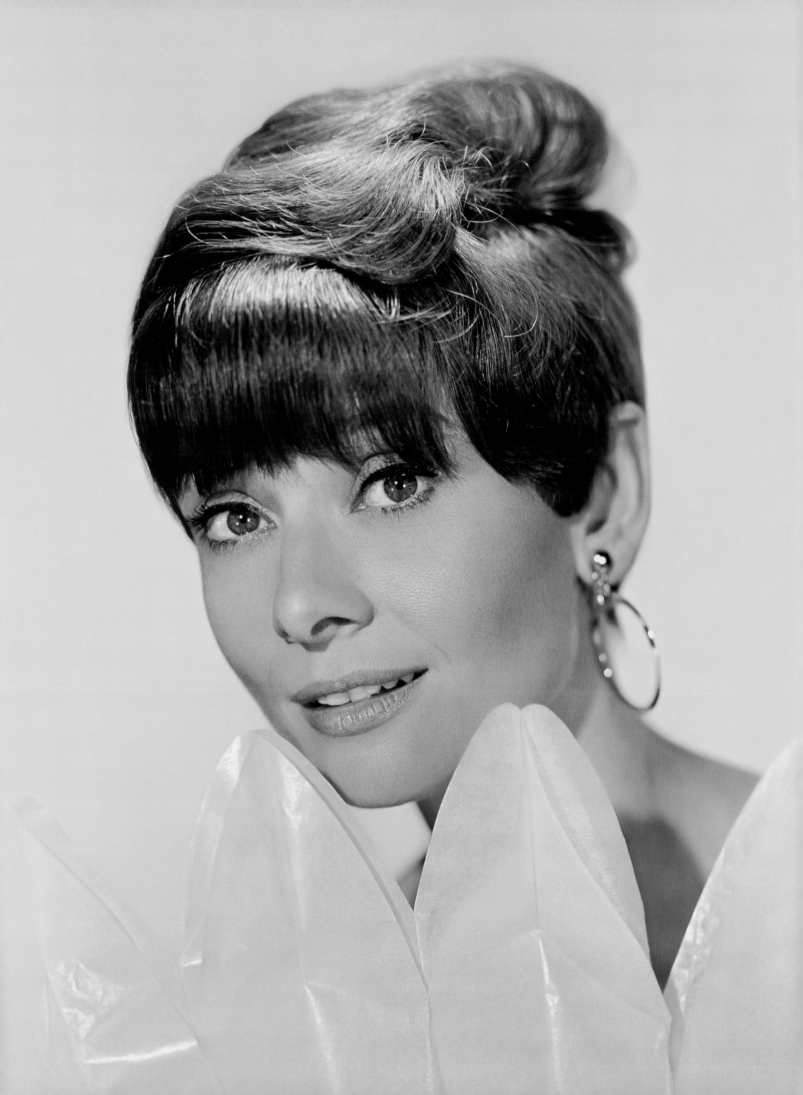

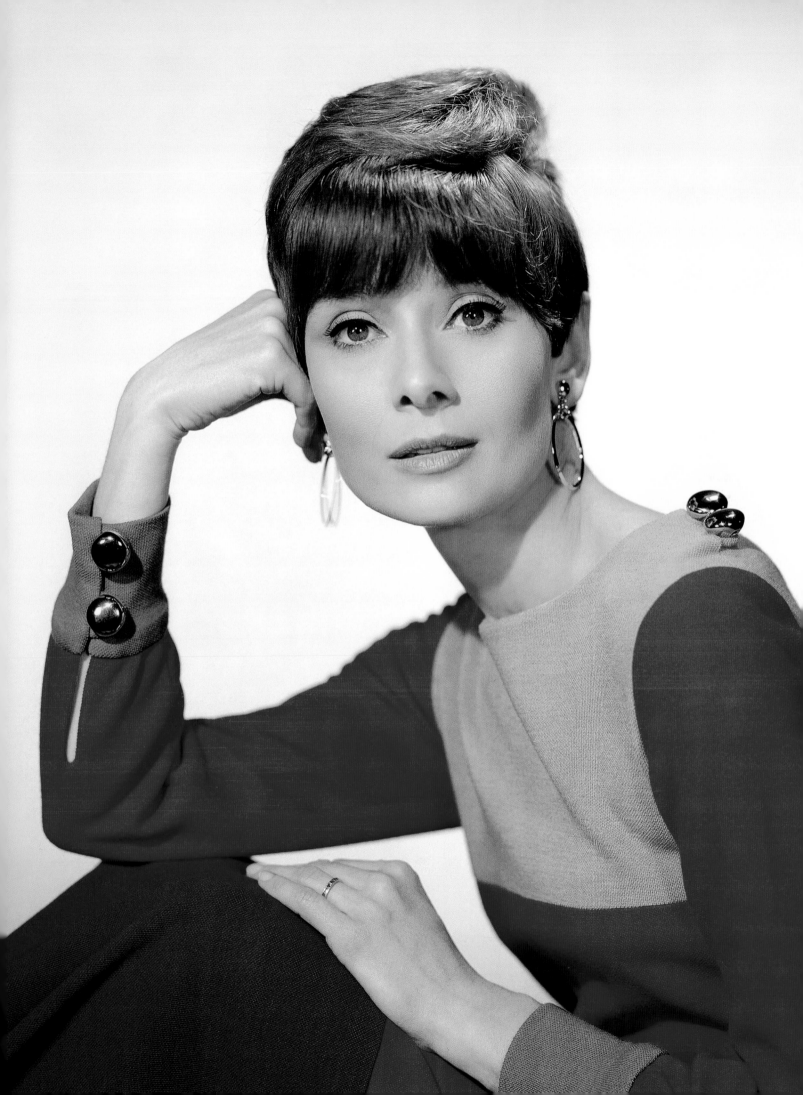

"One day in Paris I was booked for a perfume advertising campaign with Richard Avedon. It was for the fashion house Lanvin and the perfume was named 'Sinner.' The slogan they used was 'Veruschka is a Sinner.' When I entered the studio, I was surprised to see Audrey Hepburn sitting in the dressing room. She was there speaking with Avedon about a portrait he was doing of her for American *Vogue*. The atmosphere was very quiet. I had to get ready, so I sat down next to her at the makeup table facing the mirror. Needless to say, I was very impressed as I had always admired her so much and as an awkward teenager dreamed of looking like Audrey Hepburn. She was extraordinarily beautiful but her expression was clearly not a happy one that day. As I was getting busy with my makeup, I heard her whisper to Avedon, 'Please make me look like her.' I was shocked that this elegant and supremely unique woman wanted to look like *me*. I ventured to say, 'I am a big fan of yours' but it seemed too banal and I stopped before the words left my lips. Looking back, I wish I had told her how I felt about her. Perhaps we would have laughed and realized how we all feel insecure about ourselves at times, especially through difficult moments in life."

VERUSCHKA (Performance artist and model)

"She resented the word 'star'; she thought it was silly. And every time she'd realize that she was becoming too serious, too self-involved, she would poke fun at herself."

ROBERT WOLDERS (Companion)

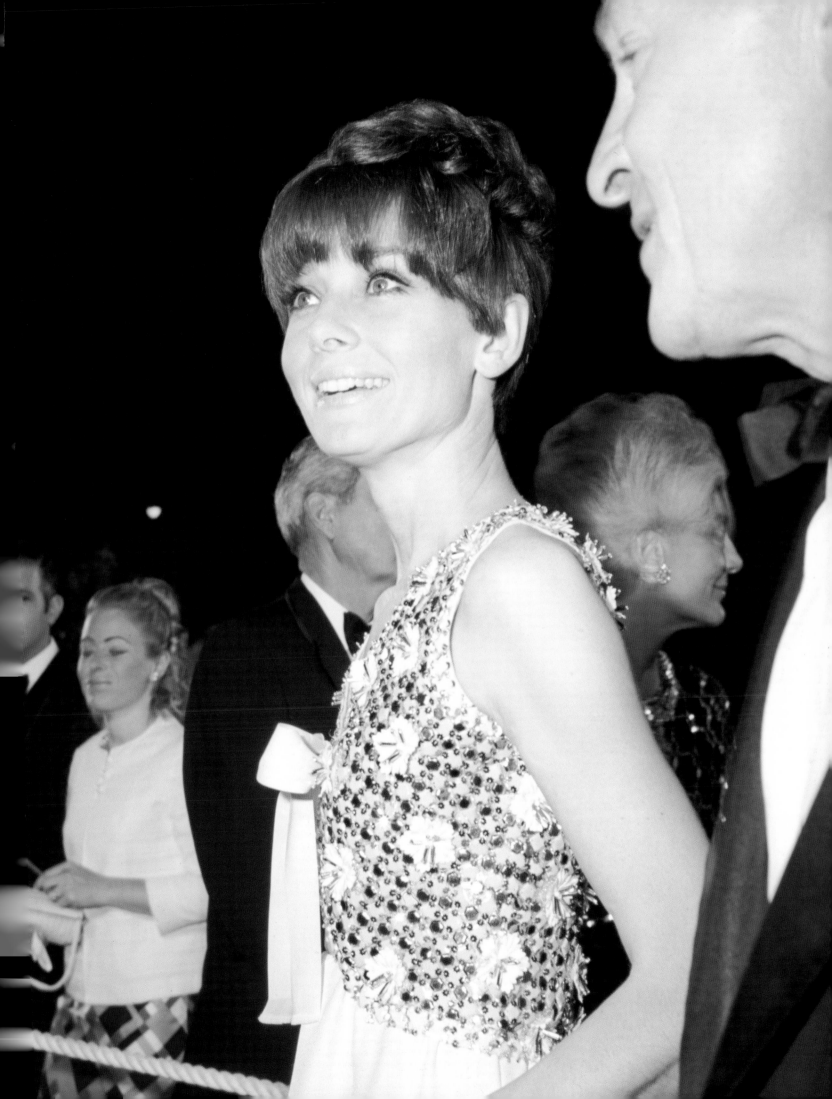

"As time progressed, Audrey Hepburn became more and more 'Audrey Hepburn.' By the 1960s she was an icon. Others didn't have the sophistication, the class, or the impeccable taste. When I photographed her for *Vanity Fair* I was scared, excited, and thrilled. She had always been one of my favorites and she lived up to every expectation. She arrived at the studio alone and I was surprised by how tall she was. She was one of the loveliest, most charming people, sweet, gentle—so gentle, and extraordinarily beautiful of course. Everyone—editor Marina Schiano, makeup artist Kevyn Aucoin, hair stylist Garren, and myself—fell instantly in love with her. She trusted us completely and took direction—not everyone will do this. The only time she hesitated was

when she was wearing the black turtleneck shift dress and her arms went up, drastically shortening the hemline. She was concerned that it was not age appropriate. I could not choose one feature about her that stood out from the others as everything was extraordinary—her bone structure, the length of her line, and the most amazing eyebrows. For lunch she ate a peanut butter and jelly sandwich—I can't remember now if she ordered it or brought it with her, but I will never forget that. We both had Jack Russell terriers so we talked a little about that. I also asked her about her movies and she told me, 'In the old days we would have a whole week just to test lighting of the face. Now everything is so rushed.'"

STEVEN MEISEL (Photographer)

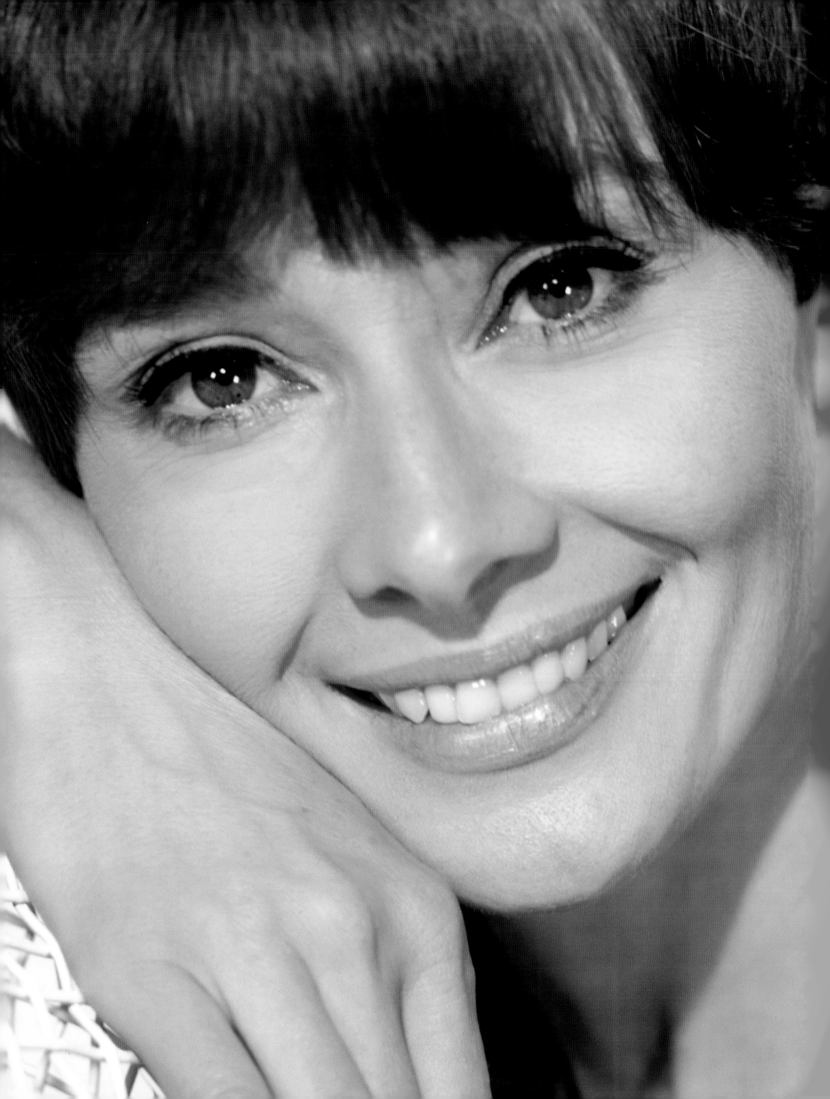

"I never think of myself as an icon. What is in other people's minds is not in my mind. I just do my thing."

AUDREY HEPBURN

PHOTO CREDITS

Cover

November 1965, Studio de Boulogne, Paris, France. During the making of *How to Steal a Million* (© Douglas Kirkland / CORBIS. All Rights Reserved).

Endpapers

Two for the Road, 1967. Directed by Stanley Donen. Dress by Mary Quant (The Kobal Collection / 20th Century Fox Film Corporation).

Introduction

VI–VII: November 1965, Studio de Boulogne, Paris, France. During the making of *How to Steal a Million* (© Douglas Kirkland / CORBIS. All Rights Reserved).

Breakfast at Tiffany's 1961

XX–1: *Breakfast at Tiffany's*, 1961. Directed by Blake Edwards. Photo by Bud Fraker (author's collection / Paramount).

2–3: *Breakfast at Tiffany's*, 1961. Directed by Blake Edwards. Photo by Howell Conant (Howell Conant / Bob Adelman Books, Inc. / www.bobadelman.net).

4–5: *Breakfast at Tiffany's*, 1961. Directed by Blake Edwards. © Paramount Pictures (author's collection).

6–7: With George Peppard in *Breakfast at Tiffany's*, 1961. Directed by Blake Edwards. Photo by Bud Fraker (author's collection).

8–9: With George Peppard in *Breakfast at Tiffany's*, 1961. Directed by Blake Edwards. Photo by Bud Fraker (Photofest / Paramount).

10: *Breakfast at Tiffany's*, 1961. Directed by Blake Edwards. Photos by Bud Fraker (author's collection / Paramount).

11: *Breakfast at Tiffany's*, 1961. Directed by Blake Edwards (author's collection / Paramount).

12–13: *Breakfast at Tiffany's*, 1961. Directed by Blake Edwards. © Paramount Pictures (author's collection).

14–15: *Breakfast at Tiffany's*, 1961. Directed by Blake Edwards. Photo by Bud Fraker (author's collection / Paramount).

16–17: *Breakfast at Tiffany's*, 1961. Directed by Blake Edwards. © Paramount Pictures (author's collection).

18: (strip) *Breakfast at Tiffany's*, 1961. Directed by Blake Edwards. © Paramount Pictures (author's collection).

18–19: With Patricia Neal and George Peppard in *Breakfast at Tiffany's*, 1961. Directed by Blake Edwards (Photofest / Paramount).

20: *Breakfast at Tiffany's*, 1961. Directed by Blake Edwards (Photofest / Paramount).

22–23: *Breakfast at Tiffany's*, 1961. Directed by Blake Edwards. © Paramount Pictures (author's collection).

24–25: *Breakfast at Tiffany's*, 1961. Directed by Blake Edwards. Photo by Bud Fraker (author's collection / Paramount).

26–27: *Breakfast at Tiffany's*, 1961. Directed by Blake Edwards. Photo by Howell Conant (Howell Conant / Bob Adelman Books, Inc. / www.bobadelman.net).

28–29: With George Peppard in *Breakfast at Tiffany's*, 1961. Directed by Blake Edwards. © Paramount Pictures (author's collection).

30: *Breakfast at Tiffany's*, 1961. Directed by Blake Edwards. Photo by Bud Fraker (author's collection / Paramount).

31: *Breakfast at Tiffany's*, 1961. Directed by Blake Edwards. Photo by Bud Fraker (author's collection / Paramount).

32–33: *Breakfast at Tiffany's*, 1961. Directed by Blake Edwards. © Paramount Pictures (author's collection).

34–35: With George Peppard in *Breakfast at Tiffany's*, 1961. Directed by Blake Edwards (author's collection / Paramount).

36–37: With George Peppard in *Breakfast at Tiffany's*, 1961. Directed by Blake Edwards. © Paramount Pictures (author's collection).

38: With José Luis de Villalonga in *Breakfast at Tiffany's*, 1961. Directed by Blake Edwards (The Kobal Collection / Paramount).

40: *Breakfast at Tiffany's*, 1961. Directed by Blake Edwards. Photo by Bud Fraker (author's collection / Paramount).

41: *Breakfast at Tiffany's*, 1961. Directed by Blake Edwards. Photo by Bud Fraker (author's collection / Paramount).

42: *Breakfast at Tiffany's*, 1961. Directed by Blake Edwards. Poster detail (author's collection / Paramount).

43: Miscellaneous magazine covers (author's collection).

44–45: *Breakfast at Tiffany's*, 1961. Directed by Blake Edwards. © Paramount Pictures (author's collection).

46: Photo by Bud Fraker, 1961 (author's collection).

48–49: London premiere of *Breakfast at Tiffany's*. Plaza Cinema, Picadilly Circus. October 20, 1961 (Getty Images).

The Children's Hour 1961

50–51: *The Children's Hour*, 1961. Directed by William Wyler (author's collection / United Artists).

52–53: With Shirley MacLaine in *The Children's Hour*, 1961. Directed by William Wyler (The Kobal Collection / United Artists).

54: With Shirley MacLaine and Karen Balkin in *The Children's Hour*, 1961. Directed by William Wyler (author's collection / United Artists).

55: With Shirley MacLaine in *The Children's Hour*, 1961. Directed by William Wyler (author's collection / United Artists).

56: *The Children's Hour*, 1961. Directed by William Wyler (author's collection / United Artists).

57: *The Children's Hour*, 1961. Directed by William Wyler. Miscellaneous lobby cards (author's collection / United Artists).

58–59: With Shirley MacLaine in *The Children's Hour*, 1961. Directed by William Wyler (author's collection / United Artists).

60: *The Children's Hour*, 1961. Directed by William Wyler (author's collection).

62–63: With Dean Martin, William Wyler, Frank Sinatra and Shirley MacLaine. *The Children's Hour*, 1961. Directed by William Wyler (author's collection).

65: *The Children's Hour*, 1961. Directed by William Wyler (author's collection).

Charade 1963

66–67: *Charade*, 1963. Directed by Stanley Donen (author's collection / Universal).

68: With Cary Grant in *Charade*, 1963. Directed by Stanley Donen. Photo by Vincent Rossell (The Kobal Collection / Universal).

70–71: With Cary Grant in *Charade*, 1963. Directed by Stanley Donen. Photo by Vincent Rossell (author's collection / Universal).

71: With Cary Grant in *Charade*, 1963. Directed by Stanley Donen. Photos by Vincent Rossell (author's collection / Universal).

73: *Charade*, 1963. Directed by Stanley Donen. © Universal Pictures (author's collection).

74: *Charade*, 1963. Directed by Stanley Donen (The Kobal Collection / Universal).

75: (strip) *Charade*, 1963. Directed by Stanley Donen. © Universal Pictures (author's collection).

76: *Charade*, 1963. Directed by Stanley Donen. Photo by Vincent Rossell (author's collection / Universal).

77: *Charade*, 1963. Directed by Stanley Donen (The Kobal Collection / Universal).

78–79: *Charade*, 1963. Directed by Stanley Donen. Photo by Vincent Rossell (author's collection / Universal).

81: *Charade*, 1963. Directed by Stanley Donen. Photo by Vincent Rossell (author's collection / Universal).

82: (strip) *Charade*, 1963. Directed by Stanley Donen. © Universal Pictures (author's collection).

82–83: *Charade*, 1963. Directed by Stanley Donen. © Universal Pictures (author's collection).

84: *Charade*, 1963. Directed by Stanley Donen (Photofest / Universal).

86–87: *Charade*, 1963. Directed by Stanley Donen (author's collection / Universal).

89: With Cary Grant in *Charade*, 1963. Directed by Stanley Donen (author's collection / Universal).

90: 1963 (The Kobal Collection).

91: 1963 (The Kobal Collection).

92–93: With photographers (Photofest).

Paris When It Sizzles 1964

94–95: *Paris When It Sizzles*, 1964. Directed by Richard Quine (Photofest / Paramount).

96: Paris, 1962 (Photofest).

98–99: With William Holden in *Paris When It Sizzles*, 1964. Directed by Richard Quine (The Kobal Collection / Paramount).

99: With William Holden in *Paris When It Sizzles*, 1964. Directed by Richard Quine. *Cosmopolitan* magazine cover (author's collection).

101: *Paris When It Sizzles*, 1964. Directed by Richard Quine. Photo by Bob Willoughby (© 1978 Bob Willoughby / mptvimages.com).

102–103: With Richard Quine. *Paris When It Sizzles*, 1964. Directed by Richard Quine (The Kobal Collection / Paramount).

104: *Paris When It Sizzles*, 1964. Directed by Richard Quine (Photofest / Paramount).

105: *Paris When It Sizzles*, 1964. Directed by Richard Quine (author's collection / Paramount).

106–107: With William Holden in *Paris When It Sizzles*, 1964. Directed by Richard Quine (author's collection / Paramount).

108–109: With William Holden in *Paris When It Sizzles*, 1964. Directed by Richard Quine (The Kobal Collection / Paramount).

111: *Paris When It Sizzles*, 1964. Directed by Richard Quine (Photofest / Paramount).

112–113: With William Holden in *Paris When It Sizzles*, 1964. Directed by Richard Quine (Photofest / Paramount).

115: *Paris When It Sizzles*, 1964. Directed by Richard Quine (The Kobal Collection / Paramount).

116: Outtake from session that originally appeared on the cover of *Ladies' Home Journal*, September 1963, and *Elle*, January 10, 1964. Photo by Howell Conant (Howell Conant / Bob Adelman Books, Inc. / www.bobadelman.net).

118–119: *Paris When It Sizzles*, 1964. Directed by Richard Quine (Photofest / Paramount).

My Fair Lady 1964

120: *My Fair Lady*, 1964. Directed by George Cukor. Photo by Cecil Beaton. Courtesy of the Cecil Beaton Studio Archive at Sotheby's.

122–123: *My Fair Lady*, 1964. Directed by George Cukor (author's collection / Warner Bros.).

124–125: *My Fair Lady*, 1964. Directed by George Cukor (author's collection / Warner Bros.).

126: *My Fair Lady*, 1964. Directed by George Cukor (author's collection / Warner Bros.).

127: *My Fair Lady*, 1964. Directed by George Cukor. Miscellaneous lobby cards (author's collection / Warner Bros.).

129: *My Fair Lady*, 1964. Directed by George Cukor (author's collection / Warner Bros.).

130: With Rex Harrison. *My Fair Lady*, 1964. Directed by George Cukor (author's collection / Warner Bros.).

133: "My Fair Lady" Audrey Hepburn 1963 / Warner Bros. Photo by Bob Willoughby (© 1978 Bob Willoughby / mptvimages.com).

134: With George Cukor. *My Fair Lady*, 1964. Directed by George Cukor (author's collection).

135: With George Cukor and Baroness Bina von Donnersmark Rothschild. *My Fair Lady*, 1964. Directed by George Cukor (author's collection).

136–137: With Rex Harrison in *My Fair Lady*, 1964. Directed by George Cukor (author's collection / Warner Bros.).

138–139: *My Fair Lady*, 1964. Directed by George Cukor. Photo by Cecil Beaton. Courtesy of the Cecil Beaton Studio Archive at Sotheby's.

140–141: With Sam on the set of *My Fair Lady*, 1964. Directed by George Cukor. Photo by Cecil Beaton. Courtesy of the Cecil Beaton Studio Archive at Sotheby's.

142–143: With Hedda Hopper at the *My Fair Lady* premiere, 1964. Photo by Chester Maydole (© 1978 Chester Maydole / mptvimages.com).

145: Audrey Hepburn officially launches the 15th anniversary UNICEF greeting card campaign in Madrid, Spain. August 15, 1964 (CSU Archives / Photofest).

Fashion 1962–1966

146–147: Audrey Hepburn wears a blue silk cocktail dress by Givenchy from Autumn 1966. Worn in 1967 to promote *Two for the Road*, 1966 (The Kobal Collection).

149: Audrey Hepburn, dress by Yves Saint Laurent, Paris studio, July 1962 © The Richard Avedon Foundation.

150–151: Audrey Hepburn seated on a pink floor, holding a white tulip, and wearing a pink chiffon evening dress with embroidered bands of pearls, gold beads, and appliquéd flowers at sleeve and skirt hems, by Givenchy. Matching pink shoes by Mancini; Photograph by Cecil Beaton; From the June 1, 1964, issue of *Vogue*; pages 70–71. (Beaton / *Vogue* / Condé Nast Archive. Copyright © Condé Nast).

153: Outtake from session that originally appeared on the cover of *Life*, April 20, 1962. Photo by Howell Conant (Howell Conant / Bob Adelman Books, Inc. / www.bobadelman.net).

154: Photos by Cecil Beaton, 1964. Courtesy of the Cecil Beaton Studio Archive at Sotheby's.

157: Audrey Hepburn covering portion of face with fabric from her sleeveless dress of silk, printed in shades of china blue. At the front, waist is slightly lifted, at the back, loose folds fall to a miniature train, by Givenchy; Photograph by Bert Stern; From the April 15, 1963, issue of *Vogue*; page 68. Stern / *Vogue* / Condé Nast Archive. Copyright © Condé Nast).

158–159: Close up profile of Audrey Hepburn wearing pink chiffon turban with white flower from Jaipur collection by Givenchy. Her head is tilted back so turban rests on ornate Indian metal table with tall slender metal tea server; Photograph by Cecil Beaton; From the June 1, 1964, issue of *Vogue*; pages 68–69. (Beaton / *Vogue* / Condé Nast Archive. Copyright © Condé Nast).

161: 1962. Photo by Howell Conant (Howell Conant / Bob Adelman Books, Inc. / www.bobadelman.net).

162–163: Outtake from session that originally appeared on the cover of *Vogue*, May 1963. Photo by Bert Stern (© Bert Stern / Bert Stern Productions Inc.).

164: Photo by Cecil Beaton, 1964. Courtesy of the Cecil Beaton Studio Archive at Sotheby's.

167: Photo by Cecil Beaton, 1964. Courtesy of the Cecil Beaton Studio Archive at Sotheby's.

168–169: Audrey Hepburn modeling a Cloqué silk evening dress by Givenchy; Photograph by Bert Stern; From the April 15, 1963, issue of *Vogue*; page 70. (Stern / *Vogue* / Condé Nast Archive. Copyright © Condé Nast).

170: Audrey Hepburn wears a blue silk cocktail dress by Givenchy from Autumn 1966. Worn in 1967 to promote *Two for the Road*, 1966 (The Kobal Collection).

172: "Audrey Hepburn at the Pret-à-Porter." *Vogue*, November 1966, pages 31 and 32. Photos by William Klein (Klein / *Vogue* / Condé Nast Archive. Copyright © Condé Nast).

173: Audrey Hepburn in an arrested twisting motion, swinging her hair, and wearing one-shouldered lamé dress with asymmetrical hemline, designed by Givenchy; coiffure by Alexandre; Photograph by William Klein; From the October 15, 1966, issue of *Vogue*; page 118. (Klein / *Vogue* / Condé Nast Archive. Copyright © Condé Nast).

How to Steal a Million 1966

174–175: *How to Steal a Million*, 1966. Directed by William Wyler (The Kobal Collection / 20th Century Fox Film Corporation).

176–177: November 1965, Studio de Boulogne, Paris, France. During the making of *How to Steal a Million* (© Douglas Kirkland / CORBIS. All Rights Reserved).

178–179: *How to Steal a Million*, 1966. Directed by William Wyler (20th Century Fox Photo Archive © 20th Century Fox Film Corporation).

180: (strip) *How to Steal a Million*, 1966. Directed by William Wyler. © 20th Century Fox Film Corporation (author's collection).

180–181: *How to Steal a Million*, 1966. Directed by William Wyler. Photo by Vincent Rossell (Photofest / 20th Century Fox Film Corporation).

182: *How to Steal a Million*, 1966. Directed by William Wyler (The Kobal Collection / 20th Century Fox Film Corporation).

183: *How to Steal a Million*, 1966. Directed by William Wyler (author's collection / 20th Century Fox Film Corporation).

184–185: With William Wyler. *How to Steal a Million*, 1966. Directed by William Wyler (World Wide / The Kobal Collection / Terry O'Neill).

186–187: November 1965, Studio de Boulogne, Paris, France. During the making of *How to Steal a Million* (© Douglas Kirkland / CORBIS. All Rights Reserved).

189: With Peter O'Toole in *How to Steal a Million*, 1966. Directed by William Wyler (author's collection / 20th Century Fox Film Corporation).

189: With Peter O'Toole in *How to Steal a Million*, 1966. Directed by William Wyler (The Kobal Collection / 20th Century Fox Film Corporation).

190: *How to Steal a Million*, 1966. Directed by William Wyler (The Kobal Collection / 20th Century Fox Film Corporation).

191: (strip) *How to Steal a Million*, 1966. Directed by William Wyler. © 20th Century Fox Film Corporation (author's collection).

192–193: *How to Steal a Million*, 1966. Directed by William Wyler (20th Century Fox Photo Archive © 20th Century Fox Film Corporation).

194: *How to Steal a Million*, 1966. Directed by William Wyler (The Kobal Collection / 20th Century Fox Film Corporation).

195: *How to Steal a Million*, 1966. Directed by William Wyler (The Kobal Collection / 20th Century Fox Film Corporation).

196–197: *How to Steal a Million*, 1966. Directed by William Wyler (The Kobal Collection / 20th Century Fox Film Corporation).

198: With Peter O'Toole in *How to Steal a Million*, 1966. Directed by William Wyler (The Kobal Collection / 20th Century Fox Film Corporation).

199: *How to Steal a Million*, 1966. Directed by William Wyler (20th Century Fox Photo Archive © 20th Century Fox Film Corporation).

200: 1965 (author's collection).

202: *How to Steal a Million*, 1966. Directed by William Wyler. Costume test (20th Century Fox Photo Archive © 20th Century Fox Film Corporation).

203: *How to Steal a Million*, 1966. Directed by William Wyler (author's collection / 20th Century Fox Film Corporation).

204–205: With William Wyler. *How to Steal a Million*, 1966. Directed by William Wyler (20th Century Fox Photo Archive © 20th Century Fox Film Corporation).

207: *How to Steal a Million*, 1966. Directed by William Wyler (Photofest / 20th Century Fox Film Corporation).

208–209: With makeup artist Alberto de Rossi. *How to Steal a Million*, 1966. Directed by William Wyler (author's collection).

210–211: Miscellaneous magazine covers (author's collection).

Two For The Road 1967

212–213: *Two for the Road*, 1967. Directed by Stanley Donen. "Rugby" dress by Mary Quant (author's collection / 20th Century Fox Film Corporation).

214–215: With Albert Finney in *Two for the Road*, 1967. Directed by Stanley Donen (The Kobal Collection / 20th Century Fox Film Corporation).

216: (strip) *Two for the Road*, 1967. Directed by Stanley Donen. Dress by Mary Quant. © 20th Century Fox Film Corporation (author's collection).

217: *Two for the Road*, 1967. Directed by Stanley Donen. Dress by Mary Quant (The Kobal Collection / 20th Century Fox Film Corporation).

218: *Two for the Road*, 1967. Directed by Stanley Donen. Vinyl slack suit by Michele Rosier / V de V (The Kobal Collection / 20th Century Fox Film Corporation).

220: *Two for the Road*, 1967. Directed by Stanley Donen. Vinyl slack suit by Michele Rosier / V de V (Margaret Herrick Library, The Academy of Motion Picture Arts and Sciences / 20th Century Fox Film Corporation).

221: *Two for the Road*, 1967. Directed by Stanley Donen. Vinyl slack suit by Michele Rosier / V de V (Margaret Herrick Library, The Academy of Motion Picture Arts and Sciences / 20th Century Fox Film Corporation).

222: (strip) *Two for the Road*, 1967. Directed by Stanley Donen. "Rugby" dress by Mary Quant. © 20th Century Fox Film Corporation (author's collection).

222–223: *Two for the Road*, 1967. Directed by Stanley Donen. "Rugby" dress by Mary Quant (author's collection / 20th Century Fox Film Corporation).

224: *Two for the Road*, 1967. Directed by Stanley Donen. Costume test—swimsuit by Ken Scott (20th Century Fox Photo Archive © 20th Century Fox Film Corporation).

225: *Two for the Road*, 1967. Directed by Stanley Donen. Costume test (20th Century Fox Photo Archive © 20th Century Fox Film Corporation).

226: *Two for the Road*, 1967. Directed by Stanley Donen. Swimsuit by Ken Scott (author's collection).

227: With Stanley Donen. *Two for the Road*, 1967. Directed by Stanley Donen. Swimsuit by Ken Scott (author's collection).

228: *Two for the Road*, 1967. Directed by Stanley Donen. Swimsuit by Ken Scott. Photo by Pierluigi Praturlon (Reporters Association, Rome).

229: *Two for the Road*, 1967. Directed by Stanley Donen. Swimsuit by Ken Scott. Photo by Pierluigi Praturlon (Reporters Association, Rome).

230–231: 1967. Ban-Lon print dress by Ken Scott (20th Century Fox Photo Archive © 20th Century Fox Film Corporation).

232: *Ladies' Home Journal*, January 1967, pages 62 and 63. Photos by William Klein (author's collection).

233: *Two for the Road*, 1967. Directed by Stanley Donen. Silk jersey dress by Ken Scott (The Kobal Collection / 20th Century Fox Film Corporation).

234: *Two for the Road*, 1967. Directed by Stanley Donen. "Rugby" dress by Mary Quant (20th Century Fox Photo Archive © 20th Century Fox Film Corporation).

235: *Two for the Road*, 1967. Directed by Stanley Donen. Silk jersey dress by Ken Scott (20th Century Fox Photo Archive © 20th Century Fox Film Corporation).

236–237: Audrey Hepburn swimming in the South of France during the filming of *Two for the Road*. 4th September 1966 (Photo by Terry O'Neill / Getty Images).

238: (strip) *Two for the Road*, 1967. Directed by Stanley Donen. "Unwearable" dress by Paco Rabanne. © 20th Century Fox Film Corporation (author's collection).

239: *Two for the Road*, 1967. Directed by Stanley Donen. "Unwearable" dress by Paco Rabanne (Margaret Herrick Library, The Academy of Motion Picture Arts and Sciences / 20th Century Fox Film Corporation).

240–241: Lobby Card. *Two for the Road*, 1967. Directed by Stanley Donen. "Unwearable" dress by Paco Rabanne. © 20th Century Fox Film Corporation (author's collection).

242: *Two for the Road*, 1967. Directed by Stanley Donen. "Unwearable" dress by Paco Rabanne (20th Century Fox Photo Archive © 20th Century Fox Film Corporation).

243: *Two for the Road*, 1967. Directed by Stanley Donen. "Unwearable" dress by Paco Rabanne (20th Century Fox Photo Archive © 20th Century Fox Film Corporation).

244–245: Audrey Hepburn, 1966. Photo by Pierluigi Praturlon (Reporters Association, Rome).

247: Presenting producer Fred Zinnemann with the Oscar® for Best Picture for *A Man for All Seasons* at the 39th annual Academy Awards® in 1967. Introduced by Bob Hope (author's collection).

Wait Until Dark 1967

248–249: *Wait Until Dark*, 1967. Directed by Terence Young (The Kobal Collection / Warner Bros.).

250–251: *Wait Until Dark*, 1967. Directed by Terence Young (The Kobal Collection / Warner Bros.).

252–253: With Richard Crenna in *Wait Until Dark*, 1967. Directed by Terence Young (The Kobal Collection / Warner Bros.).

254: *Wait Until Dark*, 1967. Directed by Terence Young. Miscellaneous lobby cards (author's collection / Warner Bros.).

255: With Alan Arkin in *Wait Until Dark*, 1967. Directed by Terence Young (author's collection / Warner Bros.).

256–257: *Wait Until Dark*, 1967. Directed by Terence Young (The Kobal Collection / Warner Bros.).

258–259: *Wait Until Dark*, 1967. Directed by Terence Young (author's collection / Warner Bros.).

260: Photo by Bud Fraker, 1967 (The Kobal Collection).

261: 1967 (author's collection).

263: Photo by Bud Fraker, 1967 (author's collection).

264: Photo by Bud Fraker, 1967 (author's collection).

266–267: Arriving at the 40th annual Academy Awards® in 1968 to present Rod Steiger with the Best Actor Oscar® for his performance in In the *Heat of the Night* (author's collection).

270–271: Photo by Bud Fraker, 1967 (author's collection).

Back Cover

Breakfast at Tiffany's, 1961. Directed by Blake Edwards. Photo by Bud Fraker (author's collection / Paramount).

ACKNOWLEDGMENTS

Emanuela Acito, Russell Adams, Bob Adelman, Susan Bernard, Lina Bey, Carolyn Bodkin, Doris Brynner, Charles Casillo, David Chierichetti, David Croland, Susan Davis, Lauretta Dives, Michael Epstein, Oscar Espaillat, Laura Ex, Jose Fuentes, Joe Gonzalez, Kim Goodwin, Chris Green, Genevieve Haverstick, Moira Heffernan, Andrew Howick, Independent Visions, Jamie Kabler, Dave Kent, Glenn Kawahara, William Klein, Lisa Lavender, Joanna Ling, Neeraja Lockart, Katherine Marshall, Jeffrey McCall, Alan Mercer, Leigh Montville, Paul Morrissey, Christopher Nesbit, Julie Newmar, Mauricio Padilha, Roger Padilha, Tiffanie Pascal, Siouxzan Perry, Adam Peters, Danniel Rangel, Paul Roth, Lawrence Schiller, Loretta Schmidt, Reynold Schmidt, Scott Schwimer, Aaron Siegel, Ramona Sliva, Jim Sorensen, Bert Stern, Victory Tischler-Blue, Sabrina Tomasi, Isabel Torres, Miyuki Tsushima, Trina Turk, Jamie Vuignier, Veruschka, Shawn Waldron, Nina Wiener, Trish Whittaker, Fay Wills, Ralph Wills.

David Wills and Stephen Schmidt would like to give special thanks to Calvert Morgan, Kevin Callahan, Mallory Farrugia and Susan Kosko at HarperCollins Publishers, Stan Corwin, Evan Macdonald, Douglas Kirkland, Françoise Kirkland, Howard Mandelbaum at Photofest, Andy Bandit and Jeff Thompson at Twentieth Century Fox, James Martin and Michelle Franco at The Richard Avedon Foundation, Steven Meisel, and Sean Hepburn Ferrer, Luca Dotti, Paul G. Alberghetti, and Ellen Fontana at The Estate of Audrey Hepburn.

REFERENCES

5th Avenue, 5 am: Audrey Hepburn, Breakfast at Tiffany's, and the Dawn of the Modern Woman, Sam Wasson. Harper Studio / HarperCollins, New York, 2010.

A Splurch in the Kisser: The Movies of Blake Edwards, Sam Wasson. Wesleyan University Press, Middletown, Connecticut, 2009.

A Talent for Trouble, Jan Herman. G. P. Putnam's Sons, New York, 1995.

Audrey Hepburn, Barry Paris. Berkeley Books, New York, 1996.

Audrey Hepburn: A Biography, Warren G. Harris. Wheeler Publishing, New York, 1994.

Audrey Hepburn, An Elegant Spirit: A Son Remembers, Sean Hepburn Ferrer. Atria Books, New York, 2003.

Audrey Hepburn in Breakfast at Tiffany's and Other Photographs, Howell Conant. Schirmer / Mosel, Germany, 2007.

Audrey: Her Real Story, Alexander Walker. St. Martin's Griffin, New York, 1994.

Breakfast at Tiffany's: A Short Novel and Three Stories, Truman Capote. Modern Library / Random House, New York, 1994.

Dancing on the Ceiling: Stanley Donen and His Movies, Stephen M. Silverman. Alfred A. Knopf, Inc. New York, 1996.

Dressed, Deborah Nadoolman-Landis. HarperCollins Publishers, New York, 2007.

Edith Head, David Chierichetti. HarperCollins Publishers, New York, 2003.

From Reverence to Rape: The Treatment of Women in the Movies, Molly Haskell. Holt, Rhinehart & Winston, New York, 1974.

George Cukor: Interviews, edited by Robert Emmet Long. University Press of Mississippi / Jackson, 2001.

Growing Up with Audrey Hepburn, Rachel Moseley. Manchester University Press, Manchester, UK, 2009.

Holding My Own in No Man's Land: Women and Men and Films and Feminists, Molly Haskell. Oxford University Press, New York, 1997.

How to be Lovely: The Audrey Hepburn Way of Life, Melissa Hellstern. Dutton / Penguin Group, New York, 2004.

I'll Have What She's Having: Behind the Scenes of the Great Romantic Comedies, David M. Kimmel. Ivan R. Dee, Chicago, 2008.

Light Years, Douglas Kirkland. Thames and Hudson, New York, 1989.

Obsessed by Dress, Tobi Tobias. Beacon Press, Boston, 2000.

Rex: An Autobiography, Rex Harrison. Macmillan, New York, 1974.

Stanley Donen, Joseph Andrew Casper. The Scarecrow Press, Inc. Metuchen, N.J., and London, 1983.

William Wyler, Alex Madsen. Thomas Y. Crowell Company, New York, 1973.

Internet references: hepburntribute.com, goodreads.com, imdb.com

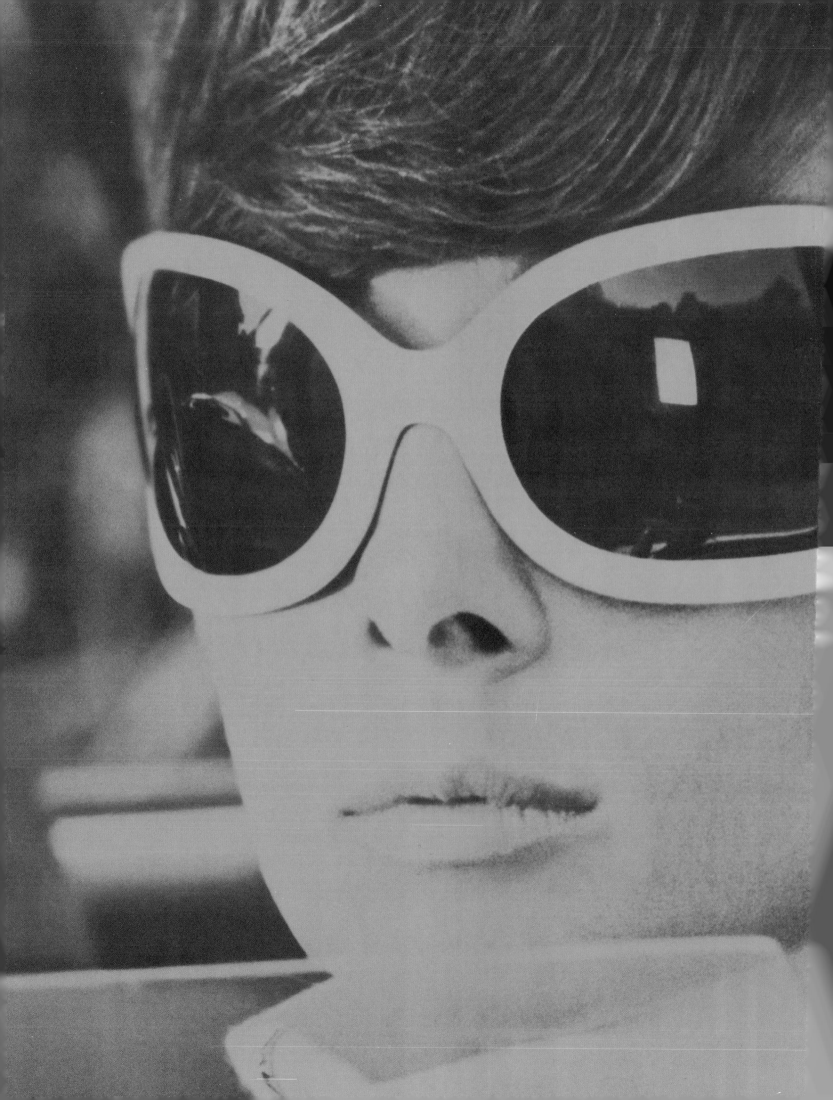